Hit the Road

**Vans, Nomads and
Roadside Adventures**

gestalten

YOU WILL FIND IT ON THE ROAD

Experiences on the road and out in the wild leave lasting memories, not our sedentary days or the things we consume. Conversations with new people leave us nourished. Seeing new places and learning new things awaken our minds. And, perhaps most importantly, fresh air and a natural engagement with the planet on which we have the privilege to live are vital. This volume presents adventurers who are just like everyone else. They had a dream—or they had enough—and when that small seed they planted was ready to sprout, they grabbed their gear and went out to play, whether for a weekend, a long holiday, a round-the-world trip, or a lifetime. Many of them say the same thing: if you're even thinking of doing it, just go for it. All you need is the vehicle, bus, or truck—a trusty companion to take you on your way. And that's not to say it's always smooth sailing. The travelers we introduce have had their fair share of challenges—money to save, wheels to put back on again and again. But there is one certainty across each and every journey: it was worth it.

Chris Scott, author of the *Overlanders' Handbook* and many more, has been traveling the Sahara since 1982–by motorcycle, bush taxi, truck, 4×4, and camel caravan. He's an adventure travel writer and a true adventurer himself.

Know Your Purpose

The harsh realities of living on the road—with no bricks or mortar, shops, hospitals, running water, or even the ambient city buzz—take some getting used to, but ultimately the city pales in comparison to the joys of wandering freely out in the world. Freedom and minimalism seem to be the first words on the lips of overland drivers, some shared sense that consumerism and the rat race are lacking in qualities fundamental to real human progress. If van lifers are the new Lost Generation, maybe it's because the younger you are, the more work you're expected to do for less these days, work that seems increasingly devoid of meaning or purpose.

Whether you're just in it for the beachside selfies, or are looking to turn away for a while from society and its inherent problems—broken labor or education systems are common push factors—living on the road can be quite natural. Nomadic life has been *de rigueur* since the beginning of human history and well into the industrialized age; it's how the West was won. You don't have to go back 10,000 years to hunter-gatherer times to find healthy, happy families moving from place to place, following the seasons, and simply exploring this incredible planet. People have always lived this way, and you can, too: cruising the highways and byways in your jalopy, seeing something new every day, and finding communities beyond the reaches of neoliberal economics. Moving seasonally may not be a grossly profitable use of your time or labor in this competitive world, but with a laptop, a 4G Wi-Fi stick, and a reliable motorhome, you can certainly make it work for you. →

Pick a Direction

The most important decision usually comes first: the destination. The initial choice is often determined by instinct or images stored in our subconscious—namely, those that promise breathtaking landscapes, wildlife, adventure, or exotic cultures. It can also be an arbitrary choice for those who subscribe to the idea that the journey itself is the reward. Those who travel from affluent Western countries to Africa, Asia, or South America often do so intending to find "true adventure," while others opt to travel the developed world with its paved roads, abundant espresso, and reliable 4G. The in-between places, like Turkey, Morocco, or Mexico, are a satisfying mix of both worlds: tough for first-timers but safer than getting lost in the wilderness. In a nutshell: understand what you want, then do your research. Africa south of the Sahara can be a challenge of chaotic capitals, costly wildlife parks, visas, and detours around volatile borders, but it's still the definitive overland adventure. Asia is enormously diverse in geography, culture, and cuisine, and abounds in relics of bygone kingdoms and empires. South America is perhaps the least demanding frontier zone in terms of language, paperwork, and infrastructure but is still—from the Amazon to the Andes—as scenically diverse as anywhere on Earth.

Plan Ahead

Choosing a vehicle and setting a provisional departure date will depend on available funds and the time needed to ready your machine. Expect delays but don't skimp on the details: the more effort you put in at this stage in terms of research, paperwork, and vehicle preparation, the fewer frustrations you'll experience later. Allow a year if you're starting without a vehicle, half that if you already have one. Buying and equipping a van, truck, or bus can cost more than the trip itself; don't assume road travel in poorer countries is inexpensive. Cooking and sleeping aboard will certainly cut costs and is a major part of the adventure. Apart from the occasional shipping charge, fuel will almost certainly be your greatest expense, so budget on €1 a liter and at least €10,000 for two people to cross any one continent. Plus, consider the costs of shipping your vehicle back if that's part of the plan. CNG or vegetable oil conversions can cut costs on thirsty engines, too.

Choose Wisely

Be it a jacked-up Jeep, a Kombi running on veggie oil, a seven-ton school bus, or a rusting hatchback, your overlander is going to be the foundation of your adventure and the only thing you'll have to rely on besides your fellow traveler/s. So don't be rash and don't necessarily assume you'll need a 4×4. Thanks to initiatives like the Chinese One Belt One Road seeking to asphalt roads like buttered toast across the developing world, the need for an all-terrain machine is not nearly as critical today. But exploring deserted dirt roads and finding sacred, untouched vistas will probably top the list of your trip's life-changing moments, so think long and hard about this one.

Your vehicle will be both home and transportation, so important considerations include your budget, how many will be traveling and for how long, space, mechanical simplicity, costs to modify and equip your rig, payload ratings, ground clearance, and size in relation to shipping containers. Get air-conditioning; you'll appreciate it when gridlocked in Lima's rush hour. And if temperatures drop, it's nice to have a preheater running on fuel or diesel for the very cold nights. A 4×4 station wagon is a common choice. There are plenty around and they look the part, but the once crude if solid 4×4s like the iconic Land Rover Defender have unfortunately evolved into staggeringly sophisticated SUVs with an electronic answer for everything. Rattle around Africa for long enough in one of these and the dash will light up like a Christmas tree with error codes. Campervans or motorhomes make sense, but good ones are either costly or unsuited to the rigors of overloading. A simpler travel van you assembled yourself means you can also fix it yourself.

Think like a farmer, not a pampered CEO. What matters is comfort, economy, and durability—and a regular car or van can still tick those boxes. Diesel used to be the fuel of choice but modern, supposedly low-emission engines are not suited to the high-sulfur

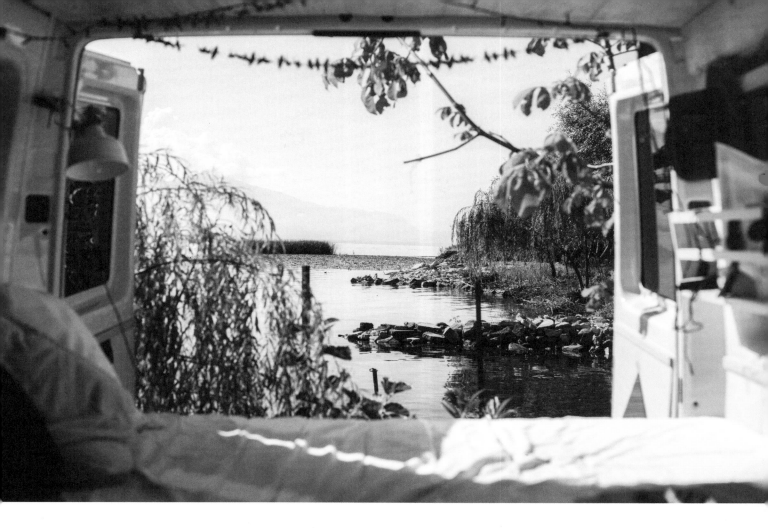

diesel found in poorer countries. Gasoline engines are thirstier but easier to fix, and unleaded fuel is now abundant worldwide, even if octane levels vary. Once you have your vehicle, modify it pragmatically with a few key upgrades like firmer and slightly raised suspension, as it'll be permanently loaded. Fit new consumables like off-road tires, clutch, drive belts, radiator hoses, brakes, and exhaust; replacements will be hard to find in Samarkand or Ouagadougou.

Make It a Home

Now, equip your rig as a place to cook, sleep, wash, work, and hang out. Visualize how you'll interact with the space and systems: core tasks like water, cooking, and sleep should be seamless. Take ideas from motorhome and sailboat designers; they worked it out years ago. Sleeping is the main issue; bedding down inside feels secure and cozy in cold environments but can be stuffy and cramped otherwise. Ensure beds deploy with minimum effort, as you may be doing it daily. A self-erecting

rooftop tent is airier, but a regular tent can go anywhere. And you're not backpacking anymore, so go big. Invest in solar panels; you'll need electricity for your lights, laptop, stereo, and phones. Cooking is best done al fresco using bottled gas, which you can buy and refill wherever you are, so add low-draw LED lighting inside and out to ease whipping up those meals in the dark. Or, stay inside in a big rig, where a propane tank comes built-in. With the cost, space, and power demands, a fridge can be considered a luxury while a cooler costs peanuts. The same goes for water: built-in pumps and sinks are nice, but a gravity feed into a washing-up bowl is bombproof. Gear is best packed on the floor in crates below a semi-fixed platform rather than in rattly side cupboards. Think about accessibility: tools and spares can be buried, but daily items must always be handy. Home-kit roller-draw systems look sleek, but plastic crates or banana boxes cost little to nothing. When you're done, schedule a test run for a taste of life on the road without the commitment; you're sure to pinpoint some oversights and refinements. →

Hit the Road

The big day has arrived, but Cape Town, Vladivostok, or Ushuaia suddenly feel very far away. You'll probably be frazzled no matter how organized you are, so it helps to think in short stages. Park over the first border for a couple of days and reappraise, fiddle about, or just chill out. The world's been around for 4.5 billion years—it can wait another week. Allow anxiety to become excitement: you're finally on the road and living the life! Driving styles abroad may be challenging, so even after you've acclimatized, take it easy and avoid congested cities. And try not to take things personally: in places like India, fighting the roadside madness will exhaust you. Within reason, it's better to ditch your rules and emulate local practices—you'll find it truly liberating.

GPS mapping is a great resource but paper maps are still the only tried and true way to give you the big picture. Recognize what you don't know and ask locals. Getting lost is all part of the adventure, so switch on the "Avoid Motorways" function, sit back, and think positive: you'll get to where you want to be, eventually.

Overlanding gives you the freedom to pull off the asphalt and park wherever you want with everything you need for a memorable evening of local wine, cheese, and stories under the stars. For the sake of security, aim to park up before dark, well away from borders and out of sight of highways and housing developments. This is where a raised vehicle or a 4×4 can be useful. Wait a bit before setting up tents and starting campfires, and if you're unsure, move on.

Obtaining visas will always affect routes and timing, especially in parts of Central Asia and in Sub-Saharan Africa. You can, or must, get some visas in your home country; get others on the road or at borders. Researching the latest visa rules takes time; ensure you have a few years validity on your passport, and keep online and paper copies of vital documents including travel insurance and bank cards. Use ATMs and pay with cash for goods and services; you'll be less vulnerable to cloning or other scams.

Besides your vehicle ownership document, you might need a Carnet de Passages en Douane (CPD). Most countries issue temporary vehicle importation permits (TVIP) at the border, but those that don't, like Egypt and others in East Africa and South Asia, demand a CPD, which can require a bond up to eight times the value of your vehicle. Lately the Carnet business has been passed from national motoring organizations to private companies with the usual increase in costs, so be warned. Motor insurance you buy as you go—or go without and drive carefully.

Your first scary border looms on the horizon. It might be Russia or Iran, Guatemala or Mauritania. You'll encounter baffling forms, a new currency, cryptic fees, the wrong queue, and stern officials who ignore you. It's a game and the key is patience and vigilance. Thousands have come before you; you too shall pass. At most land borders the sequence is as follows: police stamp passport, customs perform a search and issue a TVIP, money is changed, and insurance is purchased. Arrive early to get away before dark, and learn to read these situations and people; it's all part of becoming an overland master. Bribes can be either a hustle or a trivial ritual that keeps things moving. You'll learn to spot the difference.

Requiring medical care abroad can be frightening, but should be covered by proper travel insurance. The feared robberies, gang violence, terrorism, plagues, or attacks by venomous creatures are rare, but plan for the worst regardless. Just as in your home, the highest-risk area in the van will be the kitchen, so cook outside on a secure, spacious table with good lighting. And carry your vehicle's workshop manual: road accidents are usually bumps and scrapes rather than outright wipeouts, so you will generally be the on-hand mechanic. Approach roadside vehicle repairs systematically and well away from passing traffic, with lights and signage clearly visible to other motorists. And never work under a jacked-up vehicle without added support.

Reverse Culture Shock

Setting off on an overland adventure is one of the most daunting and exhilarating experiences you'll ever have. The key is sound preparation as you roll with the excitement. Keep your caution and euphoria in balance, and you'll be set. Back home in your cubicle when it's all over, you can guarantee most people will be more interested in their new iPhone than your tales of cross-border shenanigans, mountaintop epiphanies, or the incredible fish burritos you had in Zihuatanejo. Don't worry, it's common to feel alienated as you adjust back into everyday life. It's called reverse culture shock and if it persists, perhaps a permanent change of lifestyle is in order. Remember: the only way to win the rat race is not to take part at all. And take solace in the fact that as strangers in a strange land, the biggest surprise that overland travelers regularly report is the overwhelming warmth, generosity, and kindness of ordinary people. This is the vastly underreported but true nature of humanity; you may not see it now—but you will find it on the road. ■

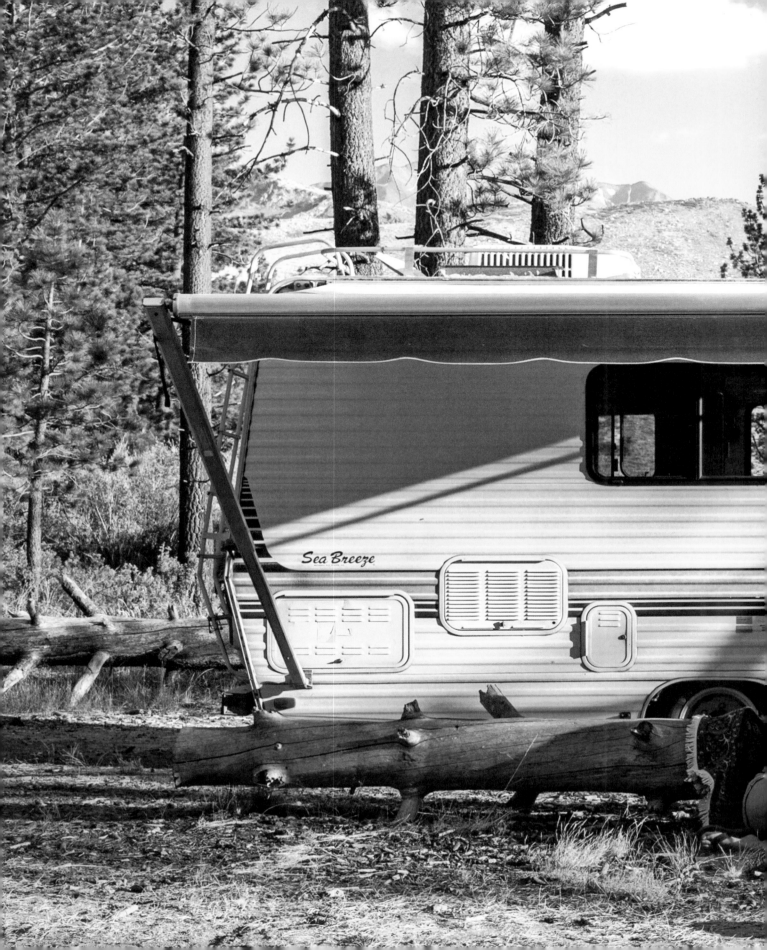

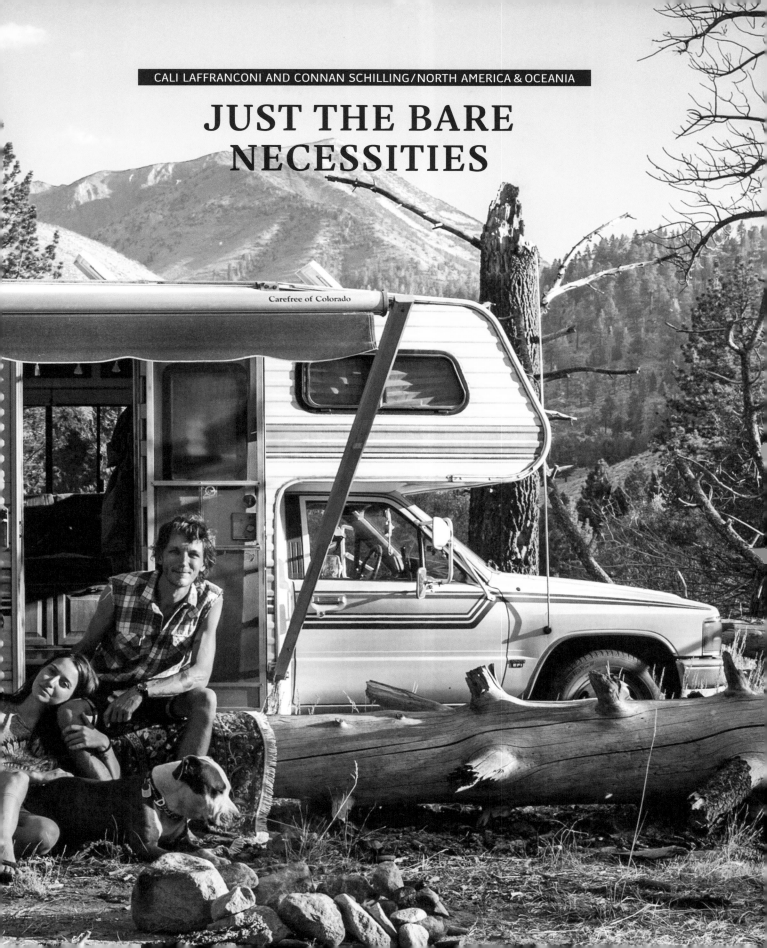

JUST THE BARE NECESSITIES

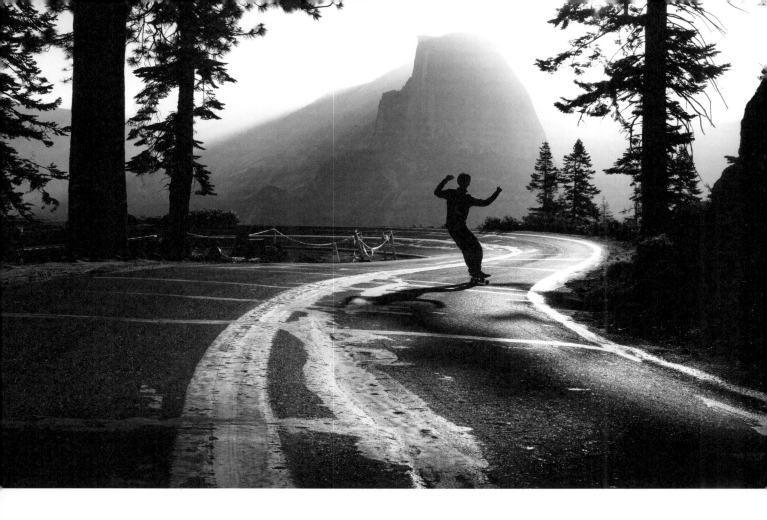

Downhill skating,
Glacier Point,
Yosemite National
Park (*above*).
Moments before
hitting the road
for the first time
(*right*). Redwood
National Park
(*opposite top*). Bali,
Richardson Grove
(*opposite bottom*).

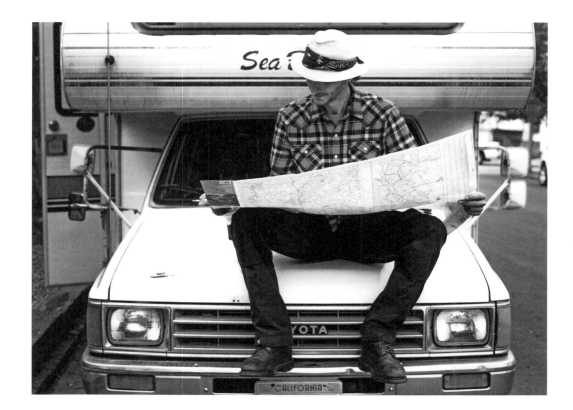

→ We are Nomads

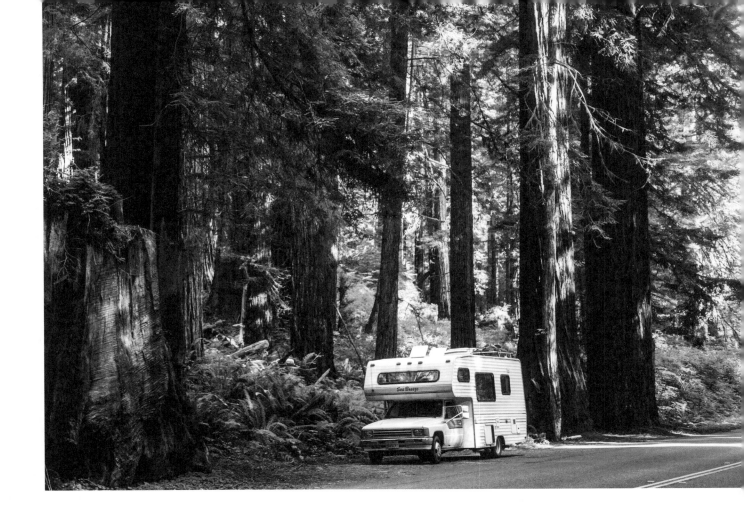

rgentine couple Cali Laffranconi and Connan Schilling had already experimented with minimalism, so when considering the right vehicle for what would eventually be a 18,500-mile (30,000 km) American odyssey, they knew they wanted space. "We took off to Australia soon after we met, hitchhiking and sleeping in the bush for three months in our beat-up tent," share the couple. "Then we came home, got a VW bus, and took off for a 15-day test drive in Patagonia, where we ended up staying for 10 months. When we blew up its (second) engine, we flew to California for a roadworthy vehicle." Their classic 1987 Toyota Sea Breeze pickup fit the bill. Built to last, the cubic holidaying roadhouse sleeps five and rivals any RV. After minimal work—some fresh paint, timber flooring, and new curtains—they were set.

"We toured the West Coast and southwestern United States, Mexico, and Canada for 15 months," they say, "realizing that where we call home is really wherever we are, just letting ourselves travel indeterminately all day until we're tired. Everything we own right now adds up to 90 kilograms and is there in the van." →

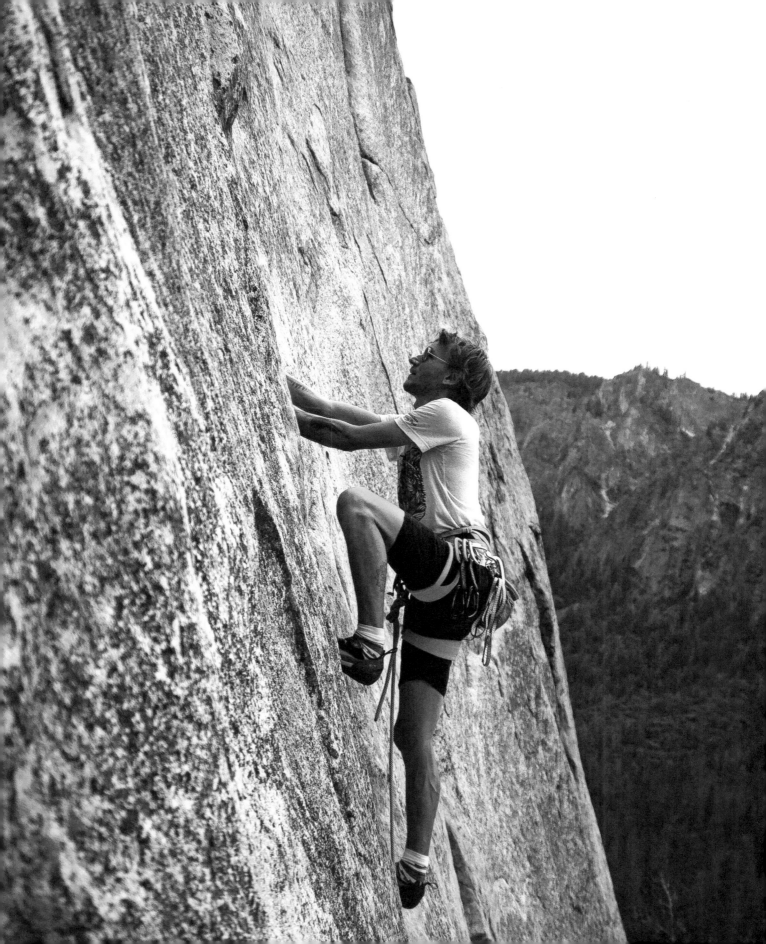

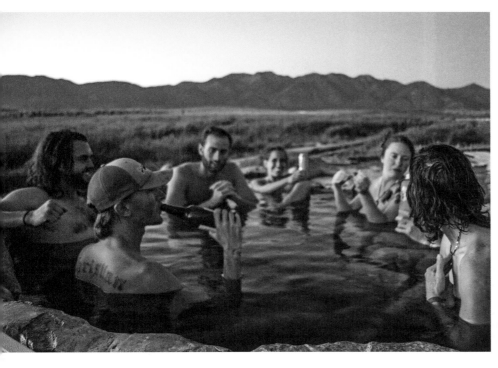

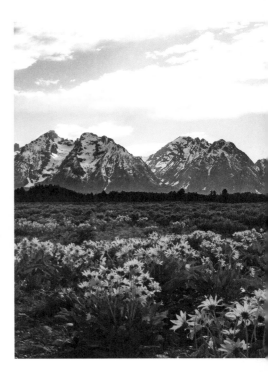

Wild Willy's Hot Springs *(above)*. Grand Teton National Park *(right)*. Kings Canyon National Park *(below)*. The Nose of El Capitan, Yosemite National Park *(opposite)*.

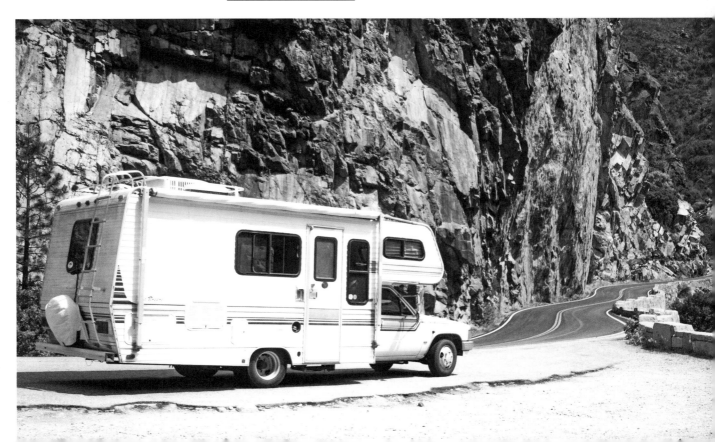

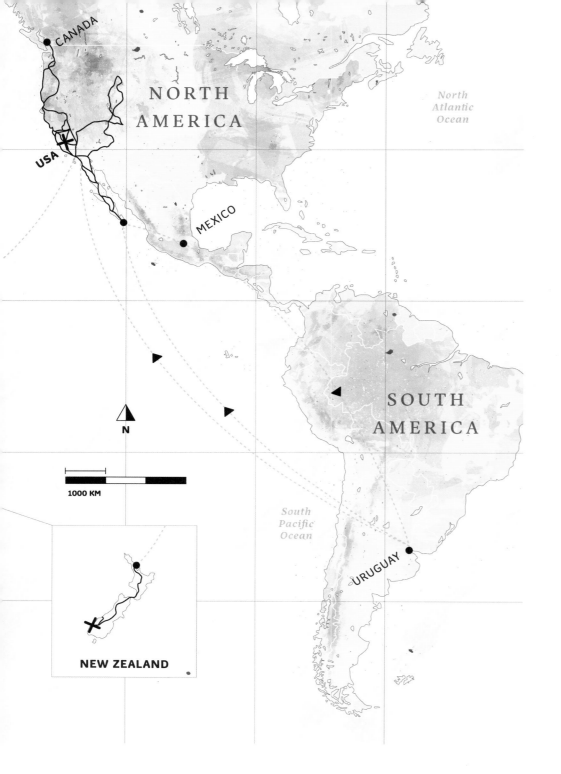

NORTH AMERICA

North Atlantic Ocean

CANADA

USA

MEXICO

SOUTH AMERICA

South Pacific Ocean

URUGUAY

N

1000 KM

NEW ZEALAND

It's a match: the Sea Breeze resting at the Historic Route 66 Motel in Arizona (above).

In Mexico, Cali and Connan's rescued Nicaraguan pit bull, Bali, developed a fast-growing cancer that killed her within two days. They were devastated, as she had accompanied them on their travels across seven countries. At that point, they decided to visit New Zealand, where the strict animal-control laws had precluded a trip before. Securing a 1992 Nissan Urvan backpacker wagon, they've devoted a year to cruising the mountainous New Zealand archipelago. Up next: Europe, where they will find a new van to permanently call home, rather than buying and selling on each new continent. ∎

14

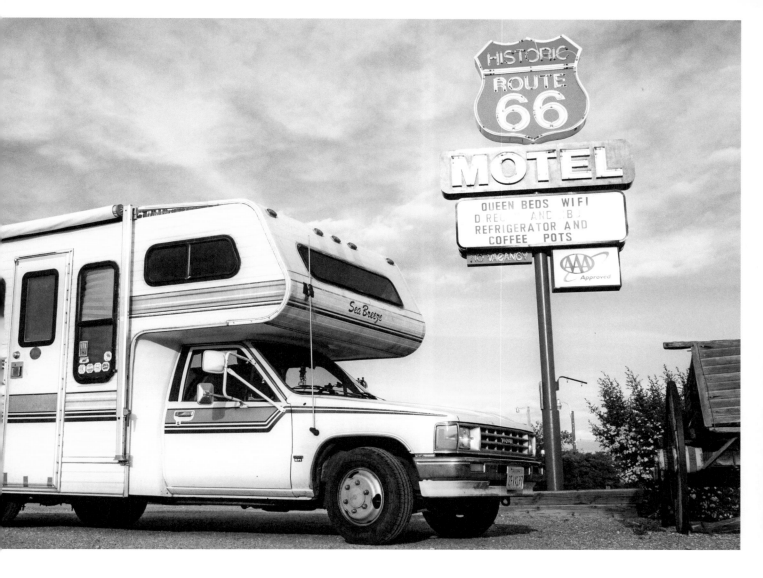

TOYOTA HILUX SEA BREEZE

As RV fever swept America in the 1970s and 1980s, more people sought to take to the roads affordably. Recognizing this, Toyota brought their fourth-generation Hilux to companies like Winnebago, Coachmen, and Chinook to be converted into mini motorhomes with one of five different interior arrangements. Known as the Sea Breeze, Cali and Connan's 1987 model is equipped with a reliable and fuel efficient 2.4-liter inline-four, which was originally rated at 106 horsepower. Their fully rebuilt interior, complete with paint, wood floors, and toilet, comfortably seats five people along with their travel gear.

MANUFACTURER: Toyota
MODEL: Hilux
YEAR OF PRODUCTION: 1987
ENGINE: 2.4 L straight four, 105 hp
TRANSMISSION: Automatic
VISITED COUNTRIES: United States (California, Oregon, Washington,

Arizona, Utah, Idaho, Montana, Wyoming, and Nevada), Mexico (Baja California Norte and Sur), and Canada (British Columbia)
MILES IN TOTAL: 18,300 miles
TRAVEL TIME: 15 months
REBUILD—YEAR: 2016
REBUILD—BODYWORK MODIFICATIONS: Cabin from National RV "Sea Breeze"

REBUILD—CHASSIS MODIFICATIONS: Stock
REBUILD—INTERIOR MODIFICATIONS: Fresh paint, wood floor, new curtains, toilet
REBUILD—OTHER MODIFICATIONS: Cold air intake and took of the generator for extra storage space outside
REBUILD—SUPPORT BY: Connan's brother in Mammoth Lakes

15

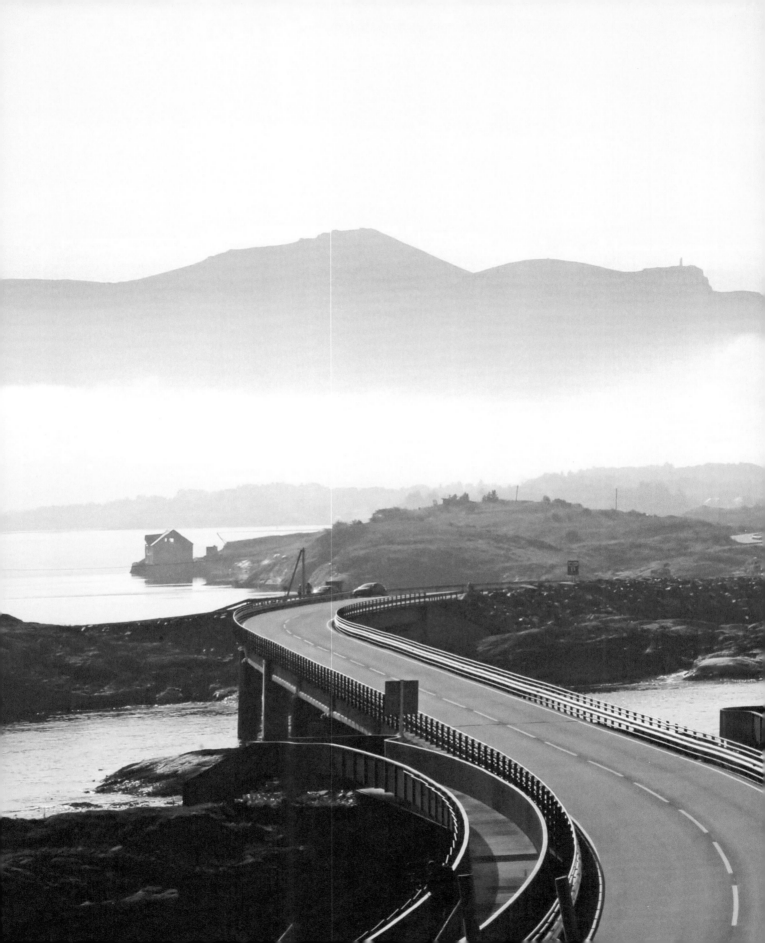

ANA DOMÍNGUEZ PÉREZ
AND MARCO ALONSO/EUROPE

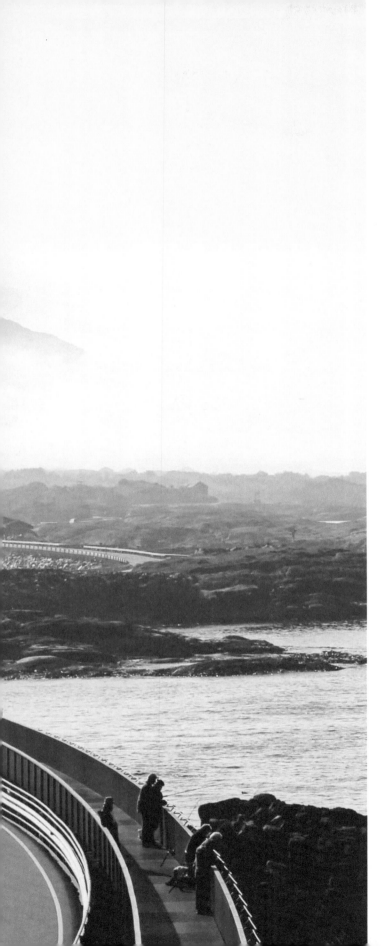

CONTINENTAL DRIFT: LEAVING NO STONE UNTURNED

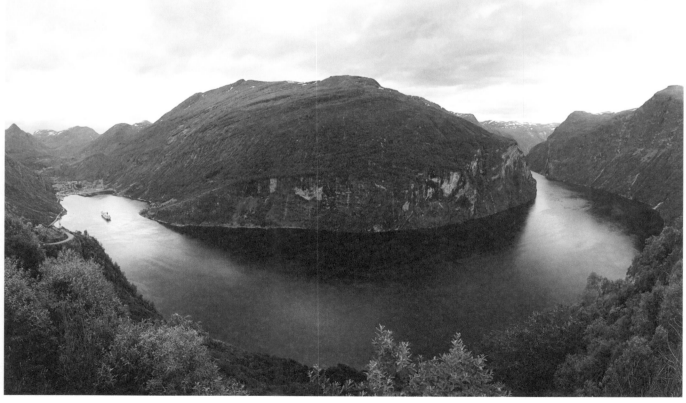

→ Road for Greta

V olkswagen dominated road culture in the mid-twentieth century. The 1960s counterculture adopted the Type 2 (the internal name for the second model developed by Volkswagen) Kombi, or "Hippie Bus," as its own. These days it is the Type 2 (known in Europe as the T3—the third generation of the bus) of the eighties generation, the Syncros and Westfalias, or Vanagons in the United States, that are back in vogue.

When filmmaking couple Marco Alonso and Ana Domínguez Pérez met in 2009, they hit the road in a weary Ford Focus hatchback that had just enough room for two once a kitchenette and blow-up mattress were installed. Marco's Volkswagen-devoted dad, believing he had raised a VW lover, watched with great alarm. He soon gifted them an impressive upgrade: a special edition 1989 T3 Multivan Magnum, festooned with every catalog extra imaginable in the late 1980s, such as a digital clock, rear windshield wiper, and tachometer.

When the van was stolen five years later on the streets of Rome, the couple managed to find another T3 they soon embraced: Greta. A meticulously cared for pop-up turbo-diesel 1987 Multivan from Stuttgart, →

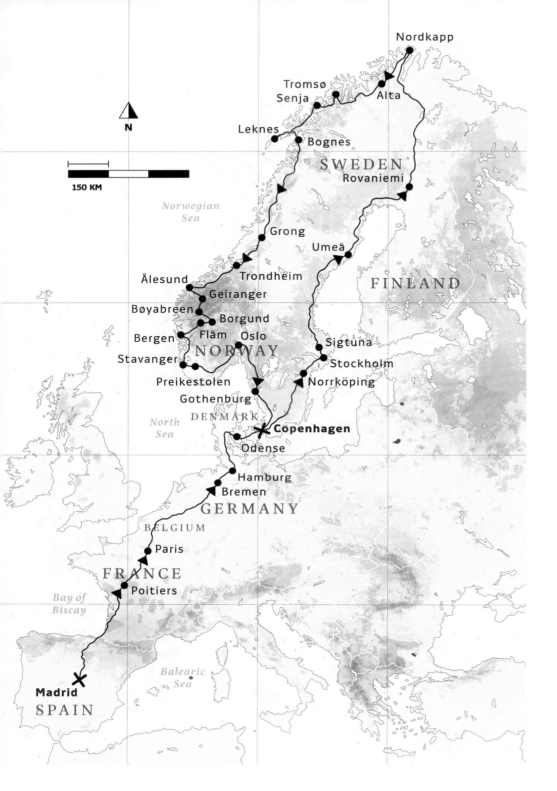

she has been their home away from Madrid for the past two years. They restored some original parts and added a bike rack, new fridge, and heating for the trips across Europe, most recently through Norway via the stunning Rallarvegen bike route along the Atlantic Road to Trondheim. "We are part-time van lifers," says Marco.

"We get away a lot of weekends and take a long trip during the summer for about a month and a half." The list of countries traveled is growing: Portugal, Norway, Denmark, Italy. And because they can lengthen a vacation when catching internet access along the road, the list will continue to grow and inspire their work. ■

→ Road for Greta

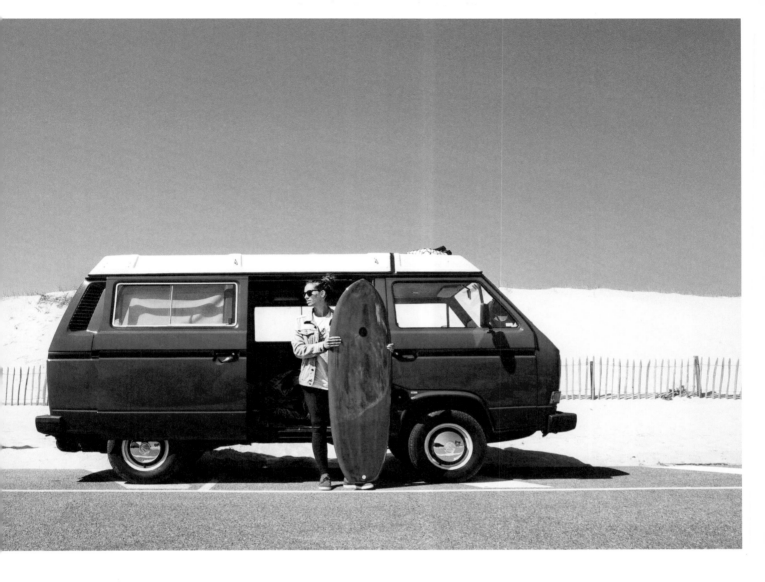

VOLKSWAGEN TYPE 2 (T3) MULTIVAN

Staying close to stock is often the best way to personalize a van. That's how Ana and Marco prefer the vans they have been traveling in for eight years. Together they have owned two Type 2 (T3) VWs, the second being a 1987 Multivan driven by 70 horsepower from a 1.6-liter diesel flat-four. They appreciate their vans the way they left Westfalia's workshops in Rheda-Wiedenbrück, thus restoring original details with care such as chrome bumpers, the original hubcaps, and round headlights. A new heater, mud tires, and fridge are the only elements that deviate from the factory-fitted equipment.

MANUFACTURER: Volkswagen
MODEL: Type 2 (T3) Multivan
YEAR OF PRODUCTION: 1987
ENGINE: 1.6 L flat-four, diesel, 70 hp
TRANSMISSION: Manual
VISITED COUNTRIES:
Norway, Sweden, Denmark, Germany, Austria, Belgium, Netherlands, Portugal, Luxembourg,

Switzerland, Northern Italy, France
MILES IN TOTAL: 186,400 miles
TRAVEL TIME: Usually six weeks
REBUILD—YEAR: 2014–2015
REBUILD—BODYWORK MODIFICATIONS:
Fitted new chrome bumpers, added original hubcaps, round headlights, mud tires
REBUILD—CHASSIS MODIFICATIONS:

General maintenance
REBUILD—INTERIOR MODIFICATIONS:
Upholstery cleaning, new rugs, more powerful fridge, preheater
REBUILD—OTHER MODIFICATIONS:
Portable outside shower and small changing room
REBUILD—SUPPORT BY: Carlos

VAN LIFE AND LA NOUVELLE CUISINE

One year ago, we decided to change our lives," says French van lifer and chef Cécile Bertrand. Unsettled by where the culinary career ladder was taking her and her boyfriend, Simon Doreau-Deléris—a sterile world of stainless steel kitchens, food deliveries from across the world, and strict French recipes—they stepped back. "We were two culinary students trying to make a career in fancy restaurants, but we wanted to learn about cooking in a different way, away from the pressure of restaurants,

closer to nature," they say. "We decided to visit every European country to learn more about gastronomy and cultures—and at the same time discovered van life online. It was a revelation. We're not only cooks but designers, so the idea of building a home from scratch was too tempting. We left our jobs and signed up for driving lessons."

They hunted down a 1997 Volkswagen T4 and crafted it pragmatically: a bespoke transformable bed/sofa, accessible food storage, a kitchen built to handle →

22

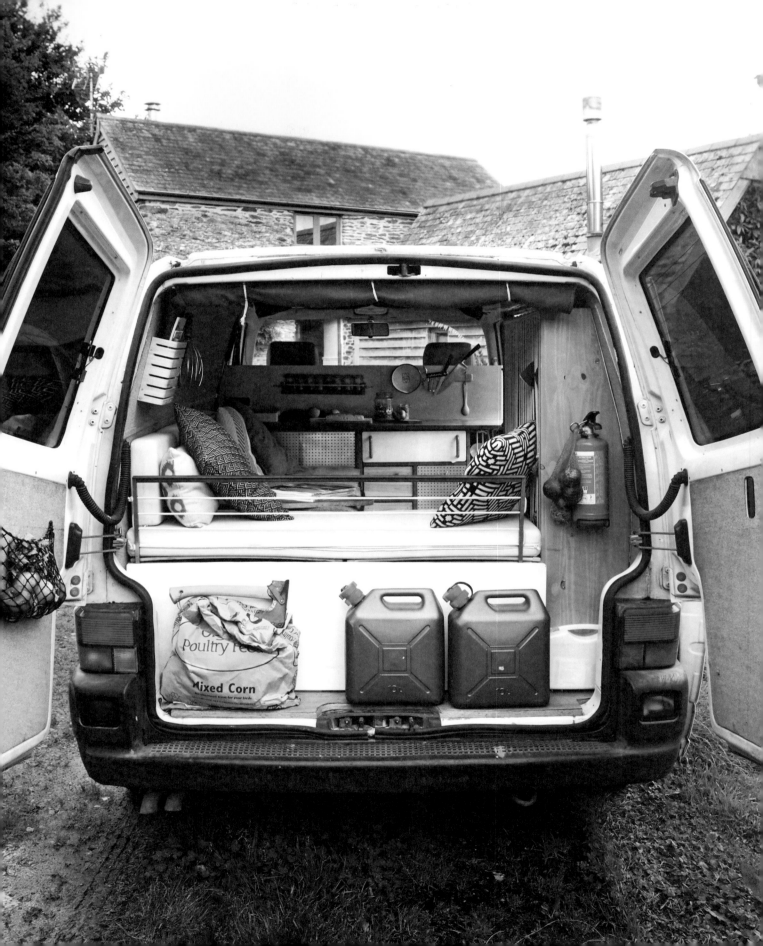

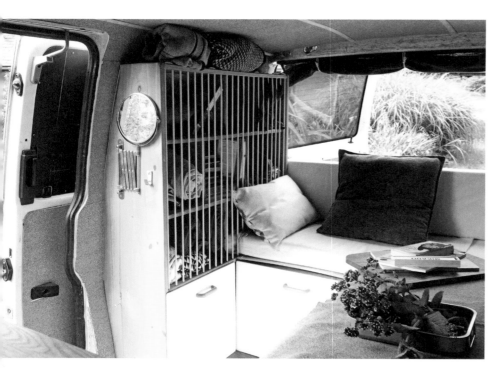

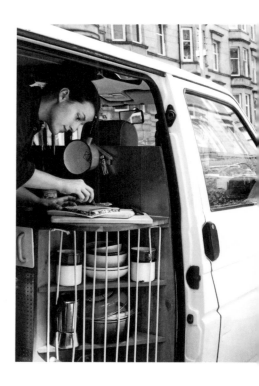

DIY elastic-rope wardrobe *(above)*. Baking granola bars in Glasgow *(right)*. The fully stocked pantry *(below)*. Côte d'Albâtre, Normandy, France *(opposite)*.

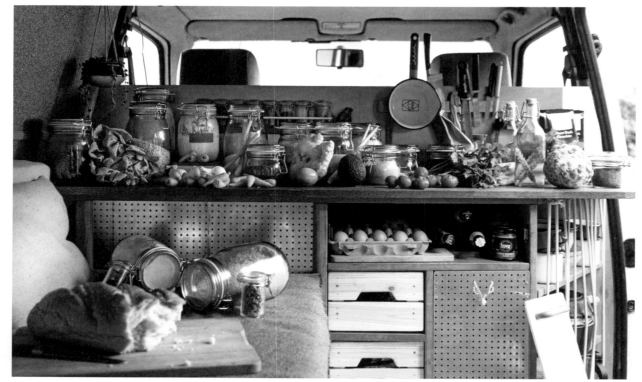

→ Radius & Ulna

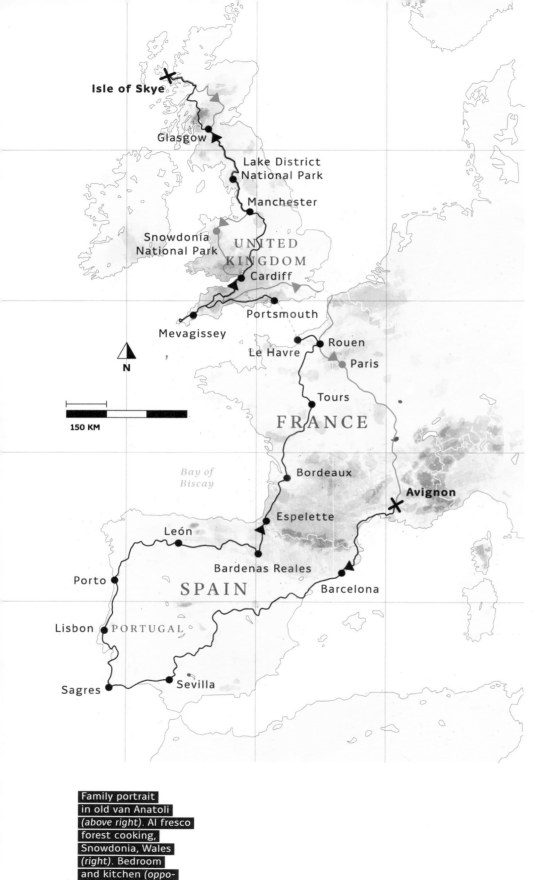

Isle of Skye

Glasgow

Lake District
National Park

Manchester

Snowdonia
National Park

UNITED
KINGDOM

Cardiff

Portsmouth

Mevagissey

Le Havre

Rouen

Paris

Tours

FRANCE

Bay of
Biscay

Bordeaux

Avignon

Espelette

León

Bardenas Reales

Porto

SPAIN

Barcelona

Lisbon PORTUGAL

Sagres

Sevilla

N

150 KM

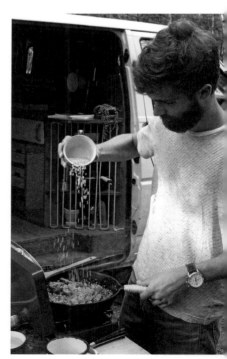

Family portrait
in old van Anatoli
(above right). Al fresco
forest cooking,
Snowdonia, Wales
(right). Bedroom
and kitchen *(oppo-
site bottom)*.

→ Radius & Ulna

VOLKSWAGEN T4

Although many companies offer superb vans, no company carries with it such immense clout as Volkswagen and their Transporter line. The T4 is the fourth iteration of this legacy of vans. The first to use a front-mounted water-cooled motor, Cécile and Simon's 1997 T4 came with a peppy 2.5-liter diesel engine. After 160,000 miles (260,000 km), the motor has surely proven itself worthy. Customized for cooking, the van has a wide kitchen and natural cork to hang items on the ceiling and walls. A couch/bed and a wardrobe complete the homey build.

MANUFACTURER: Volkswagen
MODEL: T4 Transporter
YEAR OF PRODUCTION: 1997
ENGINE: 2.5 L TDI, 102 hp
TRANSMISSION: Manual
VISITED COUNTRIES: Spain, Portugal, and United Kingdom
MILES IN TOTAL: 260,000 miles
TRAVEL TIME: 6 months

REBUILD—YEAR: 2016–2017
REBUILD—BODYWORK MODIFICATIONS: None, new windows in the near future
REBUILD—CHASSIS MODIFICATIONS: Stock
REBUILD—INTERIOR MODIFICATIONS: Complete insulation with sound-deadening mats, gray wooden floor, natural cork ceiling and walls, full-size couch/bed, a wide and pratical kitchen, wardrobe made of elastic rope, additional storage
REBUILD—OTHER MODIFICATIONS: Second battery, three LED bars on the ceiling to add some light in the van
REBUILD—SUPPORT BY: Their families

daily experimentation, and light, breathable cork every-where. The couple spent 2017 exploring Spain, Portugal, and the United Kingdom. "Our way of cooking, which is our true passion, has changed along the way," they explain. "We've worked for months on farms, surrounded by organic vege-tables and fruit, learning about what it is to grow your own food and take care of the land. Our tiny kitchen is an end-less source of creativity, as we learn how to cook great and healthy meals with very few tools and resources." ∎

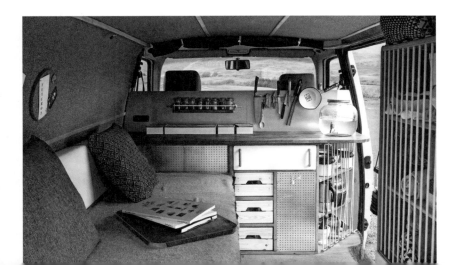

5 TIPS FOR OUTDOOR COOKING

I. STOCK RAW INGREDIENTS

Buy raw ingredients rather than pre-made or pre-packaged items. Having a variety of meats, vegetables, aromatics, and seasonings at hand allows for greater meal variations when you're on the road. A well-stocked camp pantry can cater to you whenever you're feeling lazy, or when you want to glamp it up.

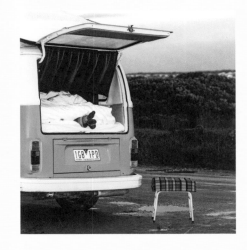

II. SEASONING IS YOUR FRIEND

Don't be afraid to use salt, pepper, or a sweetener of choice. They greatly enhance the overall enjoyment of a meal. Also note that if you are cooking at altitude versus at sea level, your taste buds will be a little more subdued. So make a mental note to increase the salt whenever you are in the mountains.

III. ALWAYS PACK LIGHT

You're pressed for space as it is. Leave any single-task cooking equipment at home. All you will need is a few pots, a good-sized cast iron skillet, a kettle, a chef's knife, and a pairing knife. You're on the road. Your food can be fancy—but your kitchen doesn't need to be.

IV. MAKE FOOD THAT TOUCHES YOUR SOUL

The further you travel from home, the further you are from whatever you're familiar or comfortable with. So whenever you break for camp, put together a meal that will make you feel right at home. Before you know it, the road will be home.

V. KEEP IT SIMPLE

Your meals should always be simple. A meal shouldn't take a lot of prep work before you actually cook. Or you might as well just stay home!

29

MISO BROTH WITH FENNEL

INGREDIENTS

1 celery stick, 1 carrot, 1 large potato, 1 tbsp each miso paste and honey, 2 pinches mustard seeds (alternatively, you can use old-fashioned mustard), 2 pinches flaxseeds, chopped sage leaves, olive oil, salt and pepper, 1.5 L of water

Coarsely chop the celery, carrot, and potato. To save time and prevent a messy van kitchen, leave them unpeeled. In a pot, fry the veggies in a little olive oil. Add the miso paste and the honey. Shake around and let it caramelize for a few minutes. Add the water, turn down the heat, and cook for 15 minutes or until the vegetables are tender. Carefully season with salt and pepper, tasting as you go. Before serving, sprinkle with the flaxseeds, mustard seeds, and sage.

MUSSELS WITH BEER AND CILANTRO

SERVES: 2–4
PREPARATION: 30 MIN
COOKING: 10 MIN

INGREDIENTS

Approx. 600 g mussels, 3 chopped shallots, 1 glass of bitter beer, 3 handfuls of cilantro for garnish

While staying at the seaside, you can collect some fresh mussels yourself. For the freshest seafood, you should forage at low tide. Be careful, though: make sure the sea is clean, as seafood and seaweed absorb pollution particles. First of all, you have to remove any brown threads from the mussels. Grasp them well between your thumb and forefinger and pull. Then, soak the mussels in salty water to clear out any sand. Heat a very large pot over high heat and add the chopped shallots. Sauté with a little oil until lightly browned. Add the mussels and shake the pot. Deglaze with beer and cover the pot. The mussels are ready when all of them are open. Garnish with cilantro and enjoy while still hot! There is no need to add salt since the mussels are already salty enough.

31

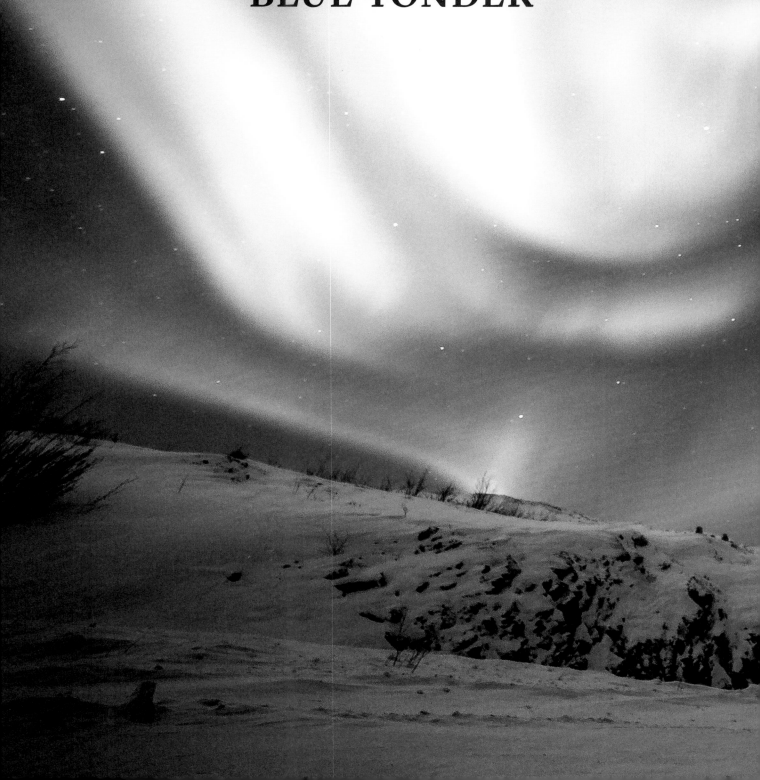

THE WILD
BLUE YONDER

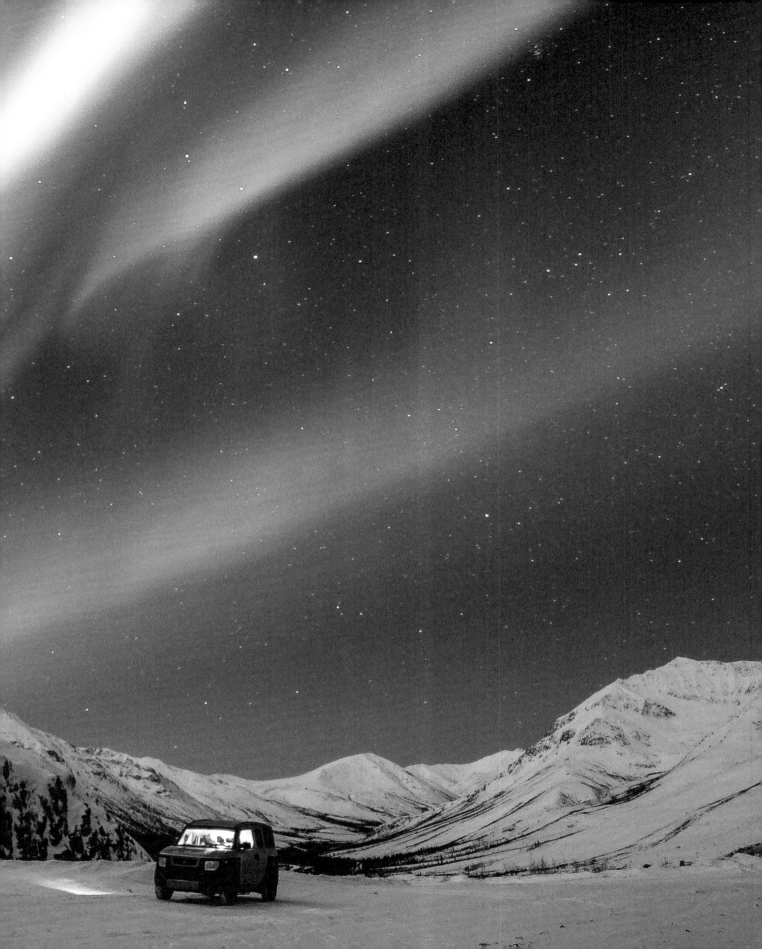

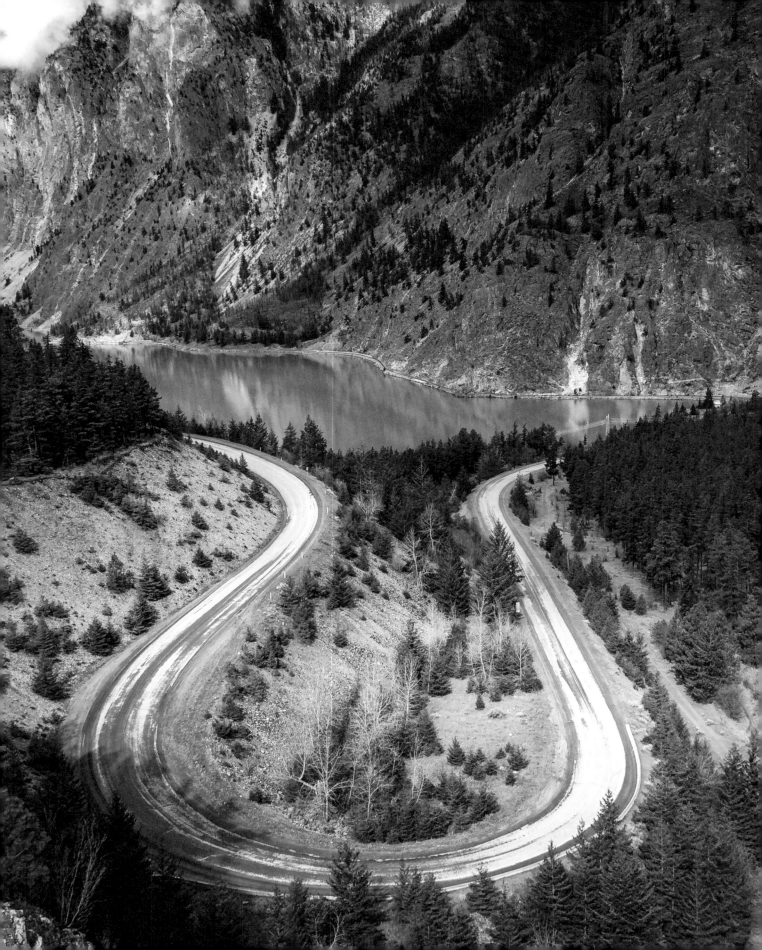

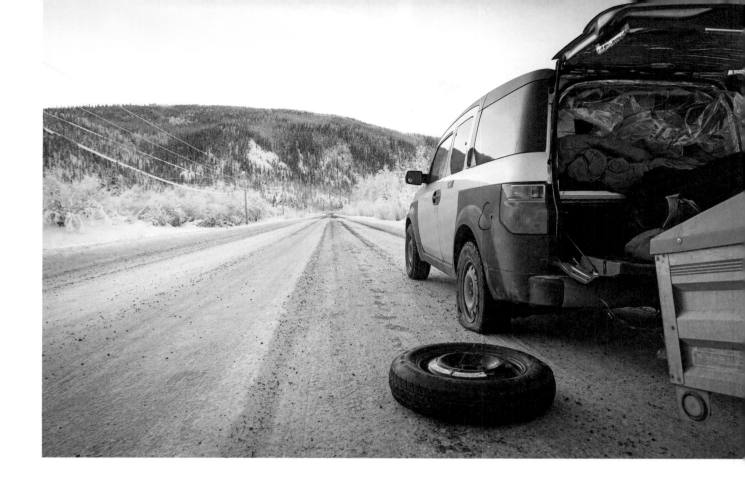

lexandre Marcouiller and Francis Fraioli set out from Montreal in January 2016 on a four-month road trip with a formidable plan to test themselves and their friendship: see the aurora borealis light up the polar night sky, and survive in solitude during the darkest, most frigid months of the year. Their vehicle of choice was a futuristic 4WD urban crossover, a 2003 Honda Element SUV, which they prepped for subzero life with insulation and deep-cycle batteries. It would soon suffer many flat tires. "At the time, we didn't know the struggles and the joys that would happen along the way," they recall, "but we knew it was going be the most challenging trip we had ever experienced."

They had to move fast to beat the blizzards, racing 3,700 miles (6,000 km) northwest clear across Canada in under a week to the dramatic Tombstone Territorial Park to hike and await the lights. →

Winding roads, British Columbia *(opposite)*.
Flat tyre en route to the Arctic Circle *(above)*.
Alexandre and Francis in the snow *(right)*.

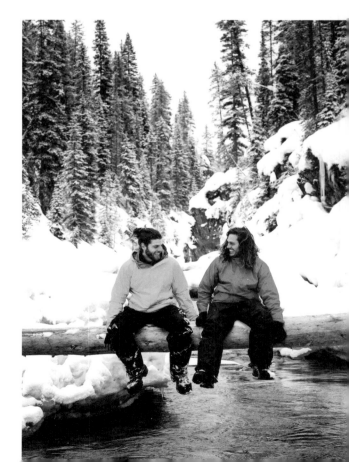

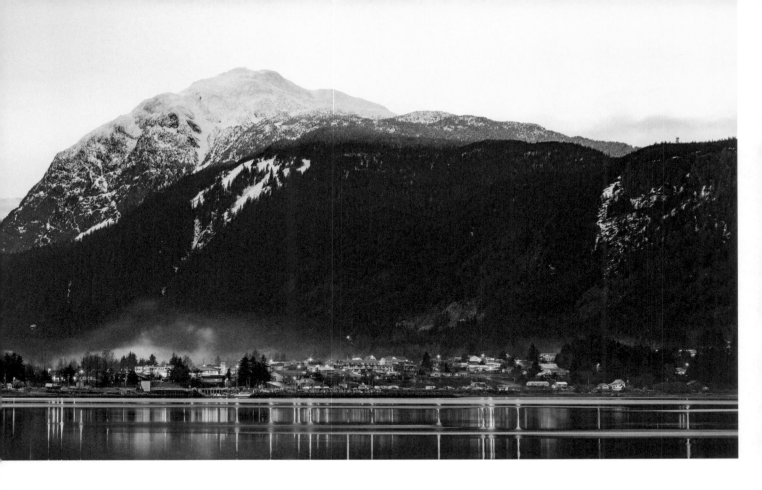

"We were told it was kind of a mad idea to camp out there alone," they say. "It's such a remote area, the whole park is shut down; there's not a soul around, and it's extremely cold (-44 °F, -42 °C). We decided to give it a go." It was the perfect setting from which to view the aurora, and it didn't take long to get what they came for. "After a couple of failed attempts on big hikes and a few dark nights, we finally received our reward. Spectacular and unforgettable, the craziest, strongest northern lights we could have wished for."

"It was going to be the most challenging trip we had ever experienced."

Plasma particles sent out by the sun's dark spots are drawn like fridge magnets into the magnetic fields at the poles, and their clash with oxygen and other earthly elements creates light shows of energy in the sky. "It was like nothing we've ever experienced."

Onward they went to Alaska by way of Kluane National Park, home to bears, salmon, ancient glaciers, and Canada's highest peaks. "Once again we were left to ourselves in this secluded part of the world. Being so isolated all the time definitely made us more resourceful and built character. Everything seems harder when it's freezing cold: all the food was frozen, the equipment badly affected by the temperature. But it got us out of our comfort zone, and also allowed us to see wild animals, such as wolves, moose, caribou, bison, and lynx."

In Haines, a mountainous Alaskan town along the Lynn Canal, they found themselves among "the most genuine people in America." Next, they took a ferry to Skagway to camp in a little cabin at Upper Dewey Lake, a true Alaskan landscape. Eventually they returned south to explore Western Canada's graceful, innumerable parks—Yoho, Kootenay, Glacier, Mt. Revelstoke—and →

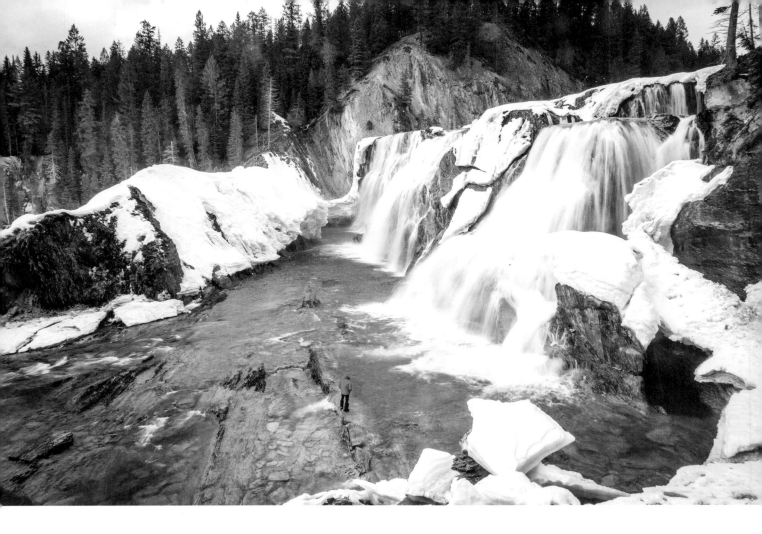

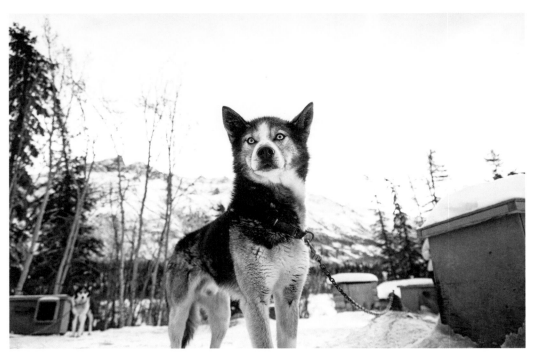

Semi-frozen waterfall, Canada *(above)*. In a dogsled camp, Yukon, Canada *(left)*. Inside a subterranean glacier *(following page)*.

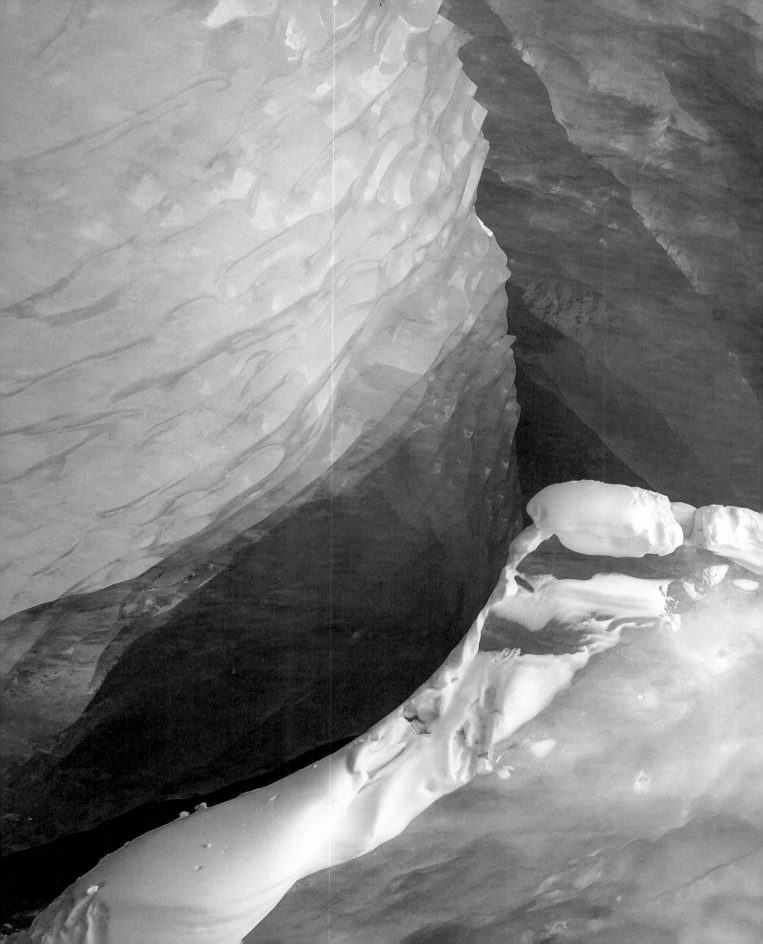

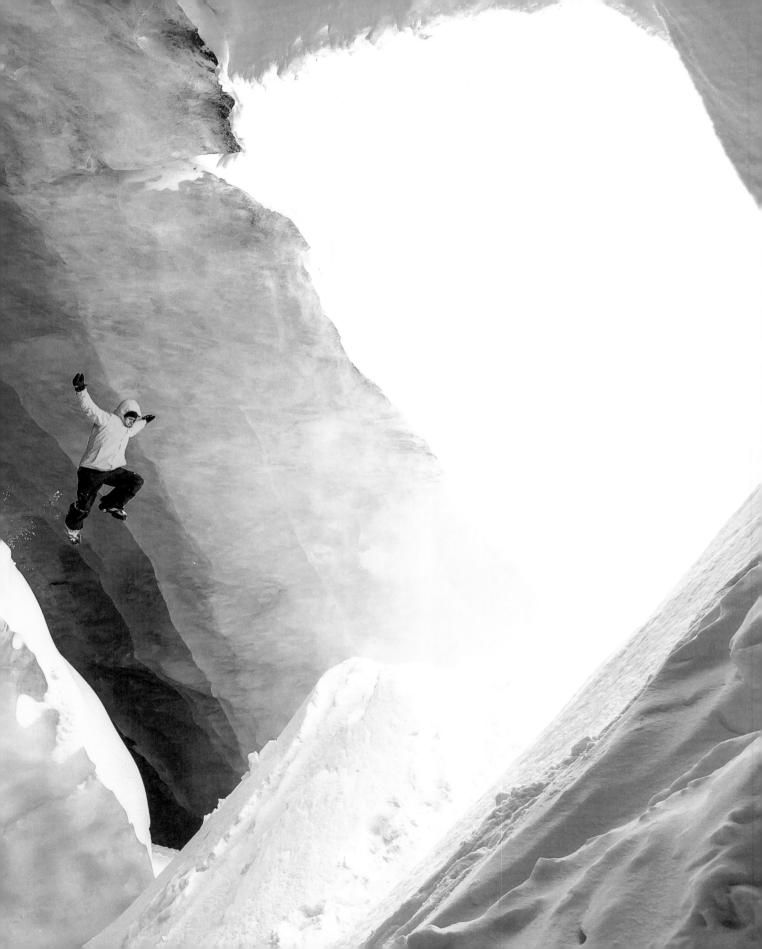

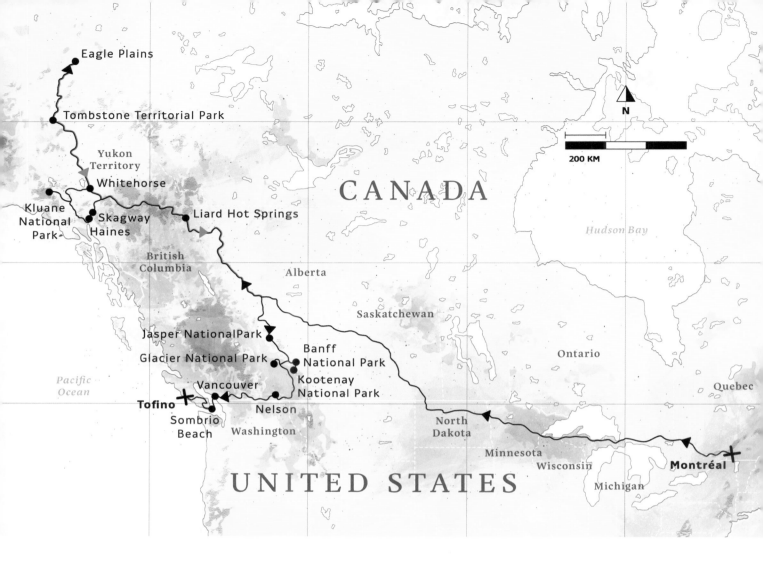

as the days got longer, they headed east to the Rockies and Banff and Jasper National Parks. "These were probably the most photogenic places in Canada—blue lakes and waterfalls, high peaks, and breathtaking landscapes," say the pair.

They spent the final month in "places that seemed unreal," heli-skiing, bathing in natural springs, camping, and hiking in Whistler and Vancouver. When spring arrived, they headed to Vancouver Island, one of the largest temperate rainforests on the planet, where they looked for uncrowded surf and camping spots at Sombrio Beach, the Juan de Fuca Trail, Tofino, and Ucluelet. Looking back, they reflect on the wonder of the experience: "How is it possible to find so much diversity and beauty in one place, one country? This trip was a great opportunity to really get deep into nature, deep into the unknown. Maybe the journey isn't about becoming anything, but about unbecoming everything that isn't really you, so you can be who you were meant to be." ∎

40

→ IamNoMad

HONDA ELEMENT

Blending an easy-to-clean light-duty truck with a versatile sport utility vehicle, the 2003–2011 Honda Element (only available in the United States) was a huge success among the outdoor crowd. Outward-opening front and rear doors omitted the B-pillar side entry, which allows for unobstructed packing of loads up to 675 pounds (300 kg). Inside, seats made of stainless fabric are entirely removable, and the floor is coated in resilient urethane for easy cleaning. 160 horsepower is provided by Honda's venerable 2.4-liter K motor, and this Element has automatic transmission. Alexandre and Francis added insulation to prepare for below freezing temperatures across Canada, and also attached a trailer for carrying excess gear.

MANUFACTURER: Honda
MODEL: Element
YEAR OF PRODUCTION: 2003
ENGINE: 2.4 L, 166 hp
TRANSMISSION: Automatic
VISITED COUNTRIES:
Canada, United States

MILES IN TOTAL: 18,000 miles
TRAVEL TIME: 4 months
REBUILD—YEAR: 2016
REBUILD—BODYWORK MODIFICATIONS:
Original factory condition
REBUILD—CHASSIS MODIFICATIONS:
Original factory condition

REBUILD—INTERIOR MODIFICATIONS:
Added insulation, bed frame and bed, deep-cycle battery, power inverter
REBUILD—OTHER MODIFICATIONS:
Additional trailer for all the gear
REBUILD—SUPPORT BY:
Friends

LET
THE EXPERIENCE
SHAPE YOU

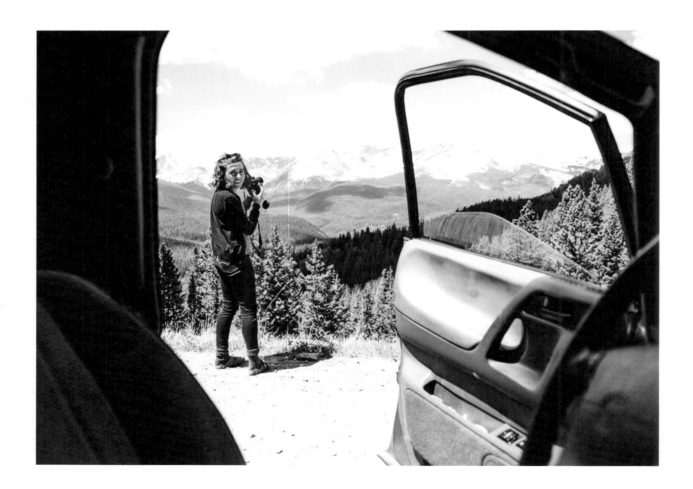

Henry David Thoreau didn't famously retreat to a shack just to live frugally; he was grieving the loss of his brother, but seclusion itself inspired a classic. Maybe *Walden* was the first of a trillion navel-gazing blog posts to come, but Thoreau honestly wanted to explore the limits of consciousness, "to drive life into a corner and reduce it to its lowest terms." In this he created a template for living by needs, not wants. "Simplicity, simplicity, simplicity!" he wrote.

Grieving her grandfather's passing and the end of a relationship, and without a set place she felt was home, Texas artist Amanda Sandlin signed up for the intense introspection of van life—in part because it's what she feared. "I viewed loneliness as a sign of weakness," she says. "It took almost the entire trip for me to realize that it is okay for me to feel… any way I feel. Instead of judging my emotions, I learned to let them be. Consequently, their grip on me began to soften." The best part of solo travel, she discovered, is that →

42

→ Amanda's North American Adventure

"There's no running **from yourself** **when it's just** **you** on the road."

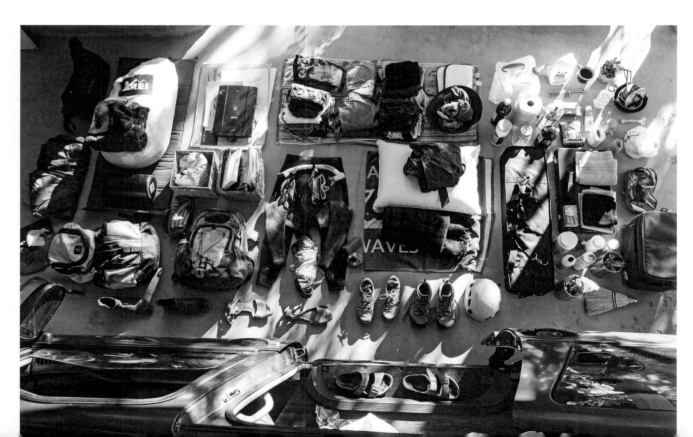

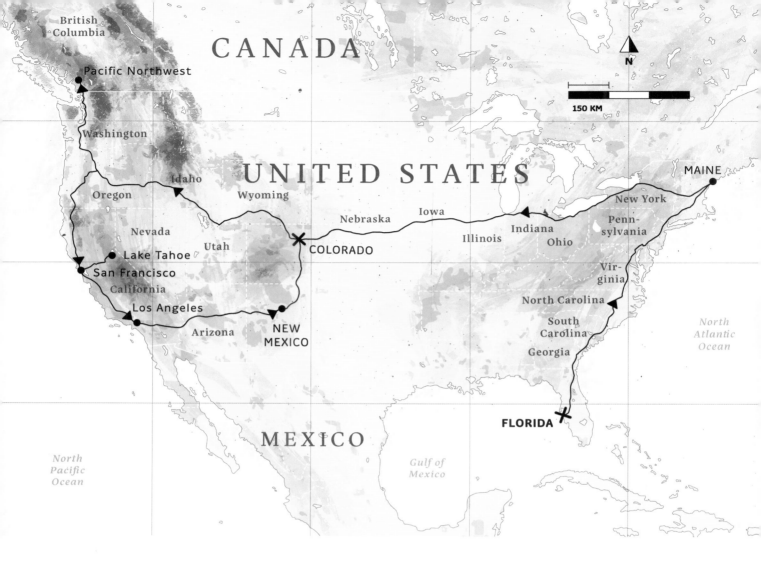

there's no running from yourself when it's just you on the road. It was fitting that the women in Amanda's family—her mother, aunt, and grandmother—helped install a two-foot (0.6 m) bed and sideboard in her 1999 Toyota Previa minivan, perhaps the most monastic homage possible to Thoreau. She contemplated the one-woman adventure as she cruised North America for a year: Florida to Maine, Oregon to British Columbia, and finally Colorado. "As a single woman, I feel the media often paints a picture of reality for me that's doused in vulnerability and fear," she says. "But ultimately, I choose to believe that most people are good, and nothing constitutes the true danger of an unlived life." ■

With space at a premium and great maneuverability, the Toyota Previa is the ultimate minimalist motorhome *(right)*.

→ Amanda's North American Adventure

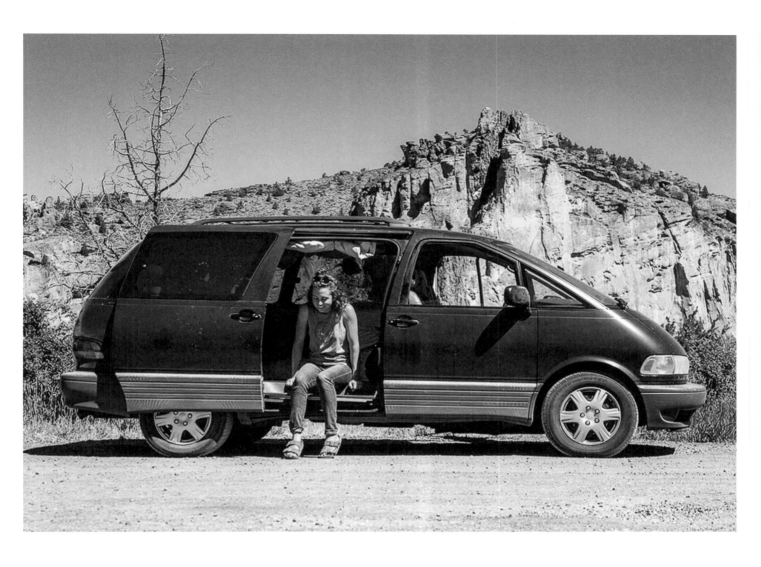

TOYOTA PREVIA

When Dodge launched its Caravan in 1984, Toyota worked quickly to stay in the game with a successful new design. By 1990, the Previa launched, featuring a unique mid-engine design that—while less powerful than its competitors—offered far superior cargo space and fuel economy. It was available as all-wheel drive or rear-wheel drive. The 1999 model year was the final one for this generation of Previa (also called Toyota Tarago or Estima). With room to create a sparsely modified interior—bed, insulation, flooring, stove, storage, and a small house plant—this truly compact minivan packs the few essential punches that Amanda needed.

MANUFACTURER: Toyota
MODEL: Previa
YEAR OF PRODUCTION: 1997
ENGINE: 2.4 L, 132 hp
TRANSMISSION: Four-speed automatic
VISITED COUNTRIES: Canada, United States
MILES IN TOTAL: Approx. 10,000 miles

TRAVEL TIME: 8 months
REBUILD—YEAR: 2016
REBUILD—BODYWORK MODIFICATIONS:
Original factory condition
REBUILD—CHASSIS MODIFICATIONS:
Original factory condition
REBUILD—INTERIOR MODIFICATIONS: Added

sound-deadening and insulating mats, a bench, a bed, new panels, additional storage space
REBUILD—OTHER MODIFICATIONS: Portable stove, water jug, a plant, candles, essential oil air freshner to make a cozy living space
REBUILD—SUPPORT BY: Her mother, aunt, and grandmother

CAVEMAN PANCAKES

INGREDIENTS

2 tbsp roasted carob powder,
2 tbsp desiccated coconut, ½ cup
buckwheat flour, 2 eggs, ½ cup
almond milk, 2 tbsp coconut
sugar, coconut oil, ½ cup coconut
chips, ½ cup sunflower seeds,
1 tbsp coconut blossom syrup,
3 bananas sliced lengthwise, juice
of 1 orange, 1 tbsp agave nectar,
coconut yogurt

For the pancake batter, put the carob powder, desiccated coconut, flour, eggs, milk, and sugar in a jar and shake until combined. Set aside for one hour. Heat a small cast iron skillet. Add 1 tablespoon coconut oil, coconut chips, sunflower seeds, and coconut syrup. When the mixture is golden brown, transfer to a plate and let harden. Return the clean skillet to the heat. Grease with some coconut oil, then pour in a thin layer of batter to cover the base of the pan. Cook until small bubbles form, then flip. Repeat with the remaining batter. In the same skillet, cook the bananas, the remaining coconut oil, orange juice, and agave nectar until the bananas are soft with translucent edges; the syrup will caramelize but still be a little runny. To serve, stack the pancakes and top with bananas, coconut chip mixture, coconut yogurt, and a drizzle of syrup.

48

→ Sarah Glover

SARDINES & SWEET POTATOES

INGREDIENTS

Grapeseed oil, 125 g high-quality canned sardines in olive oil (drained and patted dry), buckwheat flour, 1 large white sweet potato cut into sticks, salt, 10 slices prosciutto, 2 cloves garlic, 1 cup crème fraîche, zest of 1 lemon, 1 red chili pepper, endive, 1 red onion, olive oil for frying, pepper

In a small billy, pour about 4 centimeters of grapeseed oil and heat until it reaches about 350 °F–400 °F (180 °C-200 °C). Dredge the sardines in the buckwheat flour and deep-fry them for 2–3 minutes until crisp. Set aside on some paper towels. In a medium pot, cover the sweet potato with salted water and cook for about 10 minutes or until just tender. Don't overcook! Drain and refresh them under cold water to prevent further cooking. In a large frying pan, cook the prosciutto in some grapeseed oil over medium heat until just crispy. Transfer to a plate. In the same frying pan, add some more oil, the garlic, and the sweet potato, and cook for 4 minutes. Remove from heat and add the crème fraîche, lemon zest, and prosciutto. Serve in the pan, topped with sardines and garnished with finely chopped chili. Pairs well with an endive salad with red onions, olive oil, and pepper.

49

Sarah Glover ←

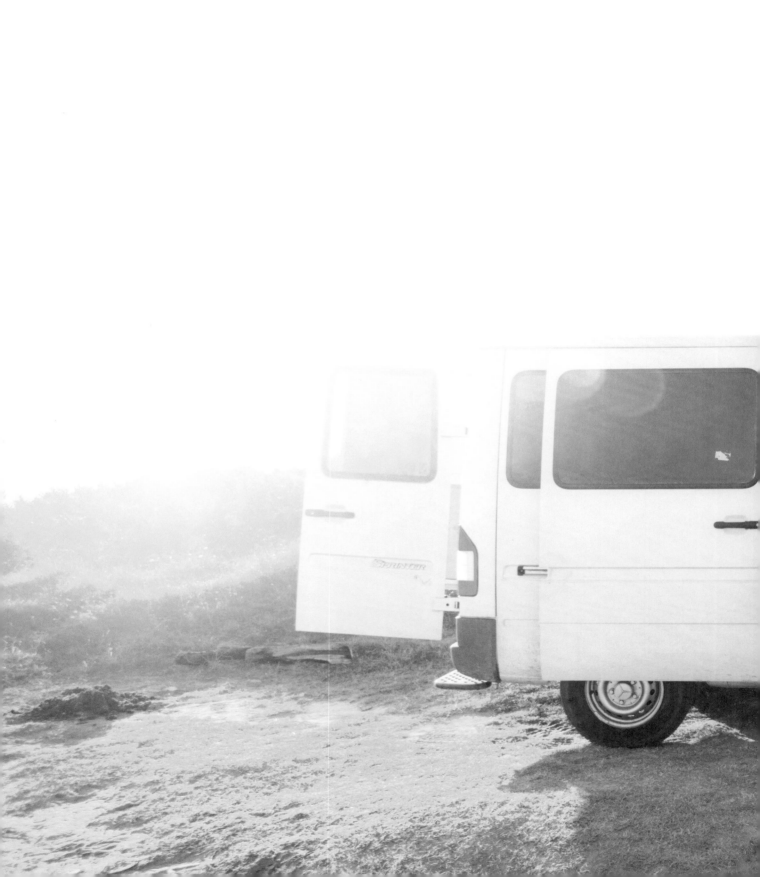

VOYAGES ACROSS EUROPE PAST AND PRESENT

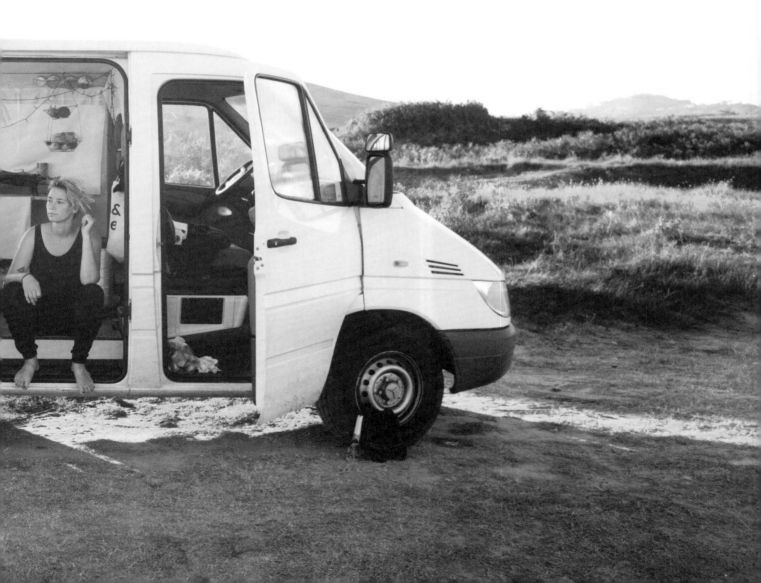

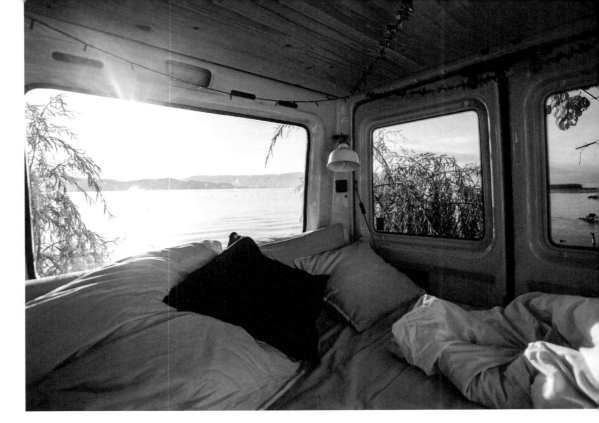

Sleeping spot at Lake Ohrid, Macedonia (*right*). Cows on the road, Carpathian Mountains, Romania (*below*). The mountains and lowlands of Albania (*opposite*).

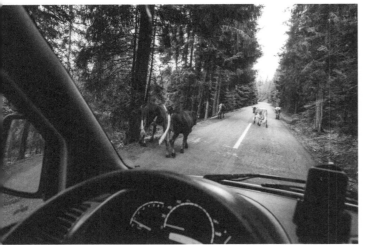

In 2016, Julia, who still had a regular job as a photographer then, took her spritely 2004 Mercedes-Benz Sprinter 208 "Emil" for their first trip. She had located him two months before and made some basic modifications. "I've always loved traveling by car—having a home with you, being flexible in where to sleep and wake up. That is my sense of freedom."

"I had been thinking about traveling to the Balkans for a long time, since seeing a documentary presenting every country, its people, and its history," says Julia, "and I just knew I needed to go there." For those raised in the economic centers of Western Europe, the Balkans have a unique mythology and intrigue with their history of war and nation-building, running from the northern Italian border near Venice for 900 miles (1,500 km) east to the Black Sea south of Odessa, and southwards, encompassing all of the former Yugoslavian states and Romania all the way to Greece.

Now Julia travels Europe for her photo project *Folk Tales* in search of remote, mystic places of European culture and folklore. "I spend a lot of time, and try to get in contact with locals, looking for old stories in the oral tradition." Before traveling to Great Britain and visiting Stonehenge, the Isle of Skye, and South Wales, Julia had been to some of the most impressive natural sites of Eastern Germany: the picturesque biosphere reserve Spreewald, the Elbe Sandstone Mountains near the Czech border, and the Kyffhäuser range with its medieval →

O n the road I feel the most alive," says Berlin photographer Julia Nimke of her lone trips to photograph the isolated and folkloric historical corners of Europe. "I love to travel solo, but I meet people on every trip who tell me how brave it is, especially as a woman. I've never considered it brave. Sleeping in remote places and being alone can be frightening for anyone, but what follows the feeling of loneliness is simply magical, and that's what makes me hit the road alone every time: it's harmony, simplicity, and peace—just you and nature."

52

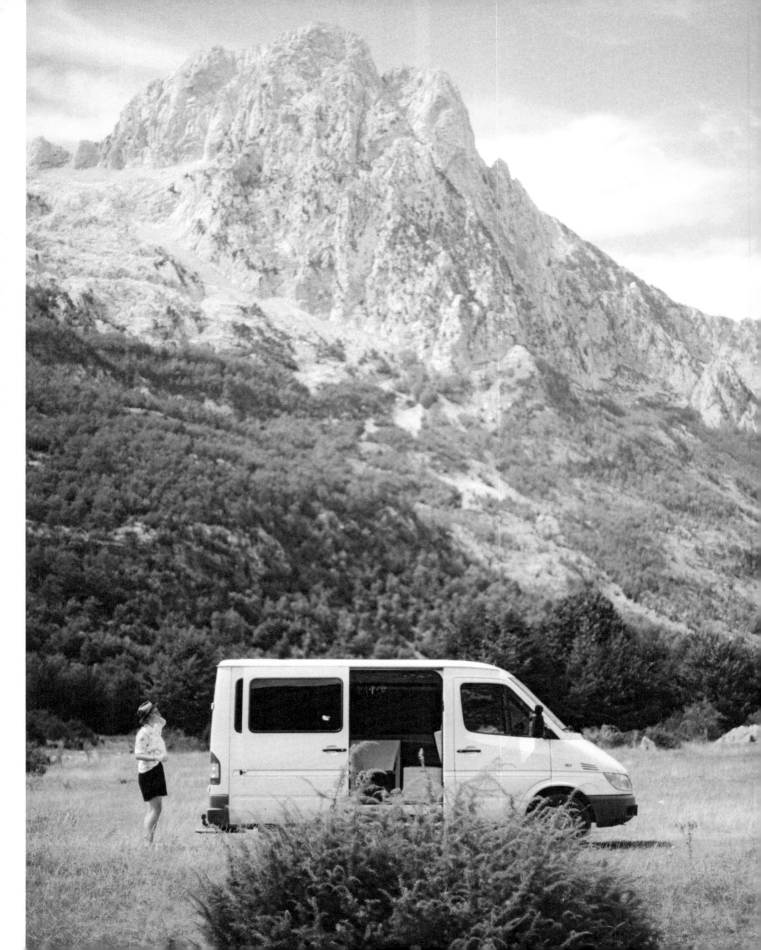

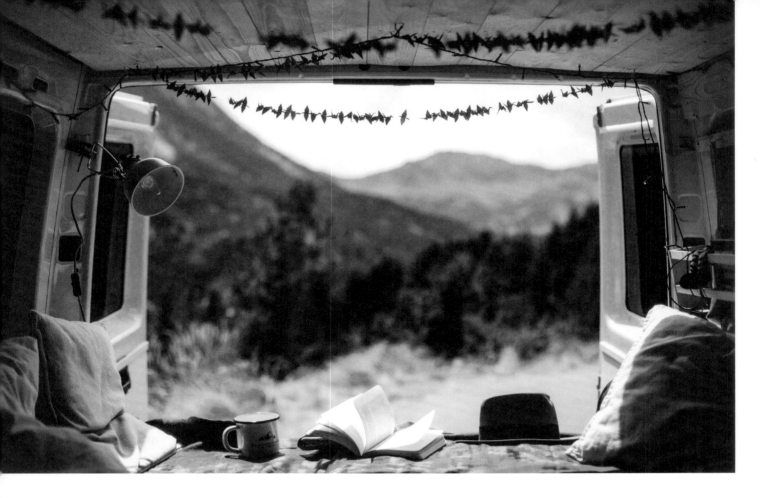

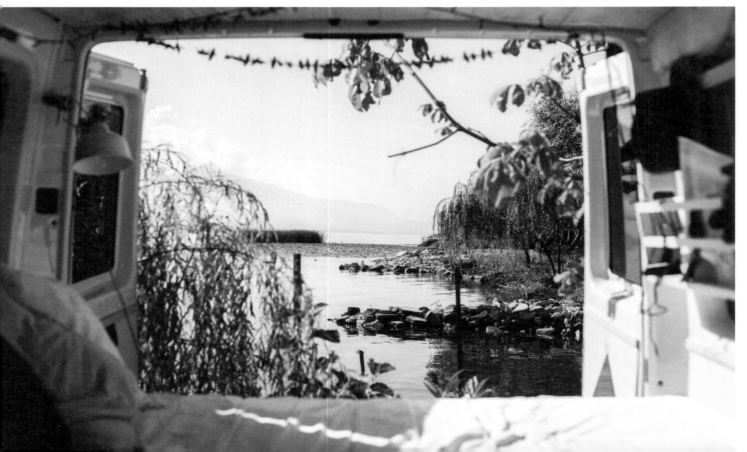

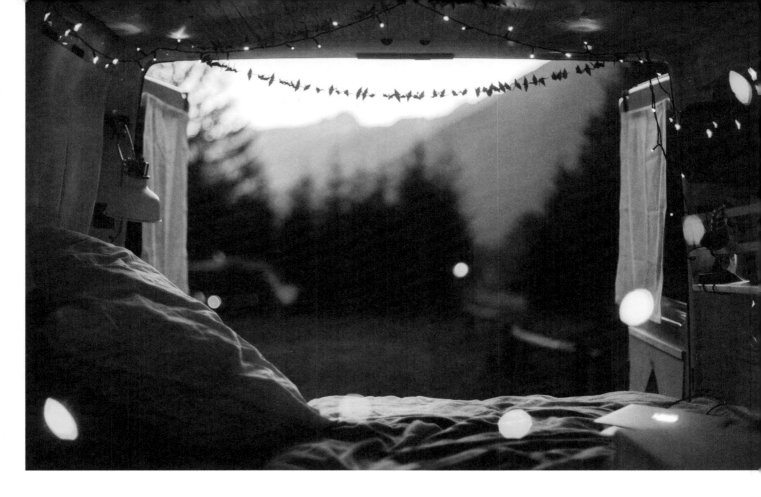
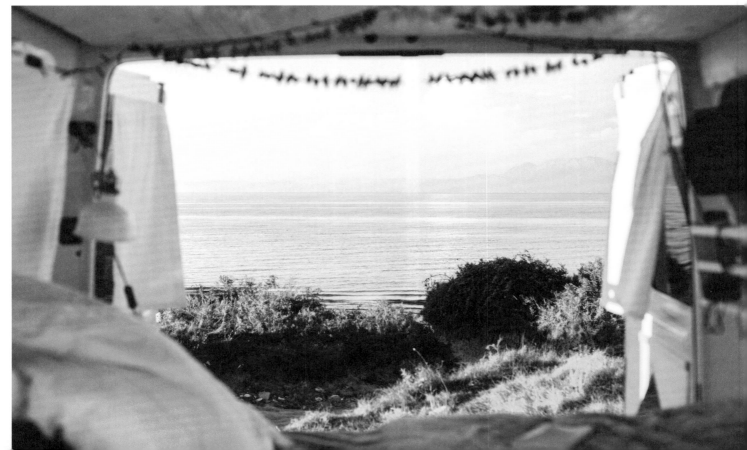

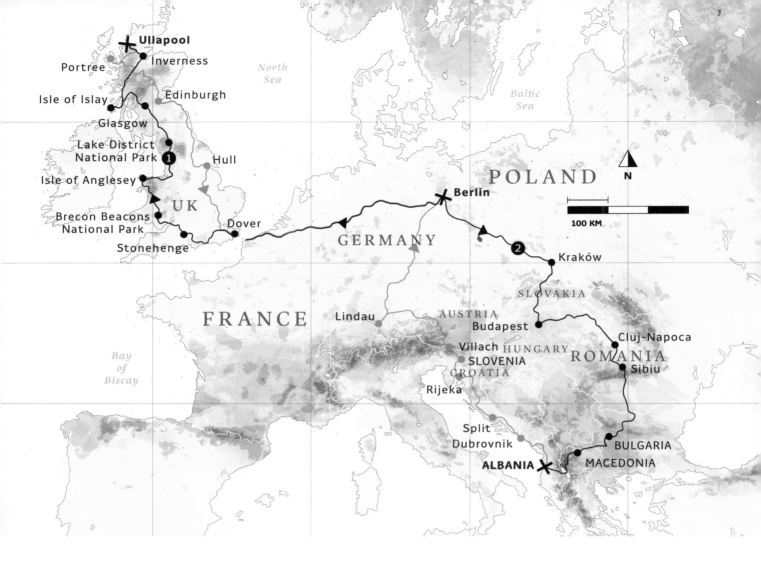

→ Emil the Sprinter Van

history. In all these places she sought out people with a store of knowledge of the respective region's ancient myths and took photos of them. "Of course, I also go for hikes and spend nights talking by the campfire," says Julia. "Meeting people is actually easier without a friend or partner—it's necessary to step outside the comfort zone and get in touch with strangers."

She believes kindness is ever-present, especially when trouble arises. "In Macedonia, I had my one and only accident," she recalls. "It was pouring and a back tire slipped into a ditch while I was avoiding oncoming traffic in a village. I thought: 'That's it.' I don't speak a word of Macedonian. But people there help one another, especially with cars—they all drive models that are so old I've never even seen them in Germany. End of story: my van was pulled out of the ditch by a tractor and I drove on to a camping site by Lake Skadar, had some local schnapps for my nerves, and stayed for a couple of days. Experiences like that always make me confident—somehow, everything's gonna be fine." ∎

MERCEDES-BENZ
SPRINTER 208

Julia rebuilt her 2004 Sprinter in 2016, adding custom touches such as a wooden ceiling, bed, fridge, and small kitchen area that put the homey comforts into traveling. Built in 1995 as a replacement for the outdated Mercedes TN van, the Sprinter seats two passengers and is designed to fulfill an impressive range of duties. One benefit is that the bright white of the utility van keeps excessive heat out during long summer days. Also, deeply tinted windows grant privacy from passersby. While the 208's inline-four engine only provides 82 horsepower, the returns in fuel economy far outweigh the necessity for speed.

MANUFACTURER: Mercedes-Benz
MODEL: Sprinter 208 CDI
YEAR OF PRODUCTION: 2004
ENGINE: 2.2 L common rail diesel, 82 hp
TRANSMISSION: Five-speed manual
VISITED COUNTRIES: France, Belgium, United Kingdom, Poland, Slovakia, Hungary, Romania, Bulgaria, Macedonia, Albania, Montenegro, Croatia, Slovenia
MILES IN TOTAL: 6,800 miles
TRAVEL TIME: 6 weeks and 3 weeks

REBUILD—YEAR: 2016
REBUILD—BODYWORK MODIFICATIONS: Tinted windows
REBUILD—CHASSIS MODIFICATIONS: Original factory condition
REBUILD—INTERIOR MODIFICATIONS: Wooden ceiling, full-size bed, kitchen area
REBUILD—OTHER MODIFICATIONS: Additional generator with converter
REBUILD—SUPPORT BY: Nobody

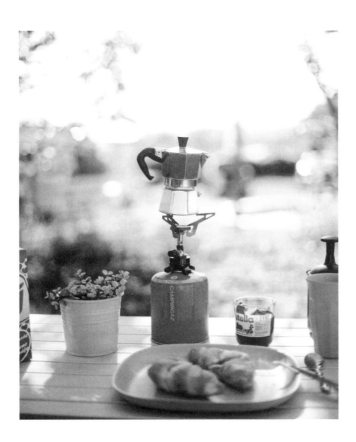

Emil the Sprinter Van ←

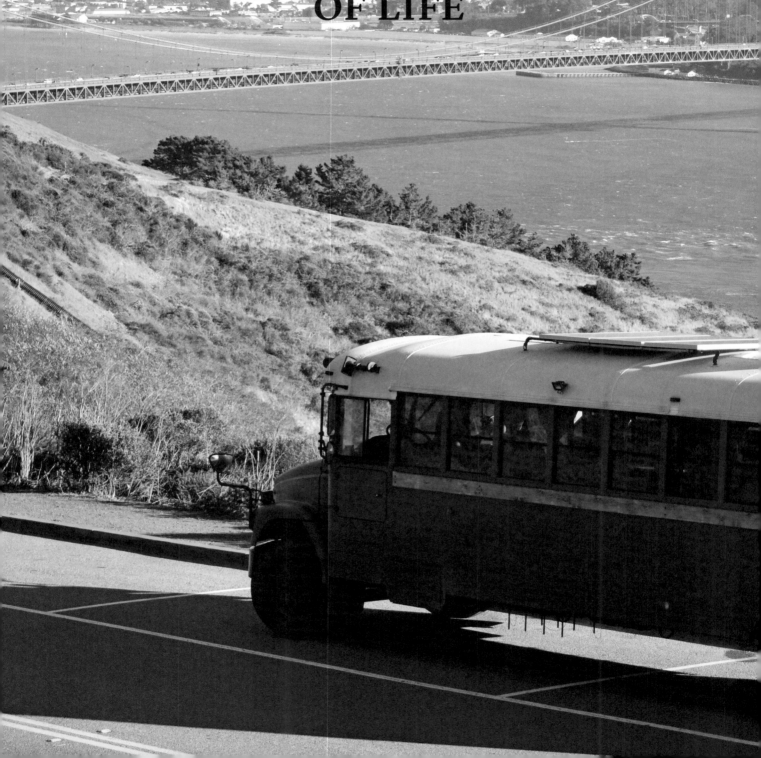

IN THE
SCHOOL BUS
OF LIFE

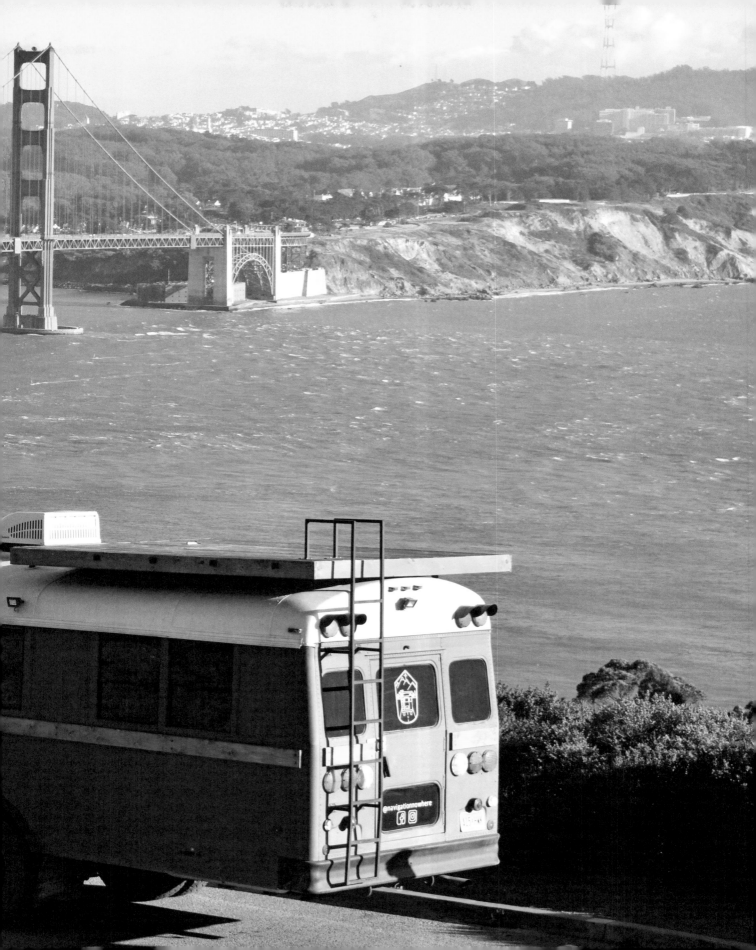

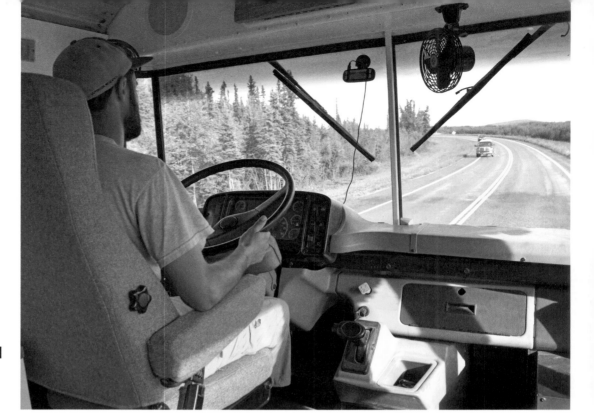

Alaska Highway, Northern British Columbia *(right)*. Lounge and dining room in bed mode *(below)*. Wood-panelled full country kitchen *(opposite)*.

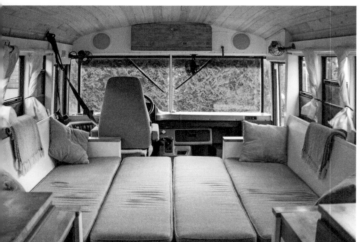

"It's not about the pavement or the miles you travel, it's about the people you meet."

When Michael Fuehrer graduated with a master's in anthropology and returned home from the itinerant student life in Philadelphia and the 40-square-foot (3.7 sq m) converted closet he was living in, the biggest surprise that awaited was home itself—or the concept of it. It was static, out of proportion, and any apartment Michael looked at seemed like an irrational waste of his meager funds. "Living in a house was unsettling—I felt stuck in one place," he says. "It was too big for my possessions, and I felt that all that space had no purpose. That's when I decided it was time to downsize and go mobile." With the support of his dad, he got online, found a public auction, and bought a mighty yellow 2004 Thomas Freightliner bus that had been retired early from its schooling duties. Though impossibly lumbering and massive, it was mechanically excellent. Father and son set to work. It was to be a home on the road—a fully functioning house on wheels with all the elements that traditionally define a domestic space.

The Freightliner is 34 feet (10 m) long and weighs in at 18,000 pounds (8,160 kg). A complete rebuild of such an object is not a job to be taken lightly, especially when loading it up even more with solid →

60

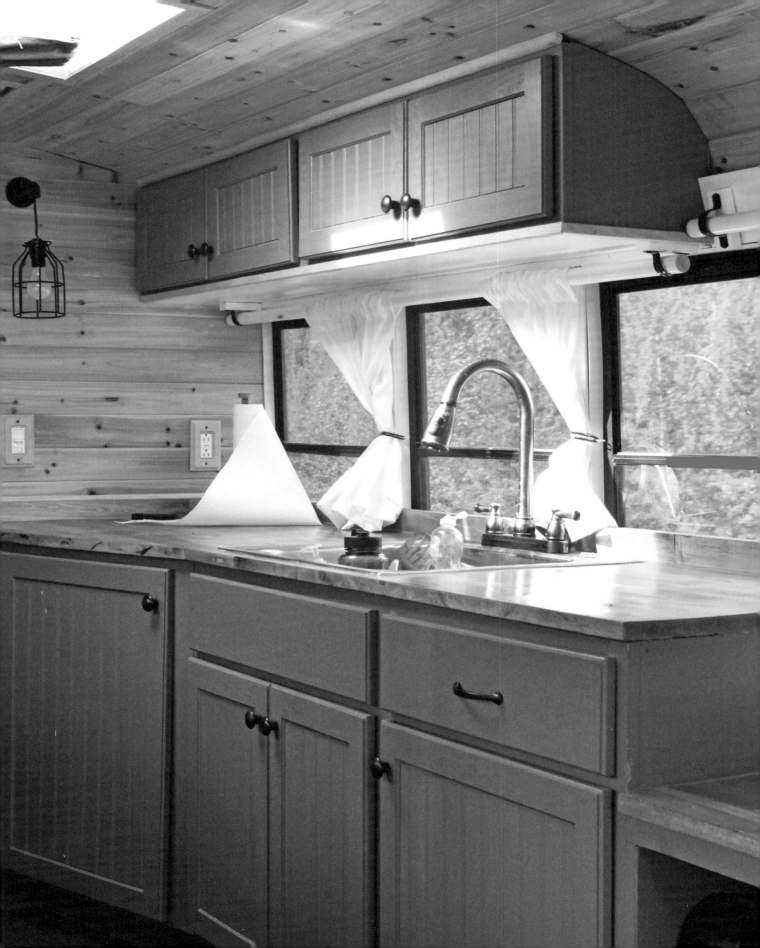

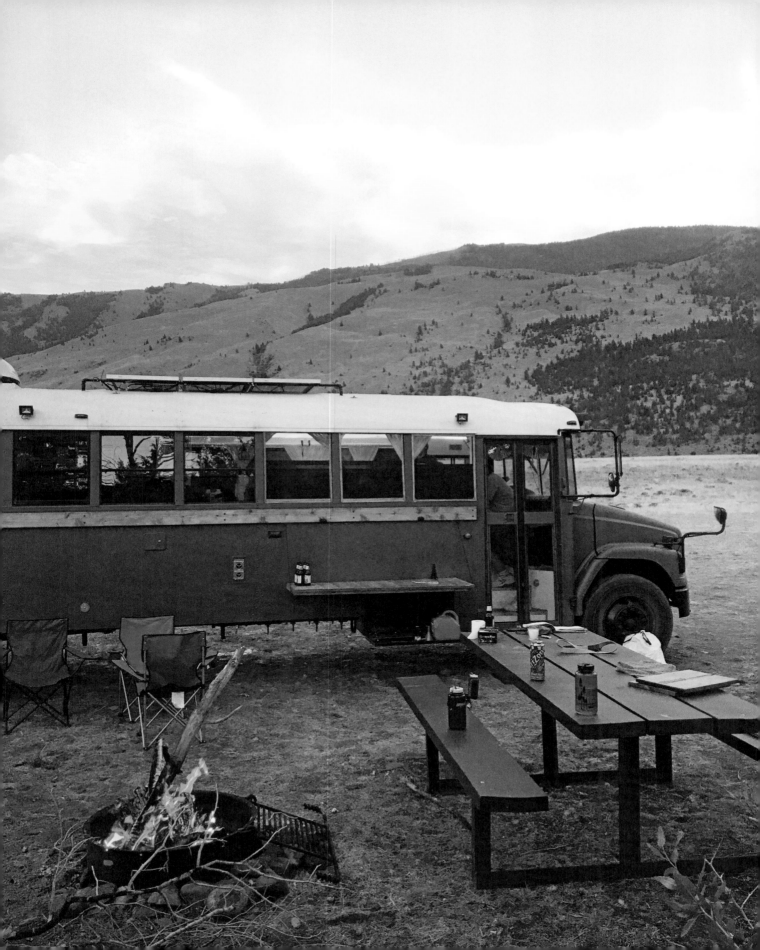

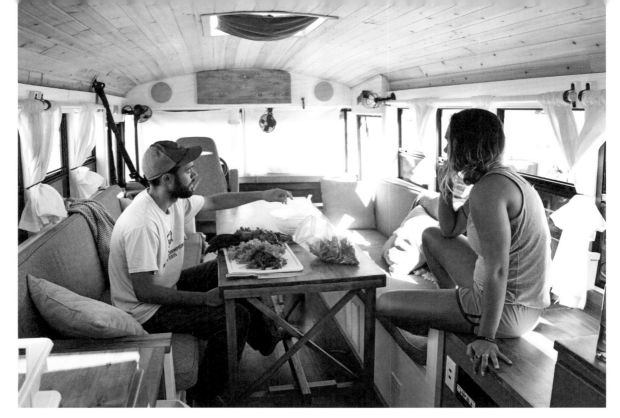

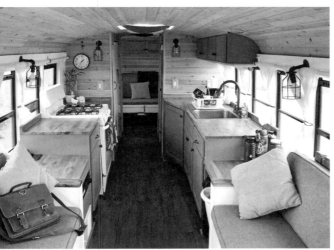

Sorting community-garden vegetables (above). Looking down-bus (left). Bureau of Land Management grazing land, Gardiner, Montana, USA (opposite).

unvarnished cedar-board cladding, and included a fully tiled bathroom, a banquet dining table, guest quarters for entertaining and housing half a dozen guests, skylights, and a moveable roof deck. They created an impressive photovoltaic system, enabling it to be an off-the-grid mobile holiday chalet. The lights and electrics are wired into the cockpit switches, so whoever's behind the wheel can press buttons and feel like a real bus driver.

It's been nearly a year on the road, and this caboose has been hauled 16,000 miles (26,000 km) up and down the Western United States and Canada. There's an eventual plan to take in the lower reaches of the continent as well as Central and South America. Along the way, Michael has found himself contemplating a career and the possible return to city life. But deep cultural exploration is probably the wisest activity an aspiring anthropologist could choose during his post-grad years; the observation and analysis of the countless subcultures and identities along the way are the lines connecting the dots of that which is learned in a classroom. "If there is one →

kitchen counters and built-ins, room divisions, a composting toilet, and every other convenience. Add to that the need for reliability in a rig that would be adventuring long-distance across the continent. The rebuild took nine months, and was made possible by essentially budgeting a whole year's rent upfront for the construction.

"The bus was stripped down to the exterior sheet metal and built back using common home-construction techniques," says Michael. "It's designed the way I wanted it because I couldn't find an apartment that I liked." This meant they lined it entirely with

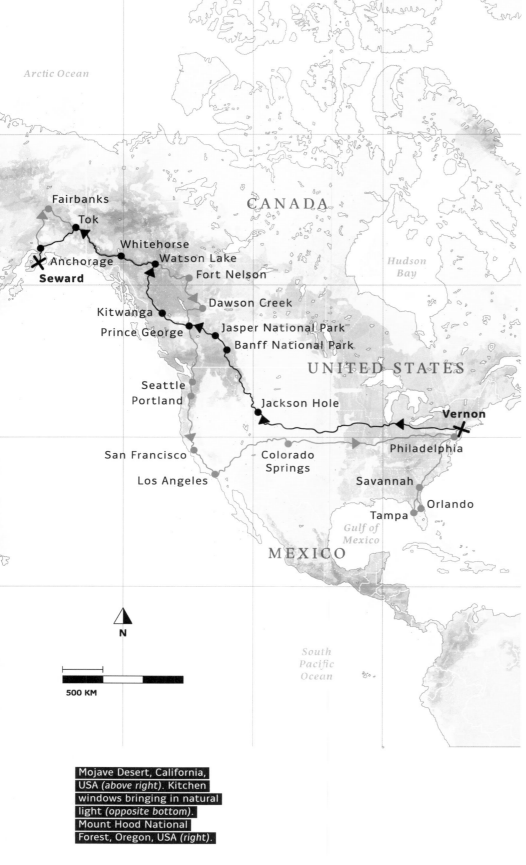

Fairbanks
Tok
Whitehorse
Anchorage
Watson Lake
Seward
Fort Nelson
Kitwanga
Dawson Creek
Prince George
Jasper National Park
Banff National Park
Seattle
Portland
Jackson Hole
Vernon
San Francisco
Philadelphia
Los Angeles
Colorado
Springs
Savannah
Tampa
Orlando

Arctic Ocean
CANADA
Hudson
Bay
UNITED STATES
MEXICO
Gulf of
Mexico
South
Pacific
Ocean

N

500 KM

Mojave Desert, California,
USA *(above right)*. Kitchen
windows bringing in natural
light *(opposite bottom)*.
Mount Hood National
Forest, Oregon, USA *(right)*.

→ Navigation Nowhere

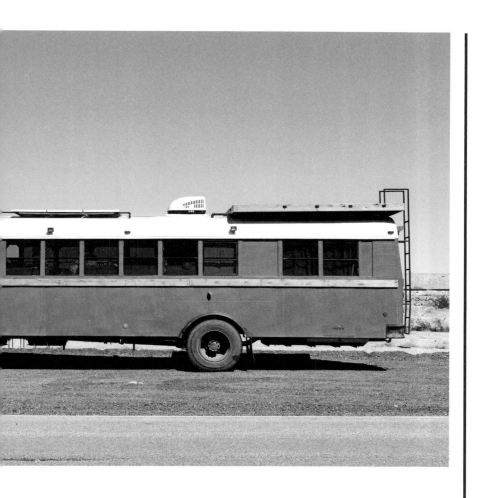

THOMAS FREIGHTLINER FS-65 SCHOOL BUS

Founded in 1916, Thomas originally manufactured desirable street cars for large cities. The 1930s transition to buses is the foundation for the company's current reputation as the oldest surviving bus manufacturer in the United States. Michael plucked this 2004 Freightliner from the heap and made it home. Disassembled down to the sheet metal, he resurrected the bus in nine months. There's enough room for six people to sleep, and additional renovations include a huge kitchen, bath, 130-gallon water supply, and solar panels. The Mercedes 900 6.4-liter diesel engine offers tremendous torque output (over 500 lb-ft) and optimized gas mileage due to a newly installed gear ratio.

thing I have learned, it's that the road and its community teach you more about yourself and people than you could ever expect," he says. "It's not about the pavement or the miles you travel, it's about the people you meet where that pavement takes you. Even at times when things look rather bleak—like during breakdowns in remote locations—it is really just an opportunity to slow down and enjoy something I would've missed otherwise." ■

MANUFACTURER: Thomas Freightliner
MODEL: FS-65 Schoolbus
YEAR OF PRODUCTION: 2004
ENGINE: Mercedes 900, 6.4 L diesel
TRANSMISSION: Automatic
VISITED COUNTRIES: Canada, United States
MILES IN TOTAL: 16,000 miles and counting
TRAVEL TIME: 7 months and counting

REBUILD—YEAR: 2016
REBUILD—BODYWORK MODIFICATIONS:
Repainted, removed rub guards and replaced with cedar wood, two side-body boxes, two side doors for propane and battery access, foldable table
REBUILD—CHASSIS MODIFICATIONS:
Rebuilt wheel wells, optimized gas mileage due to newly installed longer gear ratio
REBUILD—INTERIOR MODIFICATIONS:
Living room, dining room, three folding beds, fully equipped kitchen with oven, sink, and cabinets, shower, composting toilet, rear access garage
REBUILD—OTHER MODIFICATIONS:
Roof terrace, solar panels, exterior LED flood lights, Yamaha and Polk Audio systems
REBUILD—SUPPORT BY:
Parents (Chris and Linda Fuehrer), siblings (Ryan, Christina, and Rachel), and friends

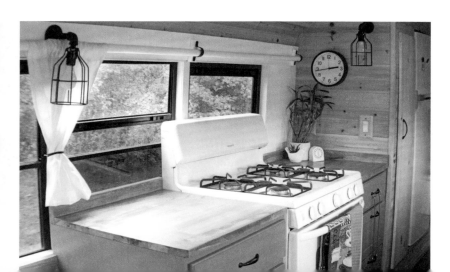

65

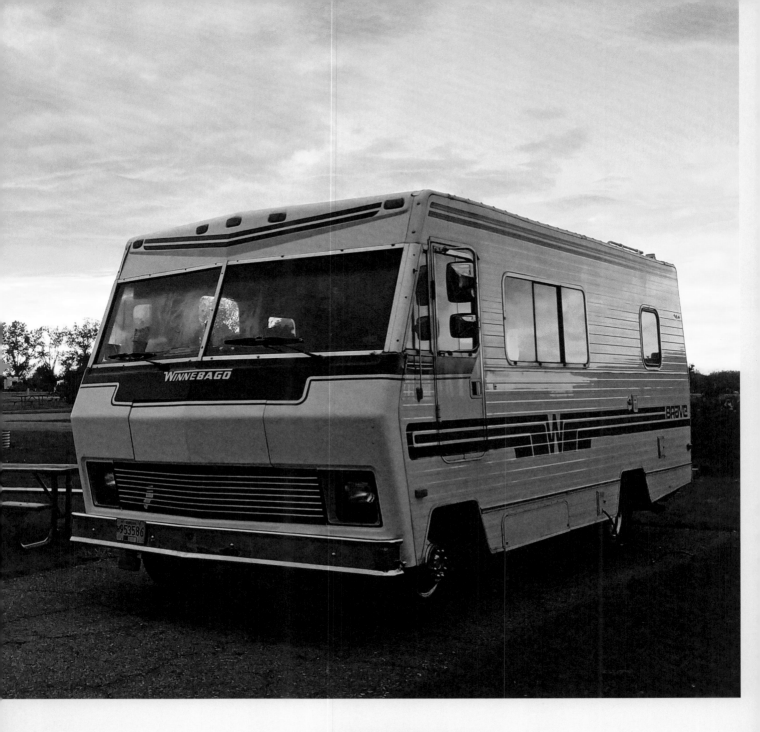

WINNEBAGO BRAVE

The Winnebago has been an American icon of continental travel for decades. Starring in films, songs, and other folklore, it's the perfect big-country cruiser. Liz and Tim Kamarul quit their jobs on a whim and purchased a 1982 Winnebago off of Craigslist for $5,000. Leaving the Chevy motor in place, they installed a new interior with custom upholstery, woodwork, and increased storage. After nine months of weekend refurbishment, they uprooted their life in Portland, Oregon. For the next five months they explored the United States in search of a new place to settle, with New Orleans, Louisiana, finally hitting the mark.

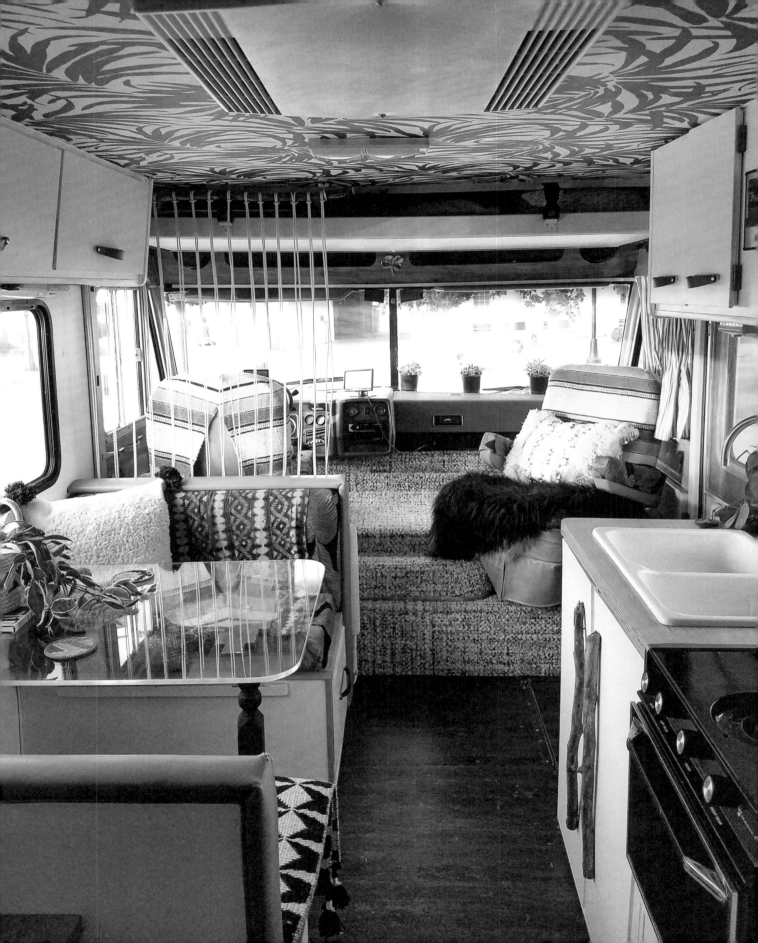

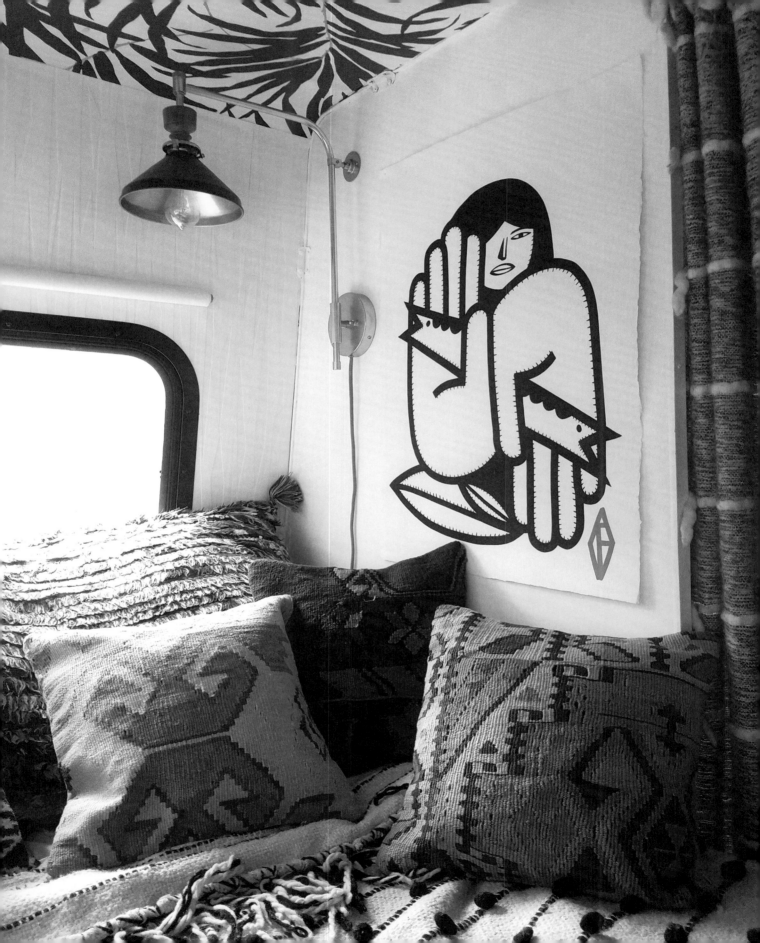

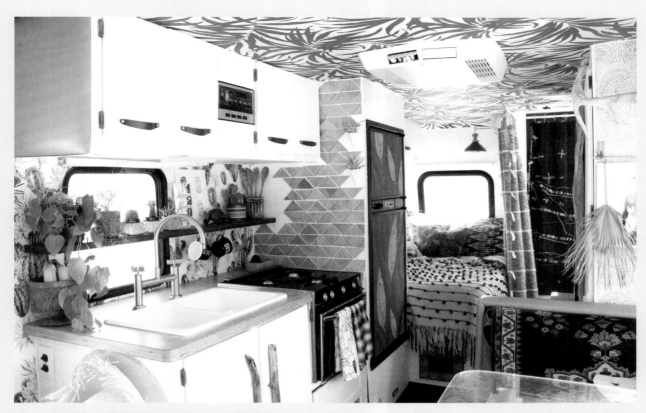

MANUFACTURER: Winnebago
MODEL: Brave
YEAR OF PRODUCTION: 1982
ENGINE: 6.2 L Chevrolet diesel
TRANSMISSION: Automatic
VISITED COUNTRIES: United States
TRAVEL TIME: 5 months and counting
REBUILD—YEAR: 2017

REBUILD—BODYWORK MODIFICATIONS:
Sealant on roof to prevent leaks
REBUILD—CHASSIS MODIFICATIONS:
General engine maintenance, new tires
REBUILD—INTERIOR MODIFICATIONS:
Cosmetic overhaul, reworked upholstery,
new acrylic table, new wallpapers,
new fabrics to get rid of the early 80s design,

refurbished the bathroom,
custom mattress from Brentwood,
speakers and stereo
REBUILD—OTHER MODIFICATIONS:
Added storage underneath the
dining benches, backup camera
REBUILD—SUPPORT BY:
Liz's parents

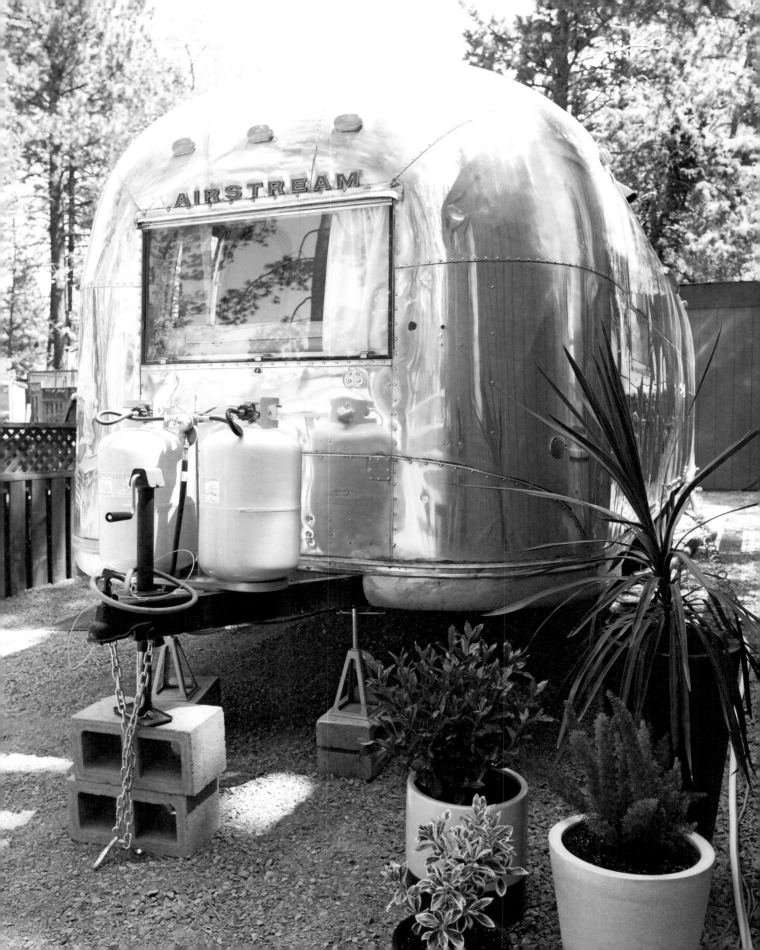

MOUNTAIN MODERN AIRSTREAM

The silver pill-shaped trailers of the American company Airstream date back to the 1930s. The only trailer company to survive the Great Depression, Airstream's production soared to unprecedented heights after the aluminum shortages of the Second World War ended, and as advances in motorcars allowed for comfortable long-distance travel. Gilda, the 1966 Airstream Overlander from Mountain Modern, comes from that golden era. A fully restored Gilda required a complete rebuild and repair, right down to the frame. This silver Streamer has been enlivened with new floors, wiring, and interior and exterior skins.

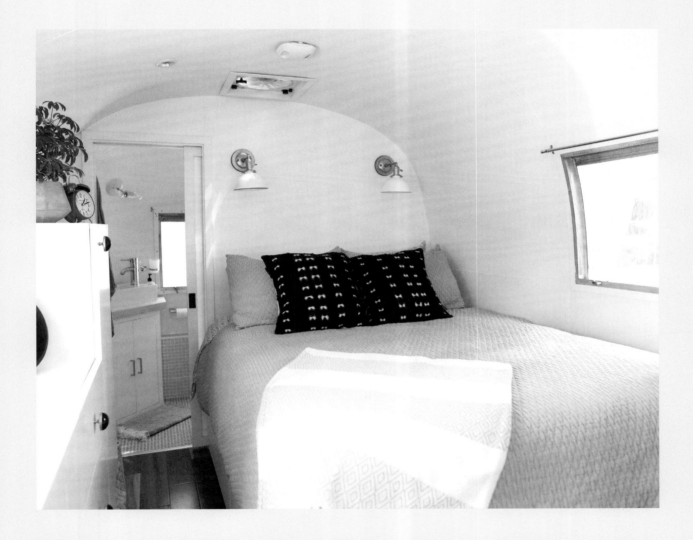

MANUFACTURER:
Airstream Trailers, Inc.
MODEL:
26-foot Overlander Gilda
YEAR OF PRODUCTION: 1966
REBUILD—YEAR: 2017

REBUILD—BODYWORK MODIFICATIONS:
New insulation, new belly pan, exterior polishing
REBUILD—CHASSIS MODIFICATIONS:
Rebuilt frame, rebuilt brakes
REBUILD—INTERIOR MODIFICATIONS: New interior skins, new electrical wiring, new propane lines, new subfloor, engineered hardwood flooring, composting toilet, custom tiled shower, tiled kitchen backsplash, front dinette with storage, telescoping dinette table, two Fantastic fans, two propane heaters, room for four people

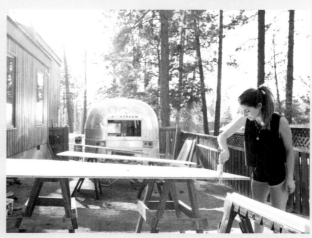

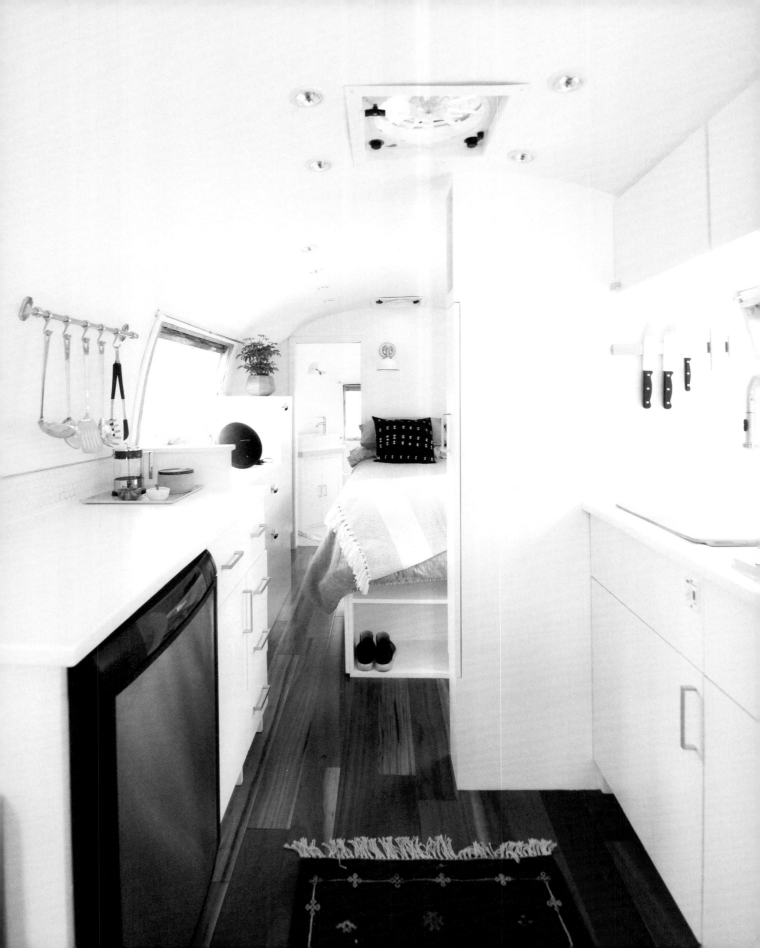

MOORMANN'S HOLZKLASSE

A minimal approach to modern luxury neatly packed inside an inconspicuous vehicle: this is what Moormann's Holzklasse exemplifies. The custom VW bus is designed by Nils Holger Moormann and built and distributed by CustomBus. Pure, high-grade materials define its simple, elegant design. Moormann is a master craftsman with an exacting eye for detail, who omits all that is unnecessary and introduces each new material with restraint, allowing its properties to shine be it wood or stainless steel. In the bus, well-balanced lighting, soft Merino wool, and nanotech laminate provide subtle warmth. A bench folds flat for sleeping, and there is an optional outdoor shower system.

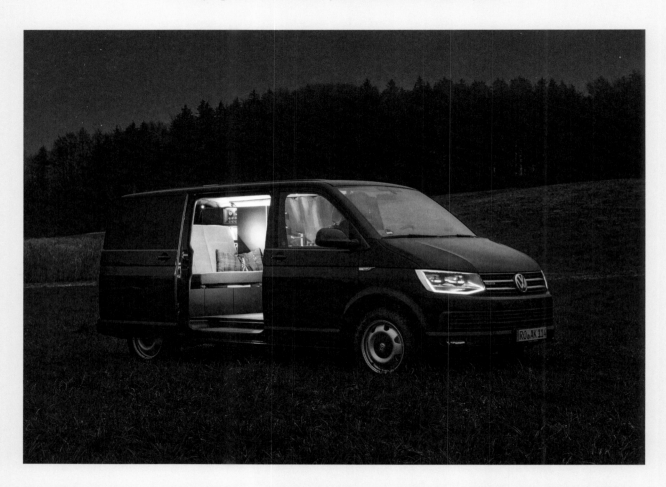

MANUFACTURER: Volkswagen
MODEL: T6 Multivan—Moormann's Holzklasse (standard class)
YEAR OF PRODUCTION: 2016
ENGINE: 2.0 L TDI, 204 hp
TRANSMISSION: Seven-speed DSG automatic
REBUILD—YEAR: On request
REBUILD—BODYWORK MODIFICATIONS: Original factory condition
REBUILD—CHASSIS MODIFICATIONS: Original factory condition
REBUILD—INTERIOR MODIFICATIONS:

Nanotech laminate with a silk-matte surface, handles of powder-coated zinc alloy with a compression latch to avoid loud vibration noises and spontaneous opening while driving, four linen compartments, cutlery drawer, spice racks, additional footstool behind the passenger seat, magnetic locks, magnetically attached hand brush, custom-made kitchen, flush gas hob with two hotplates, cast iron solid grate, compressor fridge with freezer compartment, sofa bed for

two people, matching seat covers for driver and passenger seats and sofa bed, real oak floorboards with non-slip rubber seams, atmospheric lighting, central control panel with battery display, gas display, fresh water level, and several switches for light sources, 105-liter fresh water supply, 240 Ah battery capacity, 11 kg gas supply
REBUILD—OTHER MODIFICATIONS: Outdoor shower with shower tent
REBUILD—SUPPORT BY: CB Fahrzeugbau GmbH & Co. KG

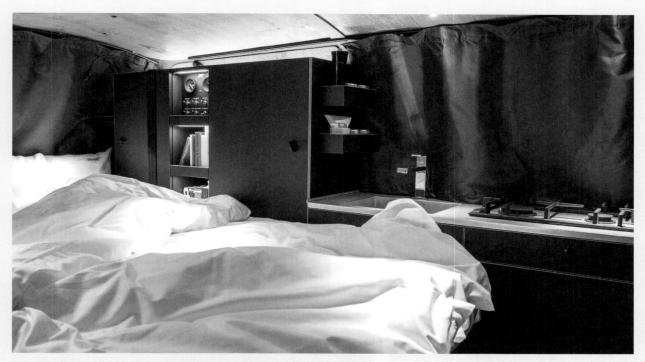

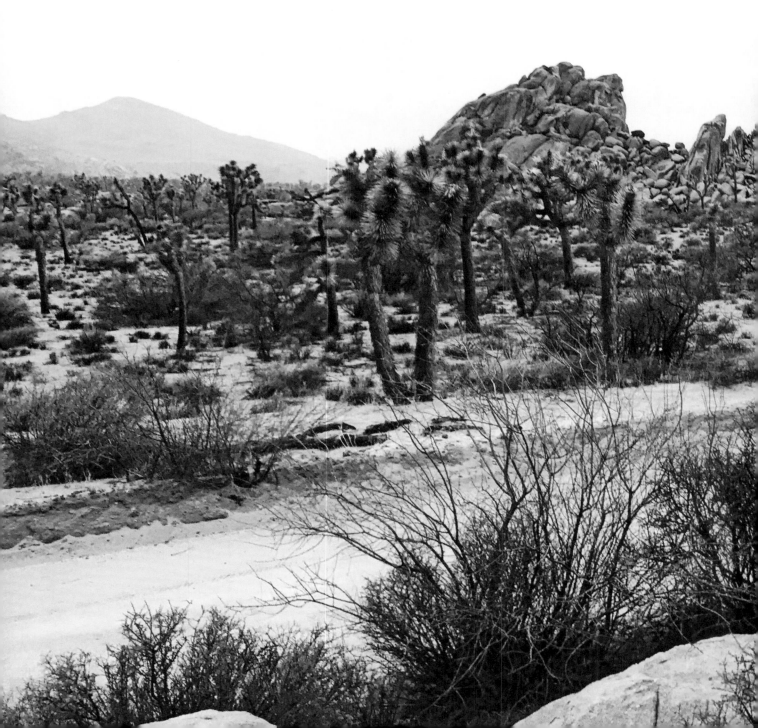

THERE'S NO BETTER TIME THAN NOW

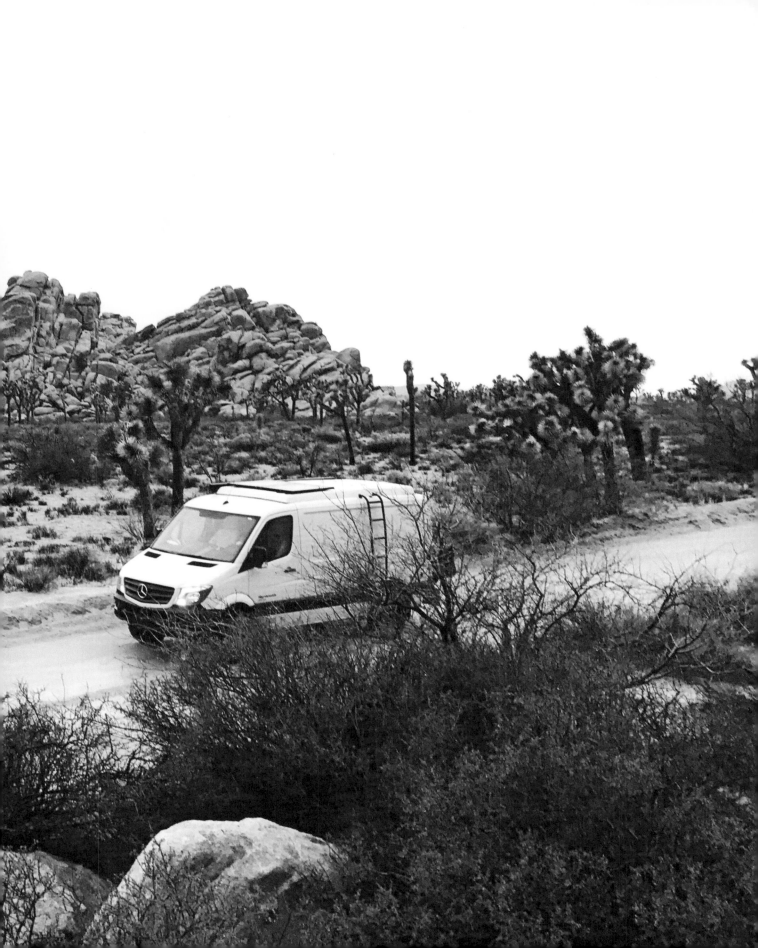

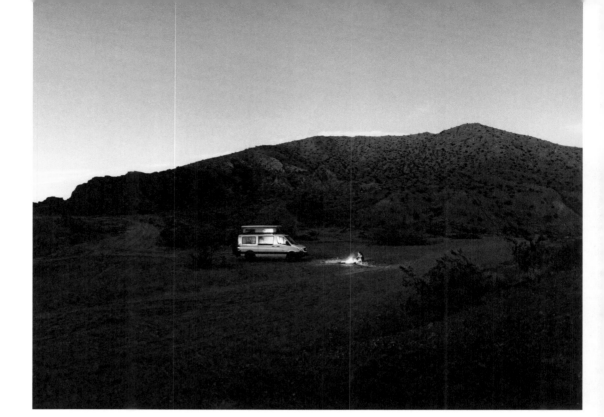

"When we visit friends we're **not just crashing for a weekend.** We visit for months."

Fitting work into a van routine can create real friction when the stated priority is to move, so young professionals often build their van lives around various mobile income sources to varying degrees, not vice versa. Katch Silva is a wedding photographer, a specialty driven by online word-of-mouth. Her work already involved flying on the dime of various far-flung customers. And her photographer and educator boyfriend Ben Sasso works mostly online, so he's also flexible by default.

Having planned for years to move into a van, the couple finally sold all their non-essential camera equipment and bought a brand-new 4WD Mercedes Sprinter, a hybrid utility/offroad camper big enough to be both home and office, which they called "The Tardis" after the time machine in *Doctor Who*. Since time is their most valuable resource, the whole build—pop-up roof, kitchen, solar, water, and heating—was outsourced to Sportsmobile. And the ace up their sleeve was the warranty. After their first winter, with ruptured water pipes and the heating on the fritz, all was politely replaced.

Their route is largely determined by the locations of wedding clients, so it's rarely an ordered life of →

→ The Tardis

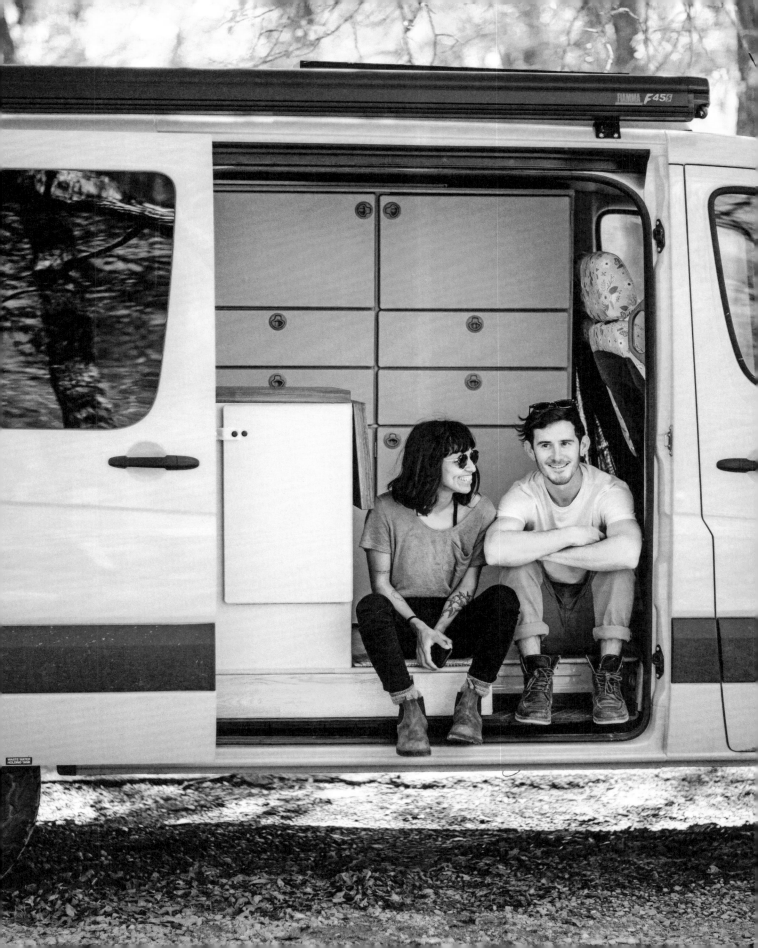

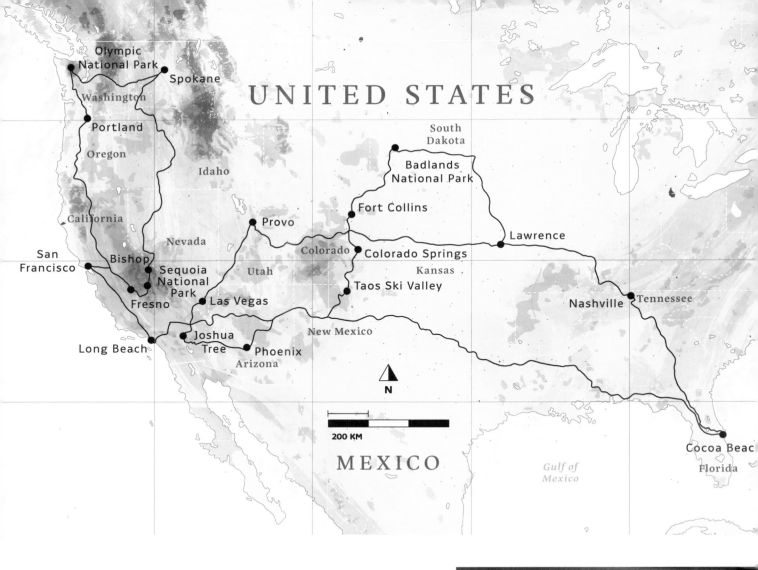

UNITED STATES

Olympic National Park
Spokane
Washington
Portland
Oregon
Idaho
South Dakota
Badlands National Park
California
Fort Collins
Provo
Nevada
Colorado
Colorado Springs
San Francisco
Bishop
Utah
Kansas
Lawrence
Sequoia National Park
Taos Ski Valley
Fresno
Las Vegas
Nashville
Tennessee
Joshua Tree
New Mexico
Long Beach
Phoenix
Arizona

N

200 KM

MEXICO
Gulf of Mexico
Cocoa Beac
Florida

consulting maps and hopping point-to-point. Katch posts her itinerary online so prospective clients know when she's near. "It hasn't been all waking up to beautiful landscapes and gorgeous views," she says. "We've spent our fair share of nights in Walmart parking lots and truck stops, but when we visit friends across the States, we're not just crashing on the couch for a weekend. We visit for months and get to actually live in a new place and spend time. The benefits far outweigh the costs." ■

Ben at work, no problem with 4G Wi-Fi and enough power resources (right). Pop-up roof hides a second double bed (top opposite).

80

→ The Tardis

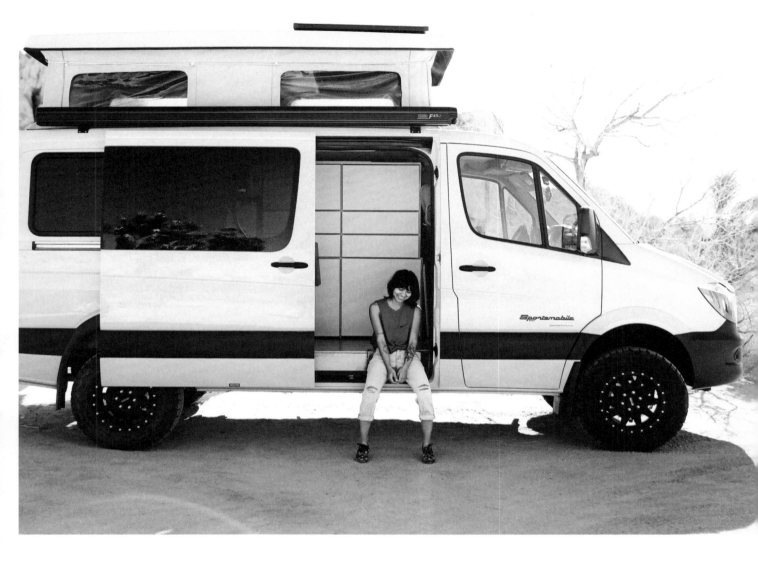

MERCEDES-BENZ SPRINTER SPORTSMOBILE

Sportsmobile is the patriarch in a fast-growing market of van conversion businesses. Their beginnings date back to 1961 when they outfitted Ford Econolines. Recently, their work has focused on the versatile Mercedes Sprinter. The Sprinter is heralded among van lifers for its accommodating design, dependability, and comfort. Working directly with Sportsmobile allowed Katch and Ben to tailor their van to suit their every need while working and living on the road. Modifications include a sink, microwave, pop-top bed, fold-out bed, floors, cabinetry, solar integration, running water, and even a built-in safe to protect their camera gear.

MANUFACTURER: Mercedes-Benz
MODEL: Sprinter 4×4 Sportsmobile
YEAR OF PRODUCTION: 2016
ENGINE: 3.0 L V6 CDI, 188 hp, 325 lb-ft of torque
TRANSMISSION: Five-speed automatic
VISITED COUNTRIES: United States
MILES IN TOTAL: 27,000 miles and counting
TRAVEL TIME: 1 year and counting

REBUILD—YEAR: 2016
REBUILD—BODYWORK MODIFICATIONS: Penthouse expandable top
REBUILD—CHASSIS MODIFICATIONS: Raised 4.3 inches in the front and 3.1 inches in the back, giving it 20% greater slope-climbing ability
REBUILD—INTERIOR MODIFICATIONS: Bespoke interior by Sportsmobile, including new floors,

cabinetry, furniture, dinette area, bed in the pop-top, bed in the main cabin, fridge, microwave, sink
REBUILD—OTHER MODIFICATIONS: Aluminess boxes on the rear rack, built-in safe, additional lights, hot water heater, shower hose in the back, two solar panels, diesel-run heater, additional awning
REBUILD—SUPPORT BY: Sportsmobile

FROM THE BLACK FOREST TO THE SEA

Deep in the Black Forest in southwest Germany is medieval Freiburg. At the heart of Central Europe—minutes to France, an hour to Switzerland, and a little longer to Belgium, Austria, or Italy—Freiburg is surrounded by rolling, dense forested hills. Nature is impossible to ignore here.

Having once toured Australia in crowded, friendly vans, local students Selina Mei and Frank Stoll were destined to return to that life. "We fell in love with →

83

Pine Pins ←

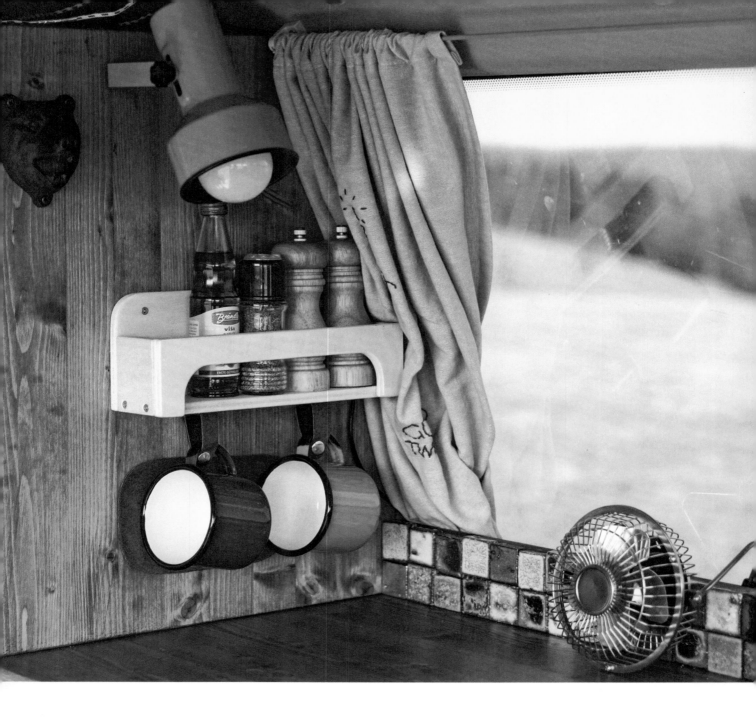

the freedom to wake up in a new spot each morning. The close and special connection you get to the environment while traveling in a van is priceless."

A mechanic friend helped them find a 2002 Volkswagen T4—a common camper in Germany—to make their own. "Its old cabinetry was perfect, so we just optimized parts to match our style," they say. They installed a pop-up roof, flooring, furniture, and a kitchen, but the biggest thing they did was repaint. "The van had rust, and we were bored by its whiteness. We gave it a new life."

→

"It's so cool to know there's a van waiting for you, ready to go."

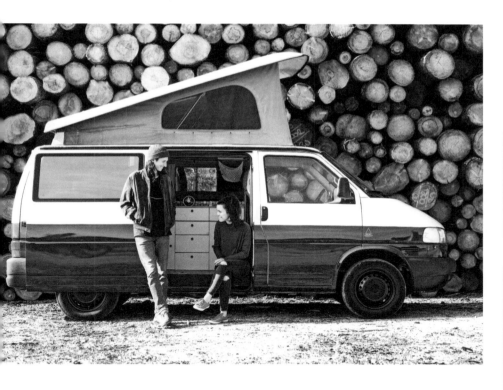

DIY spice rack and mug holder *(opposite)*. A van obtained in original or vintage condition is extremely easy to homify *(below)*. Cooking session *(bottom)*.

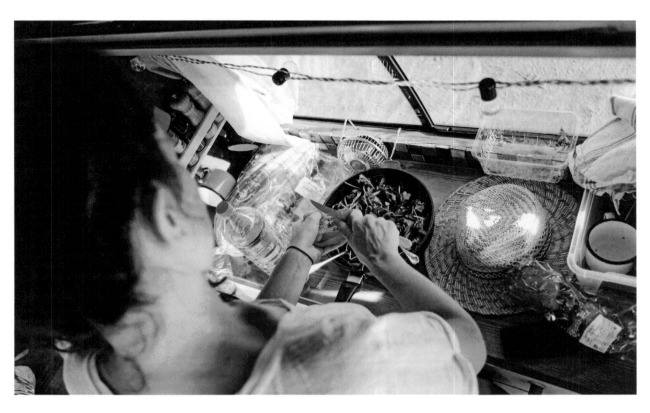

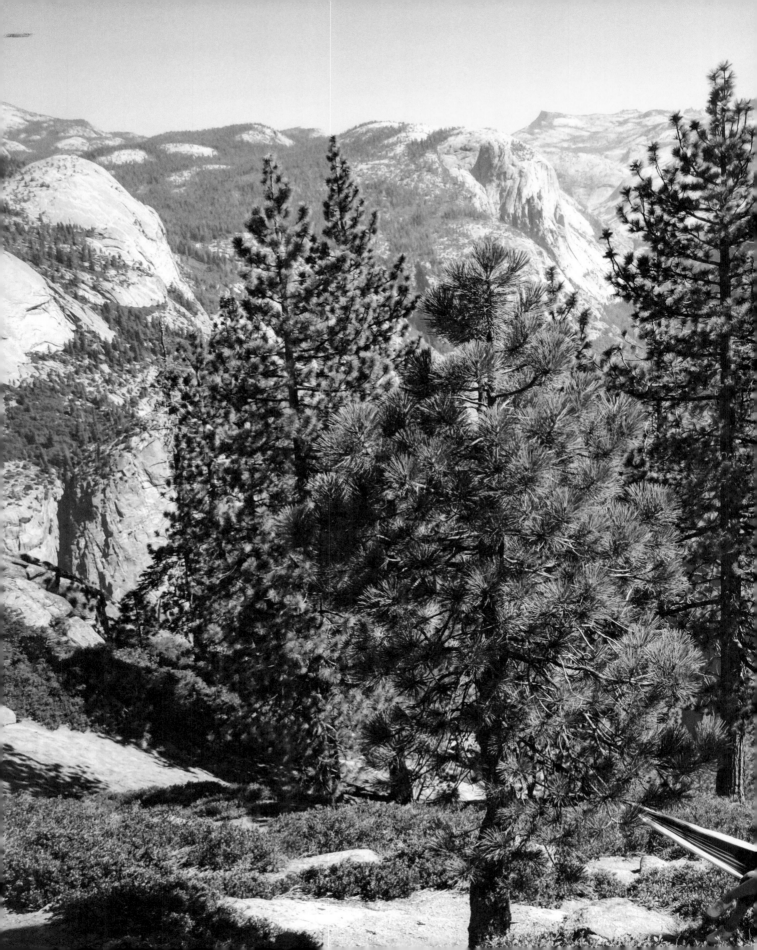

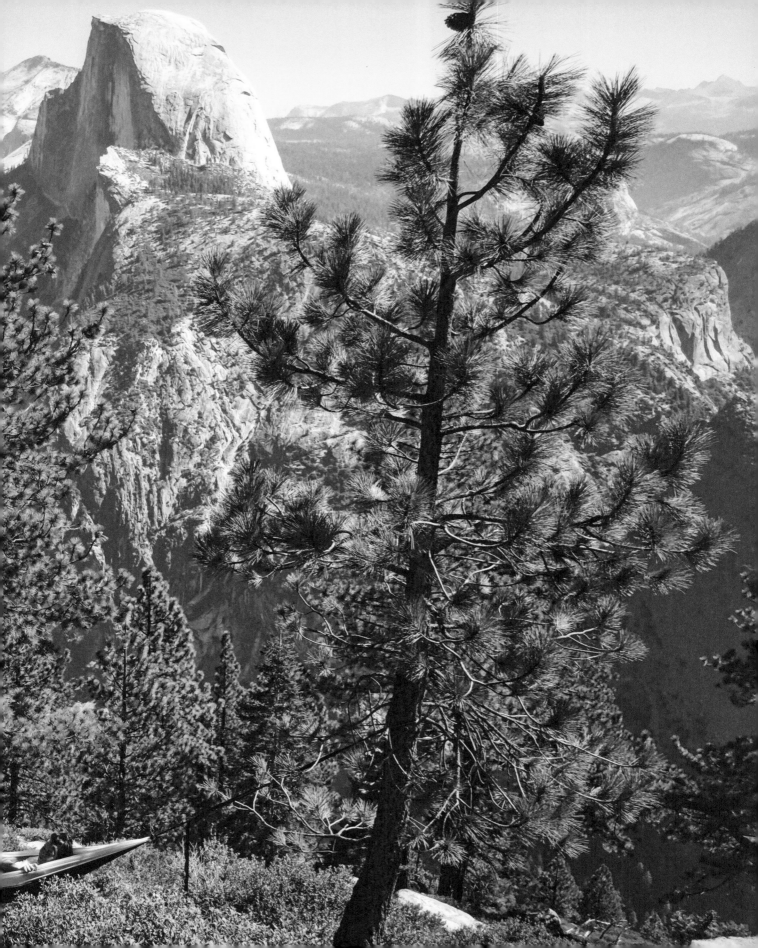

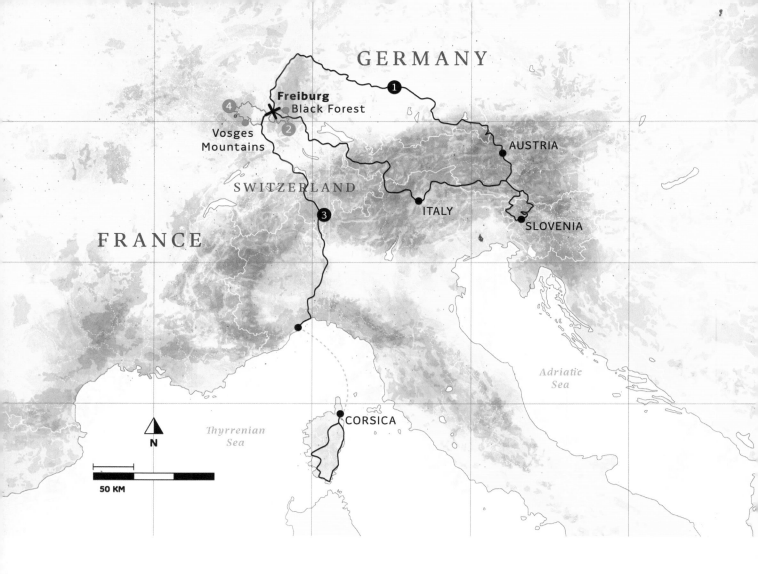

GERMANY

1

Freiburg
Black Forest

4

Vosges
Mountains

AUSTRIA

SWITZERLAND

2

ITALY

3

SLOVENIA

FRANCE

*Adriatic
Sea*

N

*Thyrrenian
Sea*

CORSICA

50 KM

Given their location, they drive as much as possible around all their neighboring countries. "But we have heaps of plans. It's so cool to know there's a van waiting for you, ready to go whenever and wherever you want." A place like the French island of Corsica, where they summered in 2017, felt to the pair like a microcosm of Europe itself. "You get everything, from giant mountains to forest to crystal-clear water in beautiful bays. Corsica was our first time waking up in the van by the ocean—that was definitely magical." ∎

Teatime at the Schluchsee, Black Forest, Germany *(right)*. Cozy night-time on the French island of Corsica *(opposite)*.

→ Pine Pins

VOLKSWAGEN T4 CARAVELLE

Unpleasant amounts of rust due to a life as a plumbing service vehicle dictated a paint job for Selina and Frank's 2002 VW T4. With a new cabinet installation in place, the couple decided to add a pop-up tent, small kitchen, and water supply to make it livable. The T4 is already a popular platform from which to start professional and do-it-yourself campervan buildouts due to its size and engine options. This 2002 model is equipped with a 2.5-liter straight five that delivers ample power (102 hp) through the five-speed setup, which can offer impressive fuel averages of 30 miles per gallon.

MANUFACTURER: Volkswagen
MODEL: T4 Caravelle
YEAR OF PRODUCTION: 2002
ENGINE: 2.5 L TDI, 102 hp
TRANSMISSION: Five-speed manual
VISITED COUNTRIES: Austria, France, Germany, Italy, Slovenia, Switzerland

MILES IN TOTAL: 160,000 miles
TRAVEL TIME: As much as possible
REBUILD—YEAR: 2017
REBUILD—BODYWORK MODIFICATIONS:
Pop-up roof, rust removed, repainted lower body
REBUILD—CHASSIS MODIFICATIONS:
Original factory condition

REBUILD—INTERIOR MODIFICATIONS: Optimized existing custom cabinet construction, rotating seat, water supply, flooring, kitchen solution
REBUILD—OTHER MODIFICATIONS:
Additional cooling box, outdoor shower
REBUILD—SUPPORT BY:
Friends

MAKING TIME TO MAKE TIME

We are continuously persuaded to buy and sell, to think about buying and selling, and are taught early on that determining our identity and expressing who we are happens through consuming," say Finnish designers Maria and Henri Vanonen. To consume more consciously requires more human connection, both to each other and to nature, continues the couple: "Hiking, talking, making dinner, listening to music, and just listening." Nearing the end of their postgraduate theses, it was time to reconnect. "We'd long dreamed of converting a van into both a summer house and moving office. After running our brand VAI-KØ for a while, we thought it was the right time to make our dream come true."

They bought a well-maintained 1995 Mercedes-Benz 308D and turned it into a roomy rectangular headquarters for their young company. The 308D is also a former favorite of the postal service. "We bought the van online and at the end of May headed up to my uncle's farm to rebuild it from scratch ourselves, which took six weeks of dedication. We →

90

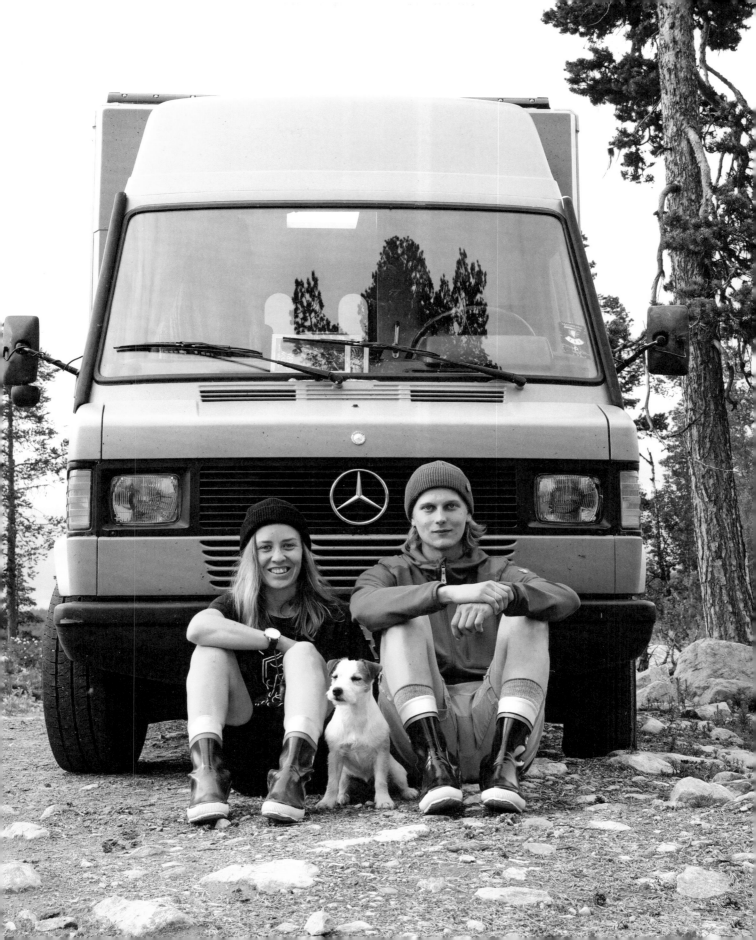

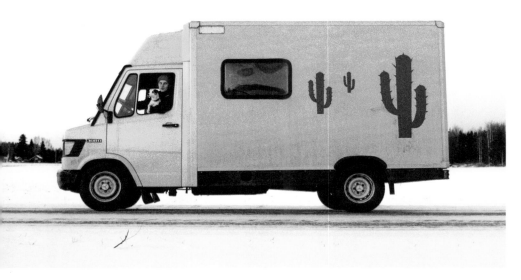

"Maybe connection is actually a by-product of simplifying—simple as that."

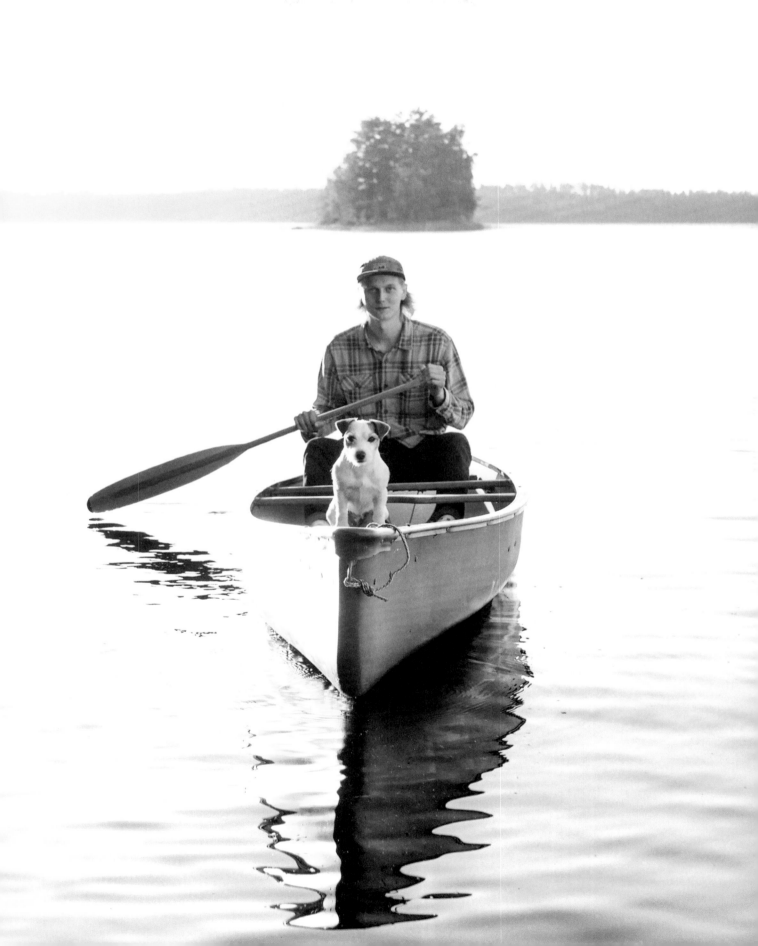

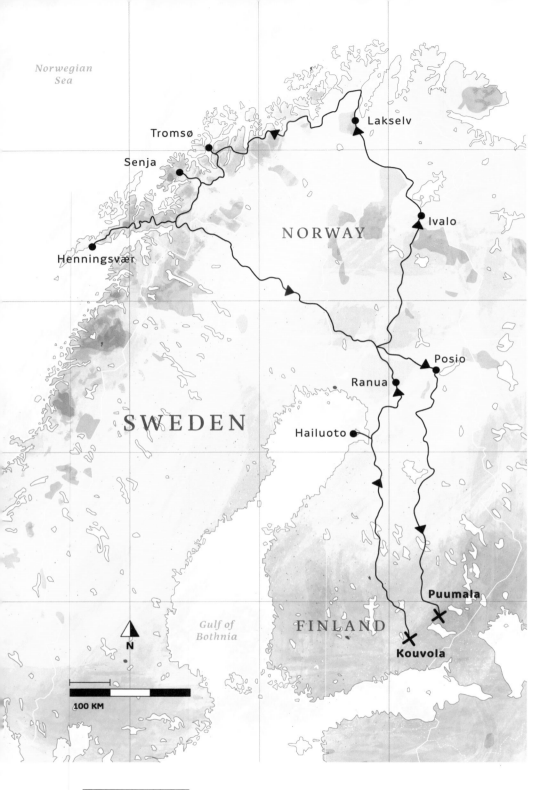

Midnight in Lapland (above right). Jack Russell lady Yoda waving at the fairy to Hailuoto island (right) Dinner somewhere in Norway (opposite bottom).

→ Nordicamper

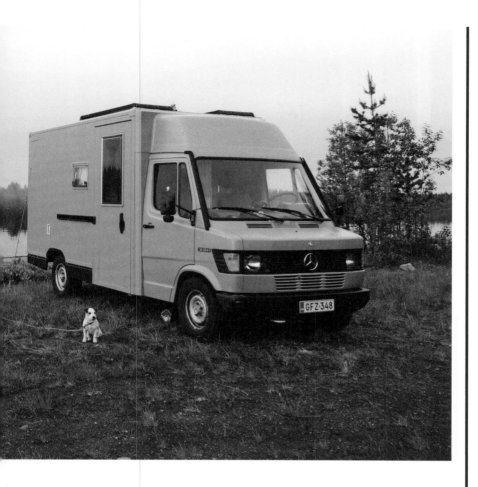

MERCEDES-BENZ
T 1 308D

Mercedes-Benz, eager to capture more of the van market share, introduced their version of the VW Transporter and Ford Transit in 1977, calling it the T 1. It was available in several configurations, including a postal service version ideal for camper conversions, and it provided much more interior space than its competitors. It came equipped with an 82-horsepower 2.3-liter four-cylinder diesel, known for its reliability and lower fuel consumption. Maria and Henri entirely rebuilt the cabin, adding new insulation, floors, walls, and a daylight sunroof. 208-Watt solar panels power kitchen and living area electronics.

MANUFACTURER: Mercedes-Benz
MODEL: T 1 308D
YEAR OF PRODUCTION: 1995
ENGINE: 2.4 L Diesel, 82 hp
TRANSMISSION: Automatic
VISITED COUNTRIES: Finland, Norway, Sweden
MILES IN TOTAL: 3,100 miles
TRAVEL TIME: Summer 2017

REBUILD—YEAR: 2017
REBUILD—BODYWORK MODIFICATIONS:
New paint, skylight, added insulating camping windows
REBUILD—CHASSIS MODIFICATIONS:
Original factory condition
REBUILD—INTERIOR MODIFICATIONS:
Complete insulation, wooden floor, walls and roof, kitchen, living area and bed, new wiring
REBUILD—OTHER MODIFICATIONS:
208W solar panel system
REBUILD—SUPPORT BY:
Family and friends, especially uncle Timo

painted it, built insulation, floor, walls, roof, all the interior and electrics, and added a rooftop solar system," shares Henri. Together, they installed a kitchen, living area, bed, and skylight, which, in the full-height cabin, is a favorite feature that creates an abundance of space and light. Their maiden late-summer trip took them to Finland's Lapland, Norway, and Sweden, and a longer journey is planned for spring 2018. "Maybe all this restlessness and exhaustion is due to too much stimuli and too little connection," they muse. "Maybe connection is actually a by-product of simplifying—simple as that." ∎

THE FEELS ON THE BUS

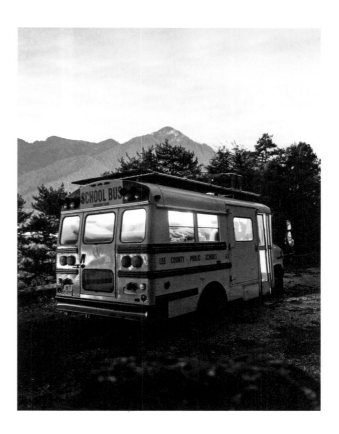

The decision of Kai Branss and his tattoo-artist girlfriend, Julie Toebel, to travel Europe in a U.S. school bus started with the idea of building a tiny house in Berlin, where they live. "It's about downsizing, living minimally," say the couple. "But we didn't like that we'd always be stuck in a certain area. It became clear we needed something that could move, and more than just a regular van, because we wanted to work at the same time."

It was a simple wish made slightly complicated by the whopping 3.9-ton 6.2-liter diesel 1993 GMC →

97

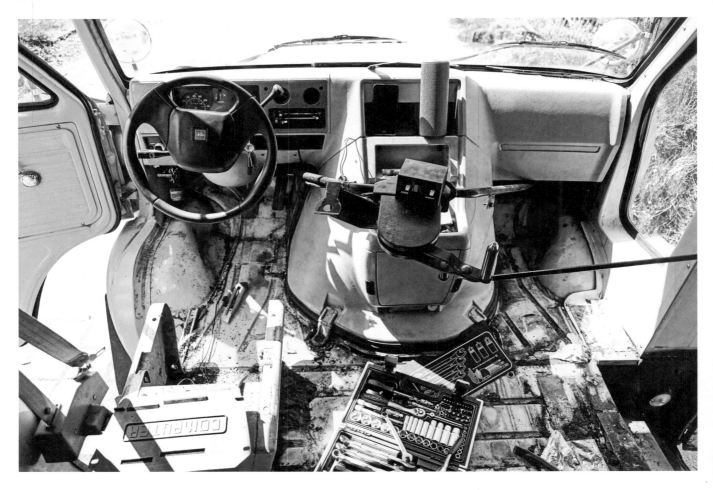

It now resembles more of a shabby chic Airbnb than a vehicle for moving children.

Work in progress on the cockpit and flooring *(above and below)*. Julie and Kai midway through the overhaul *(opposite top)*, and finally on the road *(opposite bottom)*.

Vandura 3500 bus they found one day on the way to breakfast, fresh off the boat and squatting on a Berlin street. "We bought it the next day and started the conversion immediately," they say. "After 800 hours of work we have a completely off-grid bus, with flowing water, solar power, a full-size bed, a pretty big kitchen, and huge roof racks that double as a sundeck—and soon, a woodstove." It now resembles more of a shabby chic Airbnb than a vehicle for moving children.

During the summer of 2017 they toured Germany and Austria, and went down to the north of Italy to climb among the lower Alps and lakes. "Everybody smiles →

98

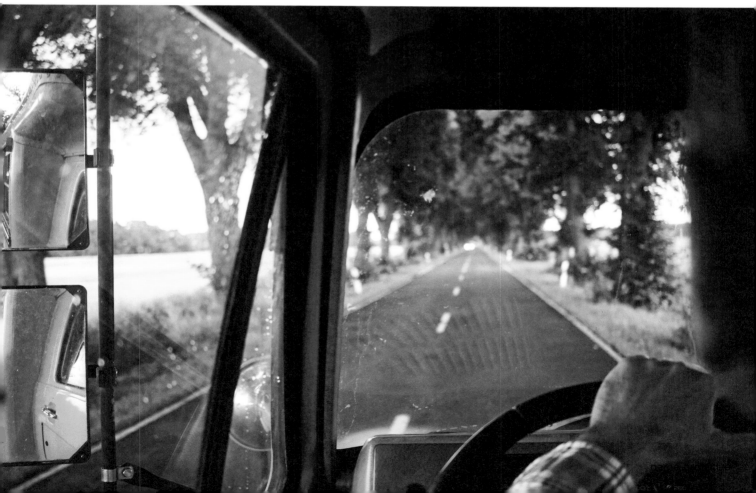

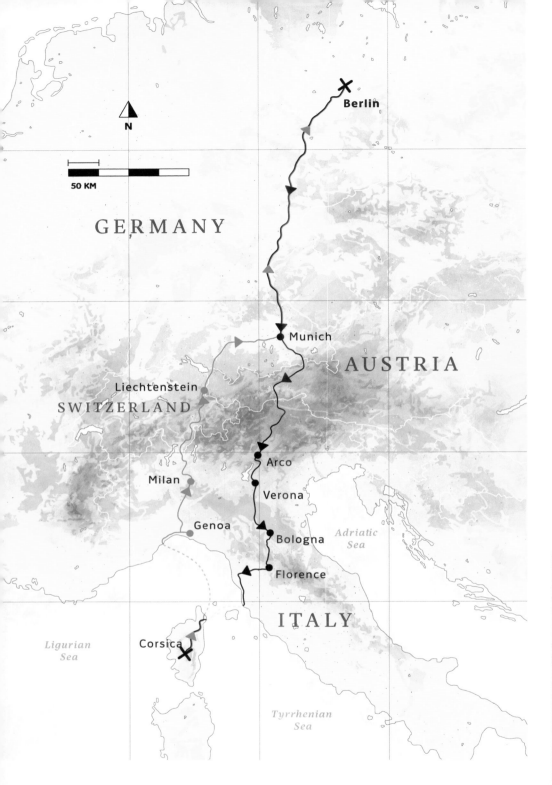

Driving through Italian
foothills (above right). Necessary
stowage: espresso maker
(opposite bottom). Julie enjoys
the sunshine (right).

→ We Travel by Bus

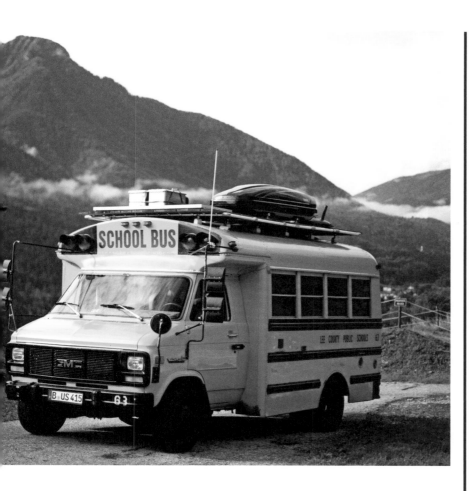

GENERAL MOTORS VANDURA 3500

In the United States, the bright yellow buses with black trim are the harbingers of the school day for children. The heavy-duty Vanduras have not changed much since their introduction to the market in 1965. The 1993 bus here comes with a super reliable 130-horsepower 6.2-liter Detroit Diesel V8 paired to a new automatic. The conversion from school bus to rolling home took 800 hours, requiring the installation of a running warm water system, wooden floors, a double bed, a solar energy system, a large kitchen unit, and—Kai's favorite—a sundeck/roof rack.

MANUFACTURER: General Motors Corporation
MODEL: Vandura 3500 school bus
YEAR OF PRODUCTION: 1993
ENGINE: 6.2 L diesel V8
TRANSMISSION: Automatic
VISITED COUNTRIES: Germany, Austria, Italy
MILES IN TOTAL: 195,000 miles
TRAVEL TIME: Every spare minute and full time in future

REBUILD—YEAR: 2017
REBUILD—BODYWORK MODIFICATIONS:
Original school bus condition
REBUILD—CHASSIS MODIFICATIONS:
Original factory condition
REBUILD—INTERIOR MODIFICATIONS:
Full insulation, wooden floor, full-size double bed, kitchen unit, woodstove coming up, composting toilet
REBUILD—OTHER MODIFICATIONS:
Roof hatch, roof rack, solar energy system, water system, pre-heater
REBUILD—SUPPORT BY: Nobody

at us when we drive by," they say. "You don't see a lot of these in Europe." And it's not just a means to see the continent; there is real altruism in road life. It's a way to try and mitigate one's effects on the planet, however small. "It is an opportunity to live more consciously, and get the most out of life. Our advice for anyone interested in it is don't overthink it. Just go for it." ∎

SERVES: 3
PREPARATION: 40 MIN
COOKING: 10 MIN

BREAKFAST SEA TORTILLA

INGREDIENTS

2 cups strong bread flour, 1 cup salted water, 2 tbsp grapeseed oil, 1 chorizo (thinly sliced or as desired), 1 400 g can red kidney beans (rinsed and drained), 1 400 g can crushed tomatoes, 1 tsp sweet paprika, 6 eggs, 100 g shaved mozzarella (or other cheese), 1 red onion, 3 radishes, 1 bunch cilantro, 3 avocados mashed with salt

Tip the flour into a bowl and make a well in the center. Pour the water and grapeseed oil into the well and mix with your hands until it comes together. Knead for 23 minutes or until dough becomes smooth. Cover and let rest for 30 minutes. To cook the tortillas, heat your grill to 400 °F (200 °C). Divide the dough into golf ball-sized portions and roll out as thinly as possible with a flour-dusted wine bottle. Cook each tortilla as you roll them for about 1 minute on each side; they will puff up and char a little. Set aside and cover with a damp tea towel while you cook the rest. Top tortillas to your heart's content! Try caramelizing chorizo with kidney beans, tomatoes, and sweet paprika, or add scrambled eggs, cheese, red onion, radish, cilantro, and avocado.

102

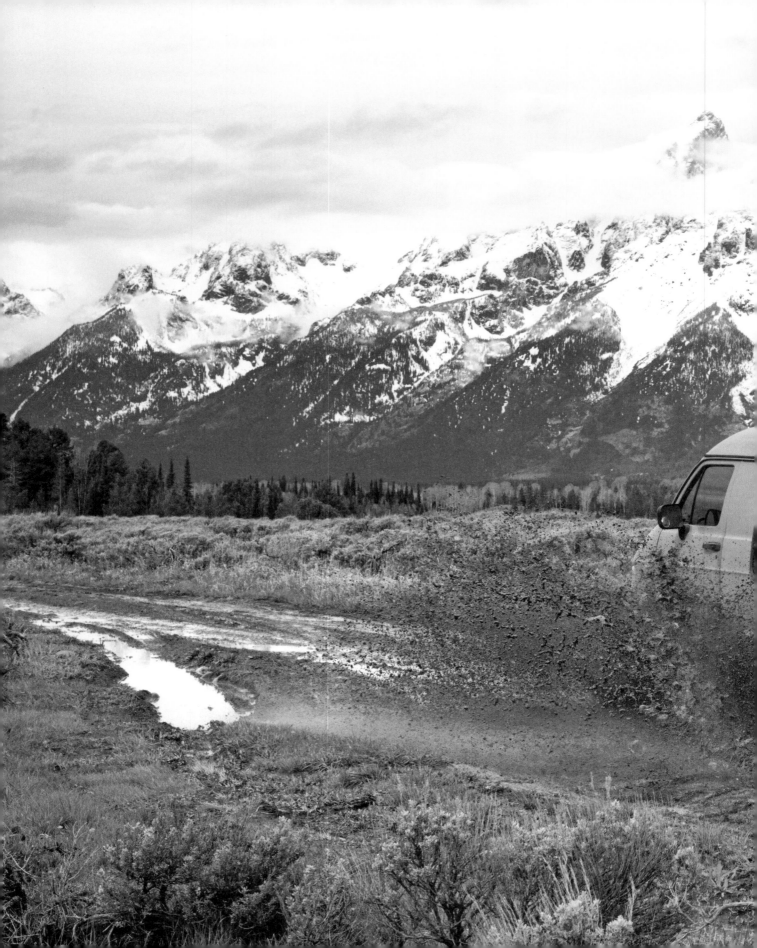

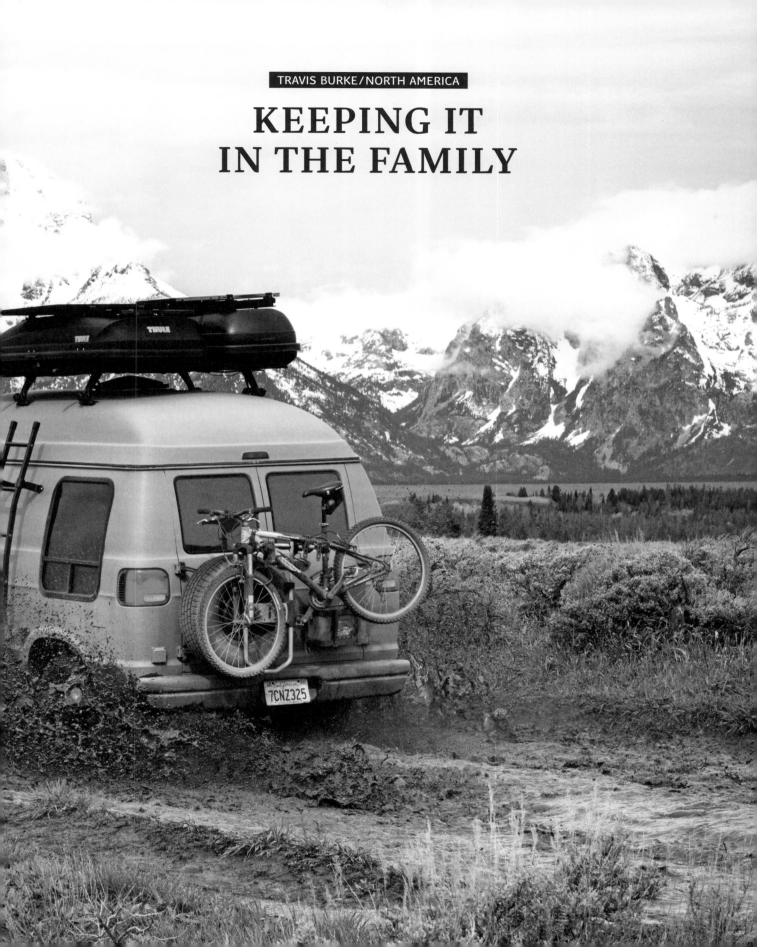

KEEPING IT
IN THE FAMILY

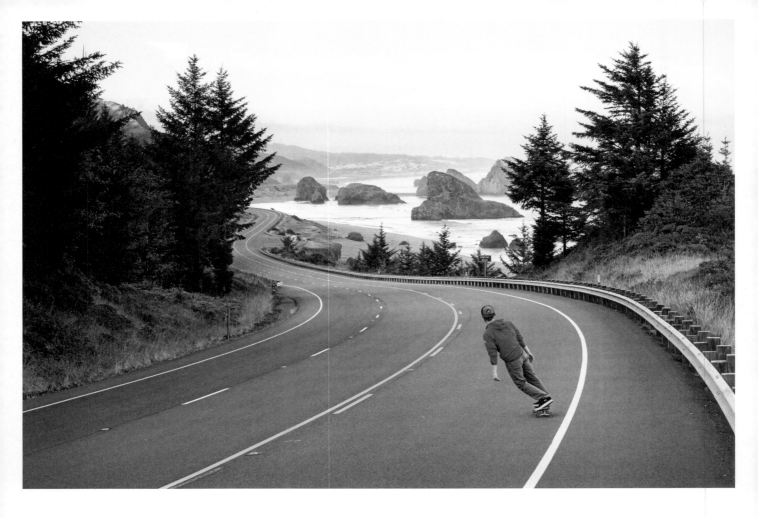

When adventure photographer Travis Burke realized he'd outgrown the Toyota Tacoma he'd been working and living in almost full-time, he had a quandary: how to afford a new $100,000 Mercedes-Benz Sportsmobile AWD camper on an $18,000 freelancer's salary? "I put a picture of the van on my vision board and knew that somehow I would make it happen," he says.

Months later, his grandma called: the old Dodge Ram Van camper sitting outside her house in Texas was his for free if he wanted it. "It meant a lot to her for it to stay in the family," he says. "I had her send me photos of the van and, needless to say, it was anything but the extreme and adventurous van I had dreamed of. But I flew over there and drove it across the desert to California."

It was a dusty old B2500 V8, and his friends christened it his "creeper van." But Travis persevered, selling the Tacoma and plowing everything into the Dodge over the spring of 2013. Outside, he gave it a lift and a paint job, offroad tires, ladders, solar panels, and racks for bikes and motorbikes; inside, new →

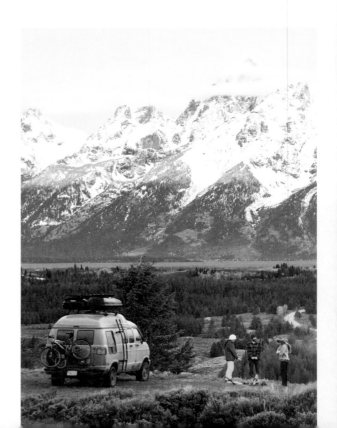

→ Betty the Grey Wolf

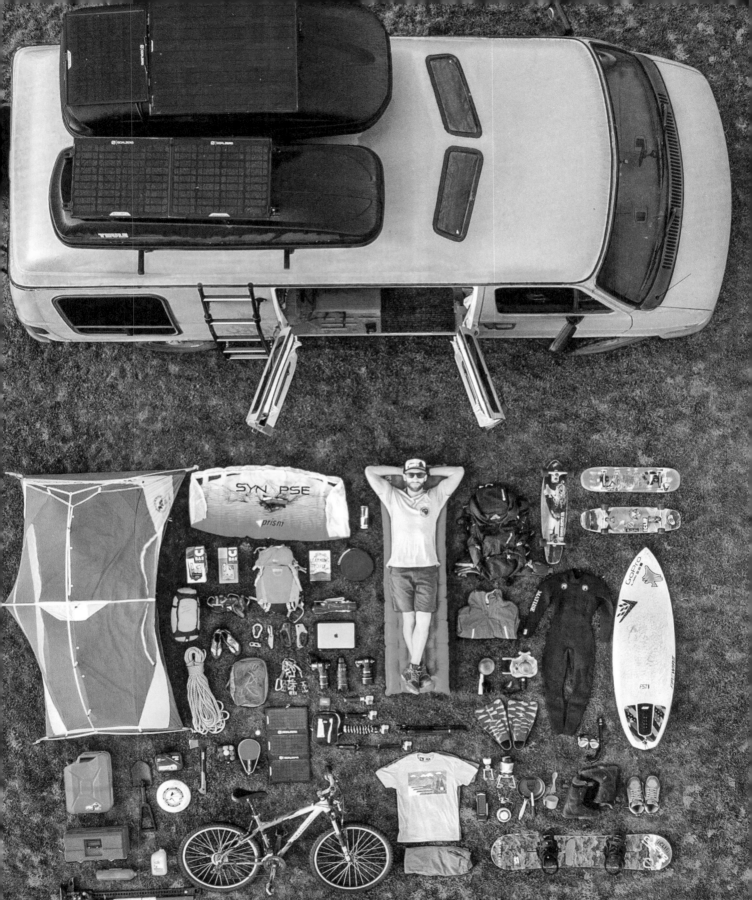

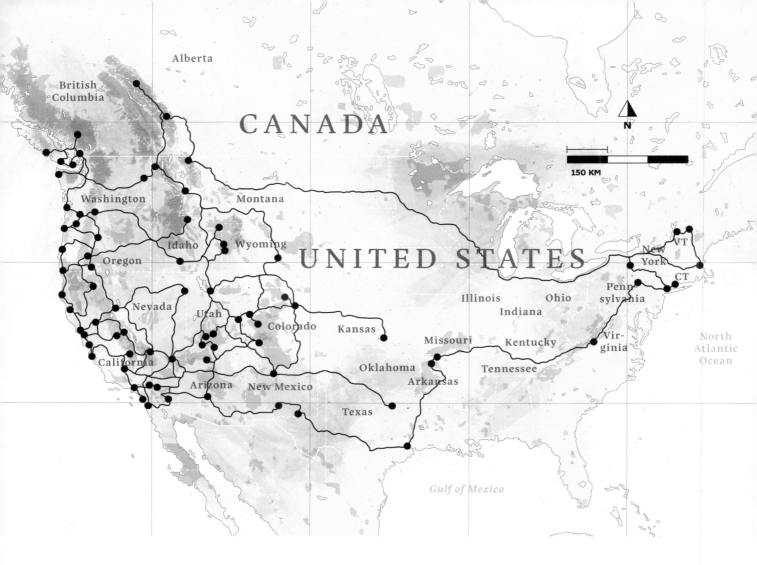

cabinetry, a kitchen, fridge, induction stovetop, floor-ing, upholstery, and a memory-foam bed. Grandma's van was ready to go. "Then I set off on my birthday to continue chasing my dreams," he says. "I had no idea if the trip would last three months or three years. But we've put in 150,000 miles (241,400 km) together and circled the country, and after a ton of highs and lows it's been the experience of a lifetime." ■

Glowing long-exposure tent at dusk *(right)*. Setting up the photo equip-ment alongside grandma's van *(opposite)*.

→ Betty the Grey Wolf

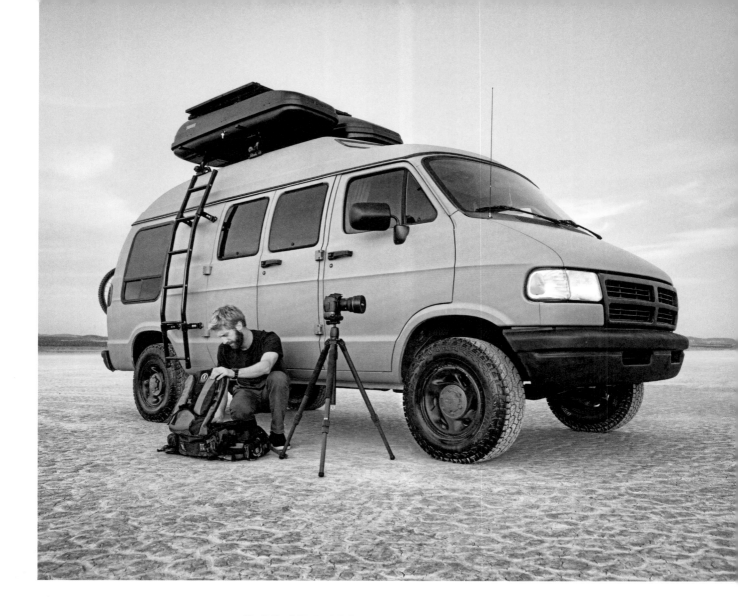

DODGE RAM VAN B2500

Some might say the glory days of classic vans that began in the 1970s are over, but the American van tradition is still alive and well. The 1994 Dodge Ram Van is part of the third generation of Chrysler's hit model, and its technical specs are nearly the same as the first generation's. Three months went into customizing the interior, which includes a full-size bed, storage, and a small sink. Under the hood, a bulletproof 5.2-liter Magnum V8 is at work delivering 230 horsepower to the rear axle. Travis repainted the van matte gray, and added a lift kit, bigger tires, racks from Thule, Goal Zero solar panels, and, most recently, a motorcycle rack.

MANUFACTURER: Dodge
MODEL: Ram Van B2500
YEAR OF PRODUCTION: 1994
ENGINE: 5.2 L Magnum V8, 230 hp
TRANSMISSION: Automatic
VISITED COUNTRIES: United States
MILES IN TOTAL: Over 150,000 miles
TRAVEL TIME: 3 years and counting

REBUILD—YEAR: 2013
REBUILD—BODYWORK MODIFICATIONS:
Matte gray paint, ladders, Thule racks,
Goal Zero solar panels
REBUILD—CHASSIS MODIFICATIONS: Lift kit
and added bigger all-terrain tires
REBUILD—INTERIOR MODIFICATIONS:
New cabinets, sink, fridge, flooring, lights,

upholstery, memory foam for the bed,
induction burner stovetop, Goal Zero Yeti 1250
battery to hold solar power
REBUILD—OTHER MODIFICATIONS:
Motorcycle rack
REBUILD—SUPPORT BY:
Goal Zero, GoPro, Clif Bar, Hippy Tree
clothing, Thule racks

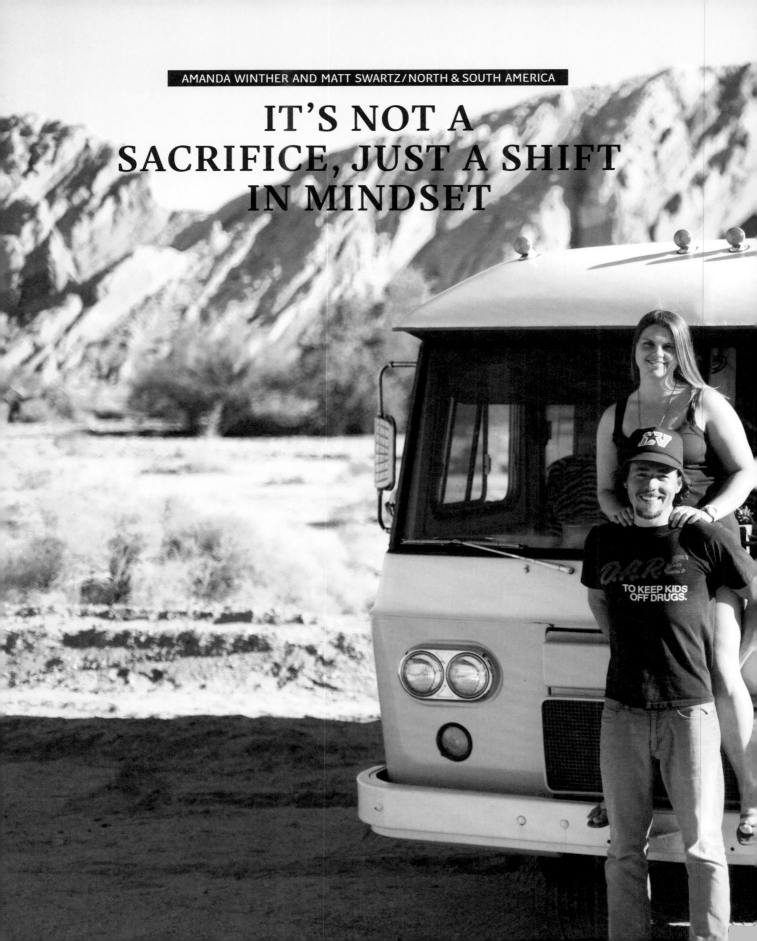

IT'S NOT A SACRIFICE, JUST A SHIFT IN MINDSET

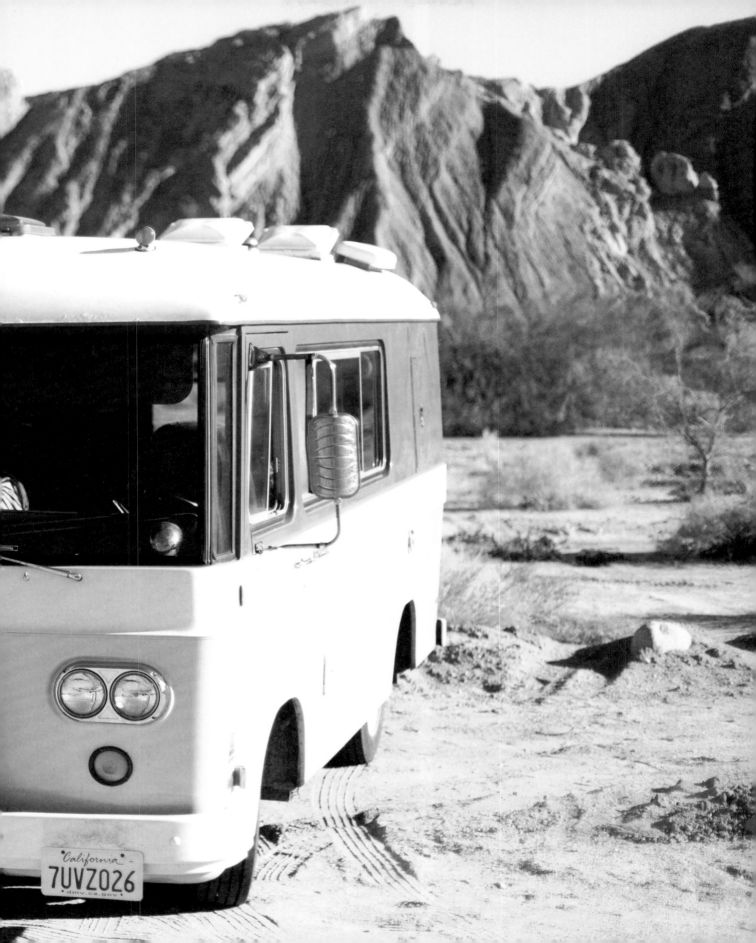

El Chaltén, Los Glaciares National Park, Argentina *(right)*. Loveland Pass, Rocky Mountains, Colorado, USA *(opposite)*. Desert rest stop, Palm Springs, California, USA *(below)*.

A natural sense they'd always had of traveling, cooperating, and existing took over.

In mid-2016, Matt Swartz and Amanda Winther flew to Portland to meet a retired railroad mechanic named King, the owner of one of only 3,211 original Clark Cortez Motorhomes remaining in the United States. King took them to his farm, put them in the 52-year-old Cortez for the night, and in the morning they paid in cash and drove it home. It had 60,000 miles (96,000 km) on the dial. "We took a chance," they say, "since all the vehicles we'd looked at were sketchier than outlined in the listing. If there'd been issues we probably would've been on long, uncomfortable buses back to San Francisco, but

we lucked out!" Heading down through Columbia River Gorge, Hood River, and the Oregon deserts near Smith Rock State Park and Bend, and toward the California redwoods, they planned their new life on the road.

Maintaining a solid workflow was paramount. Amanda was thriving in her life and career in Silicon Valley, working in marketing at YouTube, and struggled to leave it all behind and go freelance. "We have a great group of friends, so giving up our Mission apartment with two amazing roommates wasn't easy," she says. "And working in tech is an awesome thing, since you're part of things that are so fundamental to the cultural meme of the U.S. and world." For Matt, a freelance photographer mainly working in the outdoor industry, the pull factors of road life made it somewhat easier. "If we could distill the best part of van life down to a single word, it's 'freedom,'" he says. "We aren't →

112

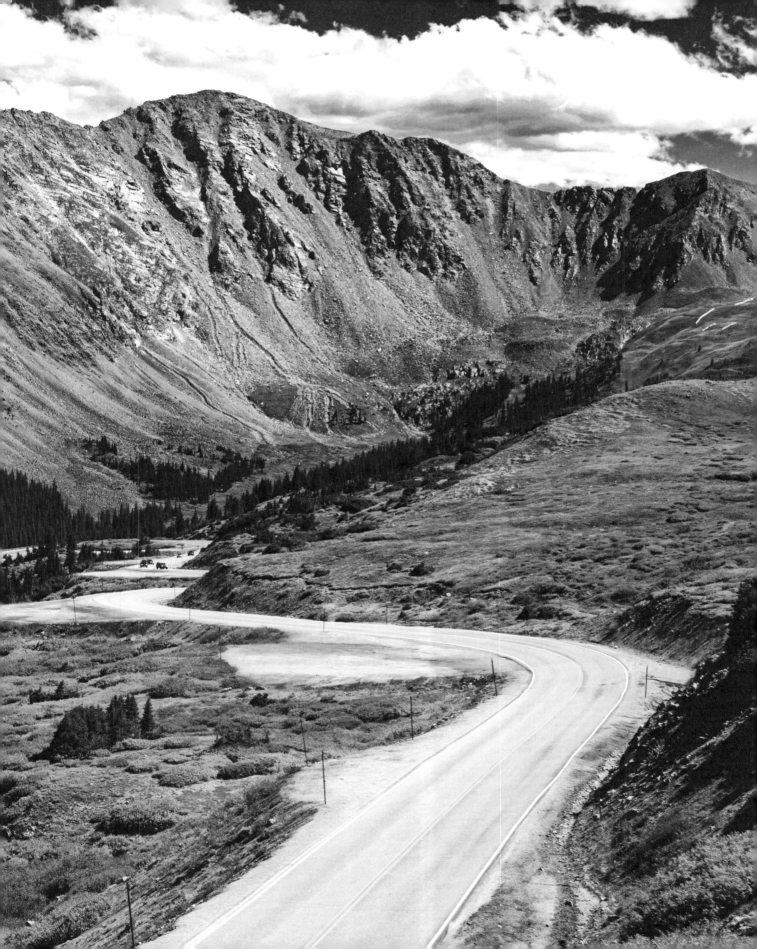

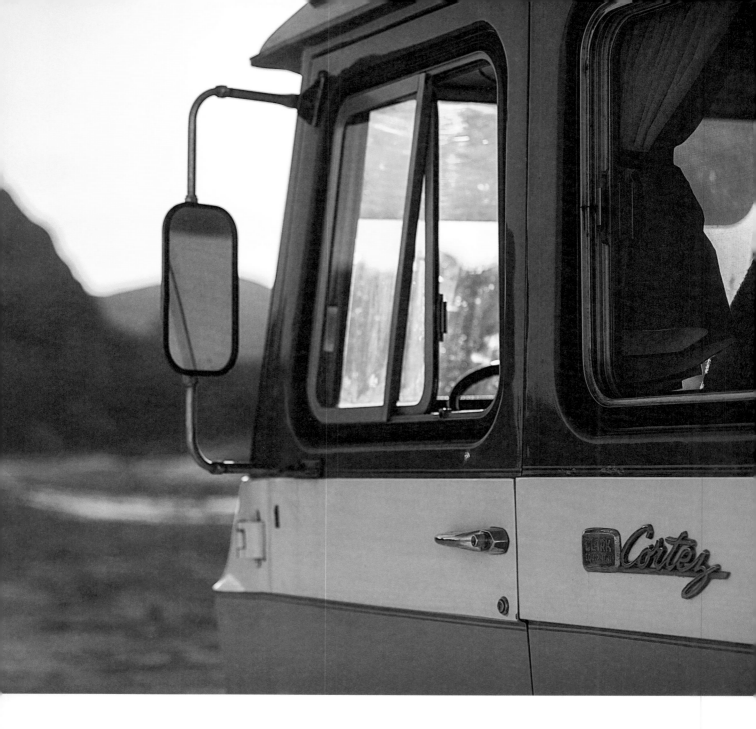

tied down to one location. We can try out jobs in new places without the commitment of signing a lease. We can move our home across the country just to get a change of scenery."

Produced by Michigan forklift company Clark throughout the 1960s and 1970s, the Cortez is a solid steel 18-foot (5.5 m) collector's item weighing 8,000 pounds (3,600 kg). The one-word reason that Clark is out of business and the Cortez is a rarity in the nation of its birth: Winnebago. From the 1960s on, there

was only ever one American RV. The myth of the road—via Jack Kerouac, *Easy Rider*, Hunter S. Thompson, and others—captured the zeitgeist in that paradigm-shifting era, and the Winnebago won the day. As founder John Hanson was famous for saying: "You can't take sex, booze, or weekends away from the American people." He outsold his competitors ten to one.

The 1964 Cortez that Matt and Amanda nabbed required a fair amount of work. Though the renovation was relatively straightforward with few major surprises, it →

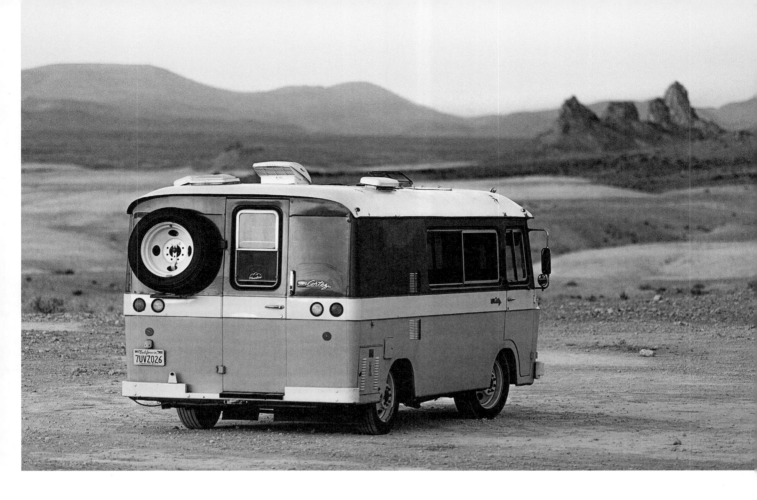

115

was still a six-month job: laminated floors, tongue-and-groove paneling and cabinetry in the new kitchen and queen-sized boudoir, all new systems to replace ancient plumbing and power, and a water tank full of mummified mice. After hitting the road, they gradually shook off the city tension, the constantly being surrounded by millions of neighbors and trillions of dollars. Soon, a natural sense they'd always had of traveling, cooperating, and existing took over, and they've spent the year peacefully surveying the West Coast and the Eastern Sierras that shield the continent beyond. San Francisco does call, and they return when they need to. "Our relationship grew as we explored together," says Amanda. "First South America, where we traveled in Ecuador, Peru, Argentina, and Chile while hiking, backpacking, and climbing; then Yosemite, where we'd escape to from San Francisco. So my soul is now a bit of a wandering soul. It felt wrong to deny that. It doesn't really feel like a sacrifice anymore and I'm not sure I ever thought of it in those terms. It's more of a mindset shift." ■

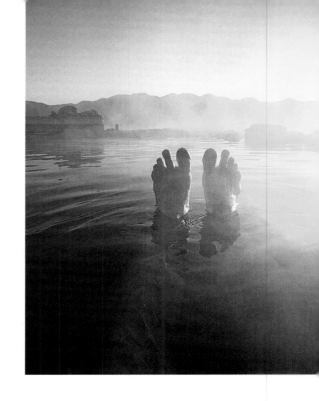

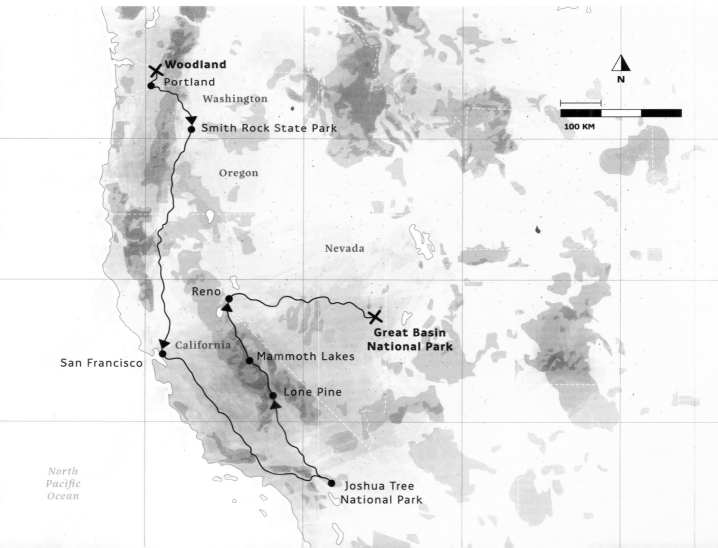

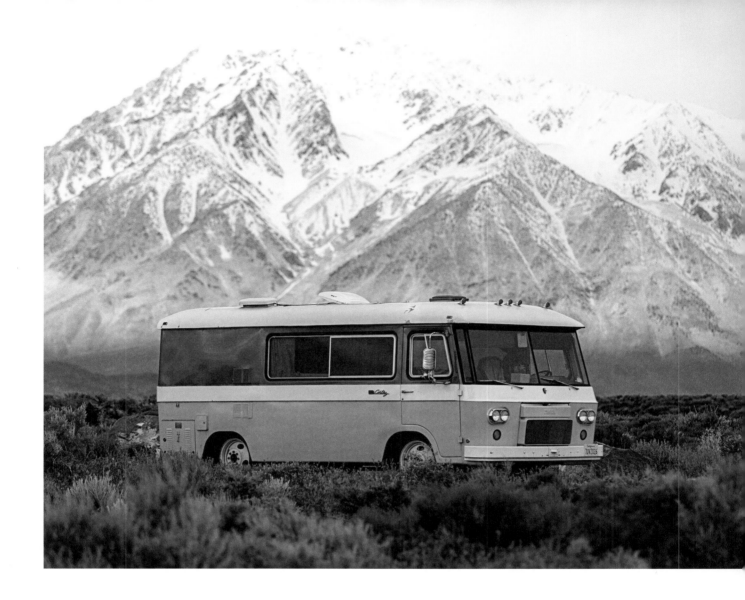

CLARK CORTEZ

The Clark Forklift Company began building Clark Cortez Motorhomes between 1963 and 1979. Relatively unknown today, Clark jump started RV production with an ingenious front-wheel-drive layout. This design removed the necessity for a driveshaft tunnel, giving the Cortez increased interior space. Early models came with a Chrysler 225 ci (3.7-liter) slant six and manual transmission; later models were fitted with a Ford 302 ci V8, and only 3,211 units were manufactured in total. This certainly makes Matt and Amanda's van a rare sight. It took them six months to do a partial restoration that included an overhaul of plumbing, electrical, and mechanical systems. At the same time, they installed new solar systems to enable off-the-grid living for up to two weeks at a time.

MANUFACTURER: Clark Forklift Company
MODEL: Cortez
YEAR OF PRODUCTION: 1964
ENGINE: 3.7 L slant six, 145 hp
TRANSMISSION: Four-speed manual
VISITED COUNTRIES: United States
TRAVEL TIME: 1 year and counting
REBUILD—YEAR: 2016–2017

REBUILD—BODYWORK MODIFICATIONS:
Original condition
REBUILD—CHASSIS MODIFICATIONS:
Original condition, general maintenance
REBUILD—INTERIOR MODIFICATIONS:
Laminate flooring, tongue-and-groove wood paneling, custom cabinetry, queen-sized bed platform

REBUILD—OTHER MODIFICATIONS:
Independent solar-powered electrical system (with AC inverter), DC lighting, ARB DC refrigerator
REBUILD—SUPPORT BY:
The OK Ranch, Stephan Shay (Epoch Restorations), Jen & Jeremy, friends, and family

117

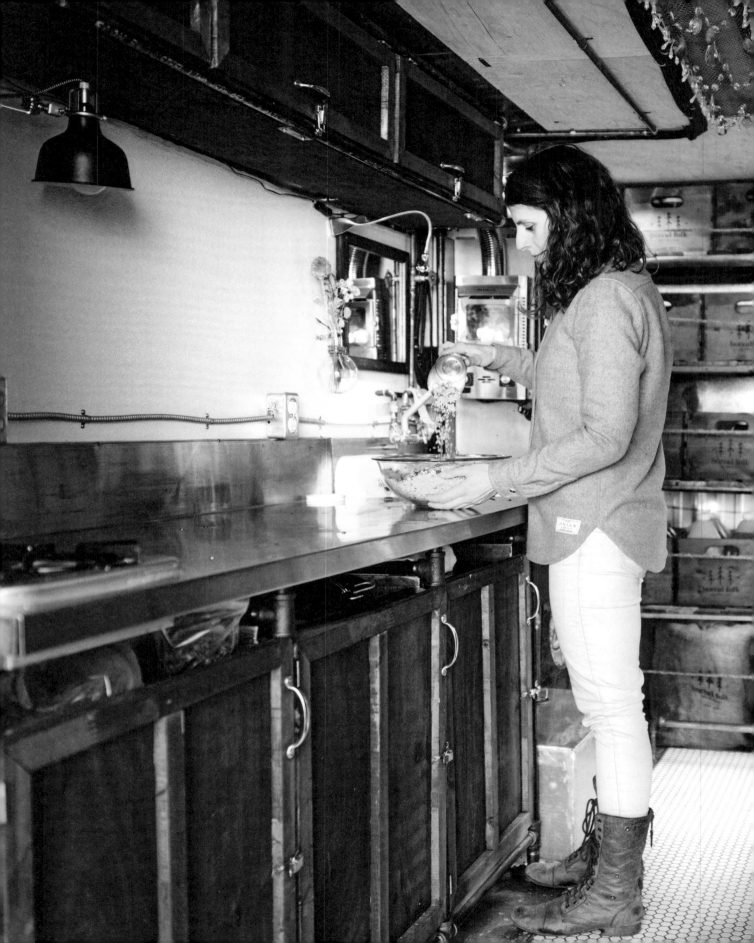

RAPHAËLLE GAGNON AND MARK COELHO/
NORTH AMERICA

A LIFE DICTATED BY FREEDOM

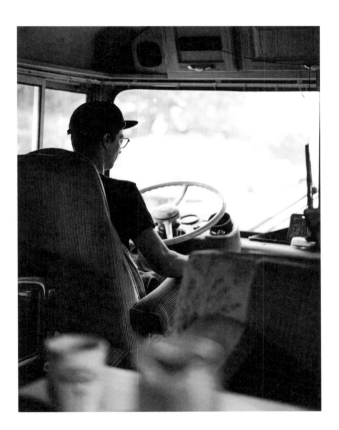

The resilient MC-5A put Canadian company Motor Coach Industries (MCI) on the map in 1967; Greyhound even chose the MC-6 to replace its fleet of iconic Scenicruiser coaches designed by Raymond Loewy, probably the twentieth century's most successful industrial designer. Canadian coaches were just better—they had to be to resist the harsh winters and underdeveloped roads.

Raphaëlle Gagnon and Mark Coelho wanted to go Canadian when they outgrew the 100-square-foot (9 sq m) postal van they'd lived in for two years. The →

119

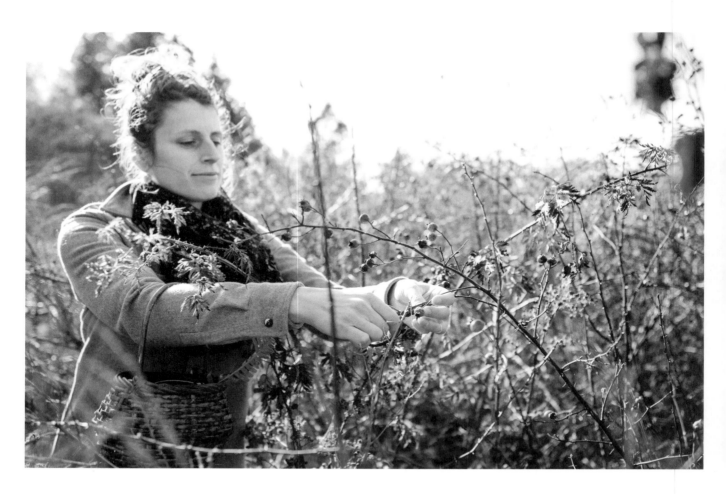

> ## "Living simply has inspired us so much that we started our business off those same principles."

Closely following the seasons enables year-round harvesting *(above)*. Raphaëlle at her apothecary door *(opposite)*.

MC-5A they found in Northern Alberta had a decent 1990s conversion and could easily tow their 14-foot (4 m) off-grid apothecary, where they create skincare products using wild plants picked along the way. They are true nomads, minimalists living in rhythm with the seasons and foraging off the land. "This lifestyle makes you appreciate moments, not things; running water, warmth, and companionship," they explain. "Living simply has inspired us so much that we starteded our business off those same principles." After a six-month renovation, their first year in the bus →

120

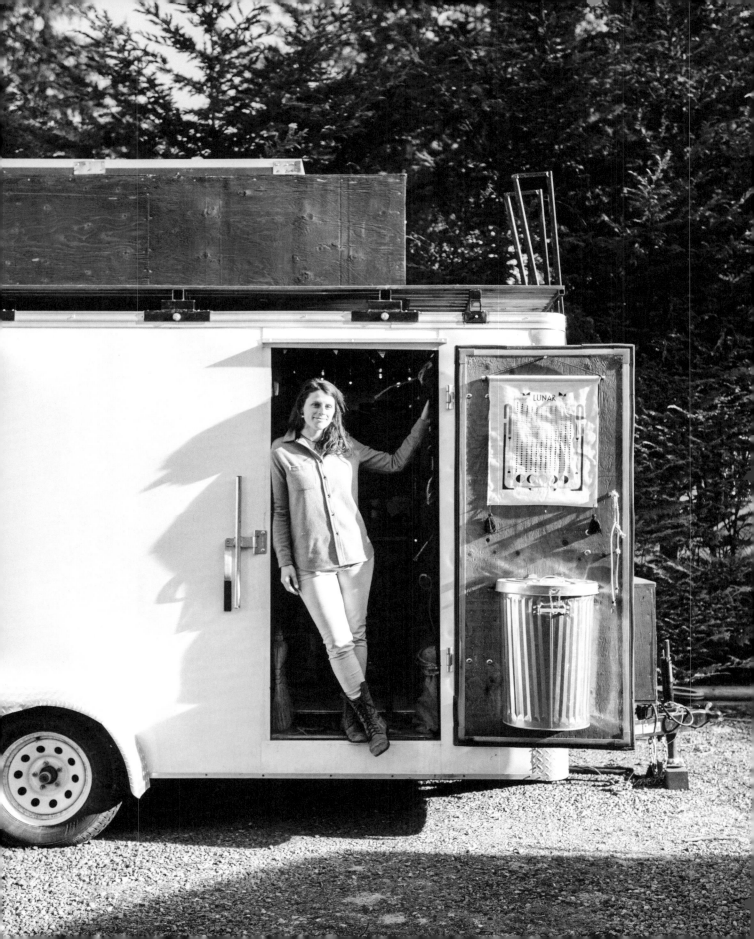

The bus's original dash *(opposite)*. The completely off-grid apothecary *(above)*. Healthy breakfast onboard *(below)*.

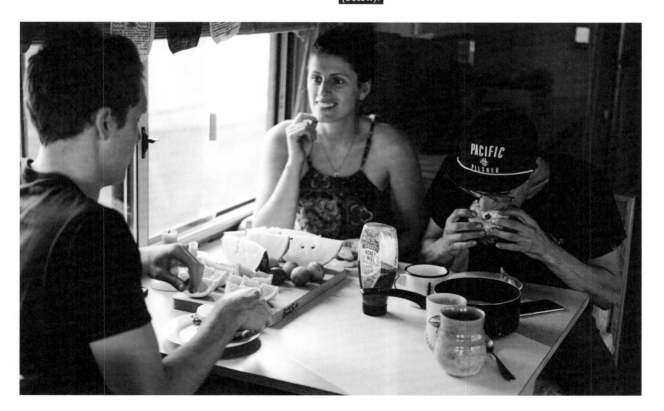

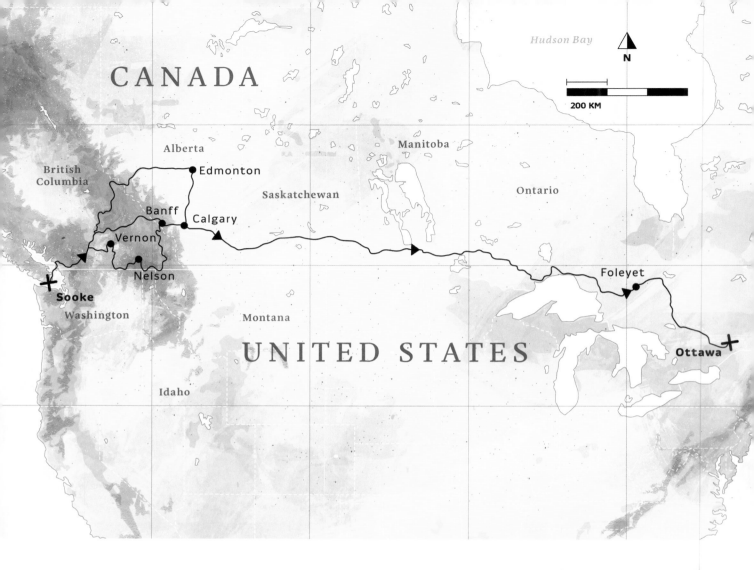

CANADA

Hudson Bay

N

200 KM

Alberta

British
Columbia

Edmonton

Saskatchewan

Manitoba

Ontario

Banff

Calgary

Vernon

Nelson

Sooke

Washington

Montana

Foleyet

Ottawa

UNITED STATES

Idaho

has had them crisscrossing the Rockies, selling their wares at markets, fairs, and festivals, or just parking somewhere remote, spending time. "The best parts are the memories we're cultivating," they say. "We'll ask ourselves: 'Remember that time our heater broke crossing Canada in the winter so we drove 3,500 miles (5,600 km) with a raging fire in the woodstove? Or that time we parked the bus on our $92 gold claim in Northern British Columbia and panned for gold while living off wild mushrooms we picked?'" Even as soap makers who have to laugh at the irony of letting their shower routine lapse when water runs scarce, they have no plans to trade in their roomy home and business on wheels any time soon. ∎

Coffee with a vintage copy of *Audel's New Automobile Guide* (right). The impressive bus in all its glory (opposite).

124

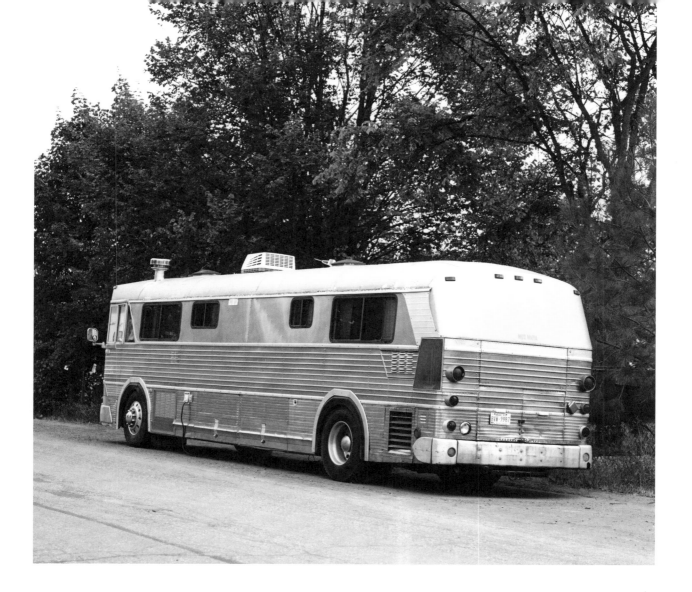

MOTOR COACH INDUSTRIES MC-5A CHALLENGER

Before commercial flights grew in popularity, hopping on a Greyhound Lines' Motor Coach Industries bus was the easiest way to travel across the United States. Taking a 1967 MCI bus and converting it into a fully fledged RV in the 1990s was an ideal way to see North America for Raphaëlle and Mark. The large bus allowed comfort to reign, with room for a queen bed, dining area, and woodstove. The original 9.3-liter Detroit Diesel V8 (8V-71) came with 318 horsepower and enough torque to comfortably cruise the American highways. It was rebuilt in 1996, which has given the vintage bus enough stamina to make eight crossings over the Rocky Mountains, logging more than 4,350 miles (7,000 km) to date during their ownership.

MANUFACTURER: Motor Coach Industries
MODEL: MC-5A Challenger
YEAR OF PRODUCTION: 1967
ENGINE: Detroit Diesel 8V-71 V8, 318 hp
TRANSMISSION: Manual
VISITED COUNTRIES: Canada
MILES IN TOTAL: Approx. 1,000,000 miles

TRAVEL TIME: 10 months and counting
REBUILD—YEAR: 1996
REBUILD—BODYWORK MODIFICATIONS: Original condition
REBUILD—CHASSIS MODIFICATIONS: Original condition, general maintenance
REBUILD—INTERIOR MODIFICATIONS: Modification from transport bus to motor coach, full solid oak interior
REBUILD—OTHER MODIFICATIONS: Engine rebuilt, 14-foot trailer customized to a formulation studio
REBUILD—SUPPORT BY: Vic Fagan (craftsman)

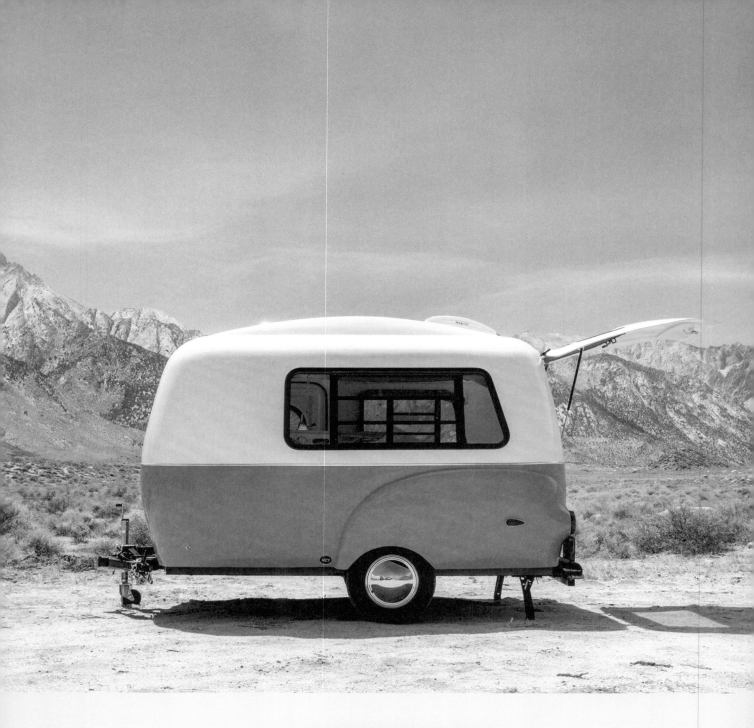

THE HAPPIER CAMPER

The Golden State of California expands out over snow-capped mountains, vast dusty deserts, and magnificent forests for an impressive 163,696 square miles (423,970 sq km). Exploring such diverse landscapes led Derek Michael to found Happier Camper so he could spread the joy. His first production trailer, the HC1, proved a great testing ground for camper-friendly design. Today, contoured solar panels, fiberglass floors, and a fully reconfigurable interior accommodate up to five people. The HC1 offers limitless cozy possibilities with optional add-ons, such as a fridge, toilet, awning, shower, and butane stovetop.

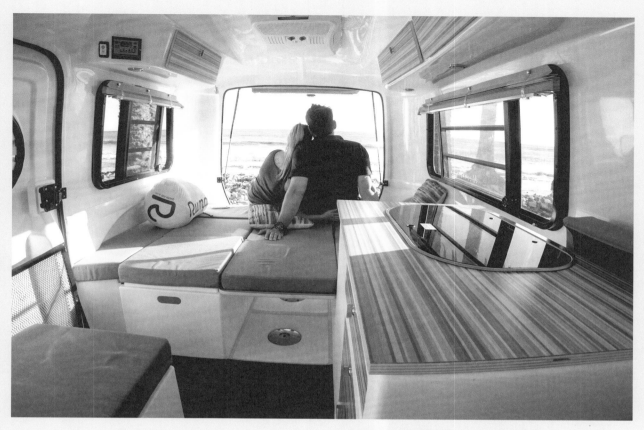

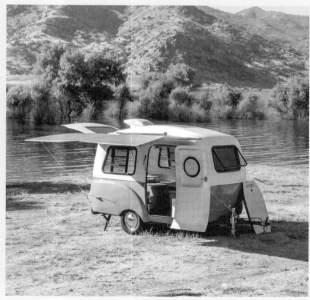

MANUFACTURER: Happier Camper
MODEL: HC1
YEAR OF PRODUCTION: 2017
BODYWORK: 100% double-hull insulated fiberglass, custom engraved door hinges
CHASSIS: Sturdy reinforced tube frame, built-in rear stabilizing jacks, torsion axle independent suspension, standard electronic braking system
INTERIOR:
Adaptiv modular interior system with features such as a huge rear hatch, wide entry door, classic fenders, honeycomb fiberglass floor, and large panoramic windows, sleeps up to five, deep cycle AGM battery with power converter, 14-inch dual air flow ceiling fan
OTHER SPECIFICATIONS:
Porch light, panoramic jalousie or flip-up vending windows, contoured solar panel

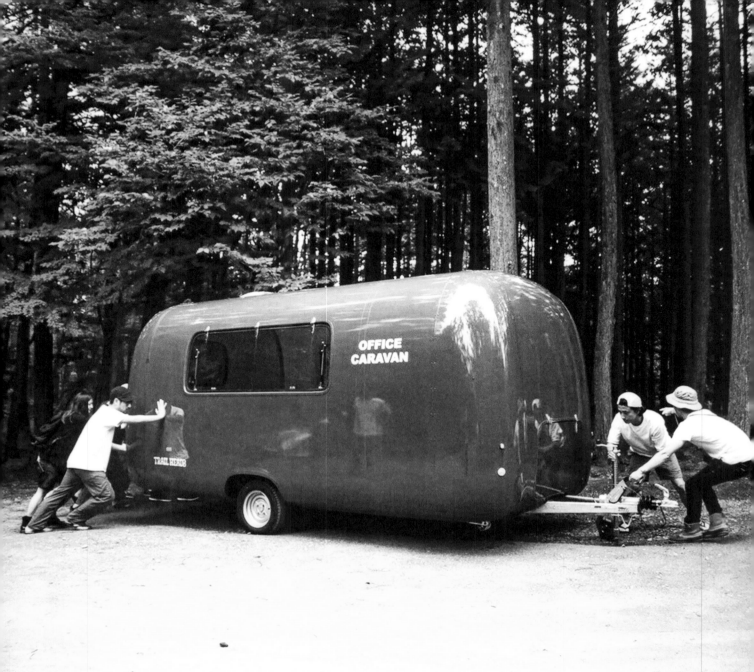

TRAIL HEADS OFFICE CARAVAN

In the dense urban jungle of Tokyo, Japan, it can be difficult to find solitude. To help employees break free, Trail Heads has created a mobile office known as the Office Caravan. Built from Croco Art Factory's 2016 Roomette, this five-person long-bodied camper can be hooked to an automobile and towed to any destination the heart desires. The Office Caravan has finely crafted interior elements: a caster chair, sofa, desk, coffee machine, fitted cabinet spaces, and plenty of power outlets that allow clients to take their work anywhere. Best of all—the tailgate lifts up to transform the camper into an open-air office.

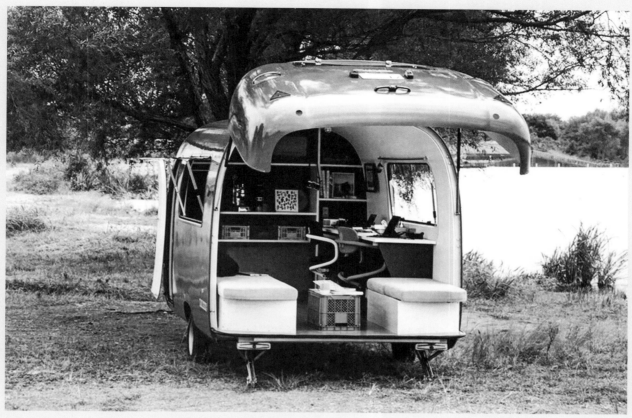

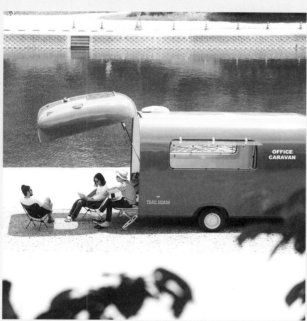

MANUFACTURER: Croco Art Factory
MODEL: Roomette
YEAR OF PRODUCTION: 2017
BODYWORK: 100% double-hull
insulated fiberglass, available in two

different sizes (short and long)
CHASSIS: Knott GmbH
INTERIOR: Interior design by Trail Heads,
power converter, wooden floor,
up to 200-liter water supply,

kitchen including coffee machine,
office chairs, fully insulated interior
OTHER SPECIFICATIONS:
Big tailgate (optional)
SUPPORT BY: Knott GmbH

129

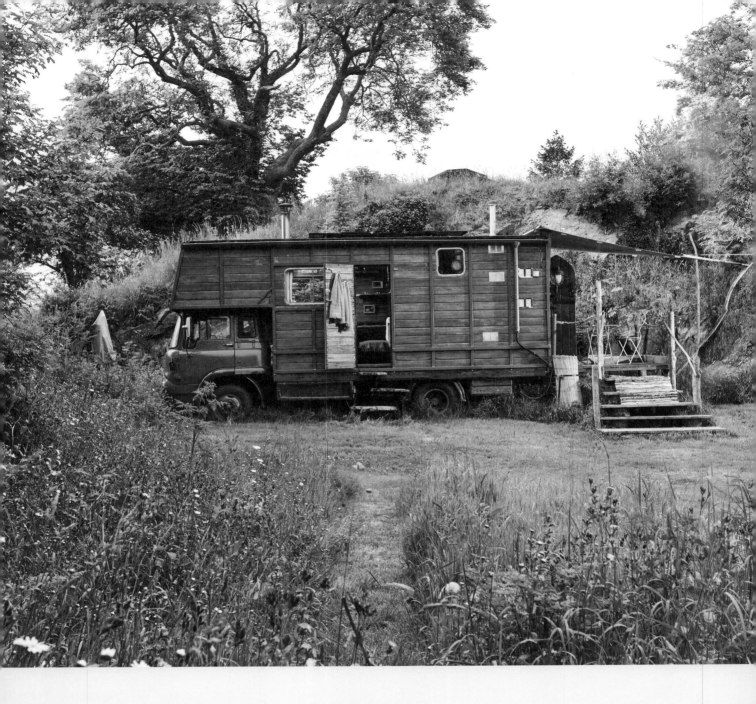

THE HOUSE BOX

After being continually weighed down by the harsh realities of paying the bills each month, Dean Crago and his partner, Hannah, decided to make the shift to green living. It began with a 1979 Bedford TK Horsebox that was stripped down to its shell and rebuilt. By harvesting solar and wind power, the Horsebox-turned-House Box has a fully equipped sound system, a hot shower, and a full-size Rangemaster stove. A wood-burning stove supplies heat on cold nights and a rainwater filtration system provides crisp, cool drinking water for the couple. A double bed, sofa, and even an office space from which to run their conversion business complete the transformation.

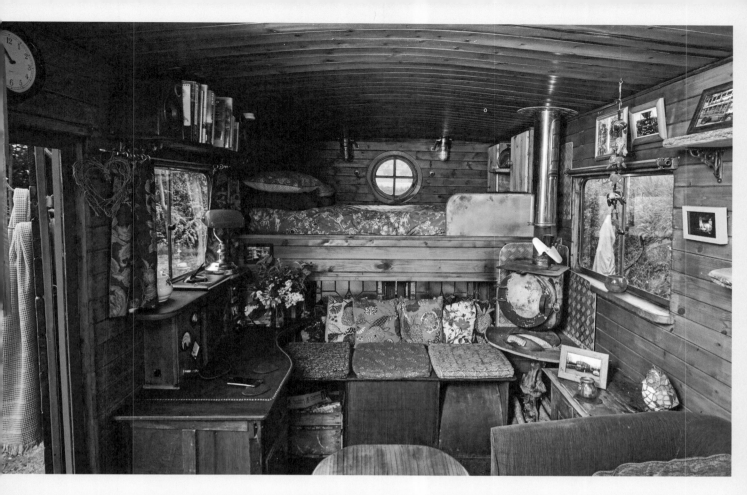

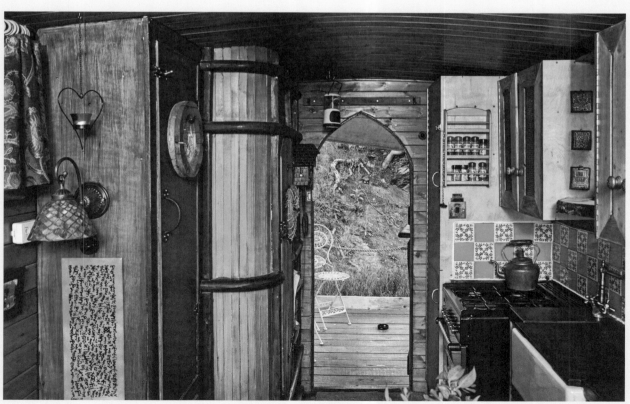

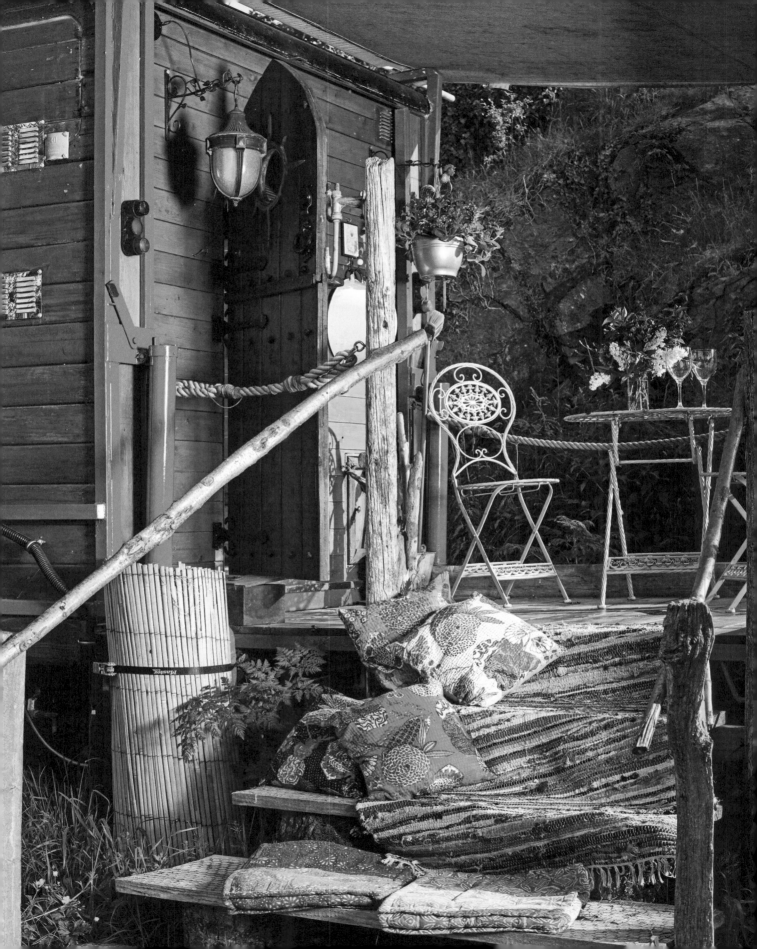

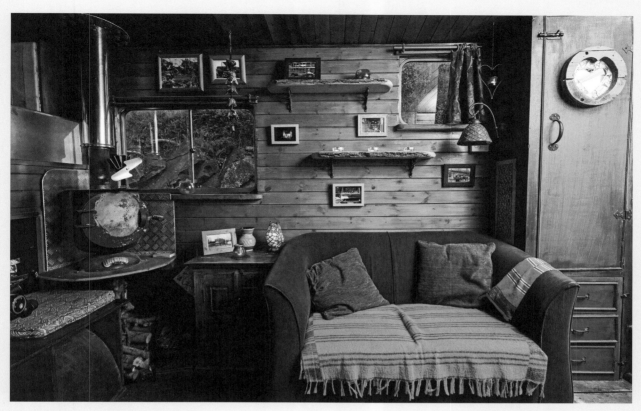

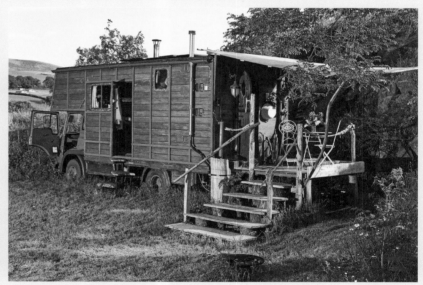

MANUFACTURER: Bedford
MODEL: TK
YEAR OF PRODUCTION: 1979
ENGINE: 5.4 L six-cylinder diesel, 102 hp
TRANSMISSION: Manual
VISITED COUNTRIES: United Kingdom
TRAVEL TIME: 3 years
REBUILD—YEAR: 2010–2011

REBUILD—BODYWORK MODIFICATIONS:
Stripped body back to frame, repainted, planed timber, underslung tanks built on chassis to house utilities, open terrace
REBUILD—CHASSIS MODIFICATIONS:
Original factory condition
REBUILD—INTERIOR MODIFICATIONS:
Complete custom interior, woodstove,

full double bed and sofa, office area, full-size Rangemaster cooker, fridge running on LPG gas
REBUILD—OTHER MODIFICATIONS: Complete conversion to green energy (solar and wind power), sound system, composting toilet, rain water harvesting system with filters
REBUILD—SUPPORT BY: Friends

THE BEERMOTH

From 1905 until 1979, Commer was a British manufacturer of commercial and military vehicles. Production of the Q4 began during the Second World War, and it was extensively used for a variety of tasks. In the post-war period, the Q4 was outfitted with four-wheel drive and a six-cylinder 4.7-liter gasoline engine churning out 95 horsepower; it was capable of carrying three tons of cargo. To transform this truck into a mobile home, its owner, Walter, raised the roof by a foot (0.3 m), laid oak parquet flooring salvaged from a Tudor mansion and slate to make a hearth, installed a wood-burning stove, and added a wooden door and Victorian double bed. The so-called Beermoth is parked in the Scottish Highlands and is available to rent.

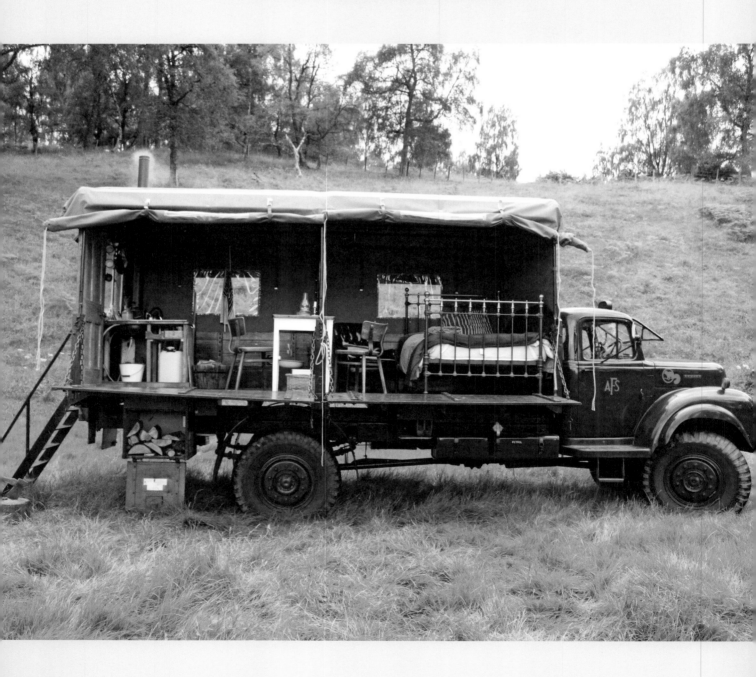

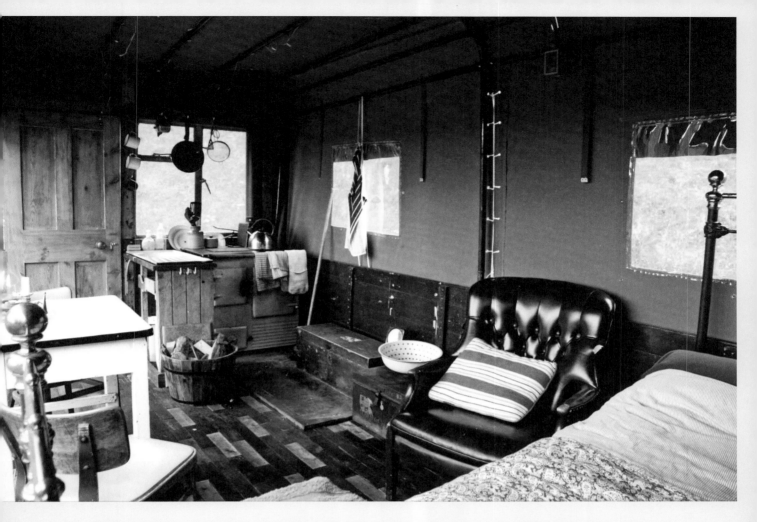

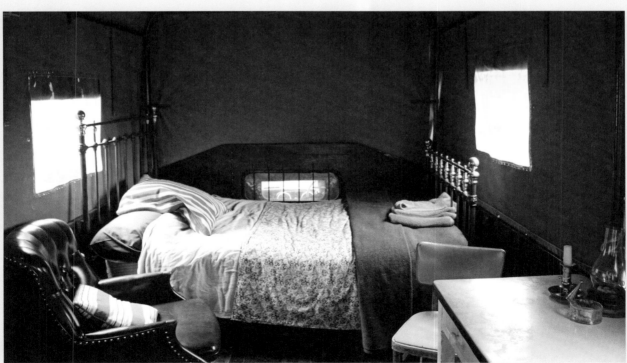

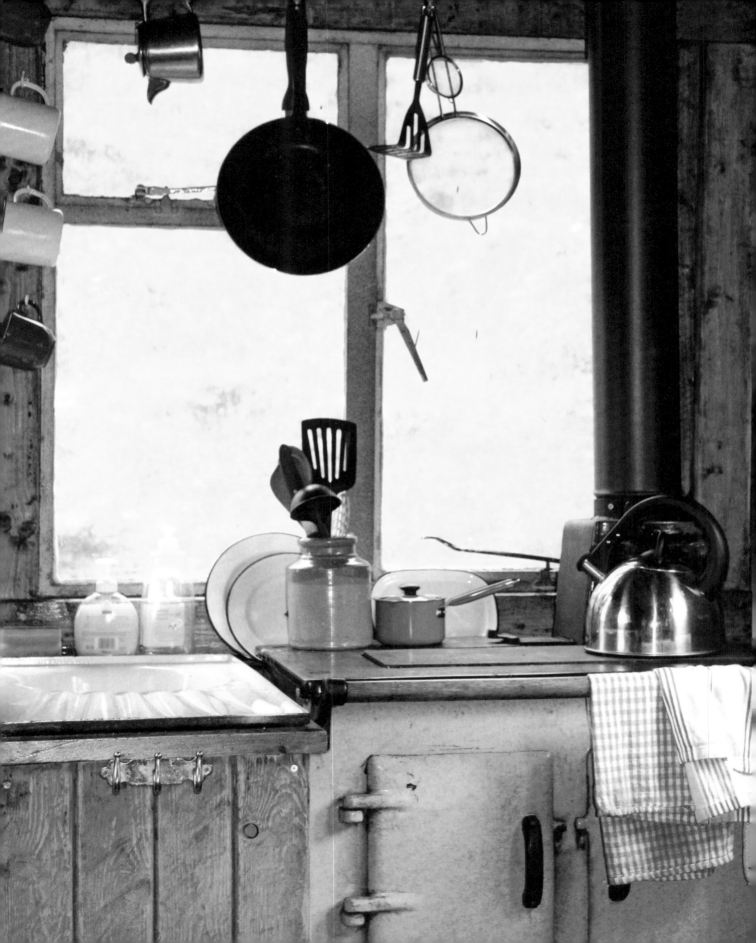

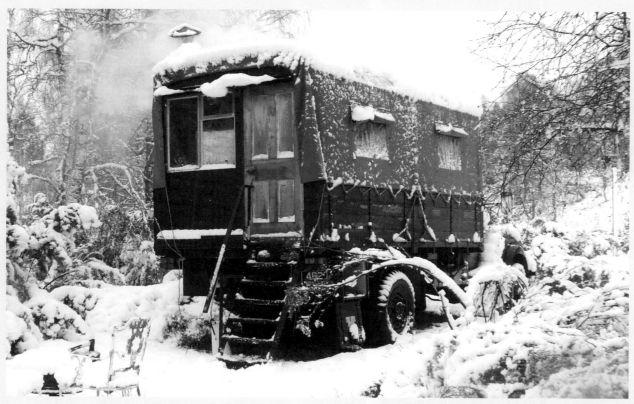

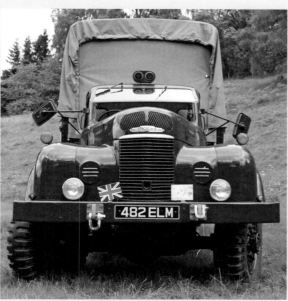

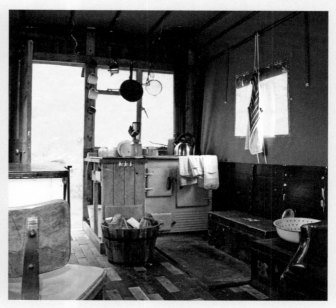

MANUFACTURER: Commer
MODEL: Q4
YEAR OF PRODUCTION: 1956
ENGINE: 4.8 L six cylinder, 95 hp
TRANSMISSION: Manual
VISITED COUNTRIES: United Kingdom
MILES IN TOTAL: Unknown

TRAVEL TIME: unknown
REBUILD—BODYWORK MODIFICATIONS:
Raised the roof by one foot,
fire escape staircase,
additional door in the rear
REBUILD—CHASSIS MODIFICATIONS:
Original factory condition

REBUILD—INTERIOR MODIFICATIONS:
Tiny kitchen, oak parquet floor, Victorian
double bed, wood burner, rollable fabric roof
REBUILD—OTHER MODIFICATIONS:
Stuffed squirrel
REBUILD—SUPPORT BY:
Probably beer

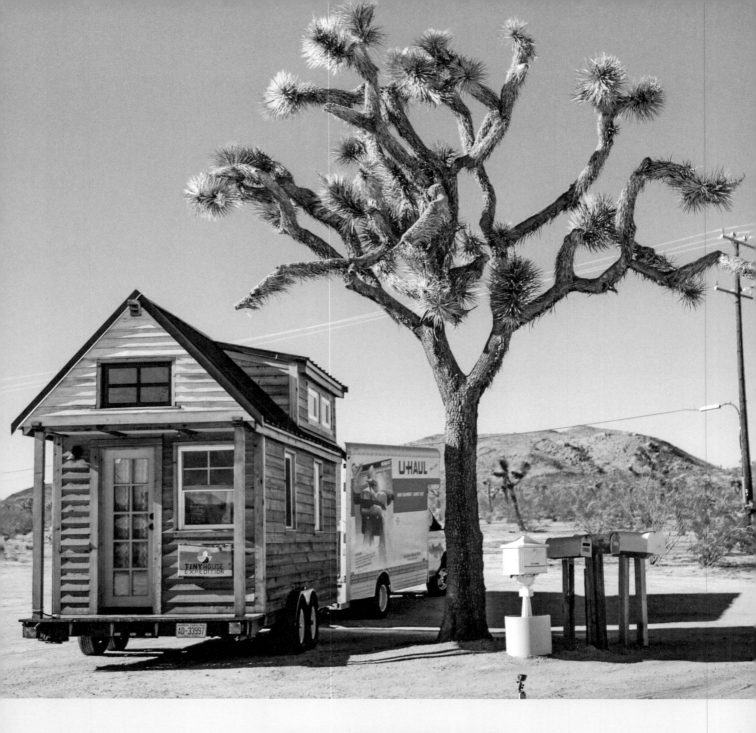

TINY HOUSE EXPEDITION

Each tiny house is custom made to suit an owner's individual needs. When Christian Parsons and Alexis Stephens embarked on their nine-month build, they knew they wanted mobility. Their 130-square-foot (12 sq m) mobile home is crafted primarily with reclaimed materials to add a quaint charm. Inside, every space serves multiple functions, such as a closet that is also a staircase and seat. The couple has traveled over 45,000 miles (72,420 km) on their journey across the United States and Canada. Their goal is to spread Tiny House inspiration in the great outdoors through trips, festivals, and national parks.

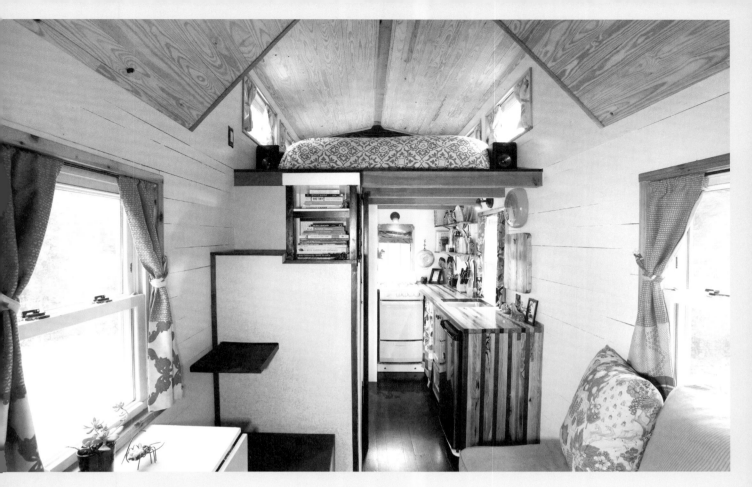

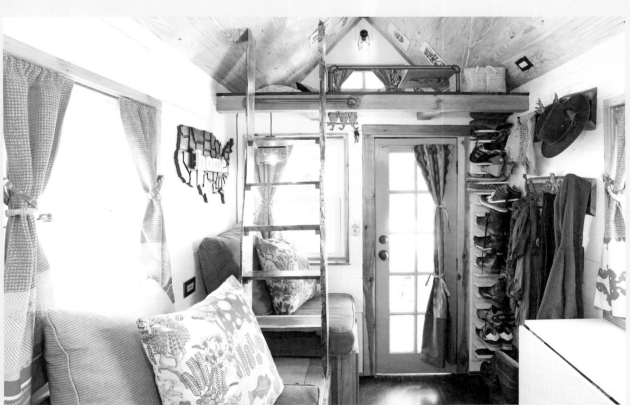

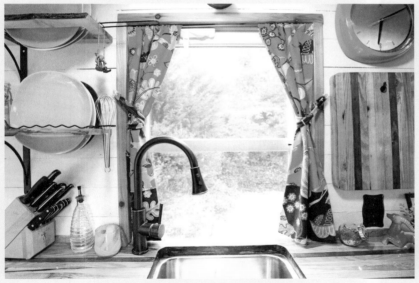

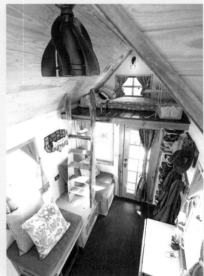

MANUFACTURER: Tiny House Expedition
MODEL: ELM, based on Tumbleweed open source plans
YEAR OF PRODUCTION: 2015
VISITED COUNTRIES: United States, Canada
MILES IN TOTAL: 45,000 miles
TRAVEL TIME: 2.5 years
REBUILD—YEAR: Completed 2015
REBUILD—BODYWORK MODIFICATIONS:
Salvaged and reclaimed materials
REBUILD—CHASSIS MODIFICATIONS:
Custom Tiny House trailer
REBUILD—INTERIOR MODIFICATIONS:
130-square-foot multi-functional interior, kitchen, bathroom, and living room, two sleeping lofts (master queen and son's loft), fold down desk, toy box, and basket on a pulley system
REBUILD—OTHER MODIFICATIONS:
The closet is also a staircase, bench seat, and book shelf, the fold down bathroom shelf over the toilet facing the full-length mirror becomes a vanity when folded down
REBUILD—SUPPORT BY:
Tom from Perch & Nest, sponsors include Habitat for Humanity of Forsyth County

DAIHATSU HIJET

Even tiny houses seem monolithic next to what Daniel Kalinowski and his girl-friend, Cathrin, call their mobile tent. The Daihatsu's diminutive dimensions, 10 × 4.5 × 6 ft (3 × 1.4 × 1.8 m), meant the couple had to utilize every sliver of available space. But their brilliant planning during the three-month construction allowed room for a bed, table, and clothing storage. Outside roof and bike racks let them travel around cities in Germany, France, Spain, and beyond. Plus, finding parking is simple. Over 25,000 miles (40,000 km) on the odometer proves that a tiny 0.9-liter motor is up to the adventurous task of traveling.

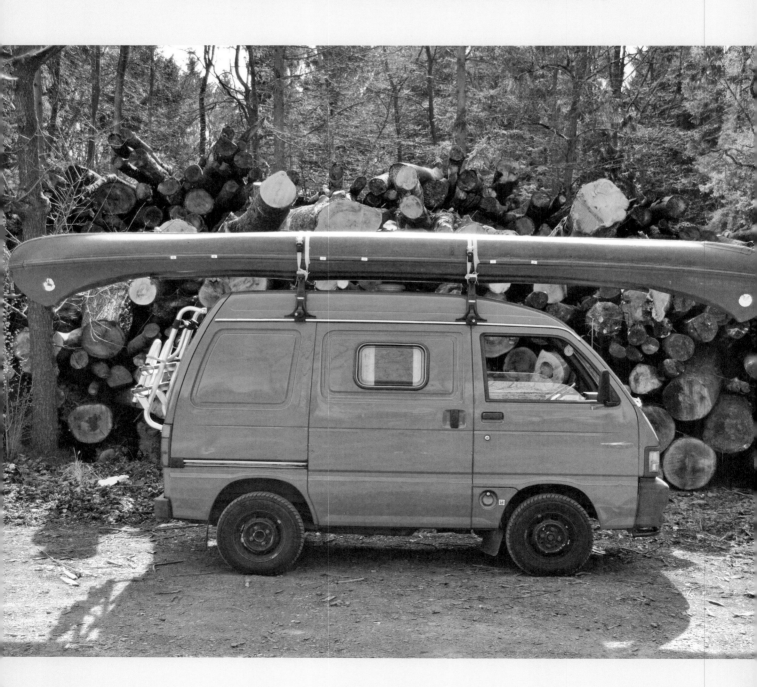

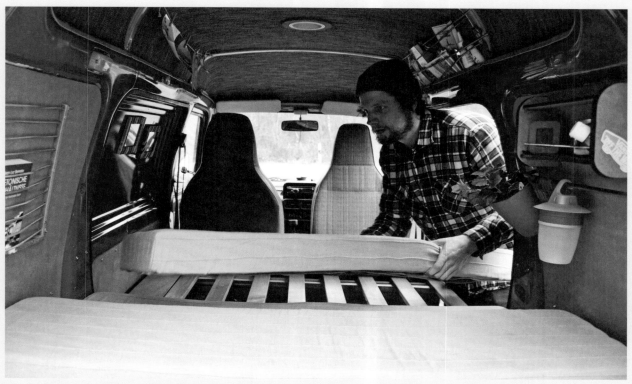

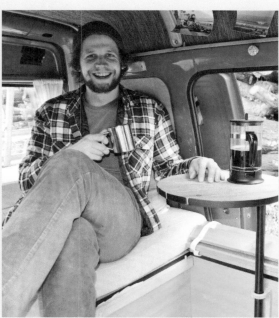

MANUFACTURER: Daihatsu
MODEL: Hijet S80
YEAR OF PRODUCTION: 1996
ENGINE: 0.9 L, 48 hp
TRANSMISSION: Manual
VISITED COUNTRIES: Netherlands, Belgium, France, Spain, Germany

MILES IN TOTAL: 74,500 miles
TRAVEL TIME: Any given day, but mostly in summer
REBUILD—YEAR: 2013
REBUILD—BODYWORK MODIFICATIONS: Window, bike rack, personal cooler mask, roof rack

REBUILD—CHASSIS MODIFICATIONS: Original factory condition
REBUILD—INTERIOR MODIFICATIONS: Cooking drawer, double bed, storage for clothes, table with four possible seats, rotatable passenger seat

143

THE GREAT AUSTRALIAN DREAM OF VAN OWNERSHIP

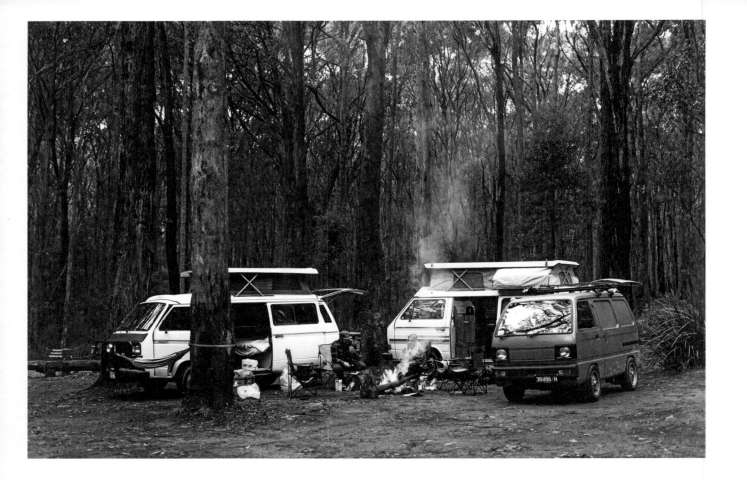

Photographer Brook James was always a reality escapist during his childhood in the picturesque New Zealand wilderness, where he spent time building and hiding out with his mates in treehouses and rickety fort structures. Living across the Tasman Sea in busy Melbourne these days, his itch to retreat remains, to find an outlet away from the noise and duties of city life and freelance work. Australia is a massive, ancient continent waiting to be explored, 2,500 miles (4,000 km) from coast to coast in any direction. "We are Kiwis," says Brook of he and partner Brittany Hart, "so we wanted to see some of this country that we have chosen to live in. The van made sense."

On a 2015 summer trip up the east coast in their old Volkswagen Polo, they got their first taste of van envy, VW Type 2 (T3) envy. "We saw a handful of T3s, mainly around Byron Bay, with young people camping or living out of them," Brook remembers. "I'd seen these vans lurking on the web and had fallen in love with them, to be honest. So the hunt began for our own. It took a year to find one that ticked all our boxes." Their 1989 Type 2 (T3) "Herman the German" had only 27,000 miles (44,000 km) on its original engine. "He is still super young, but we are racking up the kilometers." The work to be done was minor, and was performed ad hoc along the way, such as when the rear main seal and clutch demanded replacing en route to Queensland for their first van Christmas. They also noticed an oil leak while stopped for lunch in Albury. "We managed to limp the bloody thing all the way to the Central Coast," a distance of 400 miles (600 km), "pulling →

> "We would just find places that looked epic on Google Maps and then drive to them."

→ Herman the German

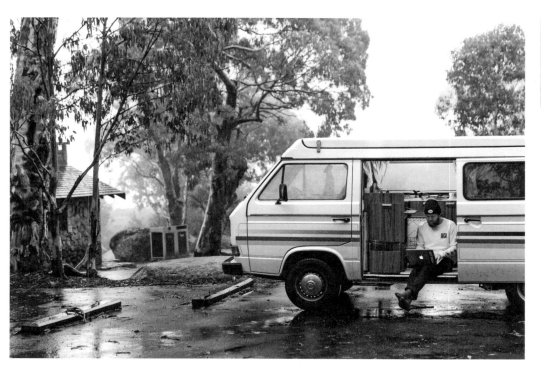

Gordon River Dam,
Tasmania (*above*).
Working remotely on
the road (*left*).
Bush van gathering,
eastern Australia
(*opposite*).

Herman the German ←

over every half-hour or so to top up the oil," Brook recalls. "He was leaking super bad. Brittany's dad, being the legend he is, rented a trailer on Christmas Eve and drove down from Brisbane to pick us up. We trailered it back and arrived at 6 a.m. on Christmas Day after driving through the night."

They've doubled the digits on the odometer in the past two years, traveling beach-to-beach up and down the long, sunny coasts of New South Wales and Queensland, or using the weekends to retreat from Melbourne and explore the endless rambling coasts and bushland of southeastern Australia: Wilsons Promontory, Mount Franklin, and Victoria's Great Ocean Road. Sometimes they only go as far as the mountainous bush that surrounds the city. But land further afield beckons. Their ferry trip across Bass Strait and through Tasmania's ancient gorges, rivers, and primordial landscapes was, as Brook describes, "unreal, so →

→ Herman the German

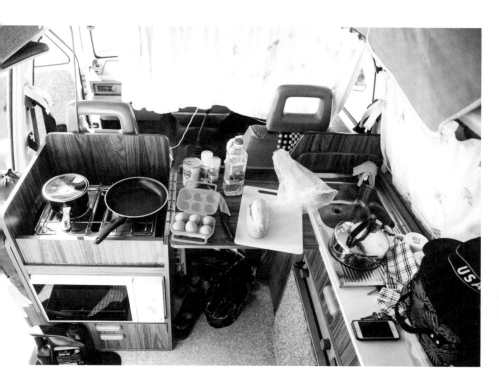

Lovely vintage colors: most of the T3's original interior features and detail have survived *(opposite)*. A proper outdoor breakfast *(this page)*.

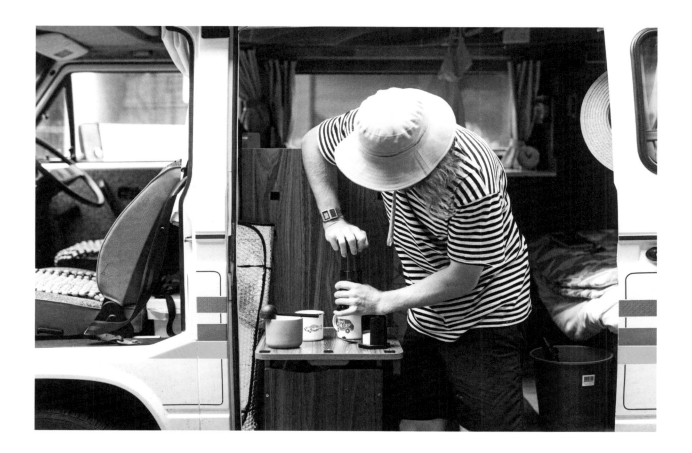

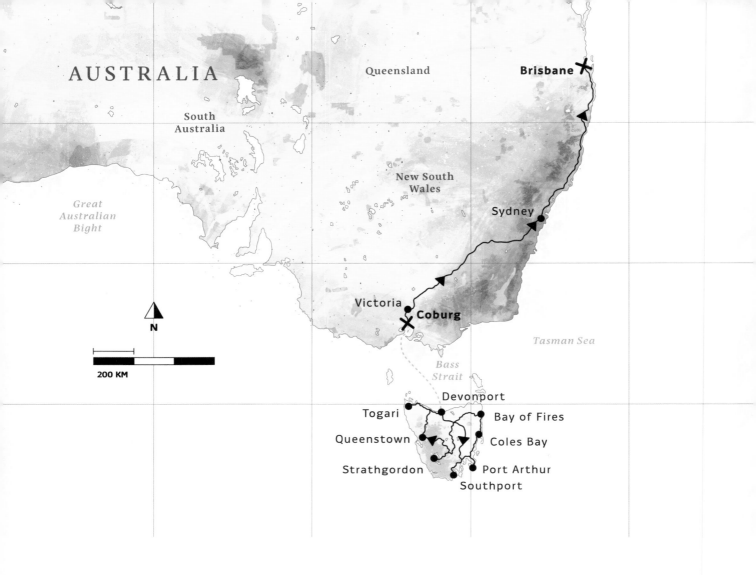

clean, and reminded us a little of New Zealand. We would just find places that looked epic on Google Maps and then drive to them before dark to set up camp. The van performed like an absolute champ and we took her back on the ferry with no issues."

They are not full-timers. Brook often files photographic stories for travel magazines on the way, but they mostly work in the city. Since they're limited by distance due to Brittany running a café in Melbourne, bigger trips must be planned well in advance. Alice Springs and Uluru, the great sacred rock in the desert, are next. "We also really want to head overseas and grab another one and see, say, Europe by van and the same with the States. All in good time," says Brook. "Whenever I jump in the van and sit in the captain's chair, the bullshit stops and I can finally let go of all the worries from the week. The city can be heavy at times. It's just really helped us to find a balance and stop to relax, and breathe." ∎

"It's just really helped us to find a balance and stop to relax, and breathe."

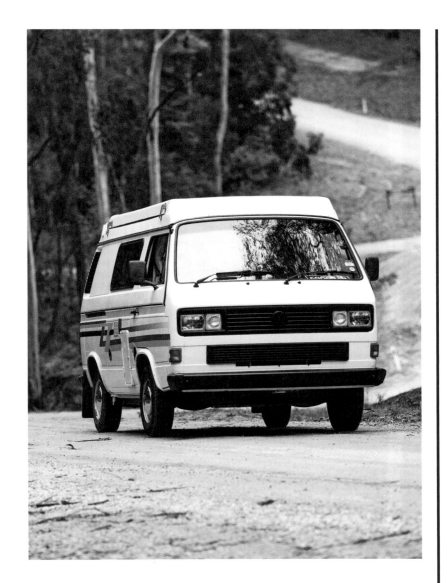

VOLKSWAGEN TYPE 2 (T3) SAFARI CAMPER

As the final edition of the rear-engined Volkswagen vans, the third generation (T3) added luxuries not included in previous models. Air conditioning, power steering, and heated mirrors were just some of the new features. For performance, the water-cooled flat-four motor allowed for 50/50 weight distribution, and the era-advanced engine management systems introduced improved fuel economy. This 1989 Volkswagen T3 retains many original elements, while LED lighting, flooring, a roof rack, and new wheels have been added. Since purchasing it in 2015, Brook and Brittany have logged over 18,650 miles (30,000 km) across Australia and Tasmania.

MANUFACTURER: Volkswagen
MODEL: Type 2 (T3) Safari Camper
YEAR OF PRODUCTION: 1989
ENGINE: 2.1 L, 95 hp
TRANSMISSION: Manual
VISITED COUNTRIES: Australia, New Zealand
MILES IN TOTAL: 24,800 miles
TRAVEL TIME:
Weekend trips and a few
2-week trips each year

REBUILD—BODYWORK MODIFICATIONS:
Original factory condition
REBUILD—CHASSIS MODIFICATIONS:
Original factory condition
REBUILD—INTERIOR MODIFICATIONS:
Original interior done by Safari Camper,
LED lighting, curtains, new flooring
REBUILD—OTHER MODIFICATIONS:
Roof rack and basket, refurbished wheels

151

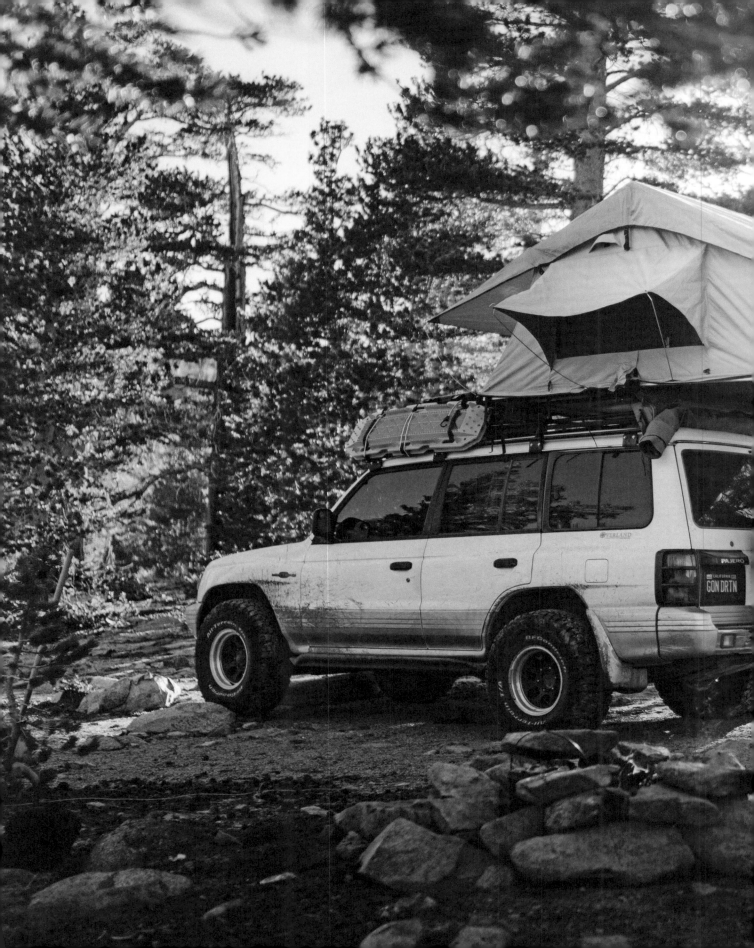

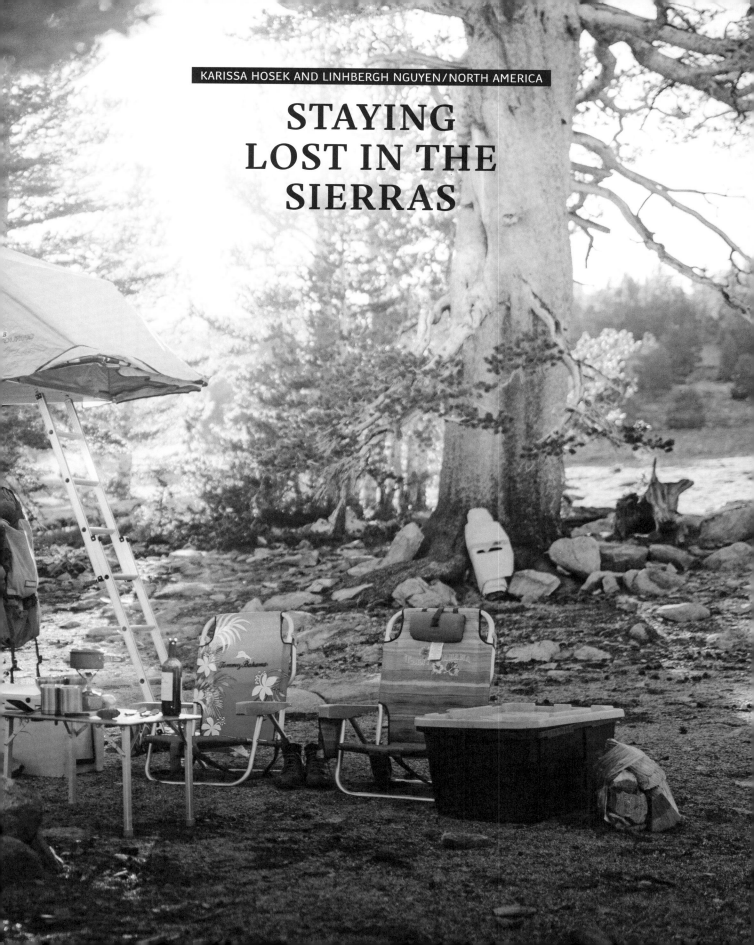

KARISSA HOSEK AND LINHBERGH NGUYEN/NORTH AMERICA

STAYING LOST IN THE SIERRAS

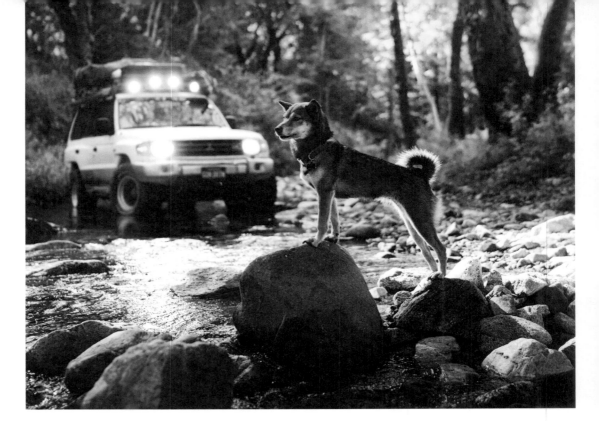

Karissa and Linhbergh in Bishop, California, USA *(below)*. Fording creeks, Big Sur, California, USA *(right)*. Winding down, Idyllwild, California, USA *(opposite)*.

> ## "Whenever the opportunity arises, we hit the dusty trail."

Car devotees, modifiers, and photographers Karissa Hosek and Linhbergh Nguyen wanted to take on work farther from their Los Angeles home, so they initially planned to purchase an SUV as a roving production vehicle. But they quickly realized how often they wanted to escape the city and seek the solitude of nature. "Whenever the opportunity arises, we hit the dusty trail," share the couple. So, they instead found a rugged, reliable 1999 Mitsubishi Montero and upgraded it: tires, suspension, rooftop tent, LED flood lights, solar power, and a long-term battery bank. Taking on remote work led to the beautiful by-product of more time spent exploring California's infamous Highway 395 in the Sierra mountains, "getting lost in public lands, trails, or hiking up to glacial lakes," and encountering "epic coastlines with stunning views that never get old, beautiful rolling hills with wildflower super blooms, and the vast, sterile expanse of the Mojave Desert."

After quickly taking to overland life and the vibrant community that exists up and down the West Coast's carved coastline and valleys, their long-term goal became full-time road living beyond Los Angeles. They realized their truest wish was to "disconnect →

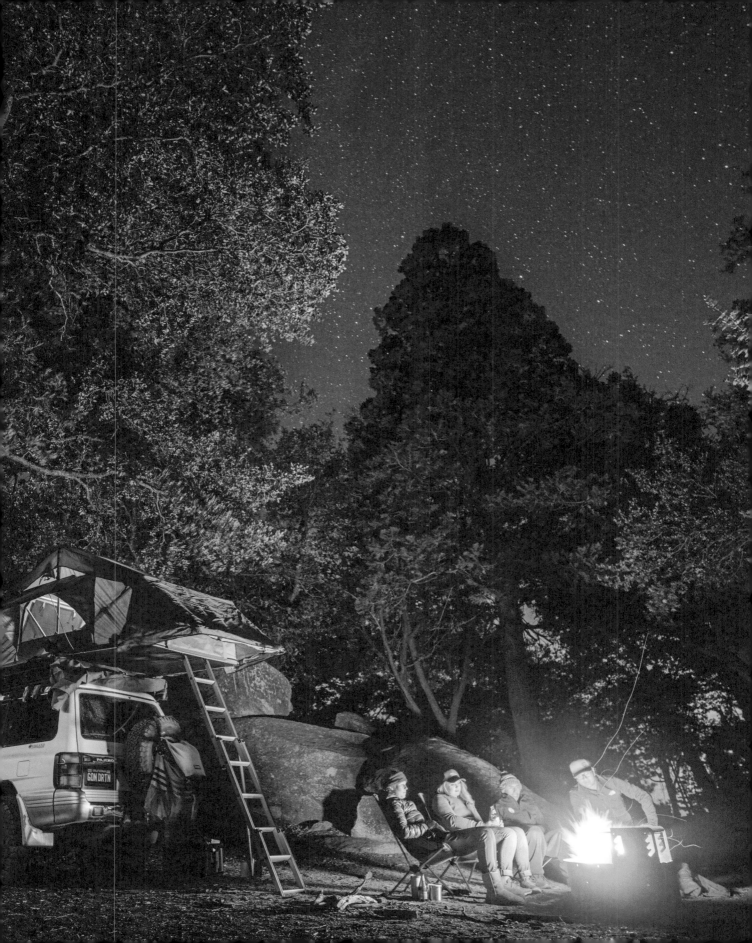

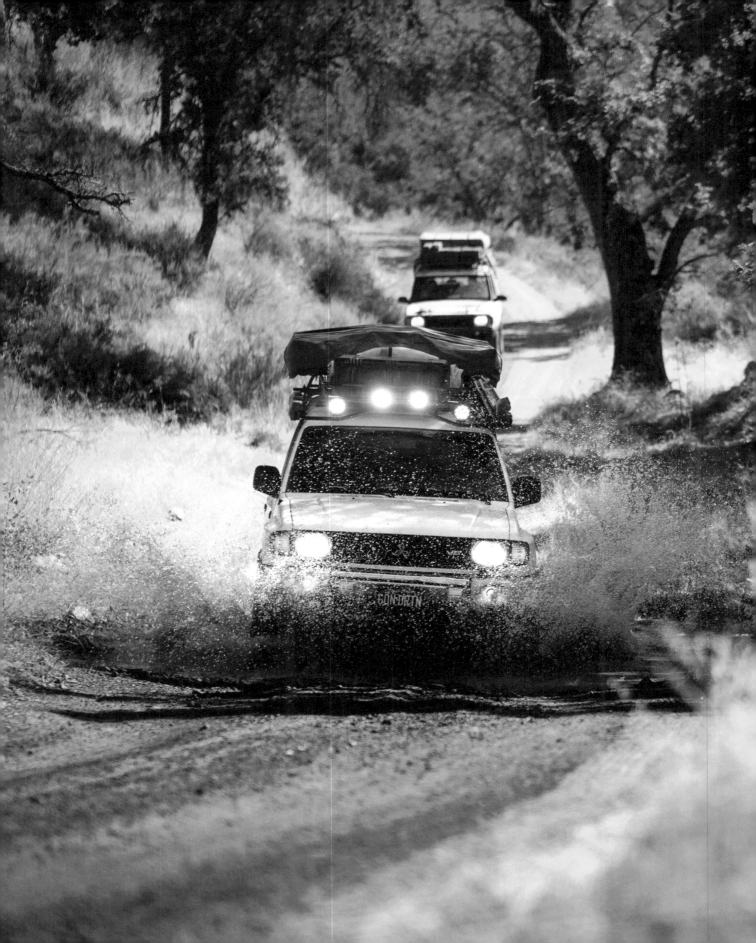

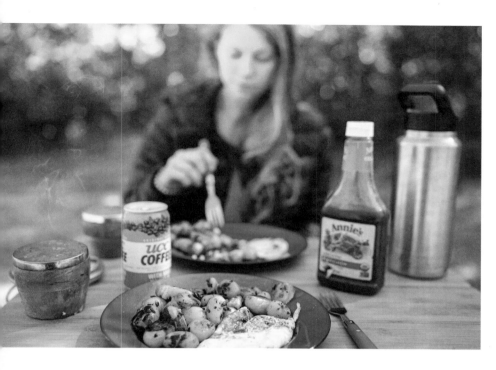

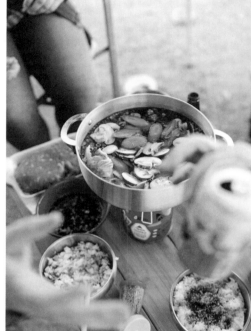

River crossing in convoy (*opposite*). Cooking on the trail: American breakfast (*above*), Japanese shabu-shabu hotpot (*right*), and ramen noodle soup (*below*).

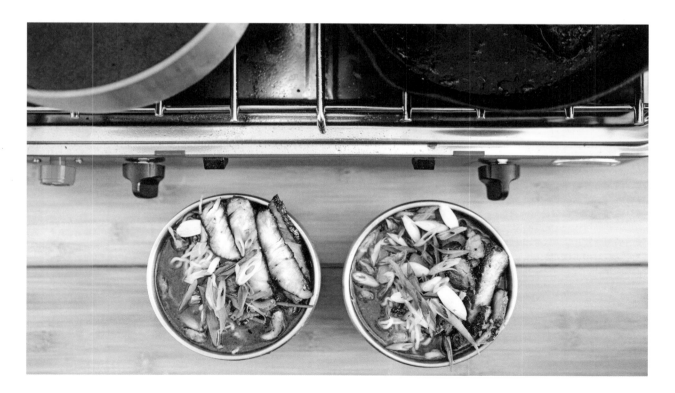

157

UNITED STATES

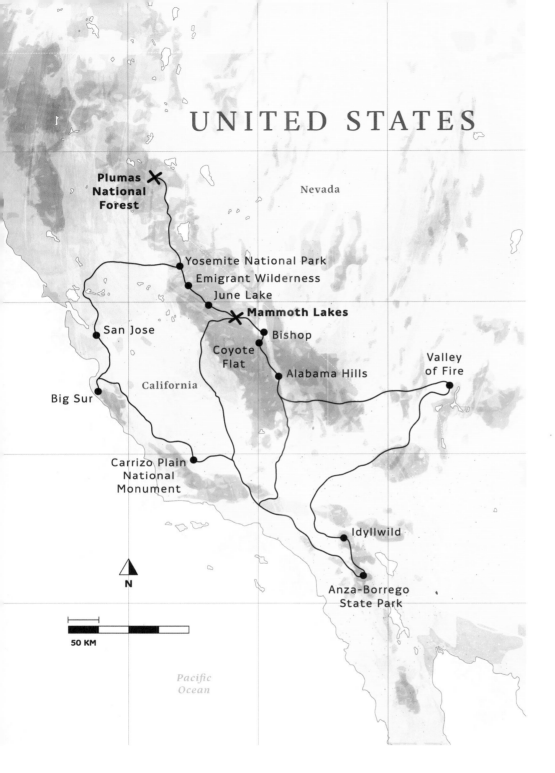

Nevada

Plumas National Forest

Yosemite National Park
Emigrant Wilderness
June Lake
Mammoth Lakes

San Jose

Bishop

Coyote Flat

California

Alabama Hills

Valley of Fire

Big Sur

Carrizo Plain National Monument

Idyllwild

Anza-Borrego State Park

N

50 KM

Pacific Ocean

from everything, take the time to relax by a stream, sit by the fire, float on the water, flow to the sounds of nature." The pair have dotted the itinerary with simple pleasures, such as finding a Christmas tree in the Pacific Northwest, New Year's in Baja California, and a trip across Chile during the 2019 solar eclipse. ■

→ We Gon Dirtin

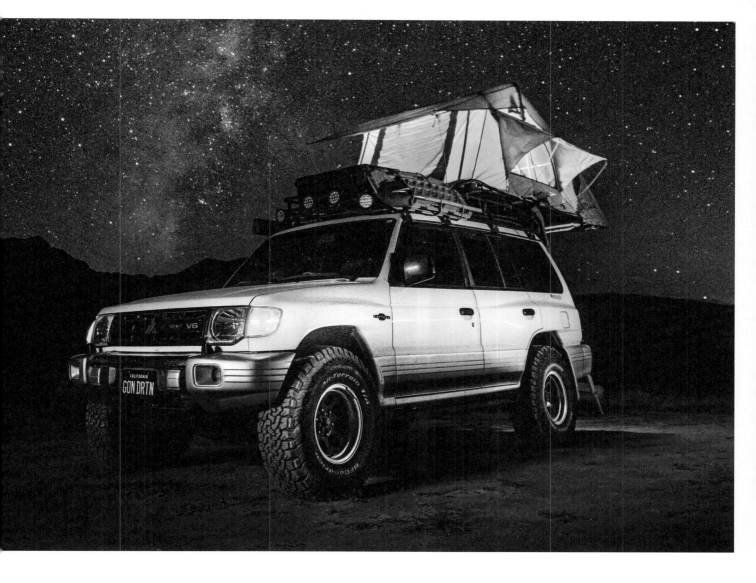

MITSUBISHI MONTERO

In the United States, the Mitsubishi Montero, or "Mountain Hunter" as it translates to in Spanish, is an off-road vehicle with a big history. Victor of its class in the Paris-Dakar Rally seven out of ten times, it is the most successful 4×4 to have ever participated in the grueling event. Although more than capable in stock form, Karissa and Linhbergh have modified their Montero with a 2.5-inch lift, a skid plate, flood lighting, and solar panels to assist with power. Even with the added weight of its accessories, the 3.5-liter V6 offers 215 horsepower and enough torque to assist Mitsubishi's sophisticated ActivTrak AWD system.

MANUFACTURER: Mitsubishi
MODEL: Montero
YEAR OF PRODUCTION: 1999
ENGINE: 3.5 L V6, 208 hp
TRANSMISSION: Automatic
VISITED COUNTRIES: United States
MILES IN TOTAL: 185,000 miles

TRAVEL TIME: Weekend trips
REBUILD—YEAR: 2016
REBUILD—BODYWORK MODIFICATIONS:
Adventure Driven Design skid plate
REBUILD—CHASSIS MODIFICATIONS:
OME 2.5-inch lift kit
REBUILD—INTERIOR MODIFICATIONS: Window

tinting, third row seat delete, added rear shelf
REBUILD—OTHER MODIFICATIONS:
Voyager Safari roof rack, ARB Simpson II
rooftop tent, PlashLights LED flood lights,
solar panel, second battery
REBUILD—SUPPORT BY: BFGoodrich, The
Adventure Vans, Hi-Pro Audio, Jonny Grunwald

159

CAMP THAI BEEF SALAD

INGREDIENTS

1 romaine lettuce, 1 onion,
1 tomato, 2 cucumbers, 2 tbsp
unsalted peanuts, 2 green onions,
1 rib eye steak, ½ cup fish sauce,
½ cup lime juice, ¼ cup sugar,
water, chili flakes

In a cast iron skillet, sear the beef on both sides so there's a nice crispy crust. Cook to your preferred doneness. The only hard thing about making Thai beef salad in the wilderness is sourcing fish sauce. Any Asian grocery should stock it. If you're lucky enough to be in a cosmopolitan city before you hit the bush, some regular grocery stores should have fish sauce in the ethnic food aisles. For the salad dressing, mix the fish sauce, the lemon juice, sugar, and chili flakes to taste. Thai food typically has a spicy kick, so you need at least some heat. Cut and slice the vegetables as you like. Thinly slice the beef and add to the vegetables. Add dressing, toss to combine, garnish with crushed peanuts, and enjoy.

CAMP VEGETABLE MELODY

INGREDIENTS

1 onion, 4 cloves of garlic, 2 cups mushrooms, 1 bell pepper, 2 cups green beans, salt, pepper, olive oil

In a deep pot over medium-low heat, add some olive oil, toss in the diced onion, and season with salt and pepper. Caramelize the onions for about 15–20 minutes to bring out their sweetness. Increase heat to high, add the diced garlic, and quickly brown. The green beans will take the longest to cook, so add those next. Note that each time you add a new vegetable to the pot, you should follow it with a good dash of salt and pepper. By the time the dish is finished cooking, there won't be any need for additional seasoning. But always take a bite at the end and season to taste. Sauté the green beans on high heat for 5–7 minutes, then add the mushrooms and cook until soft. They will release a lot of water as they cook, but the moisture will gradually evaporate with the heat. Lastly, add the bell pepper, season, sauté, taste, adjust the seasonings, and serve.

161

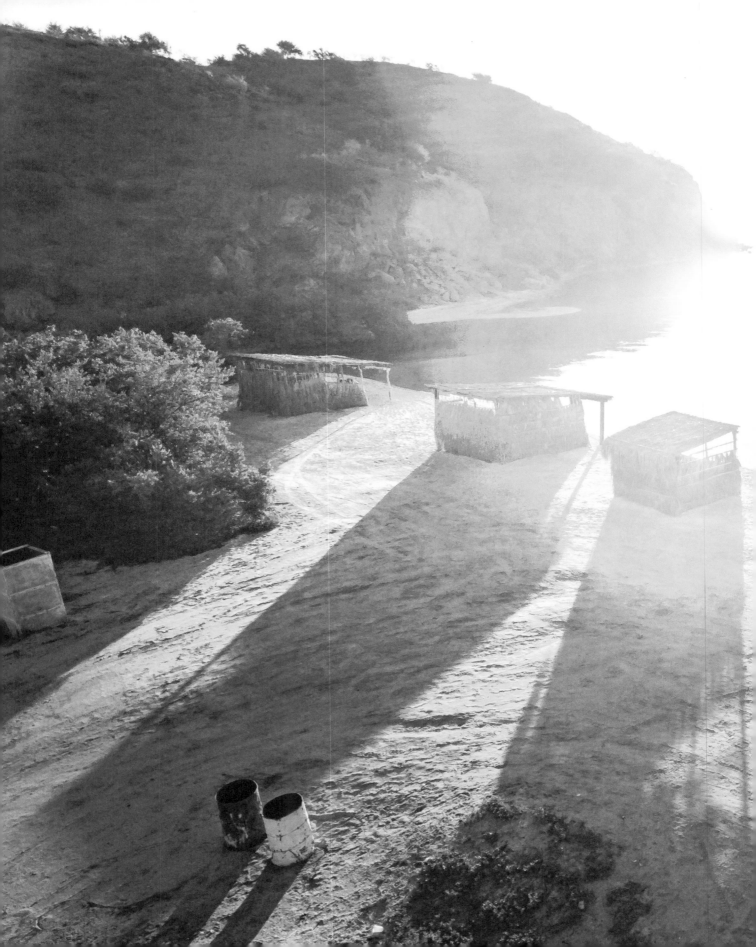

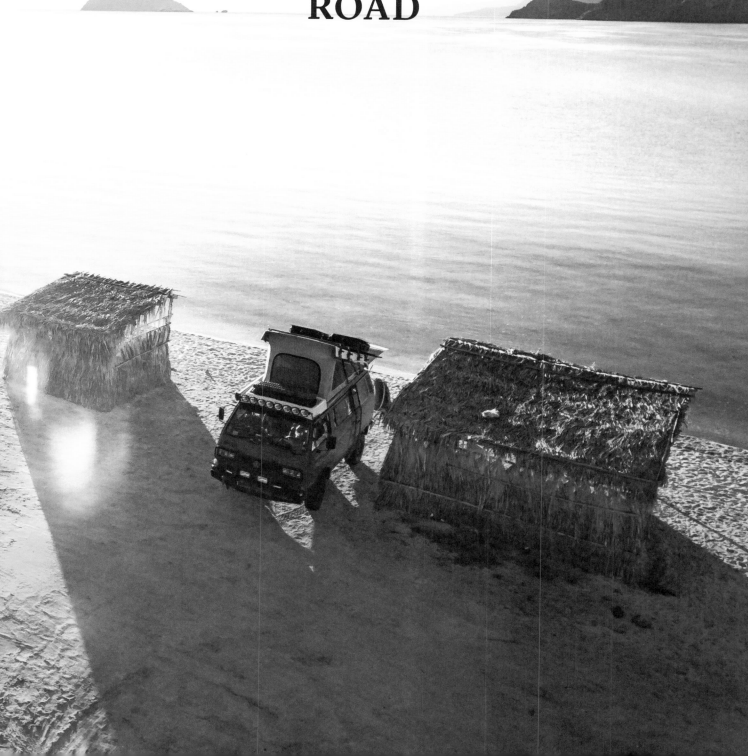

TAKING THE LONG, WINDING ROAD

Cruising through scrub, Nevada, USA *(above)*. Stray dog, Mulegé, Baja California Sur, Mexico *(opposite top)*. Downtime with Petunya and Jessica *(right)*.

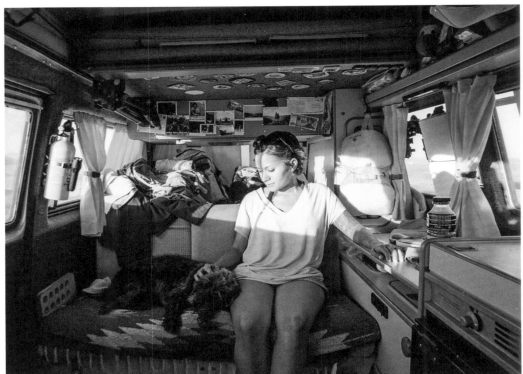

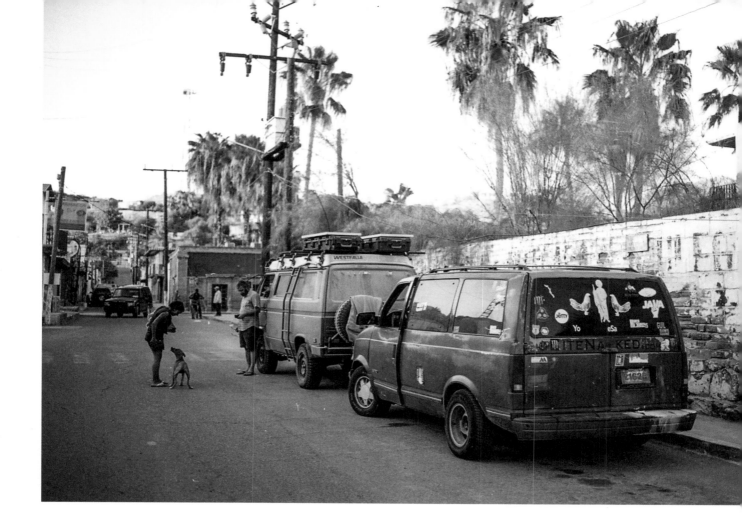

After Jorge and Jessica Gonzalez lost their business in the 2008 stock market crash, they were at a crossroads. They'd married young, navigated sometimes precarious work situations, and now out of the army and putting the Iraq war behind him, Jorge was trying to nudge them out of Atlanta in the direction of Austin. They checked out Austin on a road trip across the Southern United States to Wyoming, Utah, and California, and then up and made the move.

But after their fresh start in Texas and with an expanding portfolio of client work that could be done from anywhere, Jessica quietly dreamed up a daring suggestion when facing their lease renewal date: move into a van, work remotely, and see the world. Enter the next two years: living in a homely white Volkswagen Westfalia, and then upgrading to a 1986 VW Vanagon (T3 in Europe) Syncro.

The Syncro was purchased on a serendipitous weekend drive using their gut as their guide, but 600 miles (1,000 km) later it was already kaput. Persevering through a seemingly endless two-year restoration process full of mechanical skulduggery, wasted capital, and hearts worn on sleeves, they eventually replaced virtually every system by hand, celebrating their effort by naming the Syncro "Ripley" after the unflappable, indestructible Sigourney Weaver character from *Alien*. They lifted Ripley a couple of inches, replaced panels →

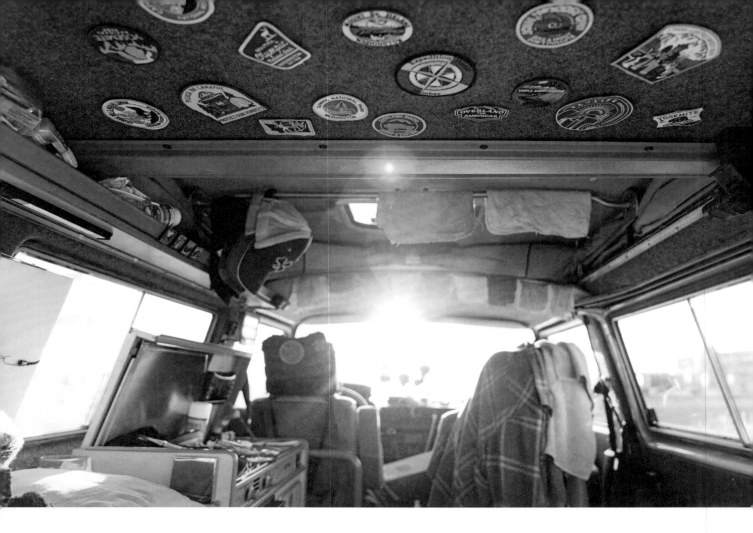

and plates, remediated rust, and installed a host of new parts and comfort accoutrements. Coming personally customized, it had a roomier and more versatile setup. In the grim process of reincarnation, they learned all the vital and underrated knowledge of bush mechanics that would ensure their survival once inevitably consumed by the fever and folly of life on the road—and they were many times over the next four years and 80,000 miles (130,000 km).

Jorge and Jessica are roamers but they work hard. Work is the structure around which their full-time travel adheres: when big multi-day design jobs come along, they sit on a mountaintop if they can manage a clear 4G signal, or descend to a city to take up in a co-working space. If it's the usual jobs, they'll stop into a town and occupy a neighborhood coffee shop for as long as it takes, or just park next to a Starbucks and steal the Wi-Fi. Of all the graphic and communication designers and illustrators living and working in vans, particularly across the United States, Jorge and Jessica are meta-designers, doing

They meander point-to-point ... This is driving as meditation.

and selling design work not just on the journey but about it. Their stickers and badges with logos and slogans like "Live Free, Drive Hard" help perpetuate other American travel traditions on the wane.

Their traveling style is a mix of the technologically analogue (the 4WD-enabled van) and digital (the Google Maps "Avoid Highways" option). They meander point-to-point, taking indirect routes at slower →

166

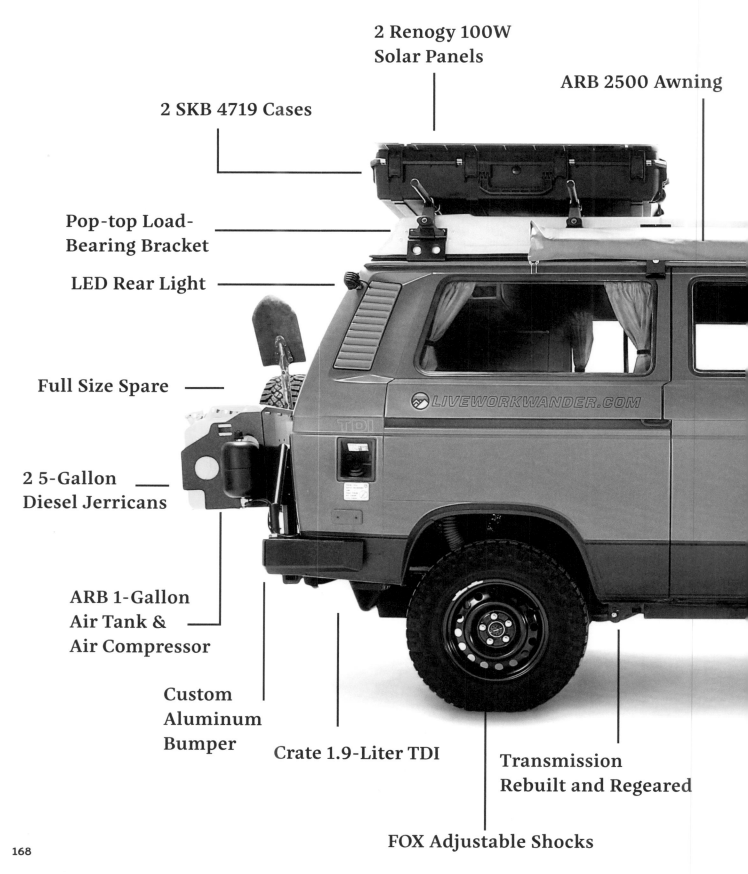

2 Renogy 100W
Solar Panels

ARB 2500 Awning

2 SKB 4719 Cases

Pop-top Load-
Bearing Bracket

LED Rear Light

Full Size Spare

2 5-Gallon
Diesel Jerricans

ARB 1-Gallon
Air Tank &
Air Compressor

Custom
Aluminum
Bumper

Crate 1.9-Liter TDI

Transmission
Rebuilt and Regeared

FOX Adjustable Shocks

LIVEWORKWANDER.COM

TDI

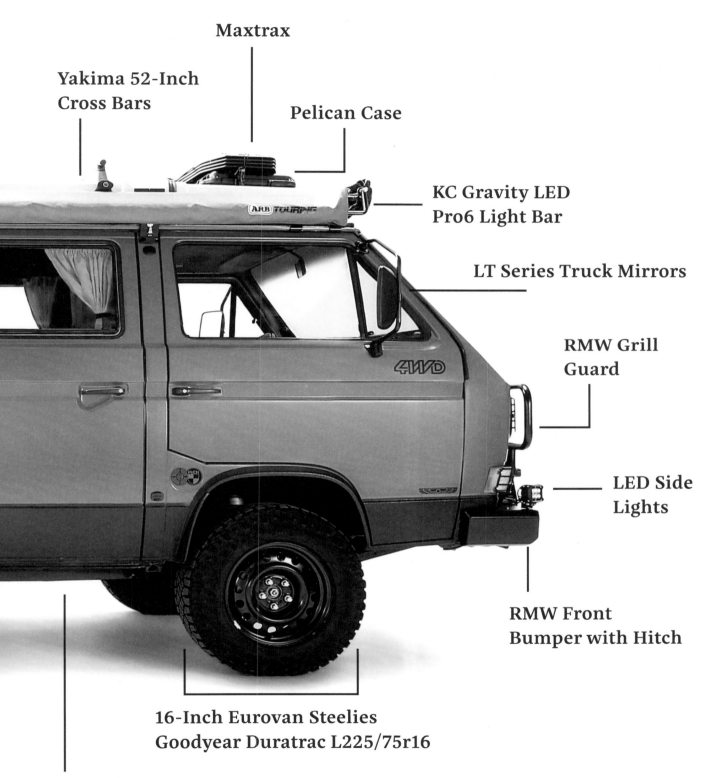

Maxtrax

Yakima 52-Inch
Cross Bars

Pelican Case

KC Gravity LED
Pro6 Light Bar

LT Series Truck Mirrors

RMW Grill
Guard

LED Side
Lights

RMW Front
Bumper with Hitch

16-Inch Eurovan Steelies
Goodyear Duratrac L225/75r16

Underfloor Storage
Compartment for Tools

169

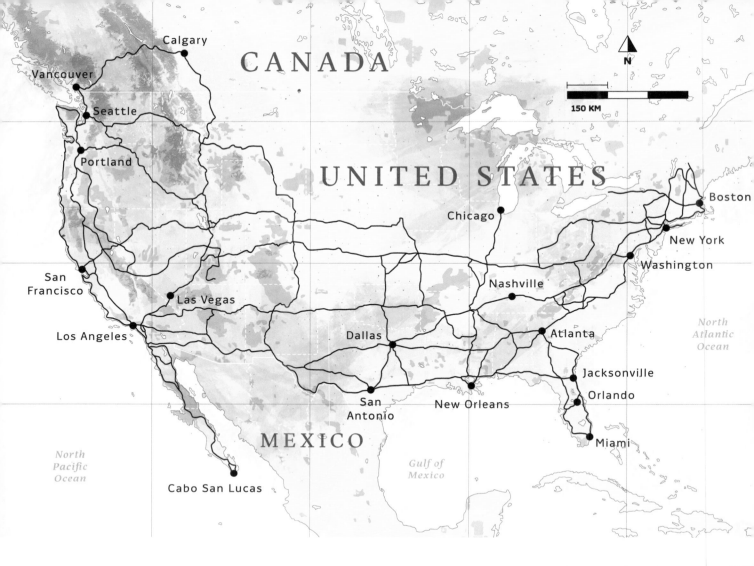

speeds along the winding byways and secondary roads of North America, through towns, truck stops, fire roads, up hills, and down dales. They've found a groove and stayed in it, crisscrossing the continent; their 80,000 total miles thus far are equivalent to driving between Los Angeles and New York City 30 times. This is driving as meditation, and it's helped them realize that to mitigate the stresses of work, debt, and life's rollercoaster, they have to feel the road and explore lost nomadic inclinations that lay dormant during their city years. ■

Looking to whatever's ahead (right). The Syncro beachside in overnight mode (opposite).

→ Live Work Wander

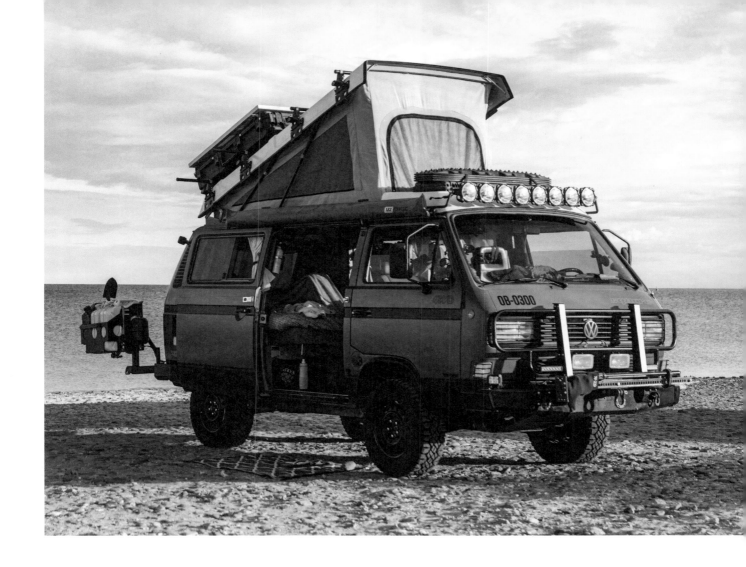

VOLKSWAGEN TYPE 2 (T3) VANAGON SYNCRO

With the assistance of Steyr-Daimler-Puch, makers of the G-Wagon's 4WD system, the Syncro became far more capable off-road than the standard T3. Today, they are highly sought after because few were made, with many adventurers praising the traction benefits of 4WD. Jorge and Jessica's van is prepared for almost anything, a veritable Swiss Army knife of vehicles. Outside is a RMW front bumper with winch, a 1.5-inch lift, adjustable shocks and Trail Master springs, two Renogy 100-Watt solar panels, a KC Gravity LED light bar, an ARB 2500 awning, and an underfloor storage compartment—just some of the modifications to make it an overland overlord.

MANUFACTURER: Volkswagen
MODEL: Type 2 (T3) Vanagon Syncro
YEAR OF PRODUCTION: 1986
ENGINE: 1.9 L PD TDI
TRANSMISSION: Manual
VISITED COUNTRIES: United States
MILES IN TOTAL: 80,000 miles
TRAVEL TIME: Four years
REBUILD—YEAR: 2015–2017
REBUILD—BODYWORK MODIFICATIONS: RMW

front bumper, Atlas Overland rear bumper (full custom), rust remediation, full skid plates front to back
REBUILD—CHASSIS MODIFICATIONS: Aluminum gear box, rear lockers, solid shaft front differential
REBUILD—INTERIOR MODIFICATIONS: Basic Westfalia interior with some modifications to doors, lithium battery supply, 19 gallons of fresh water, sink and two-burner stove, steel

locking center console, underfloor tool storage box
REBUILD—OTHER MODIFICATIONS: Warn Zeon 10-s winch, light bar, Rigid dually side shooter LED Lights, 290W flexible solar panels, Glind onboard shower, 1.5-inch lift, Trail Master stage II springs, Fox adjustable shocks, ARB awning
REBUILD—SUPPORT BY: Mountain Bus Werks, Rocky Mountain Westy, Mule Expedition, MF Auto

171

DREAM BIG
ON A
BUDGET

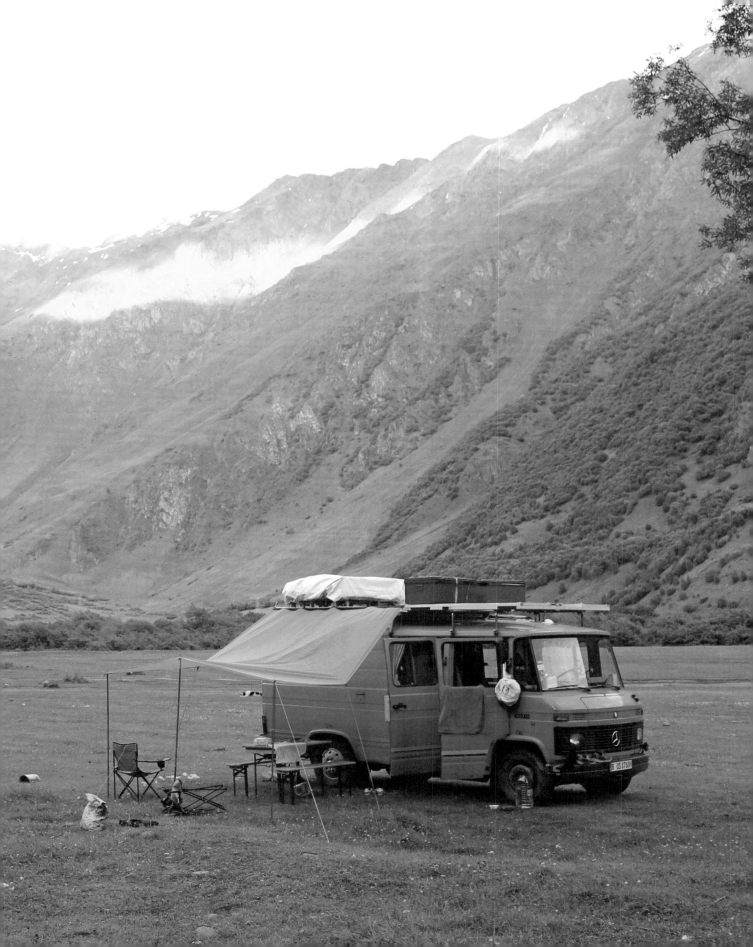

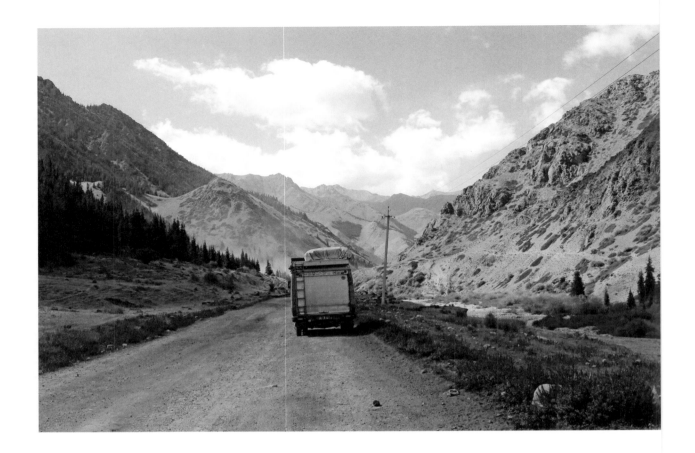

I had an interesting and cool marketing job and a safe monthly income, but I just didn't want to spend my life in an office staring at a screen," Paul Nitzschke says of his decision to flee the rat race. Berlin isn't a city famous for its intense work ethic, cutthroat corporate culture, or endless business hours—yet. But the corporate culture exists everywhere, and no one is immune to the repetition of modern-day work. "I quit my job and my flat, left behind my old life in wonderful Berlin, and hit the road," says

"Unknown countries and their beauty: that's my definition of freedom."

Paul. "Unknown, untraveled countries and their beauty: that's now my definition of freedom."

In 2013 he bought a 1987 Mercedes-Benz 407 D, a late Cold War relic-turned-cattle mover, for only €1,500, overhauled it for €3,500, and eventually headed east with his girlfriend, Christina. Bound for Siberia to see her family, the couple, adamant that life is too short to wait to see the world, are thrilled to have faced the fear and supposed shame of rejecting competitive existence for an autonomous life. Traveling in a vaguely eastward line across Eastern Europe and Central Asia, they drove from Germany to Poland →

174

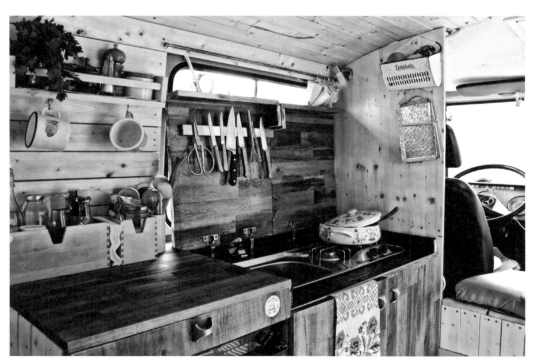

With Christina's family in Siberia *(above)*. Hand-built van kitchen *(left)*. Cooking and cruising, Central Asia *(opposite)*.

175

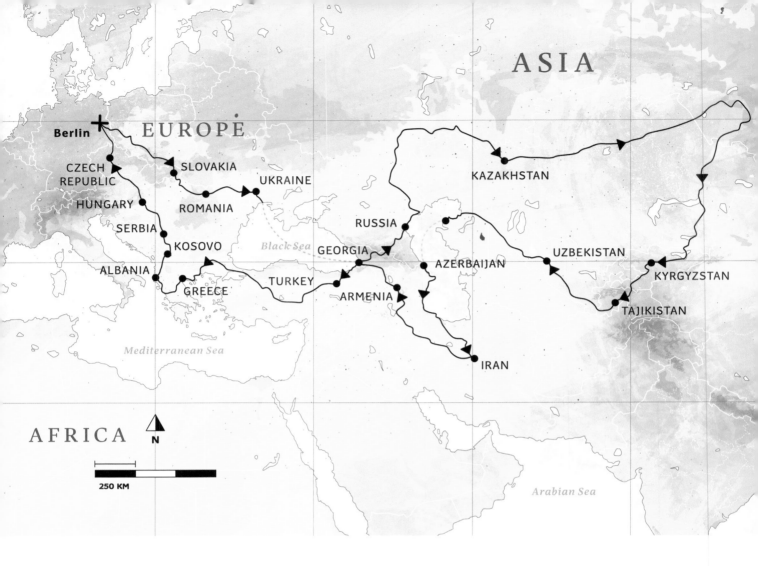

and Slovakia, from Romania to Ukraine, across Georgia and Kazakhstan to Siberia, across Kyrgyzstan and Tajikistan, and from Uzbekistan to Iran.

"I want to live life to the fullest and be proud of it," says Paul. "I travel to unknown countries to actually see them for myself—over steep passes, through uninhabited deserts and deep snow—and meet people that I probably wouldn't have met any other way. This is my dream now. And anyone can have this life." ∎

Rear of the van in rest mode (left). Cappadocia, Turkey, is one of the most popular spots in the world to go up in a hot air balloon (opposite).

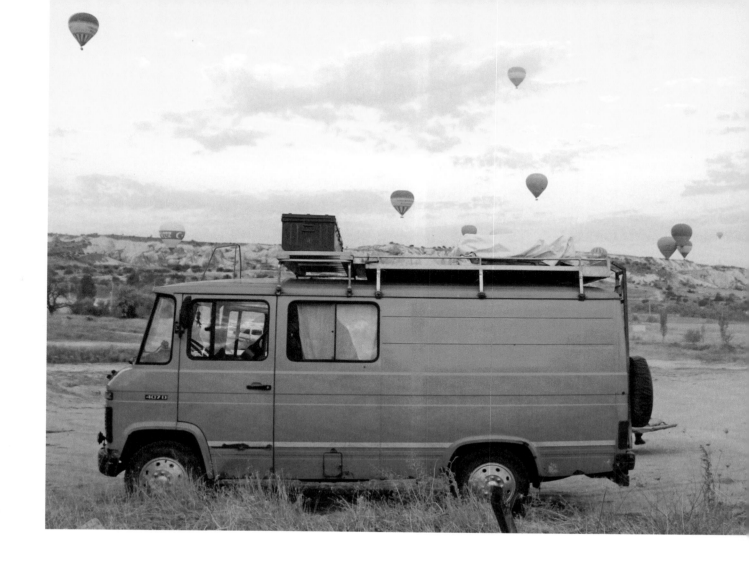

MERCEDES-BENZ T 2 (407 D)

This Mercedes-Benz 407 D was first used by the Federal Agency for Technical Relief in Germany, where it sat in a garage for the majority of its life. Its public service fulfilled, a farmer re-appropriated it for transporting calves. As a result, it had nothing but a few miles on the odometer and a proper countryside smell inside. Mechanically, the Benz is simple, which makes for unparalleled reliability, easy fixes, and a top speed of 55 miles per hour (90 km/h). It is back to the basics here, with no power steering, no power windows, no other extras. It took Paul four months to overhaul it before hitting the road, adding solar power, a kitchen, a full-size bed, and an awning.

MANUFACTURER: Mercedes-Benz
MODEL: T 2 (407 D)
YEAR OF PRODUCTION: 1987
ENGINE: 2.4 L diesel, 72 hp
TRANSMISSION: Manual
VISITED COUNTRIES:
Poland, Romania, Slovakia, Moldova, Ukraine, Bulgaria, Georgia, Russia, Kazakhstan, Kyrgyzstan, Tajikistan, Uzbekistan, Azerbaijan,

Iran, Turkey, Greece, Albania, Bosnia, Hungary, Slovenia, Czech Republic, Germany
MILES IN TOTAL:
175,000 miles
TRAVEL TIME:
2 years
REBUILD—YEAR: 2015
REBUILD—BODYWORK MODIFICATIONS:
Original factory condition

REBUILD—CHASSIS MODIFICATIONS:
Original factory condition, rust precaution
REBUILD—INTERIOR MODIFICATIONS:
Custom wooden interior panels, kitchen, full-size bed, new lighting, additional storage
REBUILD—OTHER MODIFICATIONS:
Roof rack, second battery, roof hatch
REBUILD—SUPPORT BY:
Friends

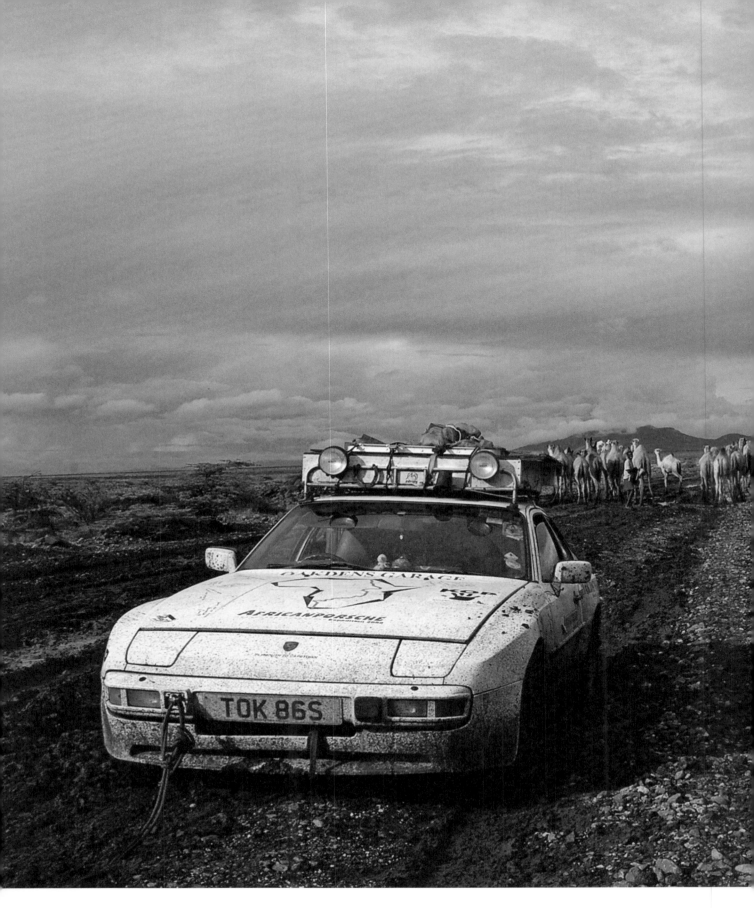

→ The African Porsche Expedition

ADVENTURE OF NO RETURN

C rossing impenetrable lands in inappropriate sports cars is a growing trope in adventuring, and touring Africa off-road, north-to-south, in a 1985 Porsche 944 is about as daring an attempt as any. Automotive writer Ben Coombs and companion Laura Reddin left Plymouth bound for Cape Town determined to destroy, rather than simply sell, his ailing Porsche. They needed an insurance policy: three friends to join them on the 13,000-mile (20,000 km) trip in a Mitsubishi Pajero (Shogun in the U.K.) 4×4.

The first week saw the convoy ferry over the English Channel into France, Germany, Eastern Europe, and →

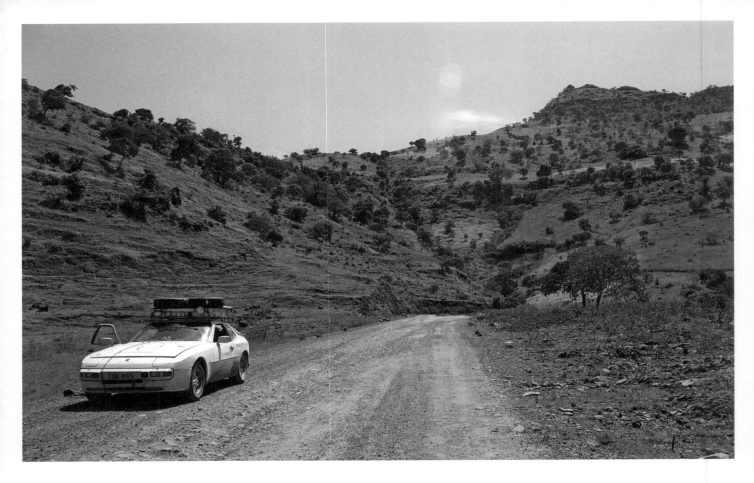

Turkey; then to Syria for a night in Damascus; a night camping by the Dead Sea and a visit to Petra, Jordan; hours of paperwork at the Egyptian border before a brisk drive to Cairo and the pyramids; and Sudan, with a rest at the threshold of the vast Nubian Desert. Here, the Porsche's exhaust broke, a sign of things to come. They bounced through the sand for three days before crossing the Nile and reaching the highway to Khartoum, where repairs were sought.

The deserts gave way to the lush Ethiopian hills. They passed Addis Ababa in a blur en route to Kenya, and here the Porsche really started to come undone. Rain had turned Kenya into a rutted quagmire, the car was not happy. A filter failure resulted in the Mitsubishi towing it 60 miles (96 km) to a small town to reassemble its underside. One breakdown later, they were in the shadow of Mount Kenya.

The convoy continued across the equator and through Tanzania, Malawi, and Zambia. In Botswana, the Mitsubishi smashed into the fragile Porsche, destroying its back end. They then limped into Namibia and entered the final desert, the long, desolate coastal Namib. Cruising along, oddly confident they'd make it,

the Porsche's front wheel suddenly fell off. The lower wishbone had cracked, with roadside repair the only option. They removed the wheel, slotted the joint back together, and tensioned everything outback-style using ratchet straps. Forward they edged, confident again.

After 20 miles (32 km) the wheel flipped off into the distance. After a repair, they lost it a third time—a repair again. With night rolling on and lightning crashing into the cooling desert, they inched on, losing and reattaching the wheel again and again. They sheltered stoically in the vulnerable cars, awaiting daybreak as the storm raged. As the sun finally crept up and the heat retreated, the comical journey continued over forlorn dusty roads, each subsequent wheel repair proving less resilient than the last, the prospect looming that abandoning the Porsche might soon be the only option.

By the eighth breakdown, collective stubbornness was all that held it together. Again the wheel was cleaned out and strapped on. Holding their breath, they crawled across the desert for six hours until the most beautiful sight appeared before them: tarmac, all the way to Cape Town. They rolled jubilantly into the city—26 countries, 28 breakdowns, and 60 days later. ∎

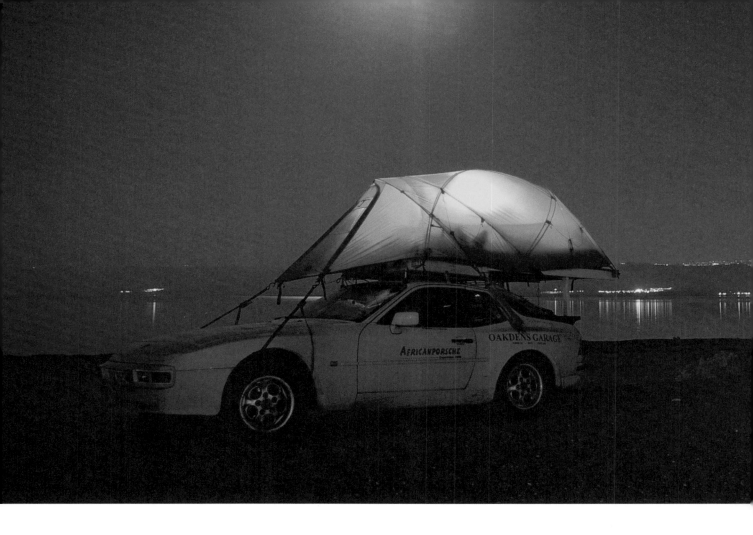

The African Porsche Expedition ←

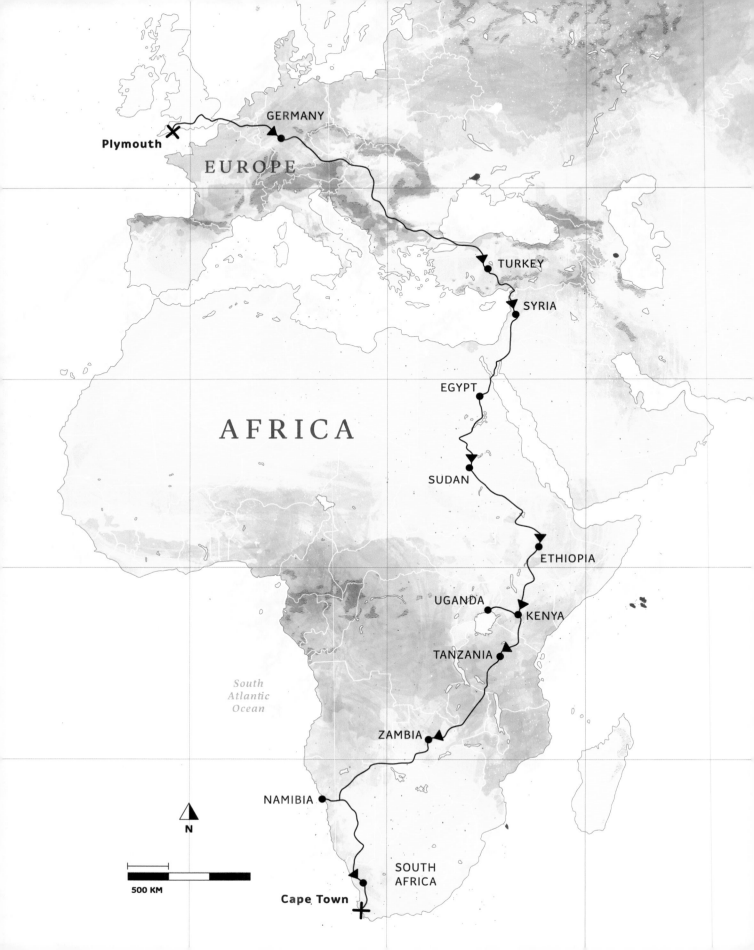

Plymouth

EUROPE

GERMANY

TURKEY

SYRIA

AFRICA

EGYPT

SUDAN

ETHIOPIA

UGANDA
KENYA

TANZANIA

South
Atlantic
Ocean

ZAMBIA

NAMIBIA

N

SOUTH
AFRICA

Cape Town

500 KM

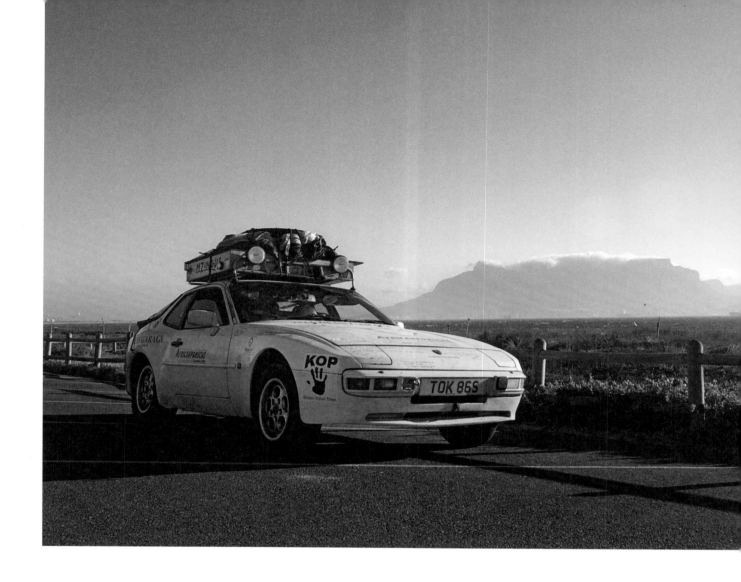

PORSCHE 944

While Porsche is well known for their successful motorsport program, it is not a name synonymous with motorhomes or overland traveling. Ben's 1985 Porsche 944 challenges this. It was first introduced in 1981 and is based on the 924 model, which was criticized for not being a "real" Porsche due to its Audi-sourced 2-liter engine. The 944 succeeded it and was met with acclaim. To make Ben's 944 a desert driver, the suspension was raised by 4 inches (10 cm). The custom-built roof rack and rooftop tent are proof that you can go almost anywhere in a 944.

MANUFACTURER: Porsche
MODEL: 944
YEAR OF PRODUCTION: 1985
ENGINE: 2.5 L straight four, 160 hp
TRANSMISSION: Manual
VISITED COUNTRIES:
England, France, Belgium, Germany, Austria, Slovenia, Croatia, Serbia, Bulgaria, Turkey, Syria, Jordan, Egypt, the Sudans, Ethiopia, Kenya, Uganda, Tanzania, Malawi, Zambia, Botswana, Namibia, South Africa
MILES IN TOTAL: 13,500 miles
TRAVEL TIME: 60 days

REBUILD—BODYWORK MODIFICATIONS:
Original factory condition
REBUILD—CHASSIS MODIFICATIONS:
10 cm suspension lift
REBUILD—INTERIOR MODIFICATIONS:
Original factory condition
REBUILD—OTHER MODIFICATIONS:
Custom roof rack, roof tent setup

THE POWER
OF A TRUSTED
TRUCK

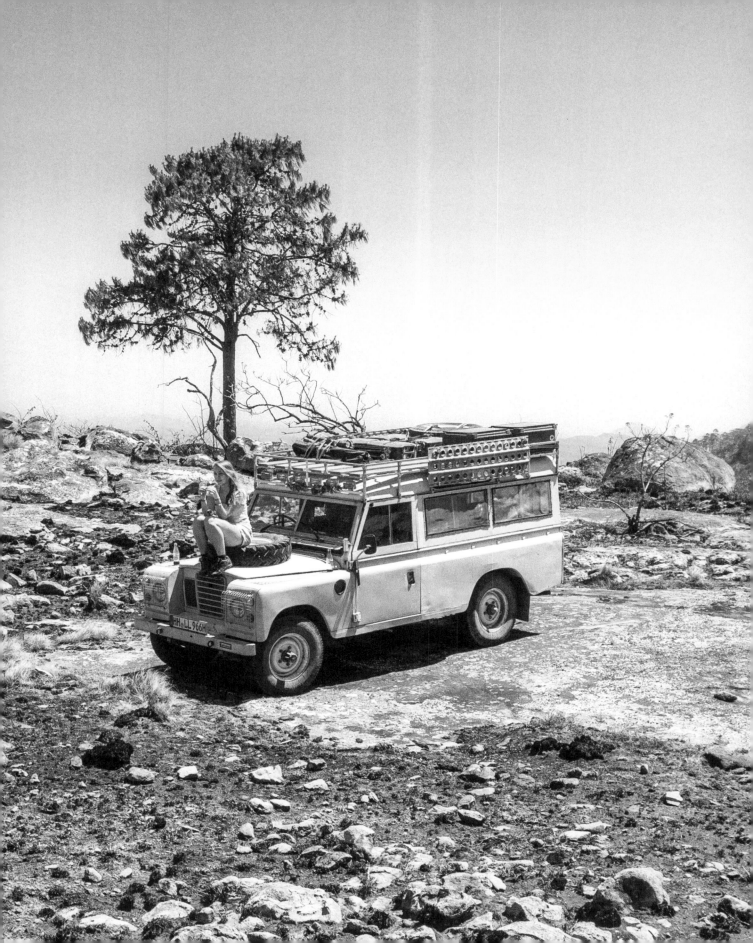

Lilli in the Namib
Desert, Namibia
(above). Lukas
on safari watch
(opposite top).
Curious hyena,
Zambia *(opposite
bottom)*. Herds
gathered at a
waterhole *(right)*.

→ Roving Down South

When new geographers are minted from university, there are two options they can credibly pursue. One: immediately enter the lower rungs of the work-force and sit at a desk using various Geographical Information Systems software to analyze, recognize, and report patterns in global data. Or two: buy a good, sturdy truck and take it far from home to chart as much foreign territory as possible, especially if it's remote. Always do so at the slowest possible speeds to thoroughly connect with the land, sea, weather, and people learned about in school. (Even for those not studying geography, this is good advice.) When Hamburg geographers Lilli Gramberg-Danielsen and Lukas Beuster graduated in 2015, they naturally chose the latter, flying off to get lost in Africa.

The classic 1983 Land Rover Series III they found in South Africa was old and heavy, but in impeccable condition and ready for another safari. With its original khaki paint fading and only weeks to prepare, the intervention was light, as were their stores and supplies after flying in from Germany with little →

more than stowed baggage. "We swapped the rotten wood on the roof rack, put some flowers in front, and fixed one or two rusty bits, but that was pretty much it," they share. They also built a storage system and sleeping area, and added a compressor fridge and two small solar panels. Their setup was fast and light: mattress in the back and business in the front. It was a travel scheme short on preparation but long on pragmatism, with the dependable early 1980s Land Rover as the masterstroke. "We spent nine months on the road with about a month up front of serious planning and modification," they say. "We then drove 15,000 miles (24,000 km) of African roads at a maximum speed of 40 miles per hour (65 km/h)—a pleasant crawl, making sure we didn't miss anything along the way."

Through Namibia, Botswana, Zimbabwe, and Zambia, they crossed through grassland, deserts, mountains, and valleys, and had countless encounters with the iconic African wildlife that wander much of the continent freely. Into tiny, protected Malawi and down to its enormous titular lake, they finally relented and

"Take much less stuff with you—most of it is unnecessary."

commissioned a ventilated rooftop tent and awning to escape the sweltering summer heat of the truck cabin. Then on to Tanzania, where they reached the ocean and stopped to take stock by the beach. "We initially wanted to visit Kenya, Rwanda, Uganda, and Mozambique as well, but there were so many beautiful places to get stuck along the way," say the couple. "No regrets."

Upon returning to Germany, they realized their lives had changed too much. They missed Africa and its →

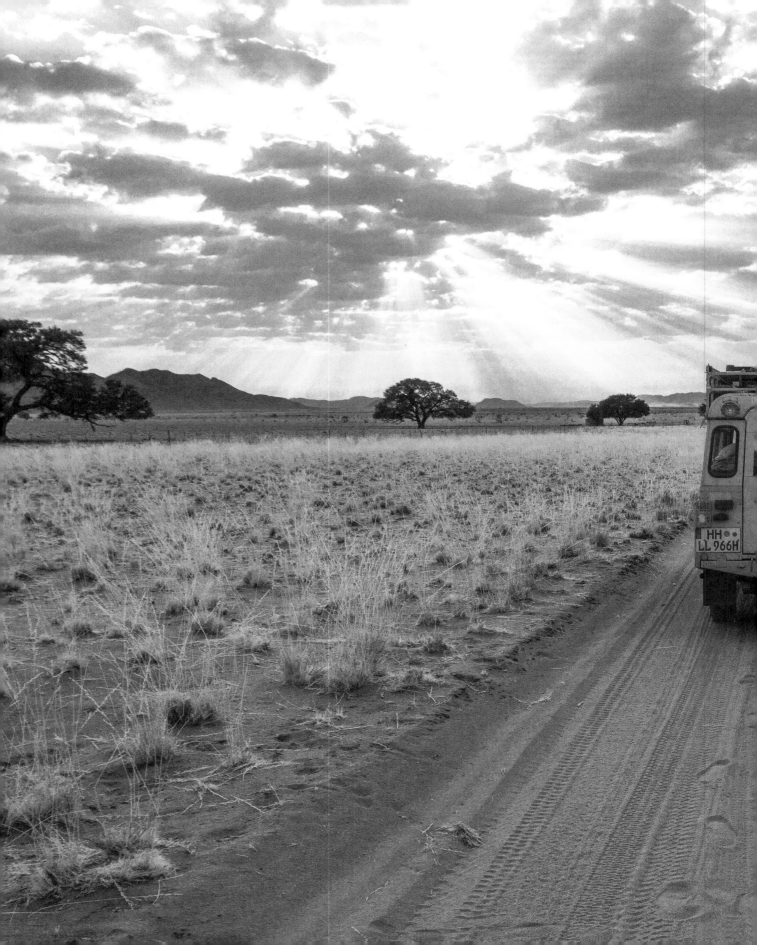

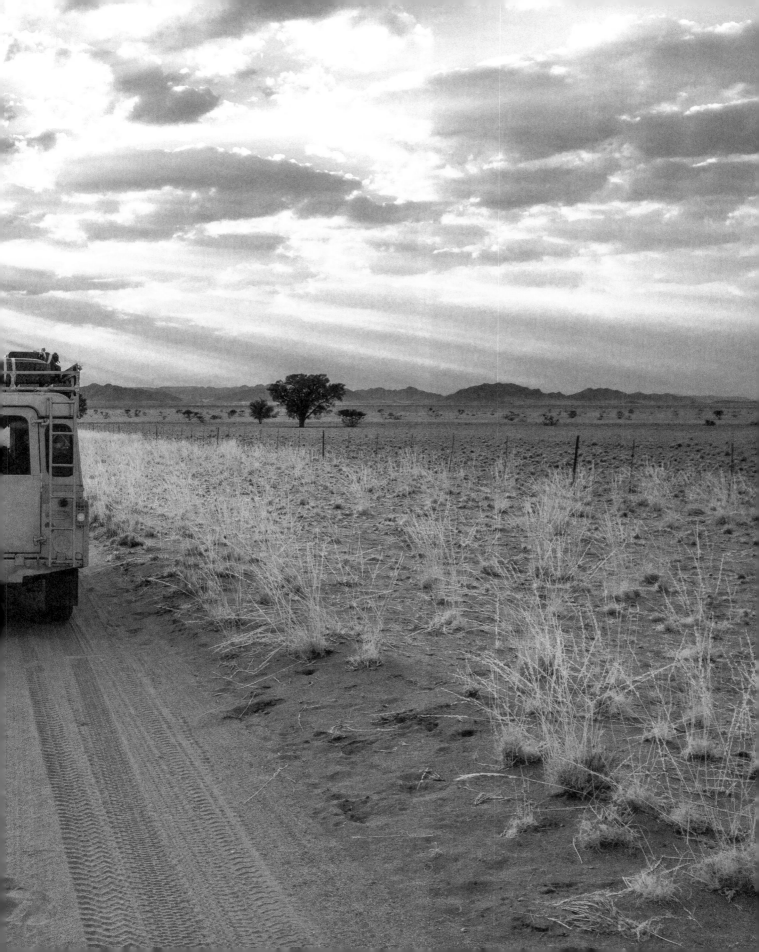

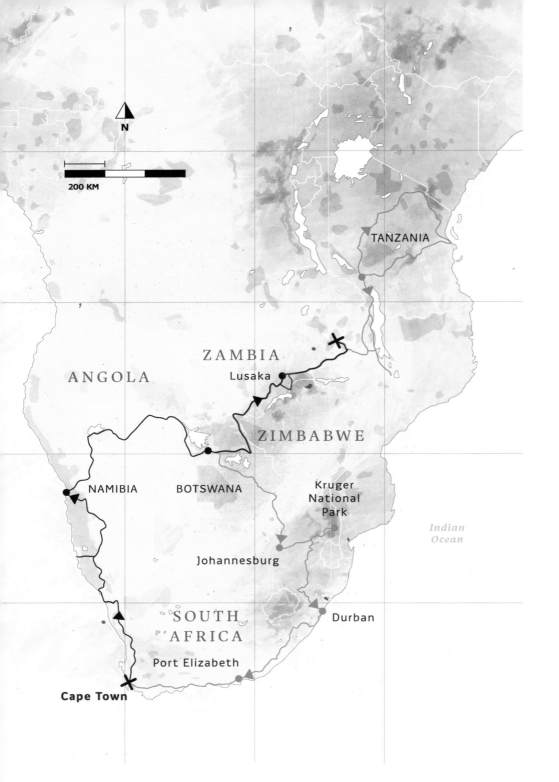

Ad hoc hammock and campsite on tour in the Namibian heat *(above)*.

many moods, and the places they had skipped weighed on them. So they turned around and returned to Africa. Now living and continuing their studies in Cape Town, they plan to use their spare time to see the rest of the continent in all its complexity and tribulation. And they plan to do it in a newer Land Rover Discovery, with little to no concern that they might encounter dangerous animals, hostile locals, or adverse circumstances. "The people you'll meet on the road are friendly and have no desire to do you any harm, so go out there and explore!" And, Lilli and Lukas advise, "Take much less stuff with you—most of it is unnecessary." ■

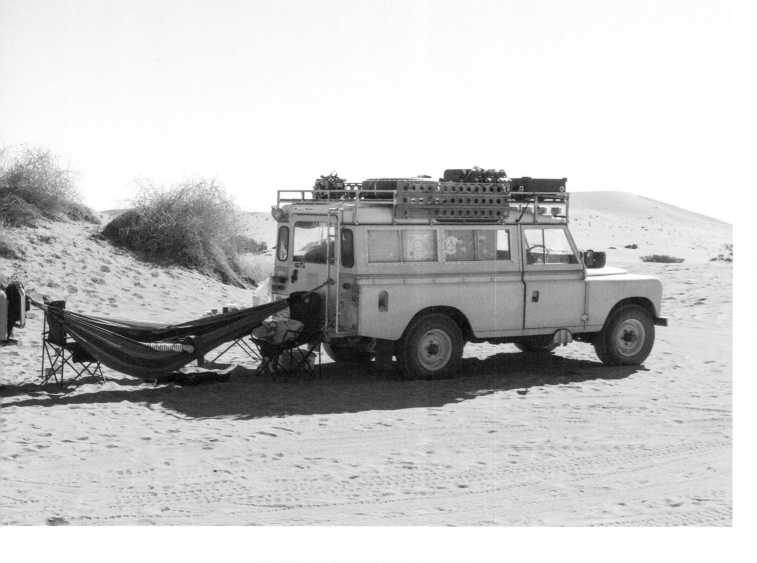

LAND ROVER SERIES III

The Series III generation (1971–1985) introduced significant mechanical improvements to the Land Rover, which was originally introduced in the 1940s. As such, Lilli and Lukas's 1983 Series III features a new synchro-mesh gearbox plus revised interior materials and gauge placement. Above all, the Series III is a favorite for adventurers given the strength added to the axles, transmission, and wheel hubs, which eliminates the heavy-use breakage seen in earlier Series. Alterations made here included a 3.9-foot (1.2 m) meter bed, storage boxes, a fridge, two solar panels, and a rooftop tent. By the journey's end, their Landy had covered over 15,500 miles (25,000 km) of Africa's roads, potholes, mud, and fields.

MANUFACTURER: Land Rover
MODEL: Series III
YEAR OF PRODUCTION: 1983
ENGINE: 2.25 L straight four, 63 hp
TRANSMISSION: Manual
VISITED COUNTRIES:
South Africa, Namibia, Botswana, Zimbabwe, Zambia, Malawi, Tanzania

MILES IN TOTAL: 15,500 miles
TRAVEL TIME: 9 months
REBUILD—YEAR: 2015
REBUILD—BODYWORK MODIFICATIONS:
Original factory condition
REBUILD—CHASSIS MODIFICATIONS:
Original factory condition, rust precaution
REBUILD—INTERIOR MODIFICATIONS:

Storage system, bed, 18-liter Waeco compressor fridge, a few aluminum boxes
REBUILD—OTHER MODIFICATIONS:
Solar panels, rooftop tent, awning by Bundutec
REBUILD—SUPPORT BY:
Grandpa's tools, tips, tricks, and other helpful inputs, snacks and hot chocolate prepared by grandma

MAKING MOUNTAINS OUT OF DUST

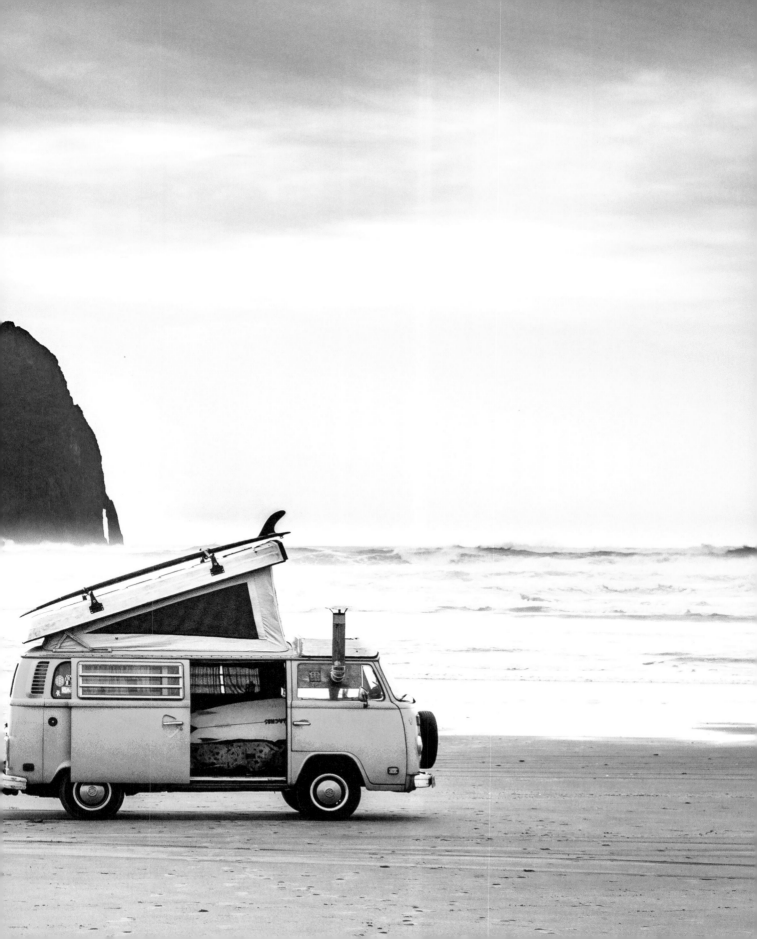

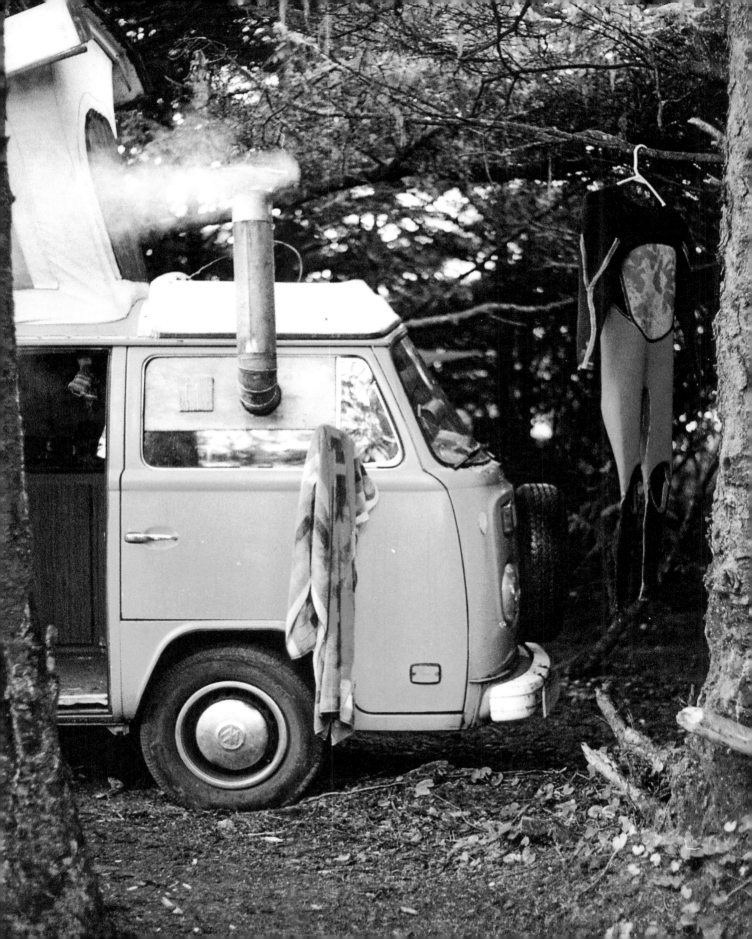

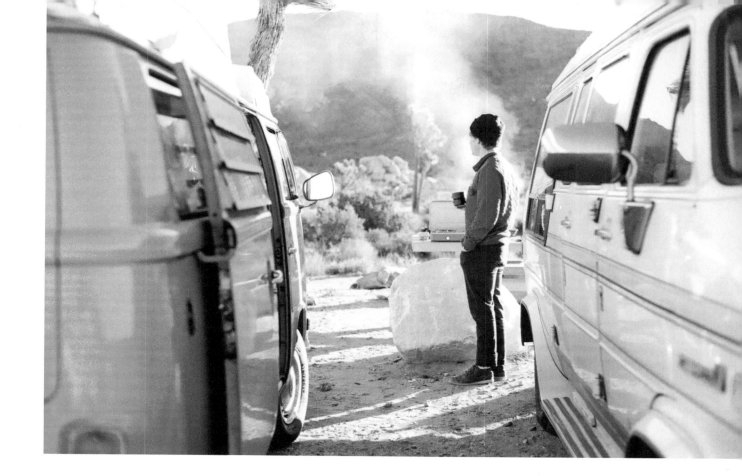

Adventure photographer James Barkman knew he'd get off his Pennsylvania ostrich farm somehow: "I dreamed of the day I'd set off in search of the wilder places of North America," he explains. He eventually bought an original 1976 Volkswagen Westfalia Campmobile from an "old lawyer off Craigslist," instantly appreciating and falling in love with her scuffs and bruises. The rusty, sheet-metal-wrapped Campmobile is the apocryphal van that grew to resemble its owner; James, who installed a pot-bellied stove and woodpile in place of his passenger seat, prefers dusty over clean, cold over warm, and risk over comfort.

Scoring an internship with Californian outdoor photographer Chris Burkard, James made his way west and spent his early twenties living out of the VW, →

Driver-side wood-stove *(right)*. Unwinding in the woods post-surf *(opposite)*. Joshua Tree National Park, California, USA *(above)*.

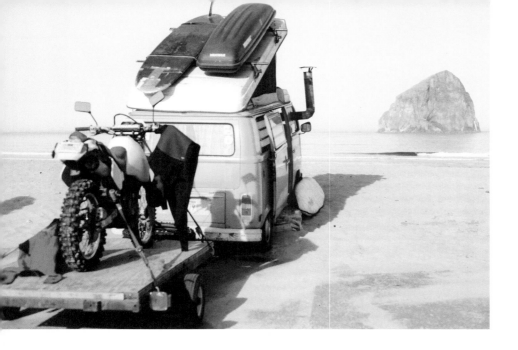

"I dreamed of the day I'd set off in search of the wilder places of North America."

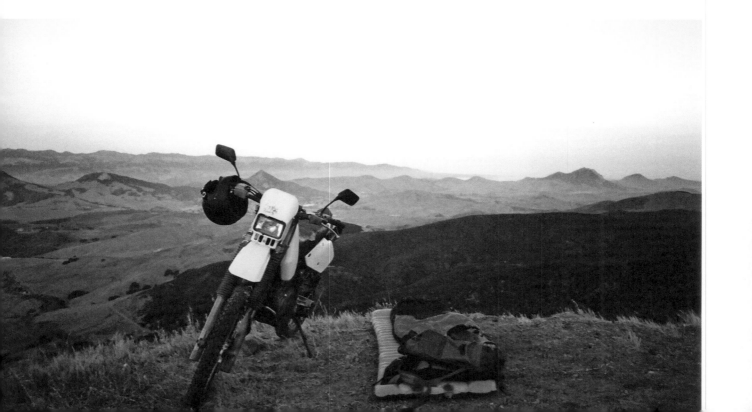

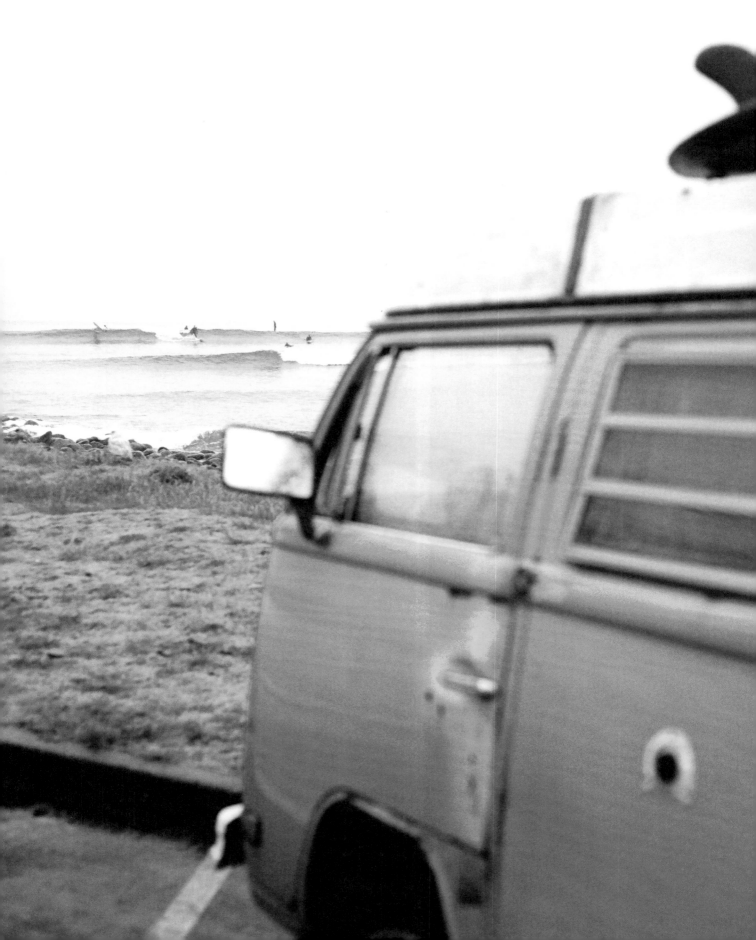

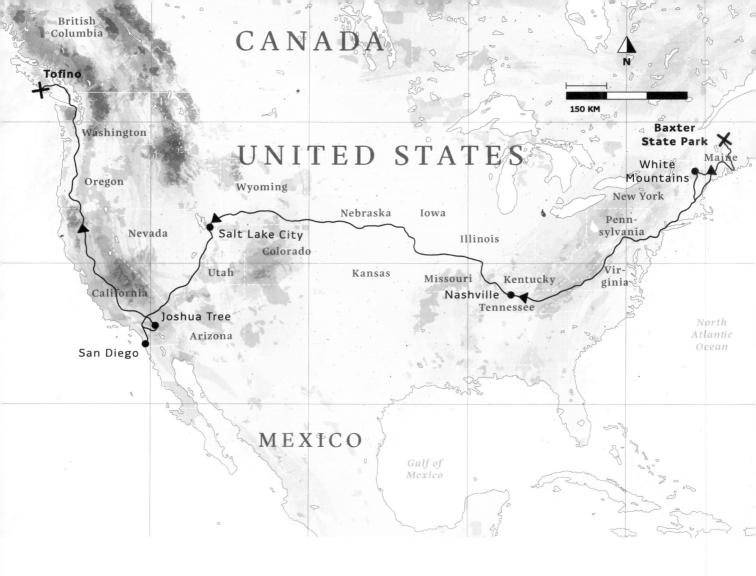

surfing, climbing, and camping along the West Coast from California to Canada. "It's been three years that I've called my vehicle home," he says. "Many of my closest friendships have been formed, important lessons learned, and memories made." In the spring of 2017, he finally garaged the VW, acquired a 1996 Suzuki DR650, and left the verdant Pacific states of Oregon, Washington, and British Columbia that had become home for a new adventure: a two-continent motorcycle jaunt down the Pan-American Highway from Alaska to Argentina. With two friends, he plans to climb every major peak along the way—there are many. ∎

→ Melody Barkvan

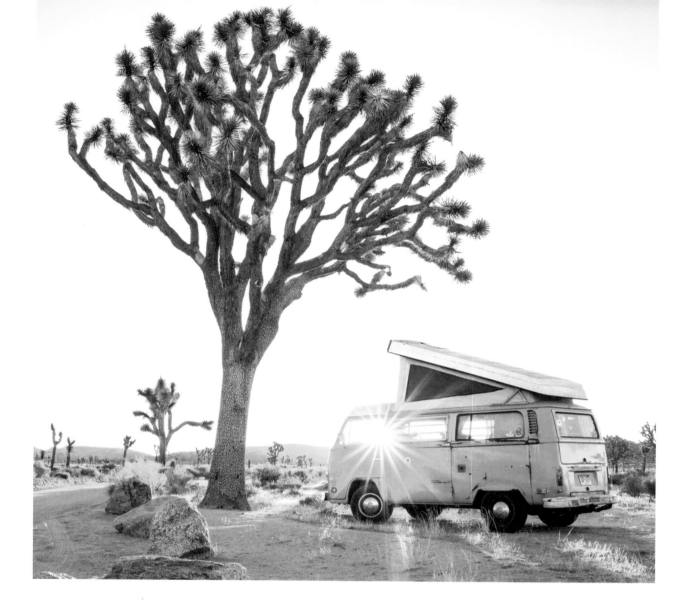

VOLKSWAGEN TYPE 2 (T2) WESTFALIA

"Mileage unknown, rusty, completely unreliable, 100% lovable." That is how James would best describe his 1976 Westfalia. After purchasing it off Craigslist, he left Pennsylvania to tour northeastern America. To make the VW livable in all climates, he installed a wood-burning stove in lieu of a passenger seat. Other additions include a roof rack, awning, and larger 15-inch wheels. He is now a seasoned adventurer across Canada and the United States, and would much rather put his money toward travel with "Melody Barkvan" instead of rent or unnecessary bills.

MANUFACTURER: Volkswagen
MODEL: Type 2 (T2) Westfalia
YEAR OF PRODUCTION: 1976
ENGINE: 1.8 L four-cylinder boxer, 68 hp
TRANSMISSION: Manual
VISITED COUNTRIES:
United States, Canada
MILES IN TOTAL:
Unknown
TRAVEL TIME:
3 years
REBUILD—BODYWORK MODIFICATIONS:
Original factory condition

REBUILD—CHASSIS MODIFICATIONS:
Original factory condition
REBUILD—INTERIOR MODIFICATIONS:
Woodstove instead of passenger seat
REBUILD—OTHER MODIFICATIONS:
Roof rack, ARB awning, 15-inch wheels, hitch and trailer, Suzuki DR650

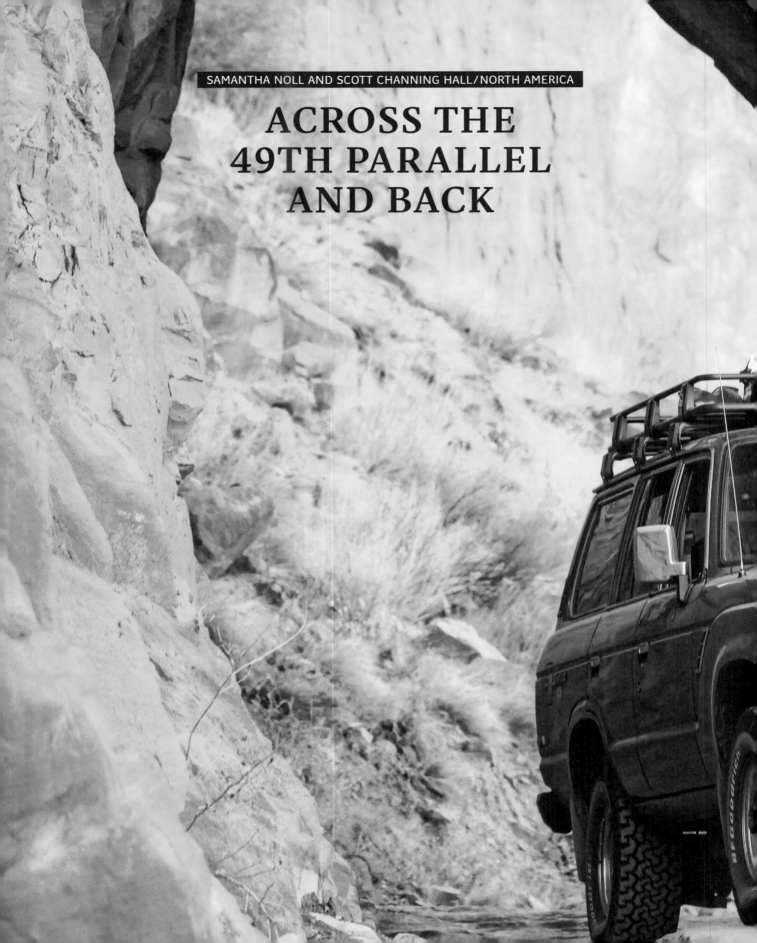

SAMANTHA NOLL AND SCOTT CHANNING HALL/NORTH AMERICA

ACROSS THE 49TH PARALLEL AND BACK

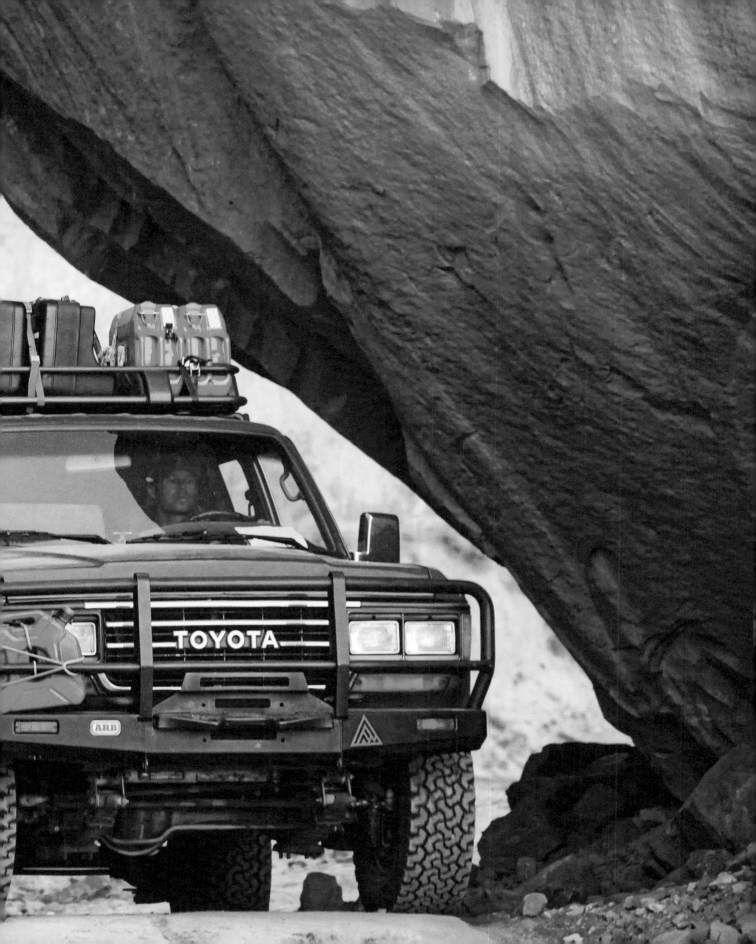

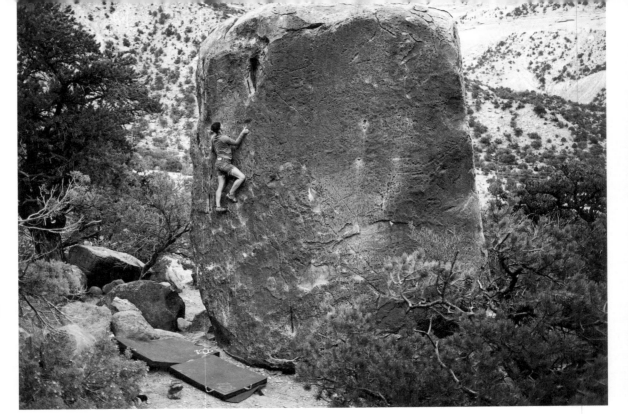

Samantha bouldering, Joe's Valley, Utah, USA (right). Ready for the evening, Utah, USA (opposite). Family portrait, Scott and Samantha (below).

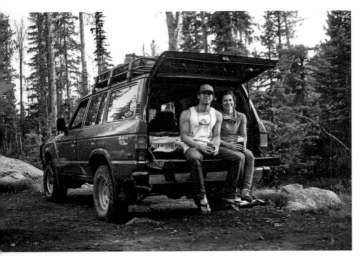

"My dad taught me that **maybe there is no destination** —just a path."

Scott Channing Hall grew up car camping in his dad's 1968 Land Cruiser FJ40. "There was never an 'Are we there yet?' question in our family, because there was no end goal. We celebrated the present wherever we were," he says. "My dad taught me the joys of keeping life simple, that maybe there is no destination—just a path." It's a lesson that's died hard in adulthood.

These days, Scott travels from his Utah home with his wife, Samantha, a fellow climber, around the wilderness of the Western United States, the Grand Tetons in Wyoming, the Sierras in California, and the North Cascades in Washington. When they set out, it's in either a VW T3 or, in the spirit of Scott's youth, a royal blue 1988 Toyota Land Cruiser FJ62.

The next trip is both more ambitious and a real leaf out of the family playbook—a vague destination, and a vastly different return route. "Destination obsession devalues the path," says Scott. They'll start as passengers: four nights in a tent under the stars on a long ferry ride through the clear, glacial waters of the Inside Passage, from Bellingham, Washington, to the remote Alaskan gold mining town of Skagway. "I've been planning and dreaming of this trip for →

204

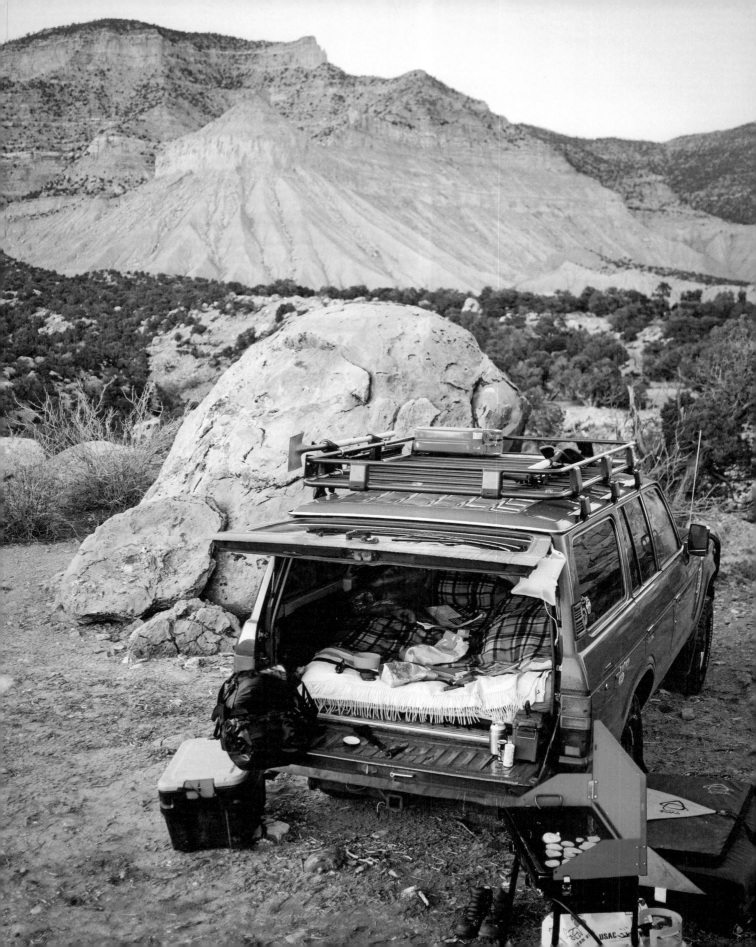

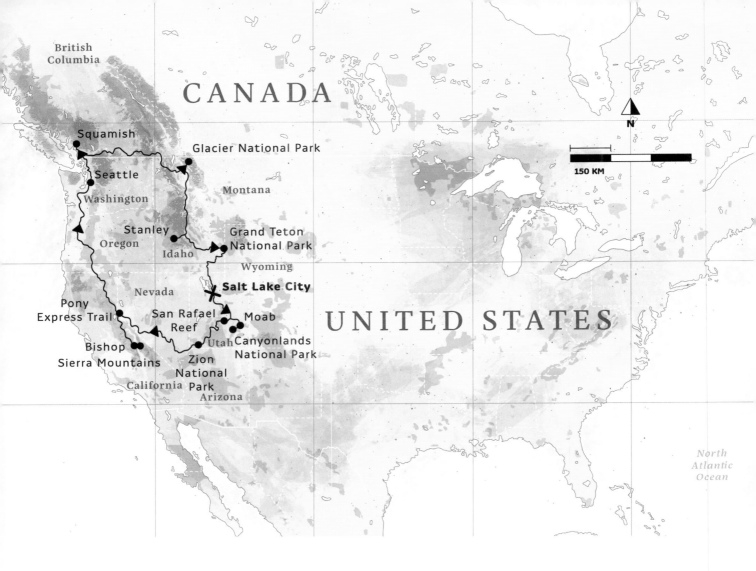

British Columbia

CANADA

Squamish

Glacier National Park

Seattle

Washington

Montana

Stanley

Oregon

Idaho

Grand Teton National Park

Wyoming

Salt Lake City

UNITED STATES

Nevada

Pony Express Trail

San Rafael Reef

Moab

Bishop

Utah

Canyonlands National Park

Sierra Mountains

Zion National Park

California

Arizona

North Atlantic Ocean

150 KM

N

years, since I bought my first old Chevy pickup truck," he says. "Once we unload the Land Cruiser we'll drive northward to Denali National Park through 1,000 miles of glaciated terrain. The drive back will simply be 3,000 more miles of beautiful scenery as we pass through the Yukon Territory, British Columbia, Alberta, Montana, Idaho, and home." ■

Scott in action: cross-country biking, Oregon, USA (right). Painted Hills, John Day Fossil Beds National Monument, Oregon, USA (opposite).

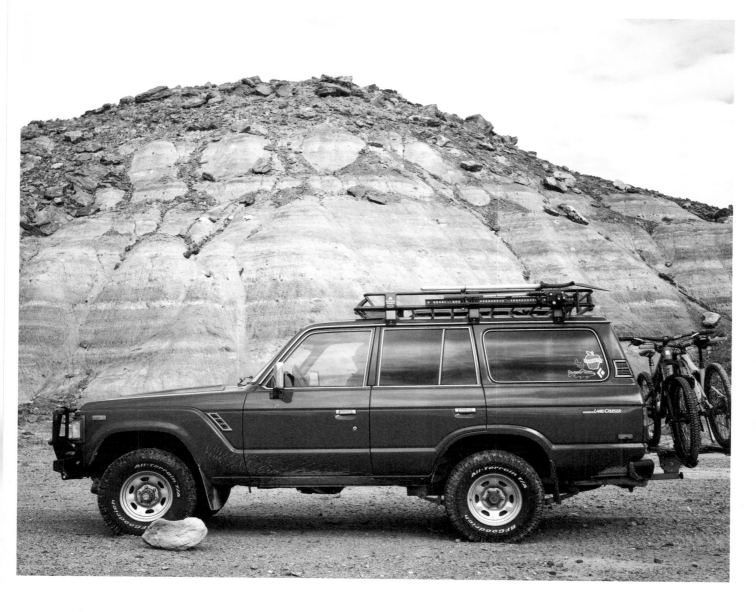

TOYOTA LAND CRUISER FJ62

Taking Scott on his trek is this royal blue 1988 Toyota Land Cruiser FJ62. Renowned for their strength and durability, the FJ was left as is in this case, with only a few modifications such as an OME three-inch lift, an ARB roof rack, and ARB front bumper. Made for ten years (1980–1990), the 1988 model was the first to offer a four-liter straight-six engine with electronic fuel injection; it was known as the 3FE. In Scott's car, this motor is paired to a four-speed automatic transmission that was new to the lineup. Foremost an off-road warrior, the FJ60 series boasted added amenities such as air conditioning, a rear heater, and interior upgrades.

MANUFACTURER: Toyota
MODEL: Land Cruiser FJ62
YEAR OF PRODUCTION: 1988
ENGINE: 4.0 L 3FE straight-six EFI, 155 hp
TRANSMISSION: Automatic

VISITED COUNTRIES:
United States
REBUILD—YEAR:
Never-ending
REBUILD—BODYWORK MODIFICATIONS:
Replaced rear quarter panel

REBUILD—CHASSIS MODIFICATIONS:
OME heavy duty 3-inch lift
REBUILD—INTERIOR MODIFICATIONS:
Original factory condition
REBUILD—OTHER MODIFICATIONS:
ARB front bumper, ARB roof rack

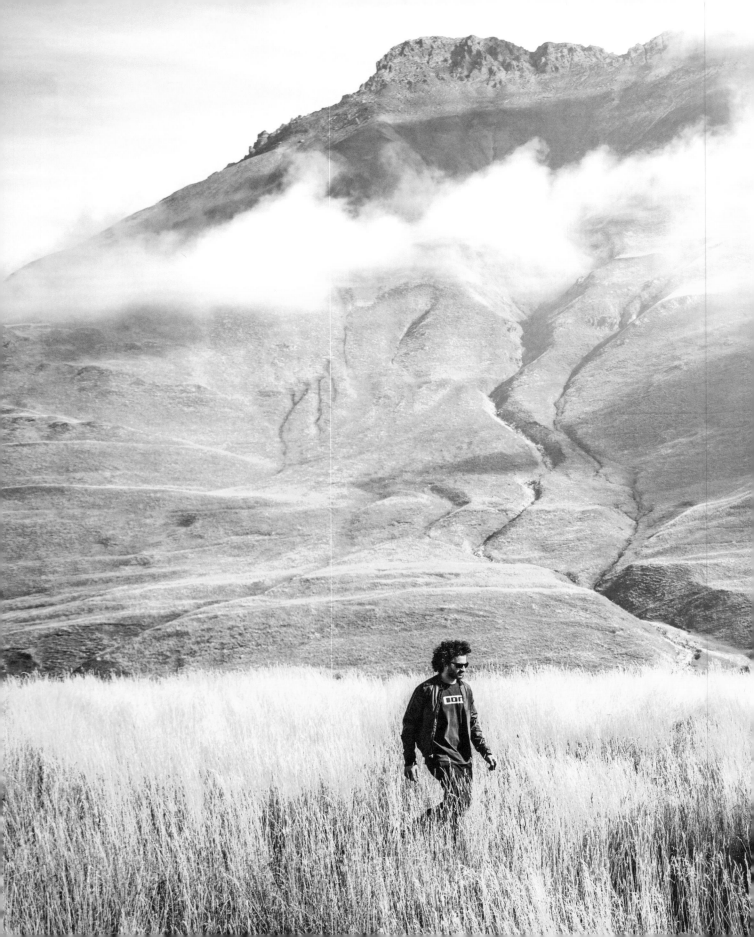

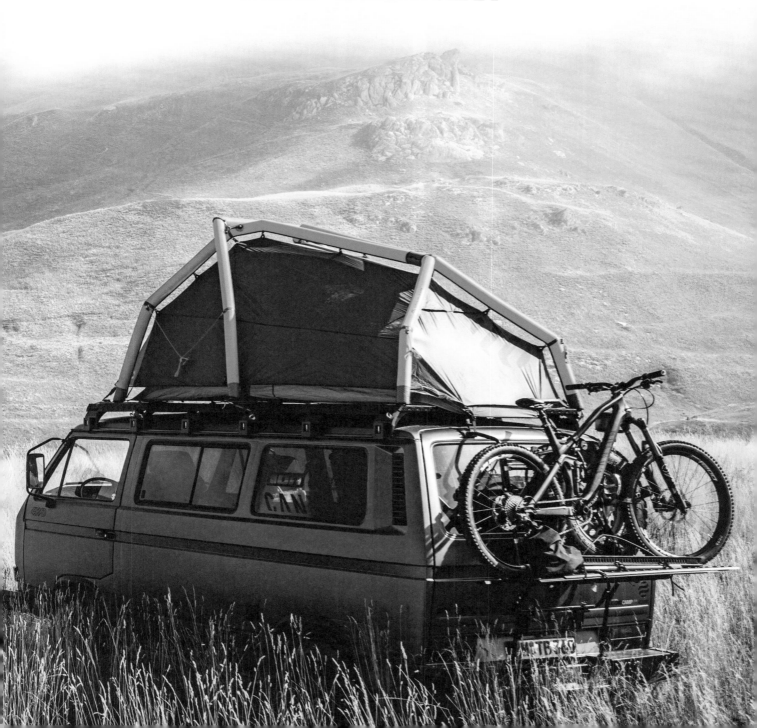

PARADISE IS JUST AROUND THE CORNER

There are a few legendary places for cyclists. Take the Maritime Alps, the grand, desolate peaks running south from Mont Blanc, separating Piedmont from Provence-Alpes-Côte d'Azur, and trickling all the way down to Nice, Monaco, and the sea. The infamous Col d'Izoard pass on the French side is a fixture in the sweaty nightmares of Tour de France riders, while the final race of the annual mountain-biking Enduro World Series is held nearby, above the crystal Italian Riviera beaches of Finale Ligure. Cyclists from across Europe and beyond make pilgrimages to this Franco-Italian border zone when it's not in heavy use by skiers. On a recent trip, Munich-based pro free-ride cyclist Rob Heran noticed something he hadn't before: dirt bikes. "They usually disappeared quickly on the rough and steep gravel roads in the mountains," he says. "I learned that in Piedmont there are some of the most beautiful off-road routes in the Alps that attract 4WD enthusiasts from all over the world. Properly planned, you could go from here to Liguria all the way down the sea." The challenge was set.

Rob had recently completed a grueling, comprehensive rebuild of his Volkswagen T3 Syncro. His relationship with the Type 2 goes back to childhood; after the early death of his mother, he was ferried around in Transporters by nuns during a stint in an orphanage. He was 20 when he eventually bought an ancient 2WD T3 for $1,000, and has been living in a van, off and on, ever since. He was finally able to afford a 1990 ex-German military T3 Syncro troop carrier in 2007 and has stuck with it through years of winter driving, but at a cost; its undercarriage was consumed by road salt, the engine and all systems eventually hanging by →

"The Alps still offer <mark>real treasures of flowing trails</mark> that no one knows."

Driving across remote hillsides, from camp to camp, searching for unmarked bike trails (*left and opposite*). Setting up camp (*above*).

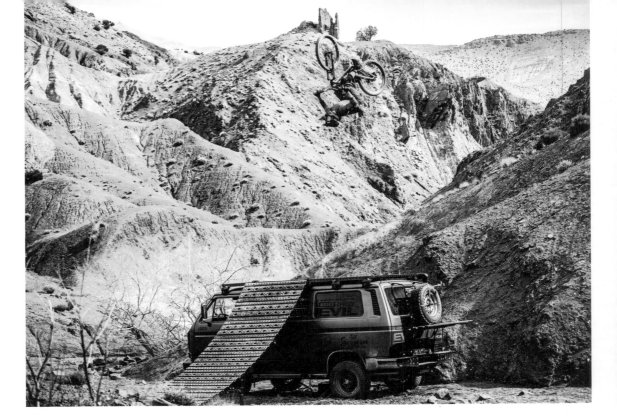

Tending to the bike racks (below). Bike flips on the custom-made ramp (right). The Ligurian Border Crest Road, Liguria, Italy (opposite).

They descended for hours at a slow walking pace, hearts in their mouths.

their bearings. Thoroughly refurbishing or replacing every component—not just for safety and comfort, but to accommodate his wife and two kids—took him two years of sweat, doubt, and the constant desire to quit before it was done. In September 2017, Rob took his friend, the photographer Sebastian Doerk, along in the Syncro over Switzerland and toward the gateway to the Alps, Italy's rolling green Piedmont; then up again to tiny, ancient Susa and through the dark, foggy chicanes of the Colle delle Finestre, an arduous Giro d'Italia stage. They took a detour in France to ride the bike parks above the lakes of Valberg-Guillaumes

and over the black volcanic sands of Digne-les-Bains, running into biking friends and troops of Vanagon drivers all whiling away the cool pre-winter months. Then it was back over the border to Limone and the main goal: the infamously narrow, terrifying old Italian military road that traces the crest of the Alps, nineteenth-century gravel goat paths twisting down to the Ligurian coast. All along are promising little branches that disappear around bends to reveal long and demanding runs, which is where they stopped to set up and spend hours riding the ridges. "The deeper we dive into the mountains and get lost on the ➔

214

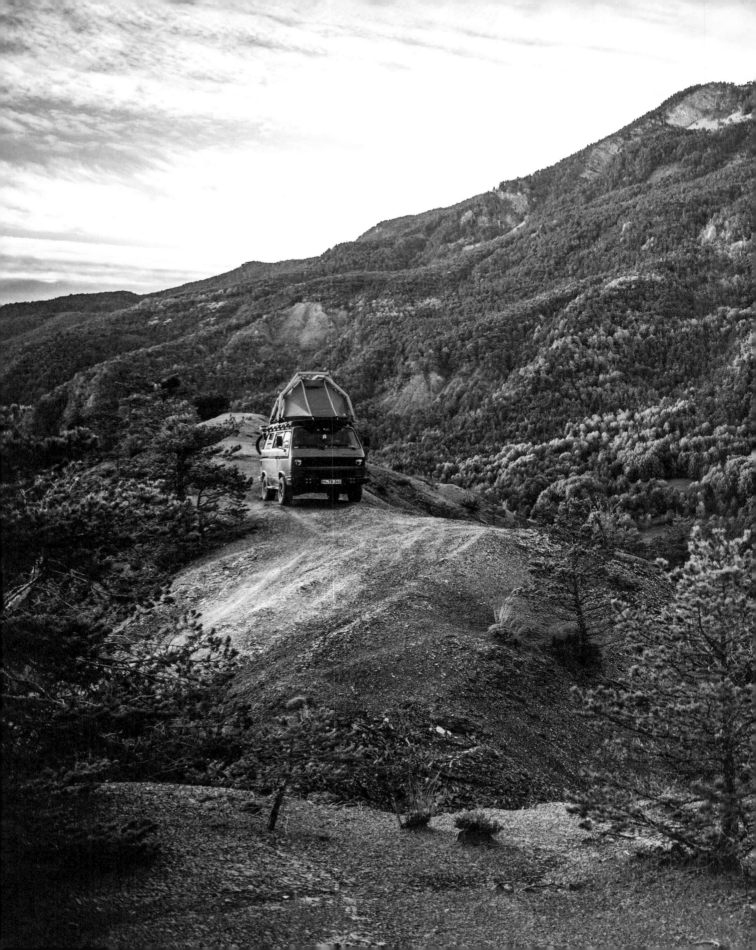

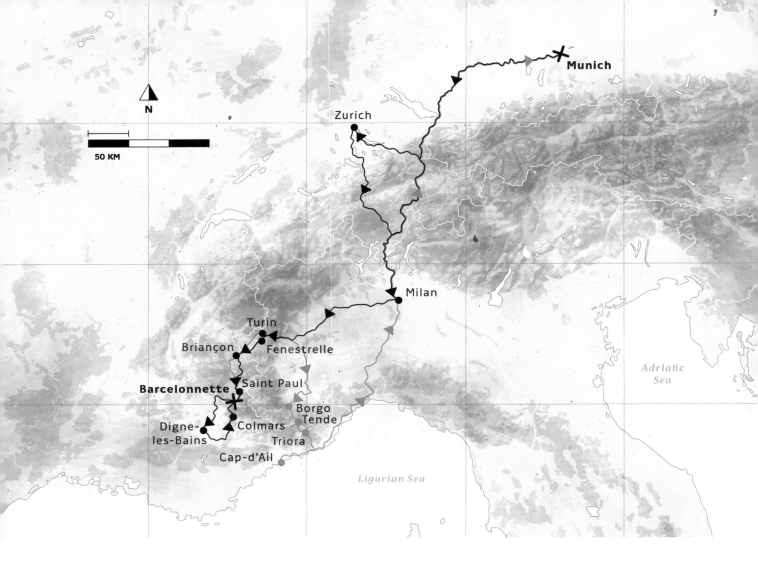

On the map: **Munich**, Zurich, Milan, Turin, Briançon, Fenestrelle, Saint Paul, **Barcelonnette**, Digne-les-Bains, Colmars, Borgo Tende, Triora, Cap-d'Ail. *Adriatic Sea*, *Ligurian Sea*. N. 50 KM.

smallest gravel roads, the more we find what we're looking for," says Rob. "A huge playground is at my feet. The Alps still offer real treasures of flowing trails that no one knows."

On the last night the pair really tested the 4WD on the crest road, lost in the dark on some very steep clifftop gravel—the path the width of the van and a wobbly-steering-wheel, tires-spinning-on-loose-and-rolling-rocks moment—with no place to turn around. They descended for hours at a slow walking pace, hearts in their mouths, and finally stopped to drink wine and sleep under a bright, full-blood moon, only to find in the morning the end of the dreaded path in plain sight.

And when they reached the sea they swam, paraded their muddy Syncro past the Lamborghinis of Monaco, and made their way to the Autostrade and the Autobahn. 10 days and 1,777 miles (2,860 km) later, they were back home in Munich, with only a few death-defying farces encountered on the dark and rainy roads. ■

218

→ The Syncronicles

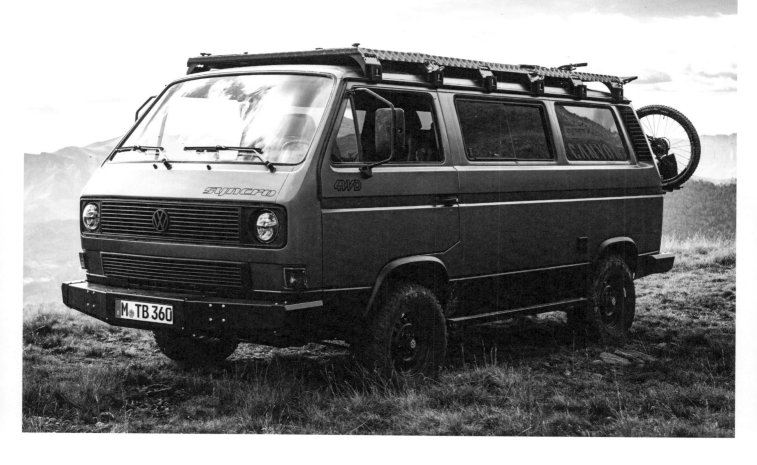

VOLKSWAGEN TYPE 2 (T3) SYNCRO

Rob started his unexpectedly long restoration on a decommissioned military Volkswagen T3 Syncro with support from Munich garage owner Marco Romaldini. They stripped the whole thing down, removed the rust, rebuilt body panels, and insulated the whole car with sound-deadening mats. Engine whiz Alexander Schank installed a modern 120-horsepower TDI with custom parts. Rob rebuilt the wiring and added Recaro seats, a new door, roof and side panels, two batteries, new chargers, and a 100-Watt solar panel. After a respray of gray paint with a matte coat on top, he also added LED headlights, 15-inch wheels, off-road tires, and a custom-made Heimplanet tent. But the jewel in this crown is the custom-built stainless steel modular system installed on the roof, which turns into a mountain bike ramp with the aluminum boards stored below the rocker panels.

MANUFACTURER: Volkswagen
MODEL: Type 2 (T3) Syncro
YEAR OF PRODUCTION: 1990
ENGINE: 1.9 L TDI AFN engine, with a larger turbo and a custom-made stainless steel air-cooling system, cyclone filter, 120 hp
TRANSMISSION: Manual
VISITED COUNTRIES: Switzerland, France, Italy, Spain, Portugal, Morocco
MILES IN TOTAL: Unknown
TRAVEL TIME: Lifelong
REBUILD—YEAR: 2009–2017

REBUILD—BODYWORK MODIFICATIONS:
Heimplanet roof tent, body insulated and sound deadened, custom metallic dark gray paint, Nolden bi-LED lights, stainless steel engine protection plates, Rocky Mountain Westy Twin Peaks bumpers
REBUILD—CHASSIS MODIFICATIONS: Stainless steel exhaust system, power steering, oil splash plates and extended 5th gear, 15-inch rims, 225/75R15 GoodYear Wrangler tires, GMB-mount Syncro (made by H&R), VW T4 disc brakes
REBUILD—INTERIOR MODIFICATIONS: Recaro

leather/alcantara seating, foldable bed and rear seating, Webasto diesel heater, alcantara-covered custom-made side panels on water-proof wood, custom-made wood-carved front storage box, rear wood storage, foldable table, walnut wood parquet flooring
REBUILD—OTHER MODIFICATIONS: GMB-mount roof rack, TK rock rails, mobile kitchen, 100W solar panel, custom Paulchen bike rack with GMB-mount off-road plates, Jackall high lift
REBUILD—SUPPORT BY: Alexander Schank, Marco Romaldini

219

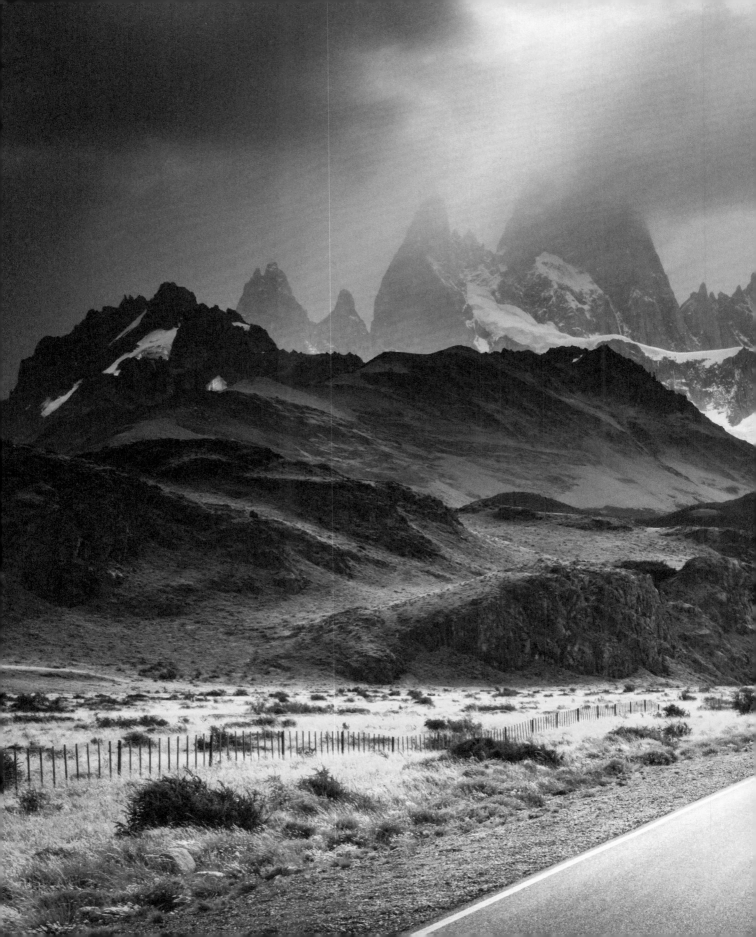

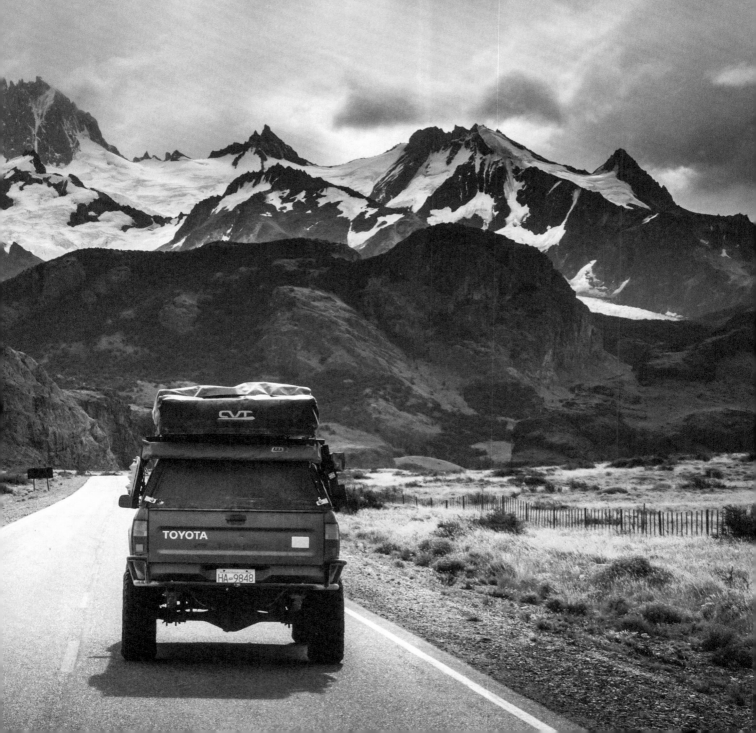

TO THE "END OF THE WORLD" AND BEYOND

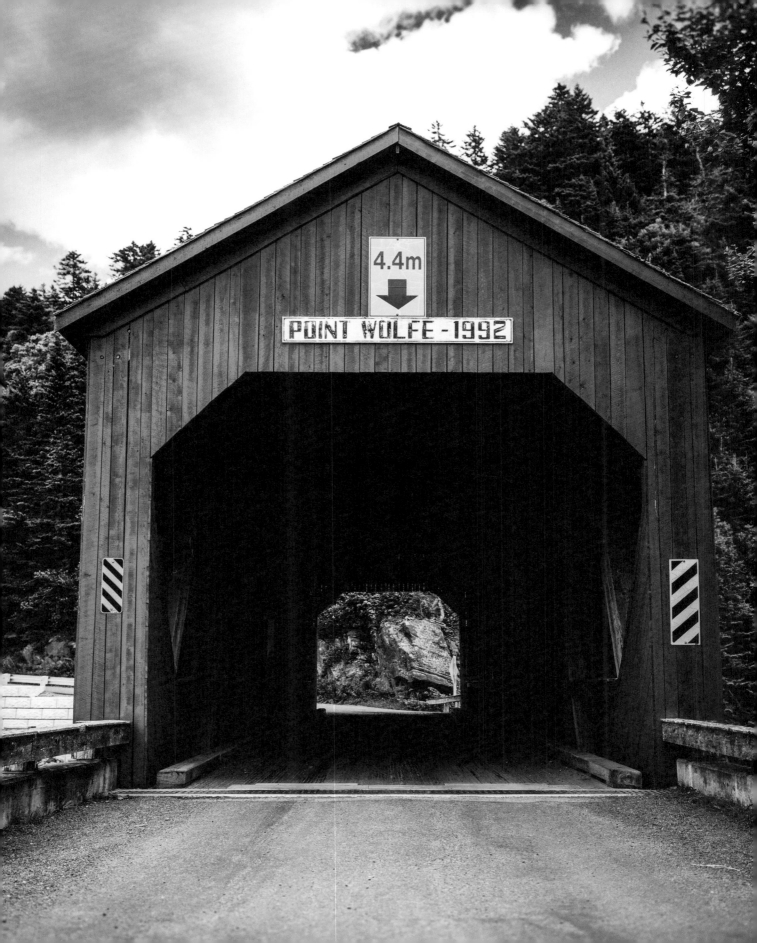

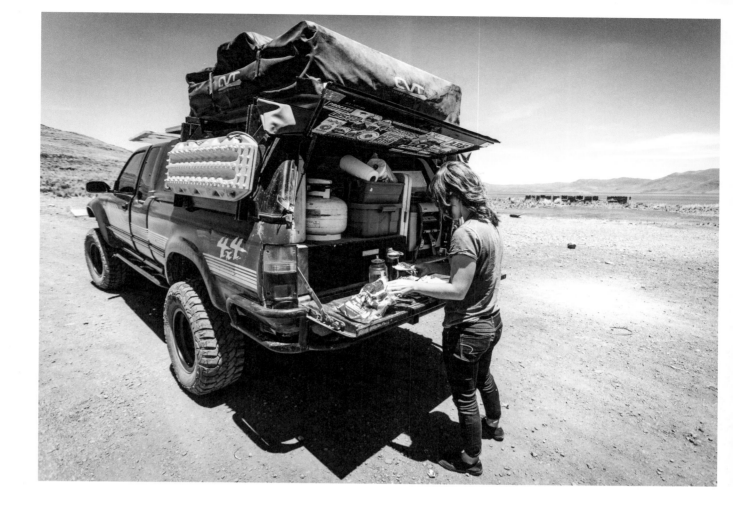

The Baja 1000 isn't the world's deadliest motor race, but it may be the craziest: a furious pack of quad bikes, dirt bikes, and raised VW Bugs speeding 1,000 miles (1,600 km) down the Baja California Peninsula across scorched, windy deserts. "It's like being in a 24-hour plane crash," says one driver interviewed in the 2005 documentary *Dust to Glory*, a testimony to the terror and joy of off-roading. Canadian photographer Richard Giordano has watched that documentary over and over again. So when he and his wife, paralegal/nutritionist Ashley, quit their Vancouver office jobs in 2013 and headed south, they had both an initial destination and a blog name ready to go: Desk to Glory.

After a burned-out Ashley announced the need to have a "life chat," the couple began to form a plan around a maroon 1990 Toyota 4WD pickup decomposing in Richard's dad's backyard. Taking inspiration from a few blogging overlanders adventuring in similarly inauspicious Toyotas, they rejuvenated the lonely pickup. They replaced a lot on the solid, boxy rig covered in period die-cut decals: suspension, mechanics, wheels, tires, bumpers, fenders, and interior. "It was →

Taking stock, Peru (top). Happy Ashley and Richard (above). Fundy National Park, New Brunswick, Canada (opposite).

223

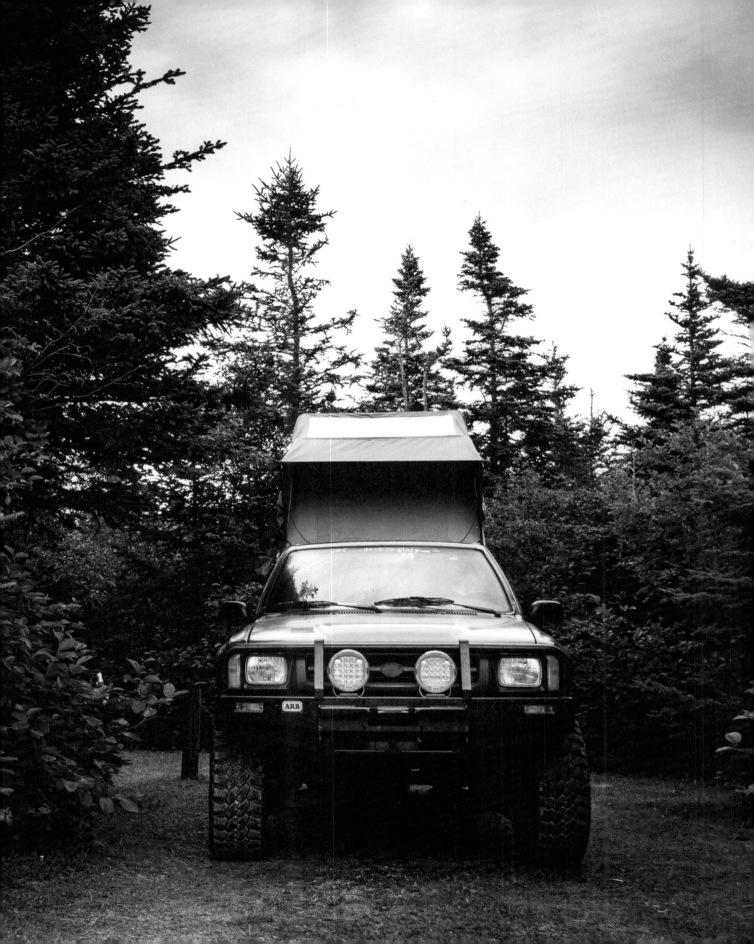

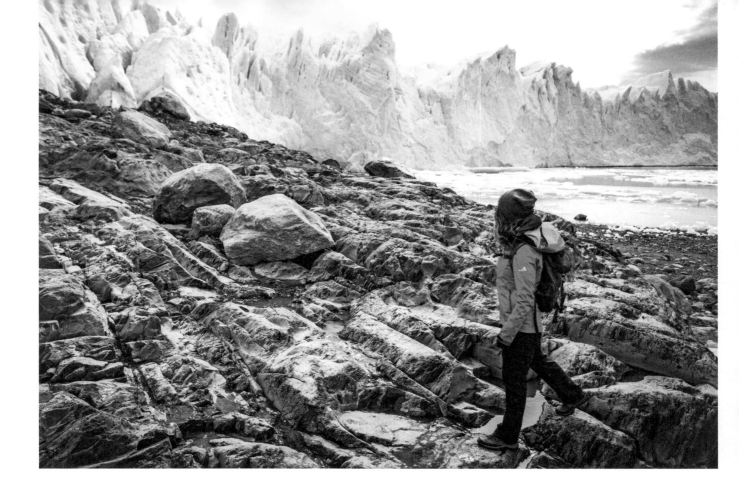

"Even now,
we look at each other
and say,
'This is crazy!'"

a function-over-form build," says Richard. "Everything on the truck was done for a purpose, to get us as far away from home as possible with as much comfort as necessary." They fastidiously rebuilt the reliable 22RE engine and installed a solar kit, 12-volt fridge/freezer, an awning, and a CVT rooftop tent. Taking a relatively late-model, mass-produced Japanese truck and keeping all possible onboard equipment as standard, they allayed family and friends' concerns and ensured minimal breakdowns and easily replaceable parts wherever they might be.

Richard and Ashley were once pretty typical of their generation. "We did what you're supposed to do." But with college degrees, jobs, marriage, and a condo under their belt, they found themselves wondering, "What were we supposed to do next? Why did we feel unhappy and trapped in our seemingly successful lives?" Identifying that it was a sense of freedom they were missing, they set a loose plan in motion: five more months at their jobs to squirrel away cash while fitting out the pickup, then hit the road. They started out south, from Vancouver through the cool, wet forests of the Pacific Northwest to Yosemite, then ambled the length of California before hitting the →

beaches of Baja to watch the spectacle of the 1000. After Ashley and Richard made this plan a reality, they continued into Mexico and joined the great north-south Pan-American Highway through Central America, getting as far as humid, rainy Panama. In fact, you can go no further. This impressive 30,000-mile (48,000 km) road system extends from Arctic Alaska almost to Antarctica, but is divided midway by a 37-mile (60 km) roadless gash of impenetrable forest in eastern Panama's ancient, untouched Darién Province.

At that juncture, they warehoused the truck in Costa Rica and flew home to regroup. Returning months later, they got back on the road where they remain today, having traveled across Colombia, Ecuador, Peru, Bolivia, Chile, Argentina, and all the way to Tierra del Fuego and Ushuaia—the "End of the World." They linger the longest when in the mountains, and are particularly in awe of the Cordillera Blanca in the Andes, the snow-capped giants shielding the Amazon from the Pacific Ocean just 62 miles (100 km) away.

After two years on the road, a sort of mini motto has arisen when thinking about the future: "Leap, and a net will appear." Like a lot of overlanders, they've now amassed enough remote work to imagine traveling full-time; but looking back on their impulsive departure, the surreality and blasphemy of what they've done so far is ever-present. "We honestly didn't think too much about the trip we were about to set off on," they explain. "Even now as we're driving, we look at each other and say, 'This is crazy! I can't believe we drove here.'" ■

Hammocking in the green wild, New Brunswick, Canada (*above*). Parked up, Nova Scotia, Canada (*opposite*). It's bacon o' clock (*right*).

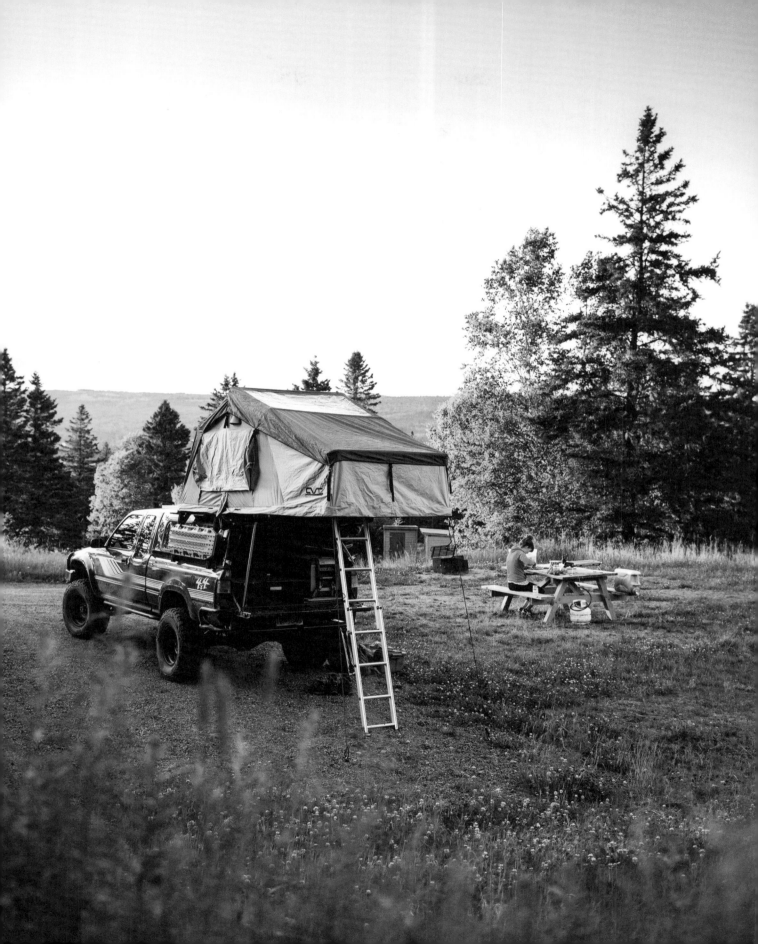

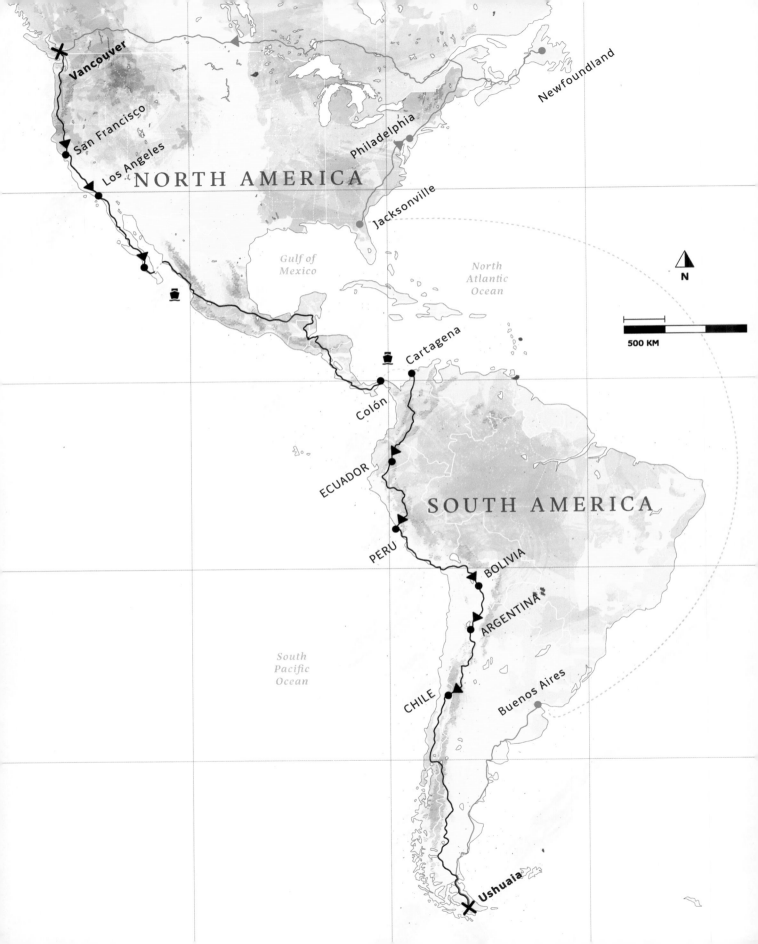

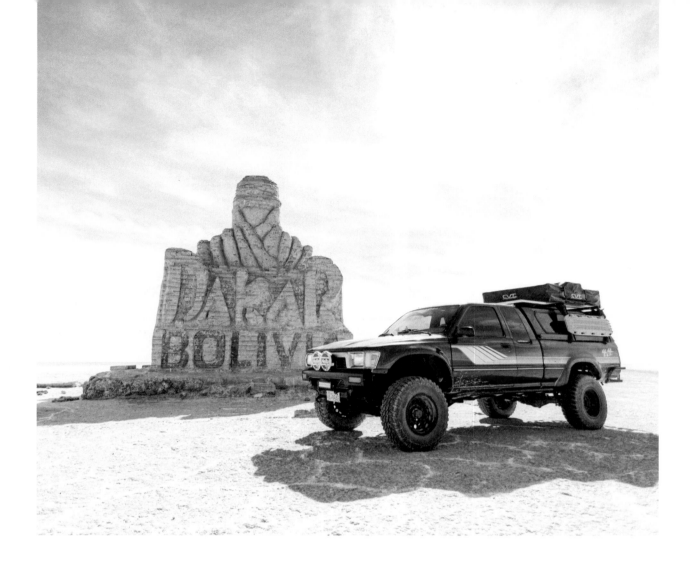

TOYOTA HILUX

Continuing their successful truck line, Toyota's fifth-generation Hilux was redesigned in 1988 with a longer wheelbase and a different cargo box. These changes eliminated rust issues while providing more space. Giving up a life of monthly bills, Richard and Ashley purchased a 1990 Toyota Hilux from Richard's father and built it out to hit the road. Some 48,500 miles (62,000 km) later, the Old Man Emu heavy duty suspension has proven a wise pairing to the pronounced durability of the 113-horsepower 22RE motor. ARB front bumper, Trail Gear rear bumper, and Toyota's lightweight fiberglass fenders help supplant the weight increase that the CVT roof tent, Samlex solar panels, dual Optima batteries, ARB fridge, and other gear add.

MANUFACTURER: Toyota
MODEL: Hilux Xtra Cab
YEAR OF PRODUCTION: 1990
ENGINE: 2.4 L 22RE, 113 hp
TRANSMISSION: Manual
VISITED COUNTRIES:
Canada, United States, Mexico, Central America, Colombia, Ecuador, Peru, Bolivia, Chile, Argentina

MILES IN TOTAL:
48,500 miles
TRAVEL TIME: 2 years
REBUILD—YEAR: 2013
REBUILD—BODYWORK MODIFICATIONS:
ARB bumper, Toyota fiberglass front fenders, Trail Gear rear bumper
REBUILD—CHASSIS MODIFICATIONS:

ARB Old Man Emu heavy duty suspension
REBUILD—INTERIOR MODIFICATIONS:
Original factory condition
REBUILD—OTHER MODIFICATIONS:
CVT rooftop tent, Samlex 85W solar kit, Optima Yellowtop dual batteries, ARB 12v fridge/freezer

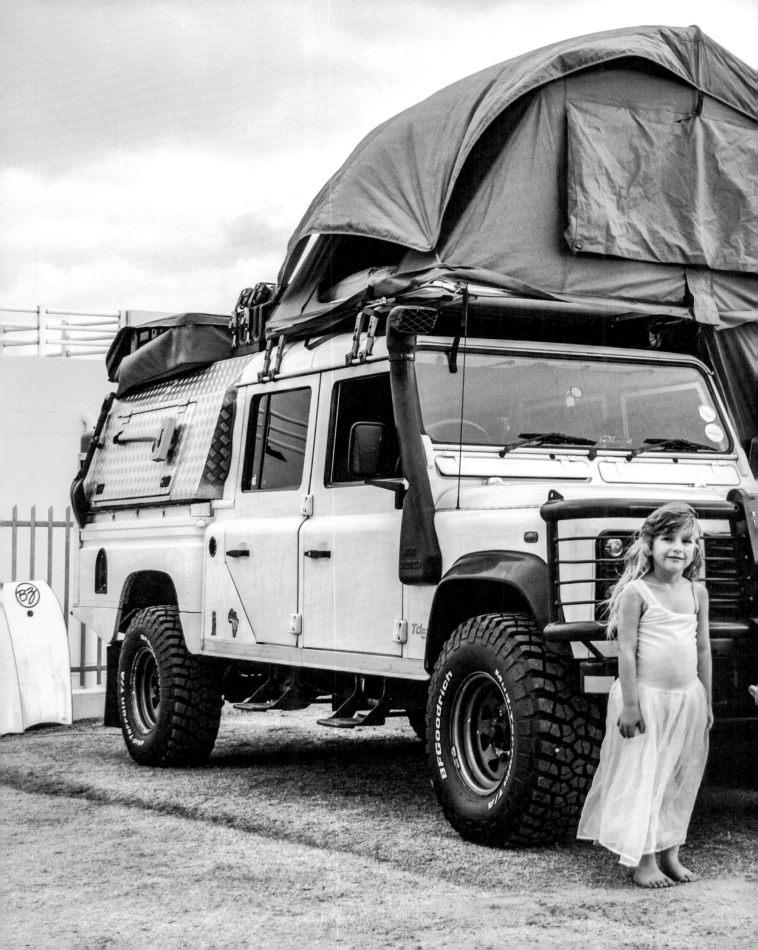

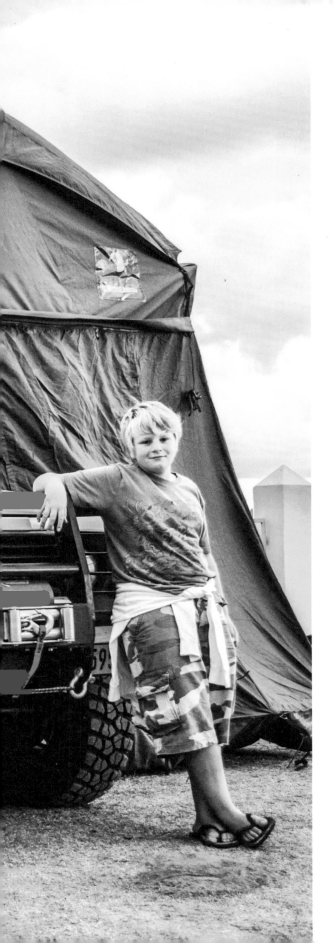

FAMILIES THAT STRAY TOGETHER STAY TOGETHER

T he last thing on most parents' minds is leaving civilization to roam the deserts and forests in a vehicle with two young children—to live nomadically, never to return home. But Graeme and Luisa Bell are not typical parents. "Once you have made the decision to hit the road and live that romantic traveler's lifestyle, you have to divorce yourself from the nest builder you are supposed to be," writes the 40-something dad in his first of →

231

A2A Expedition ←

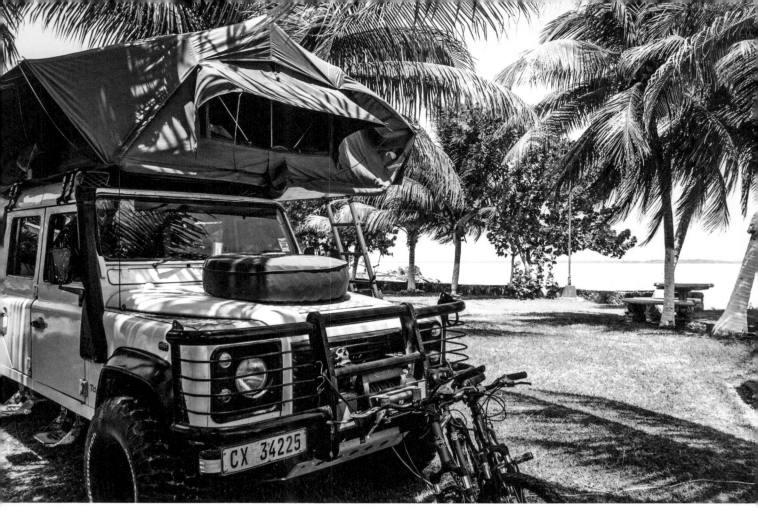

Graeme keeping up
with remote life
management *(right)*.
Respite by the
African seaside *(above)*.
Observing fishermen,
Mozambique *(opposite)*.

→ A2A Expedition

many off-roading books since departing Cape Town in 2012. Their teenage children Keenan and Jessica were infants when they first headed north from South Africa. They've not attended a regular school since, something Graeme is especially proud of. "We used to be ordinary people," he says. "We still are. Back in the pre-overlanding, suburban-bliss life we loathed but worked so hard to achieve, we went through the daily cycles spun by the vast majority of the world's people."

"We woke up reluctantly," he continues, "forced the children to wake, and fought to dress them in the colors of their school, pouring cereal down their throats and dropping them off at the gates of an institution where people indoctrinated in the philosophy of the collective waited impatiently to squeeze every last drop of the individual out of those sweet, innocent souls." The kids are schooled en route using a combination of approved national syllabi and the online Khan Academy, with the promise to Keenan that the family might stop driving soon so that he can go to university if he wishes.

Growing up in apartheid South Africa, the Bells were free spirits who met and had kids young. But as adulthood ground on and they meticulously clawed their way into the middle class, they realized that they were living just to work. "Every night I would lie in bed and dream of some form of escape, a way to leave this life of schedules, habit, routine, and chronic boredom behind," admits Graeme. "We dreamt of a life of adventure and danger, a purpose that wakes you up in the morning." They fantasized about an eight-month trip overland to Kenya to let off some steam, but it was the sudden death of Luisa's father, who would've come along, that created the impetus to move, and more ambitiously. "We decided that we must travel," says Graeme, "that life is too short to live just for money, that we did not want to live this life with regrets."

In the regional capital Bloemfontein, 500 miles (800 km) away, they found a 2003 Land Rover Defender 130 TD5, a dependable heavy-duty unit, which they stripped down to the rear chassis and progressively →

233

overhauled. Eventually, they moved from a jumbo family tent on top to a bespoke pop-top camper pod with timber floors, beds for four, kitchen and refrigeration, water tanks, converted solar power, and homespun LED lighting. The Bells spent the first year touring every stable country they could in Southern and Eastern Africa—Mozambique, Zambia, Namibia—before shipping the truck and ticking every Central and South American country off the list, and making the long journey from the Southern Ocean to the Arctic Ocean. After a southeast journey across Canada and the United States, they boarded another ship from Florida to Europe, where they now plan to base themselves while exploring the rest of the world. It has been a colossal journey, 125,000 miles (200,000 km) and counting. "We are a world away from the people we were," says Graeme, "but we are still African. We long for her nature, her wilderness, her people, her calm, and her chaos." ∎

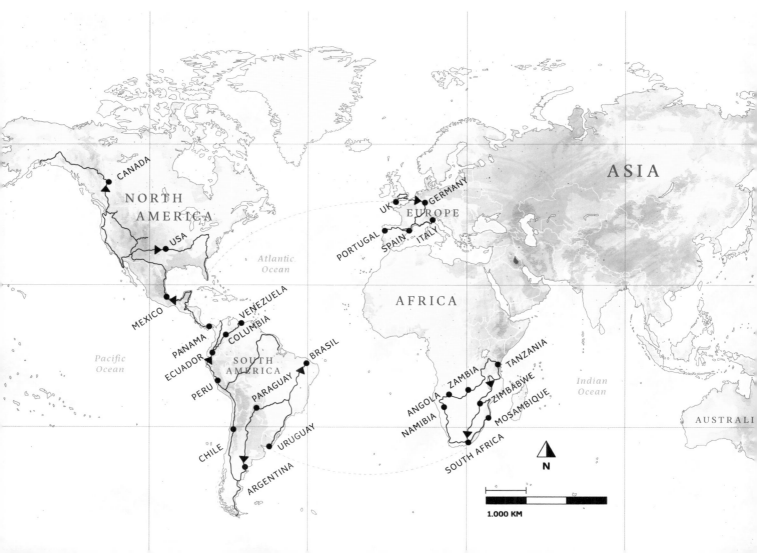

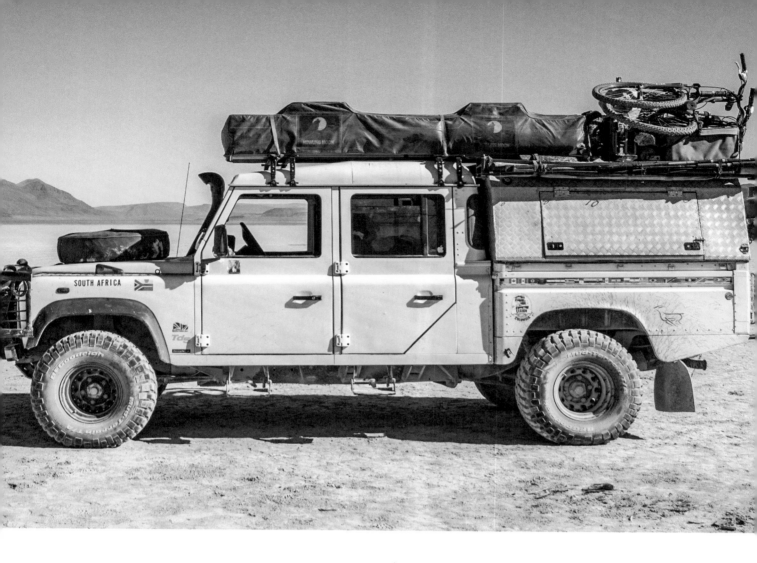

LAND ROVER DEFENDER 130

A progeny of the Land Rover Series III, the Defender, as it came to be known, was a worthy successor with the introduction of permanent four-wheel drive. Its off-road performance also benefitted greatly from a new coil spring arrangement. This made it an excellent choice for the Bell's journey, one that has seen over 124,000 miles (200,000 km) since their Defender's rebuild. Even after adding a pop-top tent that comfortably fits four adults, water tanks, LED lighting, solar panels, and a fridge, its off-road capabilities remain intact thanks to a modified steel subframe.

MANUFACTURER: Land Rover
MODEL: Defender 130
YEAR OF PRODUCTION: 2003
ENGINE: 2.5 L five-cylinder TDI (TD5), 122 hp
TRANSMISSION: Manual
VISITED COUNTRIES:
South Africa, Mozambique, Malawi, Tanzania, Swaziland, Zambia, Botswana, Namibia, Argentina, Brazil, Uruguay, Paraguay, Chile, Bolivia, Peru, Ecuador, Colombia, Venezuela, Guyana, Suriname, French Guyana, Panama,

Costa Rica, Nicaragua, Honduras, Guatemala
MILES IN TOTAL: 124,000 miles
TRAVEL TIME:
6 years
REBUILD—YEAR: 2016
REBUILD—BODYWORK MODIFICATIONS:
Pop-top camper pod (room for four adults)
REBUILD—CHASSIS MODIFICATIONS:
Steel subframe mounted in four positions
REBUILD—INTERIOR MODIFICATIONS:
Wooden floor, beds for four adults, kitchen,

load areas, water tanks, LED lighting, charging ports, solar panels, large fridge
REBUILD—OTHER MODIFICATIONS:
Roof rack with jerry cans, spare box and BBQ, LED driving lights, underbody protection, bull bar, winch
REBUILD—SUPPORT BY:
Friends and material support by Falken Tires USA, Bearmach, Total Composites, Melvill and Moon, Snomaster USA, Flexopower USA, Cibex Spain

235

AN IMPROBABLE HOME IN A WORLD WORTH LIVING IN

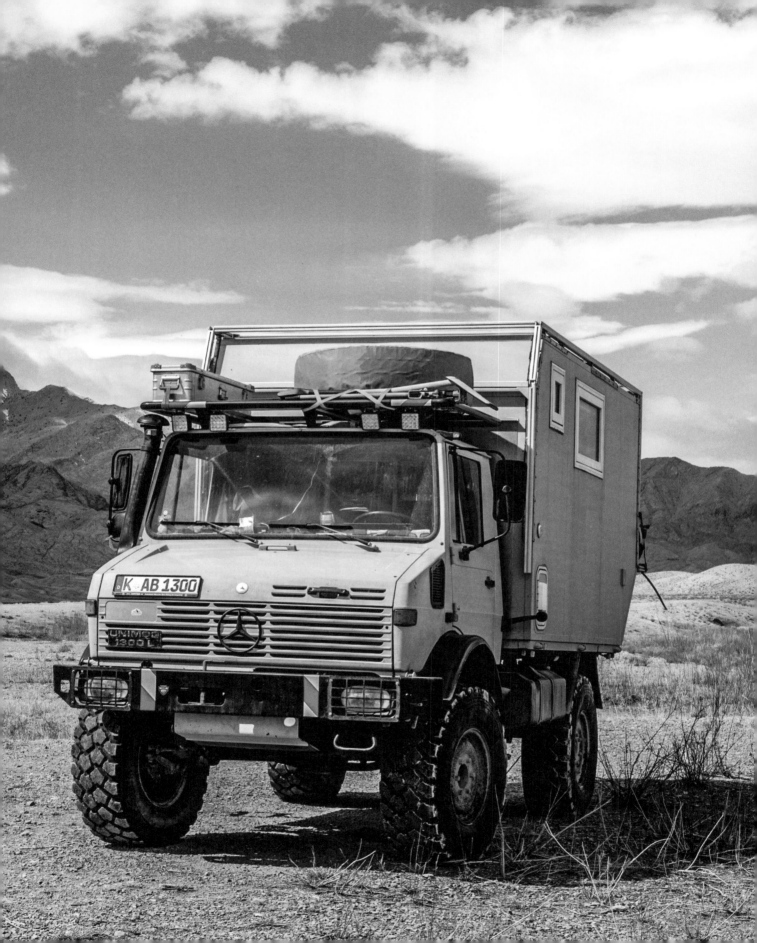

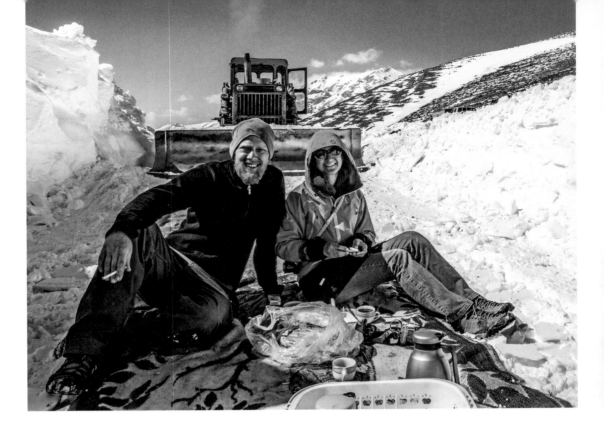

Ananda and Marco having a picnic in the snowy mountains of Iran *(right)*. Just a drive in the park for the Mog *(opposite)*.

Their mission was <mark>to take the giant Mog</mark> all the way to India.

For German video journalist Ananda Rani Bräunig and photographer Marco Lars Bräunig, home was never just one place. Marco's German mother was born and raised in Chile before eventually returning, and Rani's family, who emigrated from India, have relatives scattered across their vast ancestral home. So when the couple eventually left Cologne with an idea of homecoming in their minds, they already had their compass.

They travel with a postcard on the dash of Lakshmi, the Hindu and Buddhist goddess of power, beauty, and wealth. Lakshmi is a restless and generous goddess; the lesson Indian parents teach their children about her is that good fortune comes to those who live for each other sincerely, not just for themselves. Marco and Ananda's larger goal in documenting their travels isn't to drive people online to despair with FOMO—fear of missing out—but to "show a world that's unpredictable, breathtaking, and, overall, worth living in." The life they create on their way is equal in all these respects.

It all began with the truck. In search of either a standard or custom motorhome that would give them both vertical and horizontal space, they found an ex-military Mercedes-Benz Unimog 1300L to make their own. The 1300L was a beastly 1987 special edition built for two clients: the Bundeswehr and Feuerwehr →

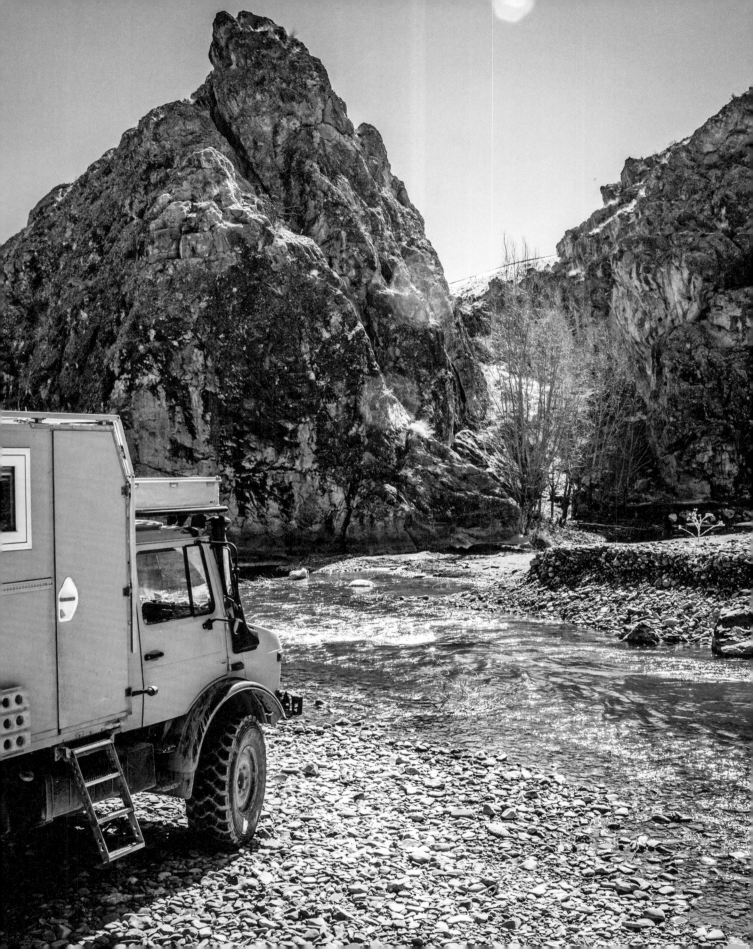

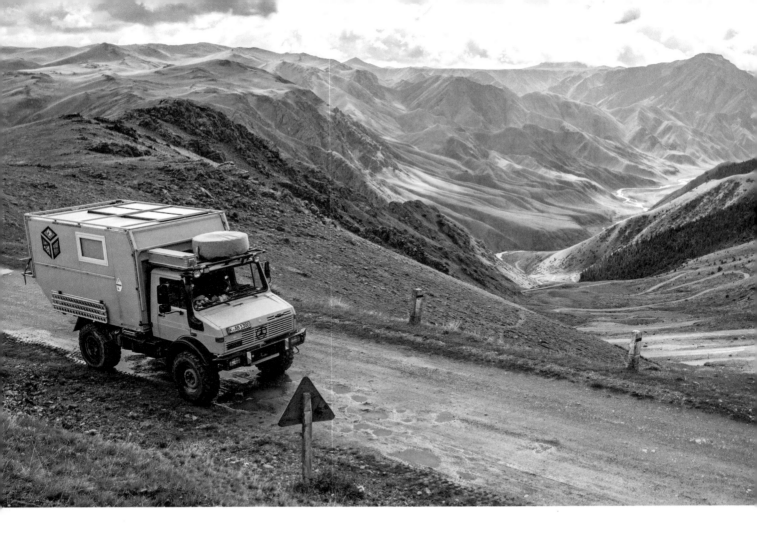

Driving to the Song Köl Lake vehicle ferry, Kyrgyzstan (*this page*). A Mog on the Beach (*opposite top*). The evaporated Aral Sea, Kazakhstan (*opposite bottom*).

→ Follow the White Mog

(the West German army and fire departments). A 5-ton 5.9-liter all-terrain colossus, it had only covered 48,500 miles (78,000 km) when they bought it, and it fit their needs as an indefatigable monster that could ford rivers, climb mountains, and cross deserts, getting them out of Europe and across the Middle East to mountainous, undeveloped North Asia. Importantly, it was also a blank canvas on which they could build a true home from the wheels up.

Overhauling a troop vehicle that first reported for duty during the late stages of the Cold War turned out to be an immense two-year job. A designed and welded aluminum frame was fitted with walls, windows, insulation, plumbing, heating and solar electrics, a full-height shower and toilet, radiators, a king-size bed, and kitchenette. The equipment needed to be supersized: bigger springs, shocks and tires, fuel and water tanks, a new exhaust, stabilizer and spares, a new fuel-injection pump, and a split 16-gear transmission for the hard terrain ahead. They packed an immense inventory of supplies for every possible eventuality, gave the Unimog a coat of white paint →

A jolly, ==ungainly presence on the road==, the Unimog looks taller than it is long.

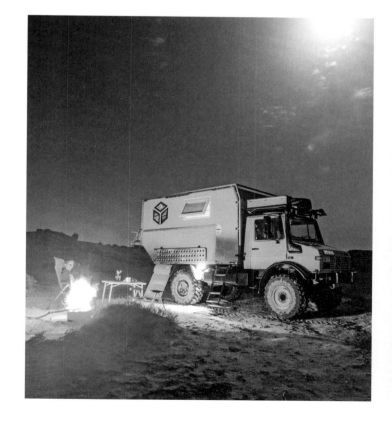

over the khaki, and a motorhome was born. It weighed an astronomical sum, but there were no compromises. Their mission was to take the giant Mog from its native Europe all the way to India.

Marco and Ananda left Cologne in early fall 2016 and headed southeast, skirting the lower Austrian Alps, winding along the Adriatic coastal highways of Croatia, Montenegro, and Albania, taking it easy along beach-filled stretches, and resting in Greece before crossing the Bosphorus to Turkey and Azerbaijan. They surveyed temples, mountains, and the Persian Gulf in newly re-opened Iran, and said goodbye to the warm sun before taking the northeastern fork toward India, crossing Armenia into the open skies and deep winter snows →

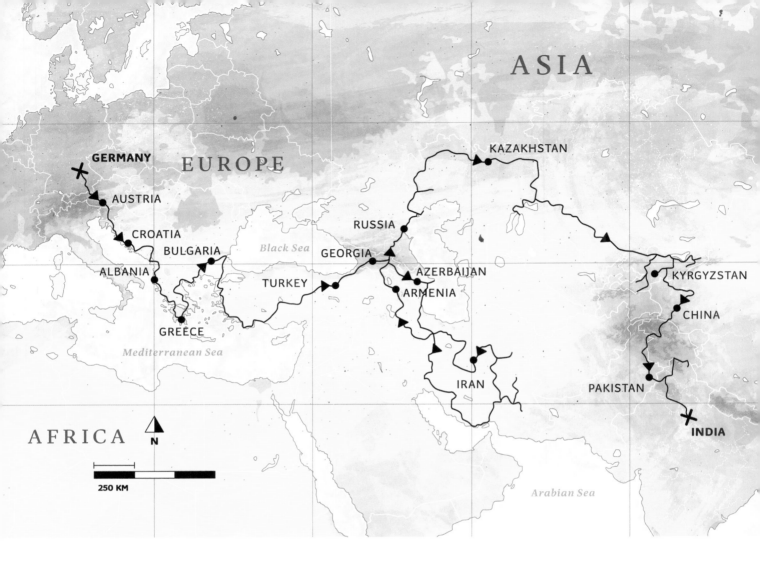

of the Georgian Caucasus. A jolly, ungainly presence on the road, the Unimog looks taller than it is long; it has so much lateral bounce on uneven roads that it's often sheer weight that keeps it upright. It turns heads everywhere, and has faithfully allowed the couple to tow stranded fellow travelers out of bogs and ditches. In Tbilisi, a repairman changed their oil with the wrong grade, and several weeks and 3,100 miles (5,000 km) later, seized pistons indicated they'd have to refurbish the engine and see a lot more of Kazakhstan than they'd planned on. But the setbacks opened up new worlds worth living in; they fell in love with the yurt-living people on horseback on the steppes of Kyrgyzstan and ended up staying through summer 2017. One day, they will reach India. ∎

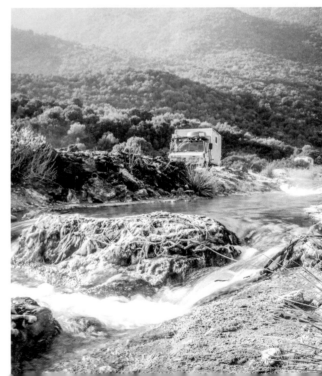

→ Follow the White Mog

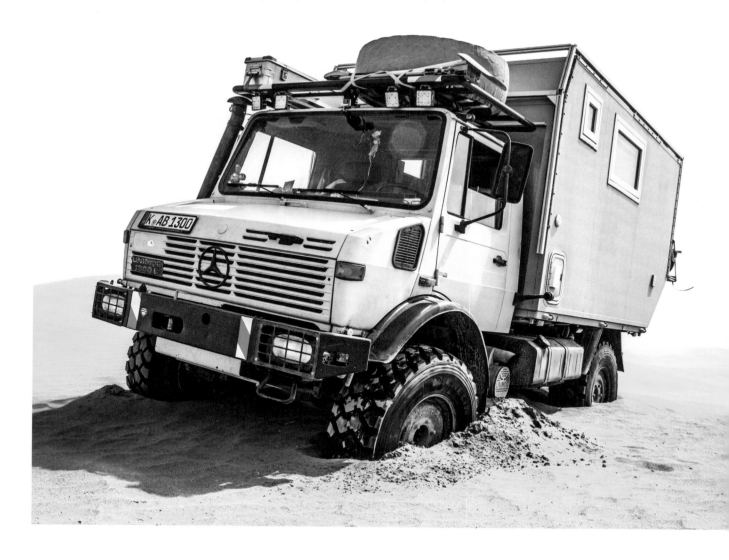

MERCEDES-BENZ UNIMOG 1300L

When production of the Unimog 404S ended in 1975, Mercedes designed its successor, the 1300L, as a 7.5-ton truck for military and fire departments. Marco and Ananda picked up this second-hand ex-military 1987 Unimog in 2014. Marco hand-built its insulated cabin with a friend in two years, installing heating, a water system, and furniture. He also added a new exhaust system, a split transmission (16 gears), and upgraded most of the suspension components. The improved gearing and and a standard 128-horsepower 5.9-liter diesel straight six puts out 268 lb-ft of torque, which helps when overtaking slower traffic. With over 26,000 miles (42,000 km) since the rebuild, they have their eyes set next on Marco's homeland, Chile.

MANUFACTURER: Mercedes-Benz
MODEL: Unimog 1300L
YEAR OF PRODUCTION: 1987
ENGINE: 5.6 L six cylinder, 131 hp
TRANSMISSION: Manual
VISITED COUNTRIES: Germany, Austria, Slovenia, Croatia, Montenegro, Albania, Greece, Bulgaria, Turkey, Georgia, Azerbaijan, Iran, Armenia, Georgia, Russia, Kazakhstan, Kyrgyzstan
MILES IN TOTAL: 26,000 miles

TRAVEL TIME: Fall 2016–ongoing
REBUILD—YEAR: 2014–16
REBUILD—BODYWORK MODIFICATIONS:
Insulated aluminum cabin, four windows, water heating system, radiators, solar panels
REBUILD—CHASSIS MODIFICATIONS: New shock absorbers, bigger springs, bigger tanks (2×230 liter), new stainless steel exhaust, stabilizer in the back, bigger tires (Michelin XZL), split transmission (16 gears instead of 8), Webasto

heating system for car and cabin
REBUILD—INTERIOR MODIFICATIONS:
Wooden floor, beds for four adults, kitchen, bathroom, load areas, water tanks, LED lighting, charging ports, solar panels, large fridge
REBUILD—OTHER MODIFICATIONS:
Roof rack and carrier in the back, upgraded fuel injection pump
REBUILD—SUPPORT BY: Friends and family, Hellgeth Engineering

245

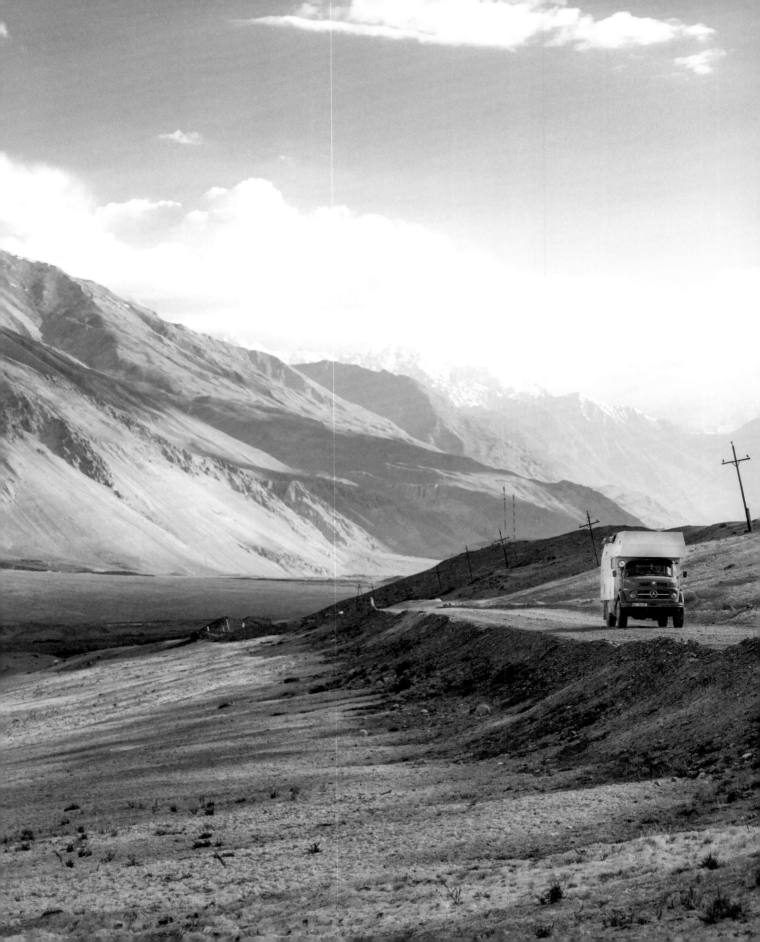

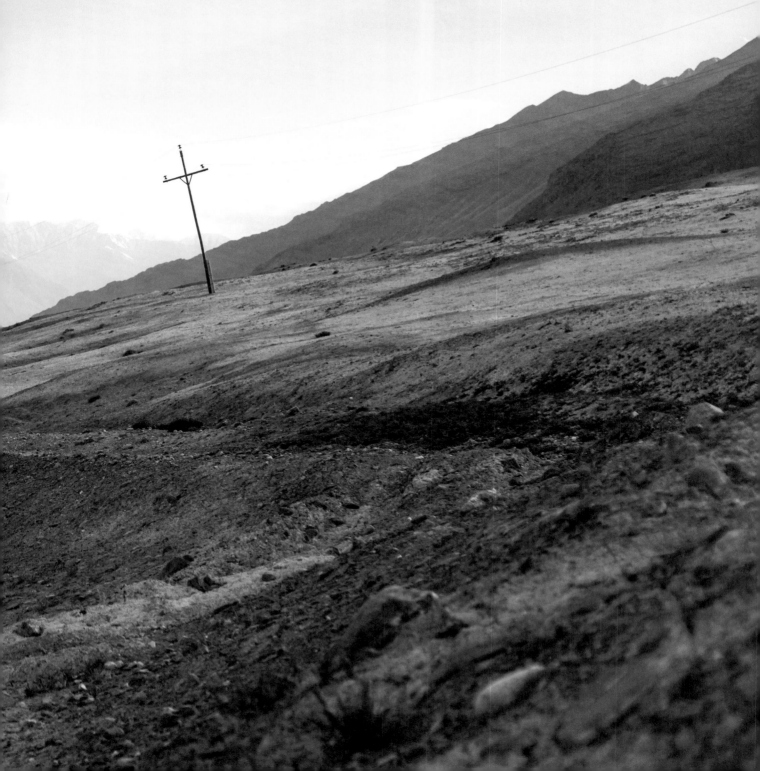

THE SCHOOL
OF LIFE

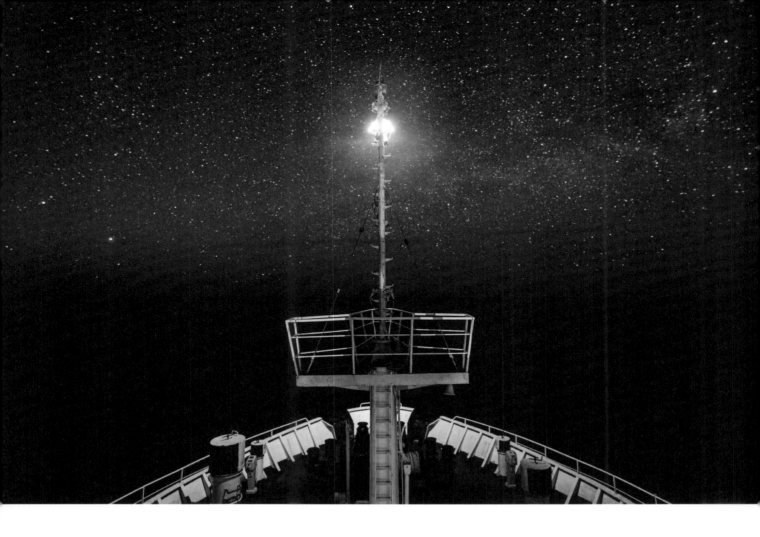

Mechanical work, Kerman Province, Iran *(right)*. Ferry in Kazakhstan *(above)*. Family and friends' portraits, Tajikistan *(opposite)*.

→ Akela

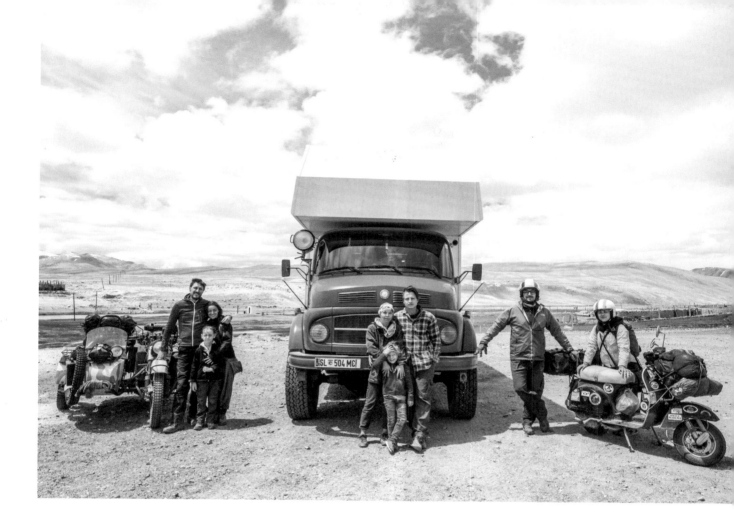

When Leander Nardin and Maria Zehentner's son, Lennox, turned three, they could finally acknowledge it was time for their shared dream to become a reality—to travel again, this time as a family, and to reach New Zealand by car, from the Austrian Alps to the Southern Alps. "For us, this trip is not just a journey," they say. "It's a way of life."

"When Lennox was born—somehow everything began with him—our priorities shifted," they explain. "We wanted to spend as much time with him as possible, bring him closer to the world. But time is a precious and rare commodity that we all waste too carelessly. It was time to focus on the essentials; time for us, time for our son, time together to discover the beauty of this planet—time to live, really!"

When Lennox was one, they took him adventuring around Thailand for a month but were exhausted by the work and the extra load. "Traveling constantly with a child, a backpack, photo equipment—it was just too cumbersome and overpriced. So we decided to buy an old truck, and prepared him for an indefinite journey." →

Rural life, Tajikistan (*this page*). Leander and Maria contemplating the day's adventures surrounded by stunning scenery (*opposite*).

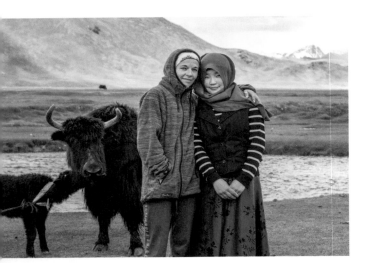

"It is a feeling as **if time would stand still**—absolute freedom."

They looked around for a suitable family transporter and settled on a rusted-out 1977 Mercedes-Benz LA 911 B. The so-called "Kurzhauber" (short-bonnet) has a 5.6-liter straight-six diesel that had been long out of service with the Austrian border patrol. The plan was to drive it clear across Eurasia and Oceania, east and then south, until they reached the remote string of New Zealand islands. The total distance as the eagle flies is approximately 11,000 miles (18,000 km).

But first they had to fix the crippled truck that would rise as "Akela," named after the caring wolf in Rudyard Kipling's *The Jungle Book*. For more than two years they labored painstakingly to create an overland house, a customized 130-square-foot (12 sq m) four-room aluminum apartment with timber flooring, a kitchen and bathroom, woodstove, and parents' and kids' areas. "It was a ridiculous amount of hard work, and we put more time and effort into the preparations than we could have ever imagined," say the couple. "It was an exhausting time. And we spent a lot more money than we expected."

It was just days before Christmas 2016 when they finally bid farewell to family, left Austria, and ambled along the Adriatic coastline, through the Croatian archipelago, and into Montenegro and Macedonia. The cool December days were a contrast to the summer months, when the coastlines are crowded with campervans and motorhomes full of other holidaying families from the northern countries. →

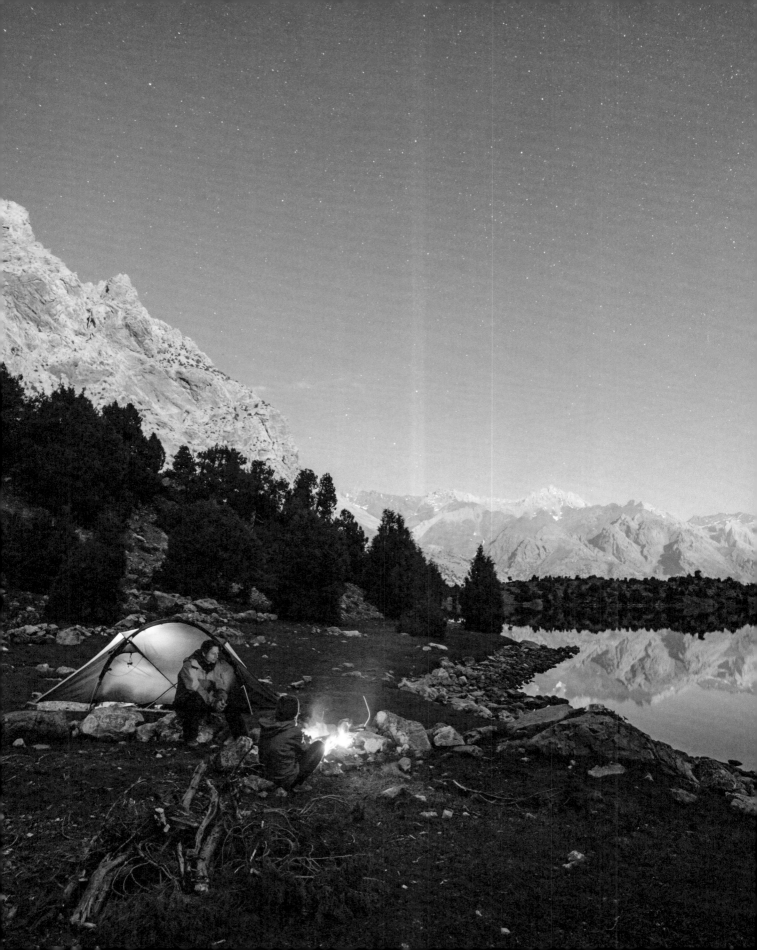

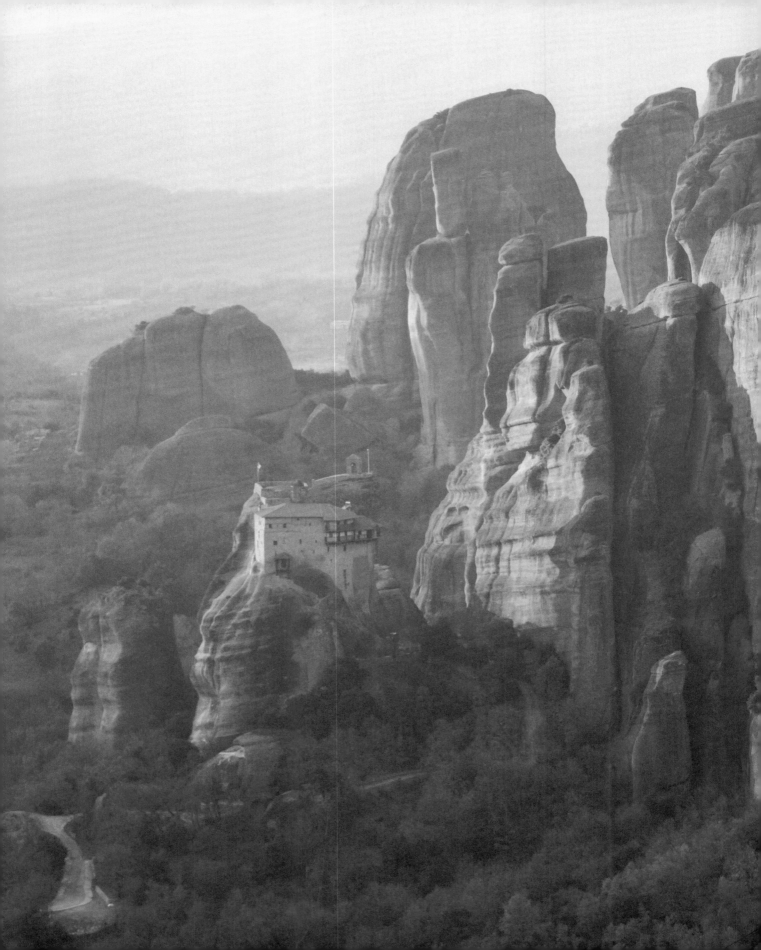

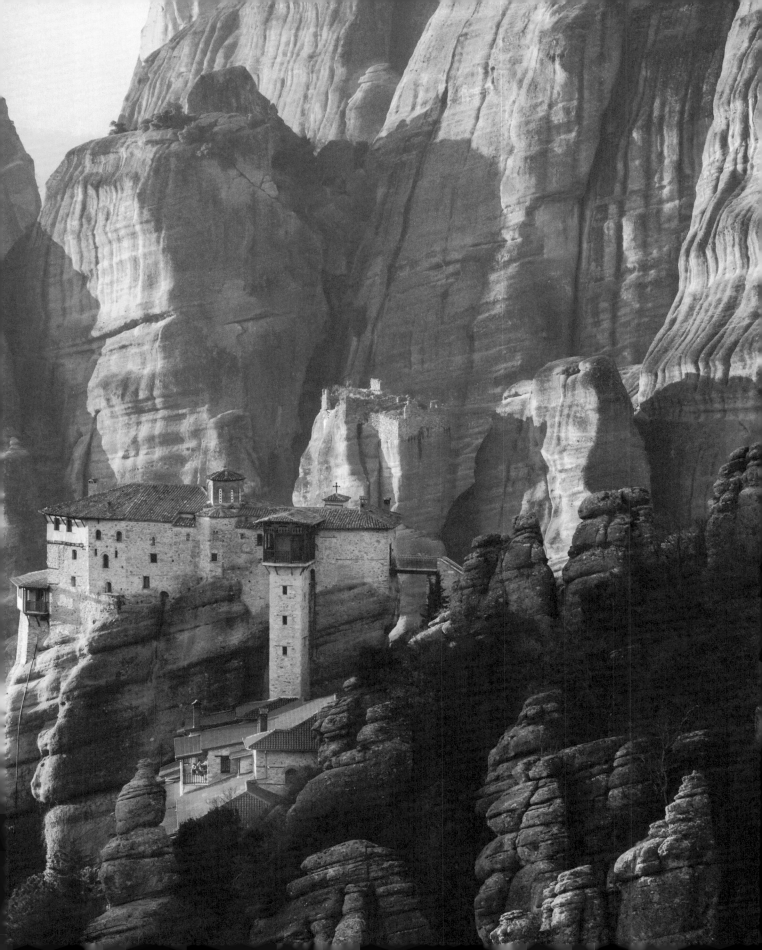

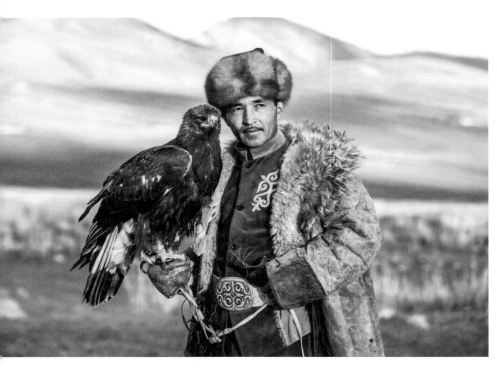

Eagle hunter, Kyrgyzstan *(above)*. Traditional meal, Tajikistan *(right)*. Remote community, Kyrgyzstan *(opposite)*. Lut Desert, Iran *(below)*.

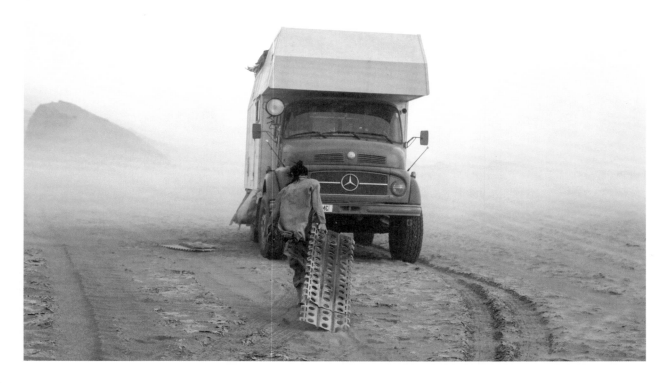

→ Akela

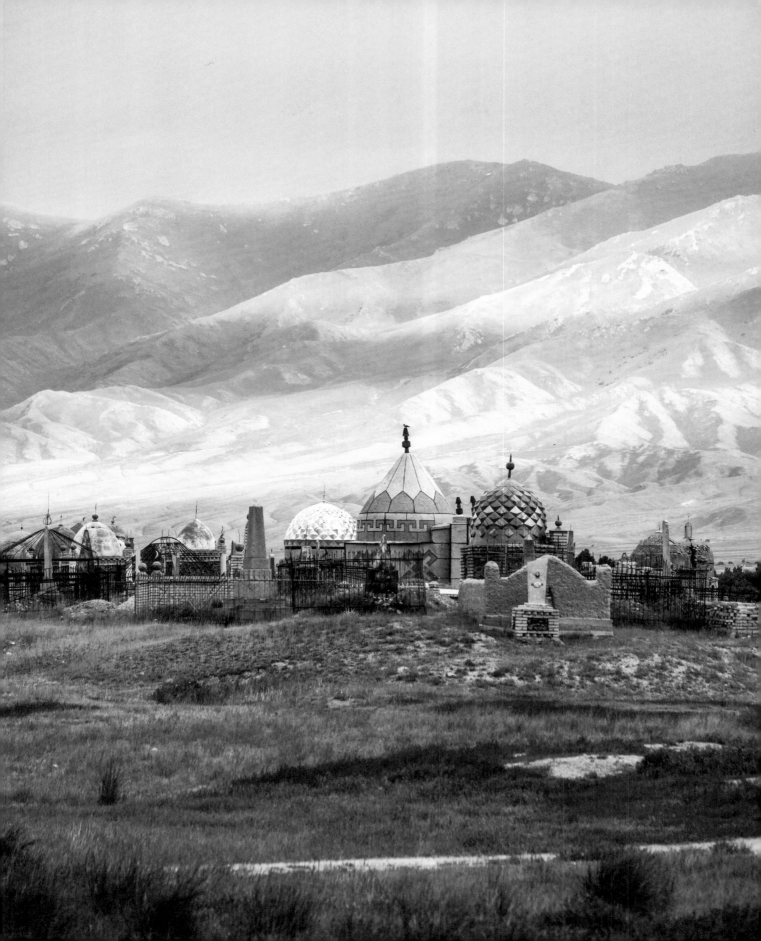

They reached the beaches of Greece by way of Kosovo and Albania, then crossed into Turkey and began their pan-Asia journey, driving for nine months across the continent to reach the very southeastern tip of Russia at Vladivostok, almost to Japan, and finally onto the overnight Russian ferry across the Sea of Japan to South Korea. This portion took them through Iran, Azerbaijan, Kazakhstan, Uzbekistan, Tajikistan, Kyrgyzstan, and Mongolia, with the Southeast Asia leg planned for 2018, which will take them across the narrow straits of Indonesia to Australia, and their ultimate destination across the sea.

After three years on the road with a boy who's almost ready for school, they remain focused on the goal and bask in their independence. "We are always close to nature and interested in foreign cultures," they share. "Curious and adventurous and immersed in the everyday life of foreign countries, a feeling that only travelers can probably understand. It is a feeling as if time would stand still—absolute freedom." ■

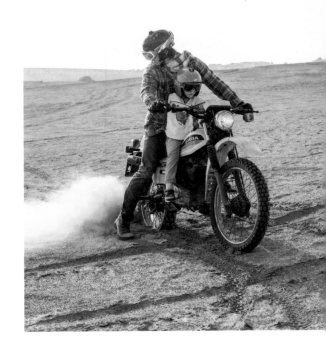

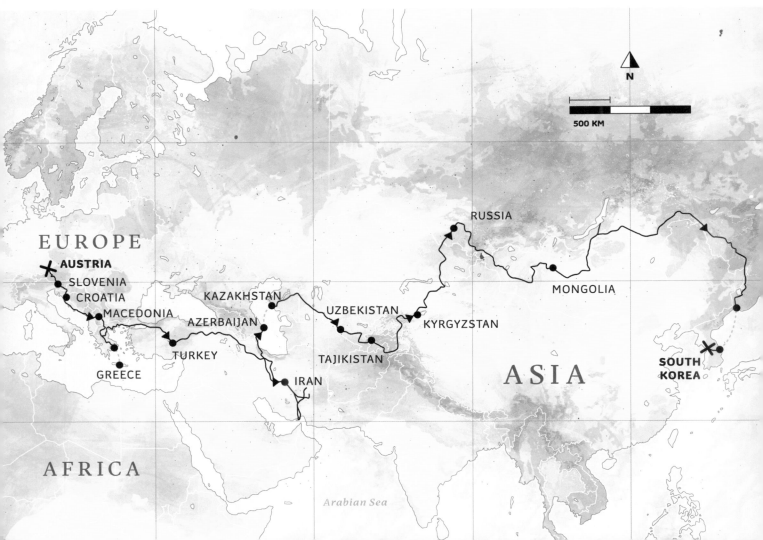

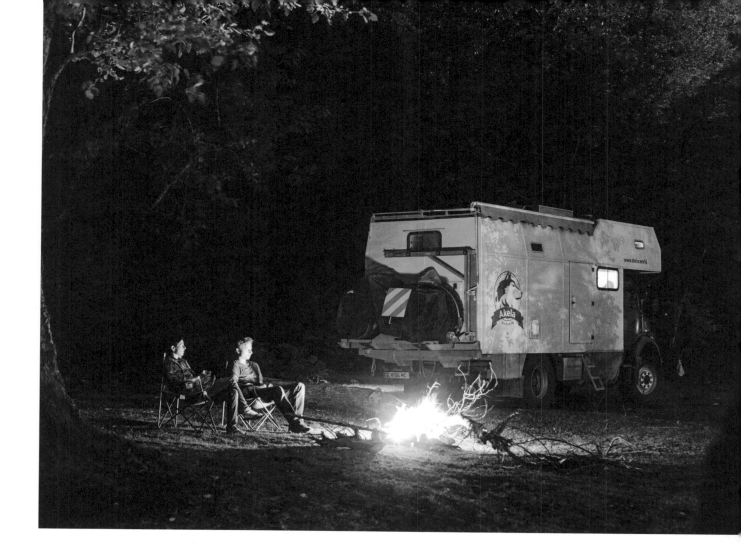

MERCEDES-BENZ LA 911 B

Rust made its mark on the original cabin of this 1977 Mercedes-Benz LA 911 B, calling for a complete refurbishment. Leander rebuilt the box with a steel frame and glued aluminum panels, building a complete lightweight cabin. Technically, the truck is almost original, with a reliable 130-horsepower, 5.6-liter diesel engine. The custom living cabin is furnished with wood floors, a kitchen with woodstove, a full-size bed, sitting area, full bathroom with shower, plus a cozy kids' area and a pre-heater. A roof rack for the solar panels was added, as well as a swiveling rack for spare tires and a Honda XL 500 Enduro.

MANUFACTURER: Mercedes-Benz
MODEL: LA 911 B
YEAR OF PRODUCTION: 1977
ENGINE: 5.6 L six cylinder, 130 hp
TRANSMISSION:
Five-speed manual
VISITED COUNTRIES:
Austria, Slovenia, Croatia, Albania, Kosovo, Montenegro, Macedonia, Greece, Turkey, Iran, Azerbaijan, Kazakhstan, Uzbekistan, Tajikistan, Kyrgyzstan,

Russia, Mongolia, South Korea
MILES IN TOTAL: 9,300 miles
TRAVEL TIME: 9 months
REBUILD—YEAR: 2014–16
REBUILD—BODYWORK MODIFICATIONS:
Insulated aluminum cabin, windows
REBUILD—INTERIOR MODIFICATIONS:
Wooden floor, kitchen, bath incl. toilet and shower, sitting area, alcoves, kids' area, Dometic Coolmatic CR110, water-jack fresh

assembly 3h, Eberspächer Airtronic D4 Plus, Elgena Nautic Therm ME boiler, Dometic Sunlight stove
REBUILD—OTHER MODIFICATIONS:
Woodstove, six Optima Yellowtop 75 Ah batteries, Goodyear Ultra Max 315 80 R22.5, solar panels, two generators (24v, 12v), Waeco reverse camera RVS 580, additional diesel tanks, rack with spare tires, and Honda XL 500

257

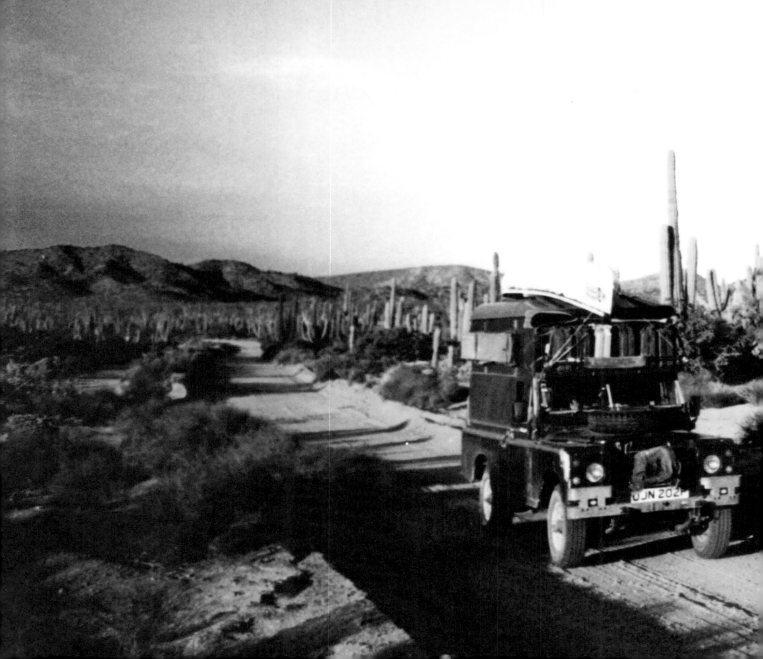

ROUND THE WORLD IN TWENTY YEARS

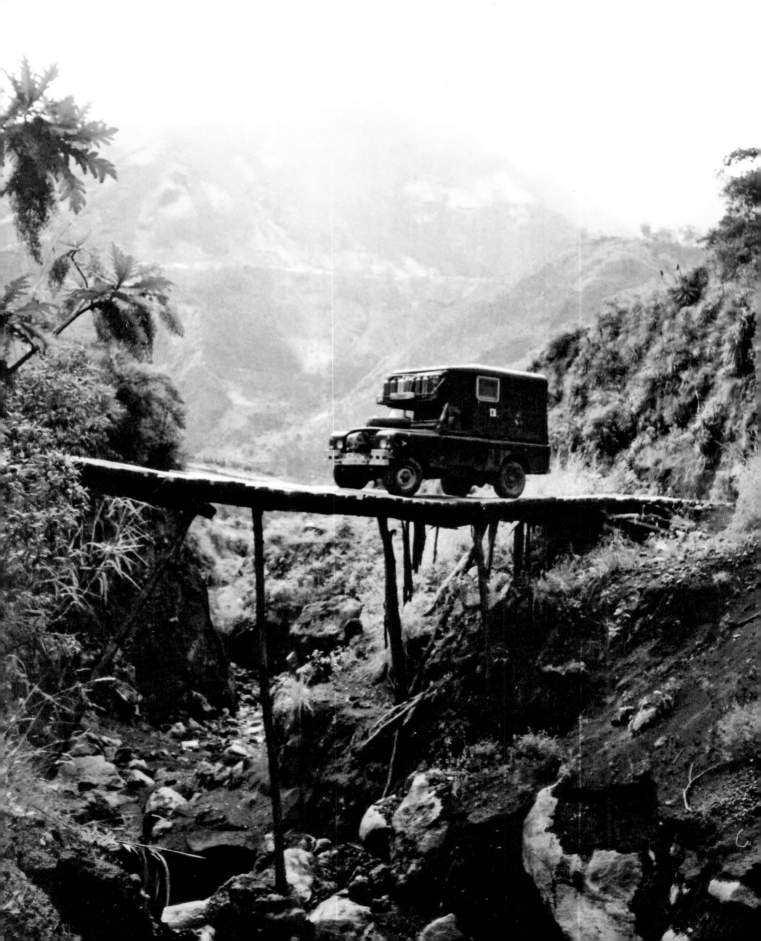

"For me, travel is 'normal.' Raising a family would be 'adventurous.'"

Wandering reestablishes the original harmony which once existed between man and the universe," wrote Anatole France. And once you reestablish that harmony, what argument is there for shedding it all over again by returning to the industrial world? German-American adventurer Christopher Many set out at the age of 27 with a grand scheme to motorcycle from Germany to New Zealand via India. That was 1997, and he never came back.

Even after 250,000 miles (400,000 km) and two decades of roving—eight years in an ancient, indefatigable →

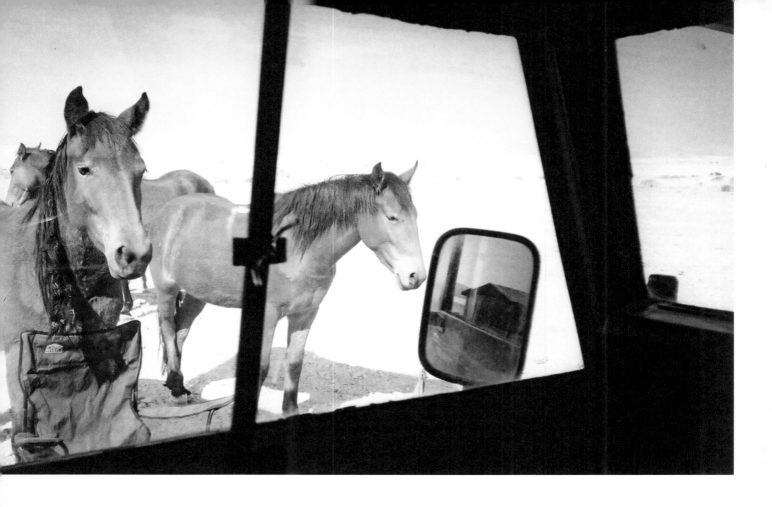

ex-military Land Rover and twelve on his trusty Yamaha Ténéré XTZ660—the only thing Christopher knows for sure is that too much of the world remains unseen. These days he explores side-by-side with his partner, travel writer Laura Pattara. "Vagabonding for a living is highly enjoyable and has become my way of life," he states. "We'll continue to live in a vehicle and overland around the globe. Life is extremely enjoyable once you've discovered your passion, no matter whether this means raising a family, devoting your life to music, the arts, sport, a profession…or traveling and writing books."

The 3,000-day, 100-country decade in the Land Rover began in 2002 on a Scottish work break after Christopher's initial motorcycle trip. The 1975 long-wheelbase Series III was a former member of the U.K. Parachute Regiment and had spent its early years being dropped from airplanes. Christopher found it, barely serviceable, in the possession of a Highlands sheep farmer who was asking only £700. With two friends he spent a month adding a roof extension and various fittings. And then it was time to put his faith in Matilda, the name he bestowed upon her.

→ Beyond the Horizon

Flipped Rover, Namibia *(above)*. Descent from the mountains *(opposite top)*. Stopping for repairs, Mongolia *(opposite bottom)*. Stripped-down Land Rover chassis *(right)*.

→ Beyond the Horizon

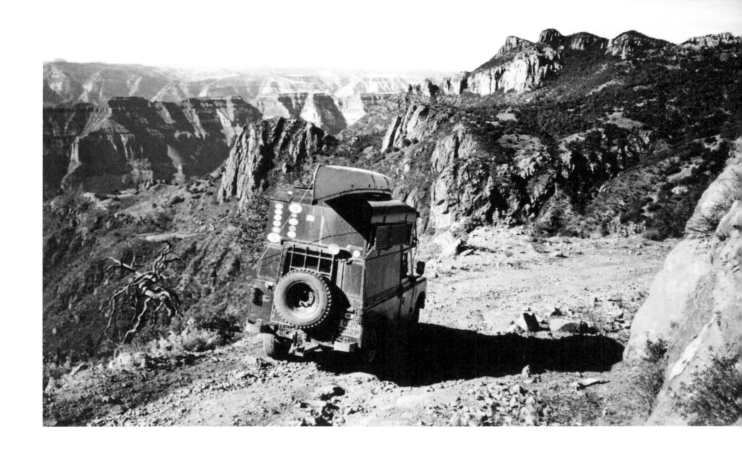

Yet faith alone couldn't prevent Matilda from mis-behaving. "The number of breakdowns I had was enormous: Precisely 1,667 times in 3,000 days I had to unpack my toolbox, open the bonnet, and tinker with faulty components. I bled the brakes 52 times, replaced 86 brake shoes, 59 suspension bushes, 20 suspension leaves, 8 universal joints, 2 prop shafts, and 65 flat tyres, and renewed 40 spark plugs, 18 con-densers, 4 coils, 12 contact-breaker plates, 4 distrib-utor caps, plus the 3 gearbox rebuilds." The steering unit seized on a steep mountain pass in Chile, the gears disintegrated on Bolivia's "Death Road," and Matilda even rolled over twice in Namibia.

He's been back on the Yamaha with Laura since 2012, traveling from Germany to Australia via China, exploring much of Europe and Asia en route. After this long on the move, Christopher is quick to point out that settled individuals are often too afraid to even contemplate long-term travels. However, the so-called challenges of road life are relative once you've been do-ing it most of your life. "I love the fact that every day is different and the pace too fast for acclimatizing," →

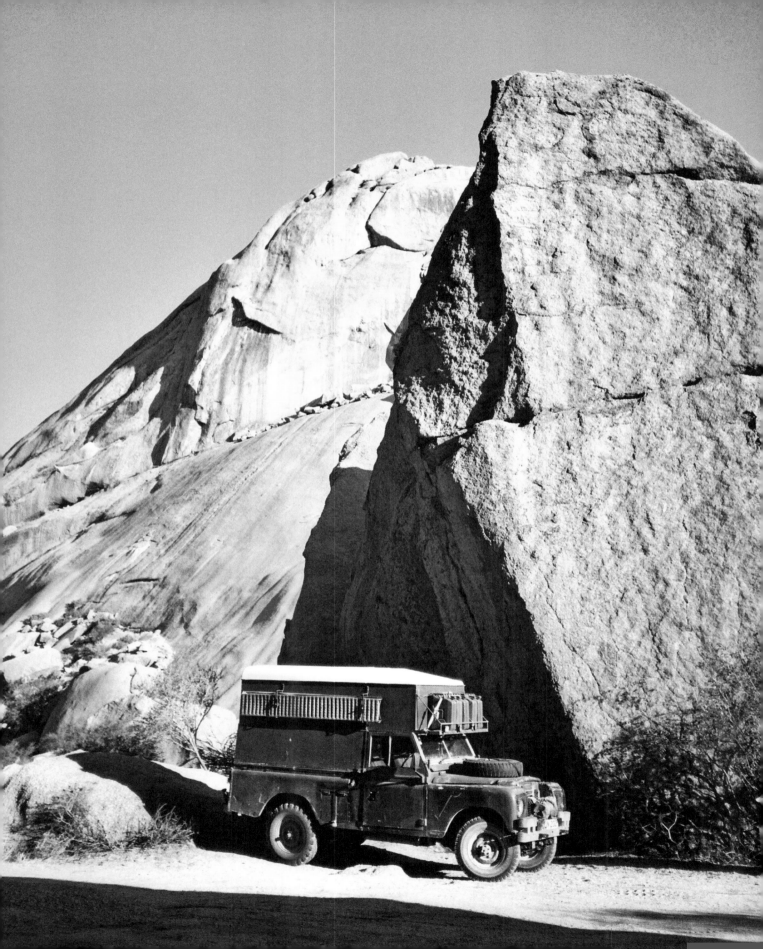

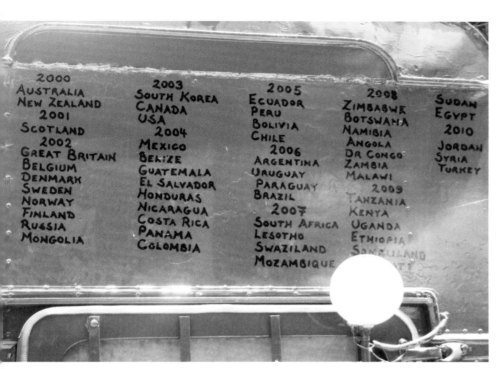

2000	2003	2005	2008	
AUSTRALIA	SOUTH KOREA	ECUADOR	ZIMBABWE	SUDAN
NEW ZEALAND	CANADA	PERU	BOTSWANA	EGYPT
2001	USA	BOLIVIA	NAMIBIA	2010
SCOTLAND	2004	CHILE	ANGOLA	JORDAN
2002	MEXICO	2006	DR CONGO	SYRIA
GREAT BRITAIN	BELIZE	ARGENTINA	ZAMBIA	TURKEY
BELGIUM	GUATEMALA	URUGUAY	MALAWI	
DENMARK	EL SALVADOR	PARAGUAY	2009	
SWEDEN	HONDURAS	BRAZIL	TANZANIA	
NORWAY	NICARAGUA	2007	KENYA	
FINLAND	COSTA RICA	SOUTH AFRICA	UGANDA	
RUSSIA	PANAMA	LESOTHO	ETHIOPIA	
MONGOLIA	COLOMBIA	SWAZILAND	SOMALILAND	
		MOZAMBIQUE		

The on-vehicle country log *(above)*. Palmyra, Syria *(right)*. Riding an iceberg *(below)*. Land Rover beneath rocky shelter *(opposite)*.

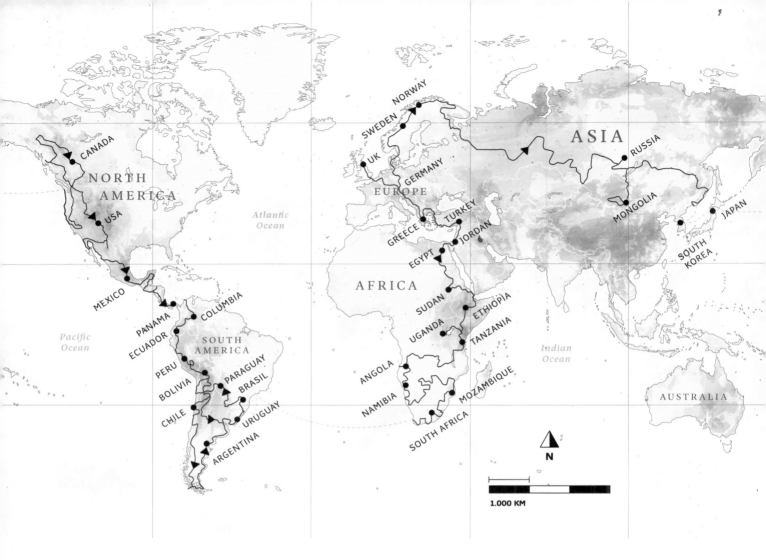

he says. "I have far fewer problems than your average homeowner with a nine-to-five job and a family to feed. For me, travel is 'normal.' Raising a family would be 'adventurous' and a 'real challenge.'"

"Generally speaking," explains Christopher, "we belong to a large nomadic community of independence-loving people, for whom freedom of movement is the main pillar of its unwritten constitution. It's a non-hierarchical society without authority. It's impossible to formulate an ideology with which every overlander agrees, but most believe in sacred personal freedoms: the right to wild-camp, to build a fire where you choose, to live in a camper without violating address-registration laws, to hunt and fish unlicensed when hungry."

Christopher's books *Left Beyond the Horizon* and *Right Beyond the Horizon* are bestsellers in Germany and are now also available in English. It appears most certain that he plans to continue exploring what lies beyond the horizon for a long time to come. ∎

→ Beyond the Horizon

LAND ROVER SERIES III

Over the past 20 years, Christopher has traveled to over 100 countries across 250,000 miles (400,000 km) with his Land Rover and his Yamaha. Few vehicles can successfully handle such a journey. Eight out of twenty years he traveled with Matilda, his four-speed manual 1975 Land Rover Series III (see his journey by car on the map, opposite). Series III production ran from 1971–1985, continuing an off-road British legacy established by the original Land Rover in 1947. Originally purchased for just £700 in the Scottish Highlands, he spent only an additional $550 for the camper conversion. Through the course of his travels he has unscrewed nearly every bolt.

MANUFACTURER: Land Rover
MODEL: Series III
YEAR OF PRODUCTION: 1975
ENGINE: 2286cc four cylinder, 72 hp
TRANSMISSION: Manual
VISITED COUNTRIES: Kenya, Lesotho, Swaziland, Mozambique, Zimbabwe, Botswana, Namibia, Angola, DR Congo, Zambia, Malawi, Tanzania, Tunisia, Uganda, Ethiopia, South Africa, Somaliland, Djibouti, Sudan, Egypt, Myanmar, India, Iran, South Korea, Laos, Malaysia, Mongolia, Nepal, Pakistan, Russian Federation, Singapore, Thailand, Turkey, Jordan, Syria, Georgia, Armenia, Azerbaijan, Kazakhstan, Uzbekistan, Tajikistan, Kyrgyzstan, China, Cambodia, Vietnam, Indonesia, Albania, Austria, Belgium, Bosnia and Herzegovina, Bulgaria, Croatia, Czech Republic, Denmark, Finland, France, Germany, Greece, Hungary, Italy, Kosovo, Liechtenstein, Luxemburg, Macedonia, Monaco, the Vatican, Montenegro, Netherlands, Norway, Poland, Romania, San Marino, Slovenia, Spain, Sweden, Switzerland, United Kingdom, Belize, Canada, Costa Rica, El Salvador, Guatemala, Honduras, Mexico, Nicaragua, Panama, United States, Bolivia, Columbia, Ecuador, Peru, Chile, Argentina, Uruguay, Brazil, Paraguay, Australia, New Zealand
MILES IN TOTAL: 125,000 miles
(by Land Rover only)

TRAVEL TIME: 20 years
(by Land Rover and motorcycle)
REBUILD—YEAR: 2002
REBUILD—BODYWORK MODIFICATIONS:
Roof extension, additional side window
REBUILD—CHASSIS MODIFICATIONS:
Original factory condition
REBUILD—INTERIOR MODIFICATIONS:
Coffee percolator, kitchenette, folding bed, cupboards, running water from 40-liter tank, "dining area" (i.e. a folding table), three fuel tanks under the seat, sink, stove
REBUILD—OTHER MODIFICATIONS:
Eight 20-liter jerricans
REBUILD—SUPPORT BY: Friends

269

INDEX

A2A EXPEDITION
The Bell Family
South Africa
www.a2aexpedition.com
pp. 230–235
Photography: Luisa and Graeme Bell

AKELA
Maria Zehentner, Leander Nardin, and Lennox
Austria
www.akela.world
pp. 246–257
Photography: Leander Nardin

AMANDA'S NORTH AMERICAN ADVENTURE
Amanda Sandlin
United States
www.amandasandlin.com
pp. 42–47
Photography: Amanda Sandlin

BETTY THE GREY WOLF
Travis Burke
United States
www.travisburkephotography.com
pp. 104–109
Photography: Travis Burke

BEYOND THE HORIZON
Christopher Many
Germany
www.christopher-many.com
pp. 258–269
Photography: Christopher Many

BOREAL FOLK
Raphaëlle Gagnon and Mark Coelho
Canada
www.borealfolk.ca
pp. 118–125
Photography: Kelly Brown (pp. 118, 120–121, 123
top right and left) and Mackenzie Duncan
(pp. 119, 122, 123 bottom, 124–125)

DAIHATSU HIJET
Daniel Kalinowski
Germany
www.woodkali.de
pp. 142–143
Photography: Daniel Kalinowski

DESK TO GLORY
Ashley and Richard Giordano
Canada
www.desktoglory.com
pp. 2, 220–229
Photography: Richard Giordano

DIRT LEGENDS
Samantha Noll and Scott Channing Hall
United States
www.dirtlegends.tumblr.com
opposite imprint, pp. 202–209
Photography: Samantha Noll and
Scott Channing Hall

EMIL THE SPRINTER VAN
Julia Nimke
Germany
www.julianimke.com
pp. 4–5, 50–57
Photography: Julia Nimke

FOLLOW THE WHITE MOG
Ananda Rani and Marco Lars Bräunig
Germany
www.laengexbreitexweite.com
pp. 236–245
Photography: Marco Lars Bräunig

HERMAN THE GERMAN
Brittany Hart and Brook James
Australia
www.brookjamesphoto.com
pp. 144–151
Photography: Brook James (pp. 144–146, 147 top,
148–151) and Brittany Hart (p. 147 bottom)

IAMNOMAD
Francis Fraioli and Alexandre Marcouiller
Canada
www.iamnomad.ca
pp. 32–41
Photography: Francis Fraioli and
Alexandre Marcouiller

LIVE WORK WANDER
Jorge and Jessica Gonzalez
United States
www.liveworkwander.com
pp. 7, 162–171
Photography: When the Road is Home (p. 7)
Jorge Gonzalez (pp. 162–163, 164 top, 166 top,
170–171), Aidan Klimenko (pp. 164 bottom, 165,
167 top), Mary Ashley Krogh
(p. 167 bottom), and Sean Grimes (pp. 168–169)

MELODY BARKVAN
James Barkman
United States
www.jamesbarkman.com
pp. 194–201
Photography: James Barkman

MOORMANN'S HOLZKLASSE
Nils Holger Moormann
Germany
www.moormann.de
pp. 74–75
Photography: We Make Them Wonder

MOUNTAIN MODERN AIRSTREAM
United States
www.mtnmodernairstream.com
pp. 70–73

NAVIGATION NOWHERE
Michael Fuehrer
United States
www.navigationnowhere.com
pp. 58–65
Photography: Michael Fuehrer (pp. 58–59, 61–62, 63 middle, 64 bottom, 65 top), Annie Montero (p. 60 top), Coriann Grunstra (pp. 60 middle left, 65 bottom right), and Luke Witten (p. 63 top)

NORDICAMPER
Maria and Henri Vanonen
Finland
vai-ko.com
pp. 90–95
Photography: Maria and Henri Vanonen

PASSPORT DIARY
Christina Klein and Paul Nitzschke
Germany
www.passport-diary.com
pp. 172–177
Photography: Paul Nitzschke

PINE PINS
Selina Mei and Frank Stoll
Germany
www.instagram.com/pinepins
opposite title page, pp. 82–89
Photography: Selina Mei and Frank Stoll

RADIUS & ULNA
Cécile Bertrand and Simon Doreau-Deléris
France
www.radius-ulna.com
pp. 22–27, 30–31
Photography: Cécile Bertrand and Simon Doreau-Deléris

ROAD FOR GRETA
Ana Domínguez Pérez and Marco Alonso
Spain
www.roadforgreta.com
pp. 16–21
Photography: Ana Domínguez Pérez and Marco Alonso

ROVING DOWN SOUTH
Lilli Gramberg-Danielsen and Lukas Beuster
Germany/South Africa
www.instagram.com/rovingplaces
pp. 184–193
Photography: Lilli Gramberg-Danielsen and Lukas Beuster

SARAH GLOVER
Australia
www.sarahglover.com.au
pp. 28–29, 48–49, 102–103
Photography: Luisa Brimble

THE AFRICAN PORSCHE EXPEDITION
Ben Coombs
United Kingdom
www.pub2pubexpedition.com
pp. 178–183
Photography: Ben Coombs

THE BEERMOTH
United Kingdom
www.canopyandstars.co.uk
pp. 134–137

THE HAPPIER CAMPER
Derek Michael
United States
www.happiercamper.com
pp. 126–127

THE HOUSE BOX
Dean Crago and Jake Churchill
United Kingdom
www.house-box.co.uk
pp. 130–133
Photography: Will Bunce

THE SYNCRONICLES
Rob Heran and Sebastian Doerk
Germany
www.thesyncronicles.com
pp. 210–219
Photography: Sebastian Doerk

THE TARDIS
Katch Silva and Ben Sasso
United States
www.katchsilva.com
pp. 76–81
Photography: Katch Silva

THE VAN PROJECT
Amanda Winther and Matthew Swartz
United States
www.thevanproject.com
endpapers, pp. 110–117
Photography: Antonin Oulicky (pp. 110–111), Matthew Swartz (endpapers, pp. 112–114, 115 top, 116–117), and Amanda Winther (p. 115 bottom)

TINY HOUSE EXPEDITION
Alexis Stephens and Christian Parsons
United States
www.tinyhouseexpedition.com
pp. 138–141
Photography: Christian Parsons

TRAIL HEADS OFFICE CARAVAN
Trail Heads
Japan
www.trailheads.jp
pp. 128–129
Photography: Yuya Shimahara

WE ARE NOMADS
Cali Laffranconi and Connan Schilling
Argentina
www.wanomads.blog
pp. 8–15
Photography: Cali Laffranconi and Connan Schilling

WE GON DIRTIN
Karissa Hosek and Linhbergh Nguyen
United States
www.linhbergh.com
pp. 152–161
Photography: Karissa Hosek and Linhbergh Nguyen

WE TRAVEL BY BUS
Julie Toebel and Kai Branss
Germany
www.instagram.com/wetravelbybus
pp. 96–101
Photography: Kai Branss

WINNEBAGO BRAVE
Liz and Tim Kamarul
United States
www.lizkamarul.com
pp. 66–69
Photography: Liz Kamarul

Hit the Road

Vans, Nomads and Roadside Adventures

This book was conceived, edited, and designed by Gestalten.

Edited by Robert Klanten and Maximilian Funk

Preface by Chris Scott
Travel reports by Guy Weress (except The African Porsche Expedition by Ben Coombs)
Vehicle descriptions by Christopher Fussner
Cooking tips by Linhbergh Nguyen
Recipes by Cécile Bertrand and Simon Doreau-Deléris, Sarah Glover, and Linhbergh Nguyen

Design by Britta van Kesteren
Layout and Cover by Mona Osterkamp
Creative Direction of Design by Ludwig Wendt
Maps by Bureau Rabensteiner

Project Management by Cyra Pfennings

Typefaces: Eskorte Latin by Elena Schneider and Ovink by Sofie Beier
Cover photography by Sebastian Doerk

Printed by Nino Druck GmbH, Neustadt/Weinstr.
Made in Germany

Published by Gestalten, Berlin 2018
ISBN 978-3-89955-938-5

3rd printing, 2018

Bibliographic information published by the Deutsche Nationalbibliothek. The Deutsche Nationalbibliothek lists this publication in the Deutsche Nationalbibliografie; detailed bibliographic data are available online at http://dnb.d-nb.de.

None of the content in this book was published in exchange for payment by commercial parties or designers; Gestalten selected all included work based solely on its artistic merit.

This book was printed on paper certified according to the standards of the FSC®.

FSC
www.fsc.org

MIX
Paper from
responsible sources
FSC® C006655

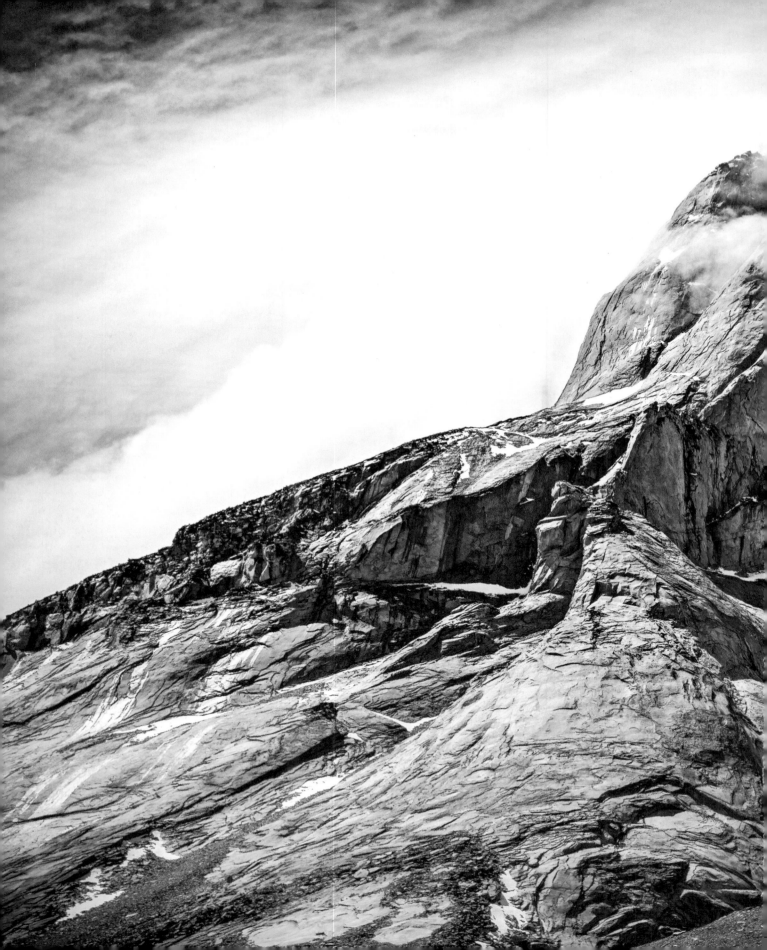